Joe Sacco

JONATHAN CAPE
LONDON

Dedicated to

Kenji, Erlis, Jamileh, Jad, Jemal, and Shafeek

HOMAGE TO JOE SACCO

by Edward Said

Comic books are a universal phenomenon associated with adolescence. They seem to exist in all languages and cultures, from East to West. In subject matter they go the whole range from inspired and fantastic to sentimental and silly; all of them, however, are easy to read, to pass around, store, and throw away. Many comics are like *Asterix* and *Tin-Tin*, a continuing serial adventure for the young people who read them faithfully month after month; over time, like the two I mentioned, they seem to acquire a life of their own, with recurring characters, plot situations, and phrases that turn their readers, whether in Egypt, India or Canada, into a sort of club in which every member knows and can refer to a whole set of common assumptions and names. Most adults, I think, tend to connect comics with what is frivolous or ephemeral, and there is an assumption that as one grows older they are put aside for more serious pursuits, except very occasionally (as is the case with Art Spiegelman's *Maus*) when a forbiddingly grim subject is treated by a serious comic book artist. But, as we shall soon see, these are very rare occasions indeed, since what is first of all required is a first-rate talent.

I don't remember when exactly I read my first comic book, but I do remember exactly how liberated and subversive I felt as a result. Everything about the enticing book of colored pictures, but specially its untidy, sprawling format, the colorful, riotous extravagance of its pictures, the unrestrained passage between what the characters thought and said, the exotic creatures and adventures reported and depicted: all this made up for a hugely wonderful thrill, entirely unlike anything I had hitherto known or experienced.

My incongruously Arab Protestant family and education in the colonial post World War Two Middle East were very bookish and academically very demanding. An unremitting sobriety governed all things. These were certainly not the days either of television, or of numerous easily available entertainments. Radio was our link to the outside world, and because Hollywood films were considered both inevitable and somehow morally risky, we were kept to a regimen of one per week, each carefully vetted by my parents, certified by some unrevealed (to us) standard of judgment as acceptable and therefore not *bad* for children.

Not quite thirteen, I entered high school just after the fall of Palestine in 1948. Like all the members of my family, male and female, I was enrolled in British schools, which seemed to be modeled after their story-book equivalents in *Tom Brown's Schooldays* and the various accounts of Eton, Harrow, Rugby that I had gleaned from my omnivorous reading of almost exclusively English books. In that late imperial setting of a highly conflicted world of mostly Arab and Levantine children, British teachers, in largely Muslim Arab countries themselves undergoing turbulent change, where the curriculum was based on the Oxford and Cambridge School Certificate (as the standardized English high school diploma was called in those days), the sudden intrusion of American comic books

Japanese photographer Saburo (who seems to get lost at one point), Joe is a listening, watchful pres-ence, sometimes skeptical, sometimes fed up, but mostly sympathetic and funny, as he notes that a cup of Palestinian tea is often drowned in sugar, or how perhaps involuntarily they congregate in order to exchange tales of woe and suffering, the way fishermen compare the size of their catch or hunters the stealth of their prey.

The cast of characters in the many episodes collected here is wondrously varied and, with the comic draughtsman's uncanny ability to catch the telling detail, a carefully sculpted mustache here, overly large teeth there, a drab suit here, Sacco manages to keep it all going with almost careless virtuosity. The unhurried pace and the absence of a goal in his wanderings emphasizes that he is neither a journalist in search of a story nor an expert trying to nail down the facts in order to pro-duce a policy. Joe is there to be in Palestine, and only that — in effect to spend as much time as he can sharing, if not finally living the life that Palestinians are condemned to lead. Given the reali-ties of power and his identification with the underdog, Sacco's Israelis are depicted with an unmis-takable skepticism, if not always distrust. Mostly they are figures of unjust power and dubious authority. I am not referring only to obviously unattractive personages like the many soldiers and settlers who keep popping up to make life for Palestinians difficult and deliberately unbearable but, especially in one telling episode, even the so-called peaceniks whose support for Palestinian rights appears so hedged, so timid, and finally ineffective as to make them also objects of disappointed scorn.

Joe is there to find out why things are the way they are and why there seems to have been an impasse for so long. He is drawn to the place partly because (we learn from an exceptionally weird earlier comic *War Junkie*) of his Maltese family background during World War Two, partly because the post-modern world is so accessible to the young and curious American, partly because like Joseph Conrad's Marlow he is tugged at by the forgotten places and people of the world, those who don't make it on to our television screens, or if they do, who are regularly portrayed as marginal, unim-portant, perhaps even negligible were it not for their nuisance value which, like the Palestinians, seems impossible to get rid of. Without losing the comics' unique capacity for delivering a kind of surreal world as animated and in its own way as arrestingly violent as a poet's vision of things, Joe Sacco can also unostentatiously transmit a great deal of information, the human context and historical events that have reduced Palestinians to their present sense of stagnating powerlessness, despite the peace process and despite the sticky gloss put on things by basically hypocritical leaders, policy-makers and media pundits.

Nowhere does Sacco come closer to the existential lived reality of the average Palestinian than in his depiction of life in Gaza, the national Inferno. The vacancy of time, the drabness not to say sordidness of everyday life in the refugee camps, the network of relief workers, bereaved mothers, unemployed young men, teachers, police, hangers-on, the ubiquitous tea or coffee circle, the sense of confinement, permanent muddiness and ugliness conveyed by the refugee camp which is so

by Edward Said

iconic to the whole Palestinian experience: these are rendered with almost terrifying accuracy and, paradoxically enough, gentleness at the same time. Joe the character is there sympathetically to understand and to try to experience not only why Gaza is so representative a place in its hopelessly overcrowded and yet rootless spaces of Palestinian dispossession, but also to affirm that it is there, and must somehow be accounted for in human terms, in the narrative sequences with which any reader can identify.

If you pay attention therefore you will note the scrupulous rendering of the generations, how children and adults make their choices and live their meager lives, how some speak and some remain silent, how they are dressed in the drab sweaters, miscellaneous jackets, and warm *hattas* of an improvised life, on the fringes of their homeland in which they have become that saddest and most powerless and contradictory of creatures, the unwelcome alien. You can see this all in a sense through Joe's own eyes as he moves and tarries among them, attentive, unaggressive, caring, ironic, and so his visual testimony becomes himself, himself so to speak in his own comics, in an act of the profoundest solidarity. Above all, his Gaza series animates and confirms what three other remarkable witnesses before him, all of them women, have written about (one of them Israeli, another one American-Jewish, a third one an American with no previous connection with the Middle East) so unforgettably: Amira Hass, the brave Israeli *Ha'aretz* correspondent who lived in and wrote about Gaza for four years, Sara Roy, who wrote the definitive study of how Gaza's economy was de-developed, and Gloria Emerson, prize-winning journalist and novelist who gave a year of her time to live among the people of Gaza.

But what finally makes Sacco so unusual a portrayer of life in the Occupied Palestinian Territories is that his true concern is finally history's victims. Recall that most of the comics we read almost routinely conclude with someone's victory, the triumph of good over evil, or the routing of the unjust by the just, or even the marriage of two young lovers. Superman's villains get thrown out and we hear of and see them no more. Tarzan foils the plans of evil white men and they are shipped out of Africa in disgrace. Sacco's *Palestine* is not at all like that. The people he lives among are history's losers, banished to the fringes where they seem so despondently to loiter, without much hope or organization, except for their sheer indomitability, their mostly unspoken will to go on, and their willingness to cling to their story, to retell it, and to resist designs to sweep them away altogether. Astutely, Sacco seems to distrust militancy, particularly of the collective sort that bursts out in slogans or verbal flag-waving. Neither does he try to provide *solutions* of the kind that have made such a mockery of the Oslo peace process. But his comics about Palestine furnish his readers with a long enough sojourn among a people whose suffering and unjust fate have been scanted for far too long and with too little humanitarian and political attention. Sacco's art has the power to detain us, to keep us from impatiently wandering off in order to follow a catch-phrase or a lamentably predictable narrative of triumph and fulfillment. And this is perhaps the greatest of his achievements.

Author's Foreword
to the complete edition of *Palestine*

This book collects all nine issues of a comic book series called *Palestine* under one cover for the first time. Previously, the series had been collected in two volumes. I wrote and drew *Palestine* after spending two months in the Occupied Territories almost ten years ago in the winter of 1991-92. Since that visit, a "peace process" was initiated, culminating in a number of agreements or near-agreements — some highly touted as "breakthrough" — and the installation of a Palestine Authority headed by Yasser Arafat in some areas from which the Israelis have withdrawn. While Nobel Peace Prizes have been awarded, no major outstanding issues — the return of or compensation for Palestinian refugees, the illegal Jewish settlements, the status of Jerusalem — have been resolved. (As far as the settlers go, they have continued to add to their number by the tens of thousands.) But even if you skip over those difficult points — and you can't — the "peace process" has not provided the Palestinian people living in territory conquered by Israel in 1967 with many tangible benefits. In fact, their land is still expropriated, their dwellings are still bulldozed, their olive groves are still uprooted. They still encounter an occupying army, as well as the settlers, who are often the armed adjuncts to the occupying army (or vice versa, it's hard to tell sometimes). Through closures and the lasting effect of long-term strangulation by Israel of the Palestinian economy, the lives of Palestinian workers and their families have been made even more wretched than they were when this work was first published. One must add the mismanagement and corruption of the Palestine Authority into the unfortunate mix.

This book is about the first intifada against the Israeli occupation, which was beginning to run out of steam at the time of my visit. As I write these words, a second intifada is taking place because, in short, Israeli occupation, and all the consequences of the domination of one people by another, has not ceased. The Palestinian and Israeli people will continue to kill each other in low-level conflict or with shattering violence — with suicide bombers or helicopter gunships and jet bombers — until this central fact — Israeli occupation — is addressed as an issue of international law and basic human rights.

Joe Sacco
July 2001

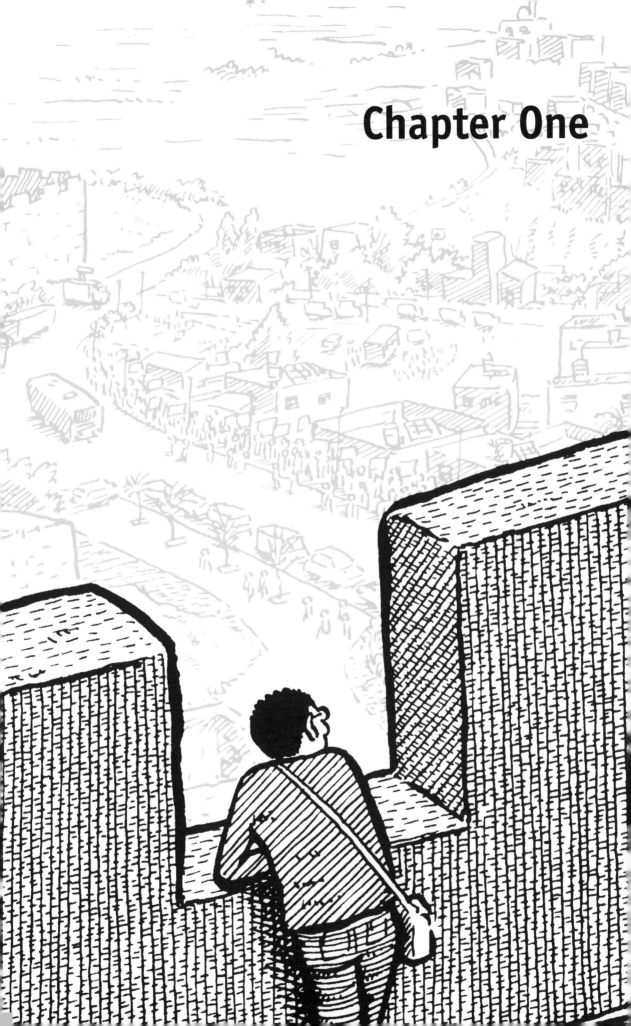

Chapter One

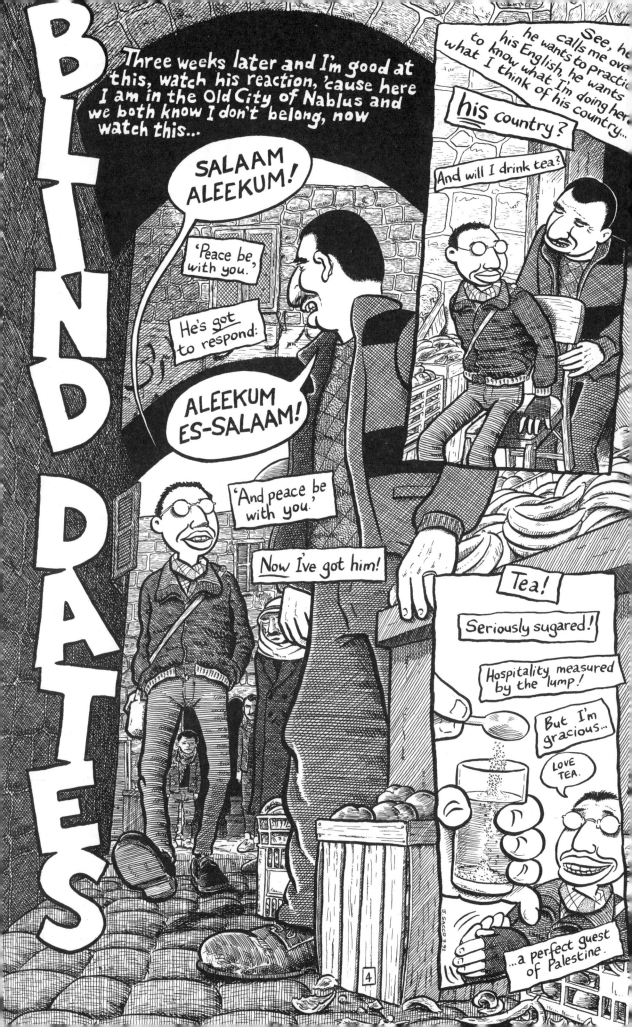

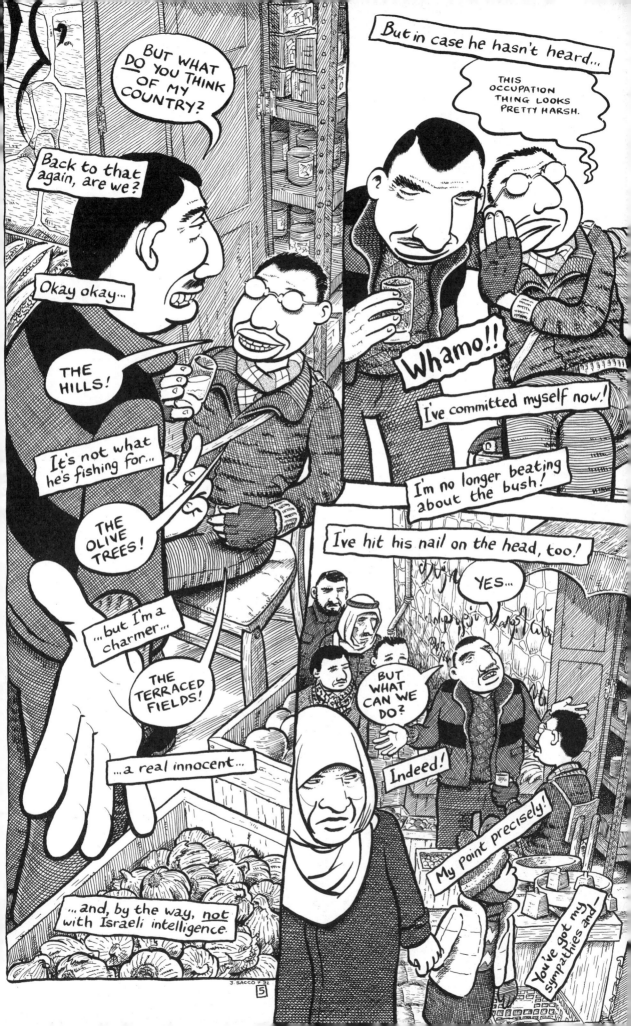

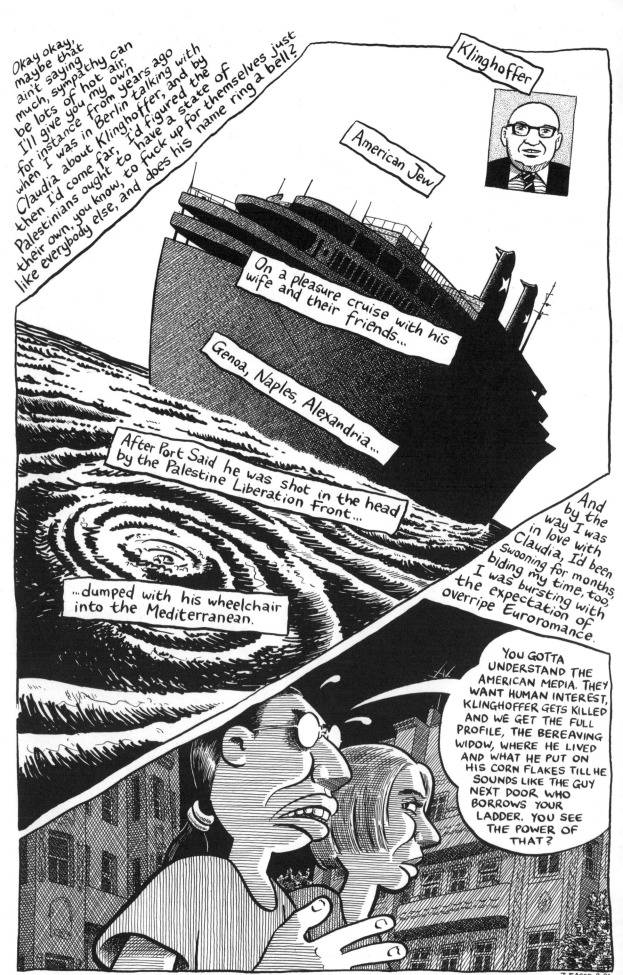

Okay okay, maybe that ain't saying much, sympathy can be lots of hot air, I'll give you my own instance from years ago when I was in Berlin talking with Claudia about Klinghoffer, and by then I'd come far, I'd figured the Palestinians ought to have a state of their own, you know, to fuck up for themselves just like everybody else, and does his name ring a bell?

Klinghoffer

American Jew

On a pleasure cruise with his wife and their friends...

Genoa, Naples, Alexandria...

After Port Said he was shot in the head by the Palestine Liberation Front...

...dumped with his wheelchair into the Mediterranean.

And by the way I was in love with Claudia, I'd been swooning for months, biding my time, too, I was bursting with the expectation of overripe Euroromance.

YOU GOTTA UNDERSTAND THE AMERICAN MEDIA. THEY WANT HUMAN INTEREST, KLINGHOFFER GETS KILLED AND WE GET THE FULL PROFILE, THE BEREAVING WIDOW, WHERE HE LIVED AND WHAT HE PUT ON HIS CORN FLAKES TILL HE SOUNDS LIKE THE GUY NEXT DOOR WHO BORROWS YOUR LADDER. YOU SEE THE POWER OF THAT?

J. SACCO 8-92

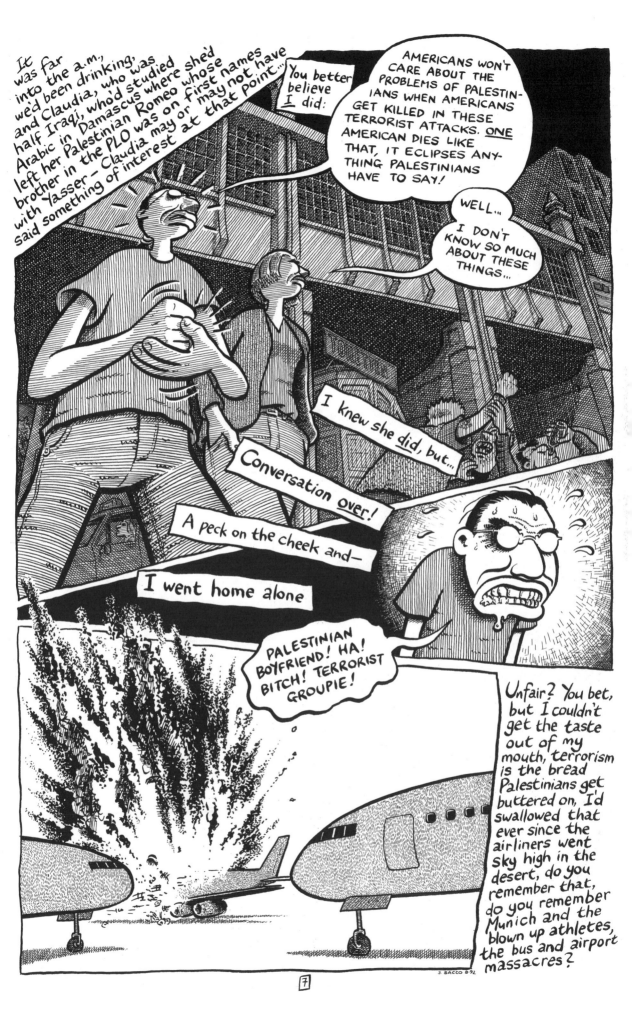

It was far into the a.m., we'd been drinking, and Claudia, who was half Iraqi, who'd studied Arabic in Damascus where she'd left her Palestinian Romeo whose brother in the PLO was on first names with Yasser— Claudia may or may not have said something of interest at that point...

You better believe I did:

AMERICANS WON'T CARE ABOUT THE PROBLEMS OF PALESTINIANS WHEN AMERICANS GET KILLED IN THESE TERRORIST ATTACKS. ONE AMERICAN DIES LIKE THAT, IT ECLIPSES ANYTHING PALESTINIANS HAVE TO SAY!

WELL... I DON'T KNOW SO MUCH ABOUT THESE THINGS...

I knew she did, but...

Conversation over!

A peck on the cheek and—

I went home alone

PALESTINIAN BOYFRIEND! HA! BITCH! TERRORIST GROUPIE!

Unfair? You bet, but I couldn't get the taste out of my mouth, terrorism is the bread Palestinians get buttered on, I'd swallowed that ever since the airliners went sky high in the desert, do you remember that, do you remember Munich and the blown up athletes, the bus and airport massacres?

J. SACCO 8·92

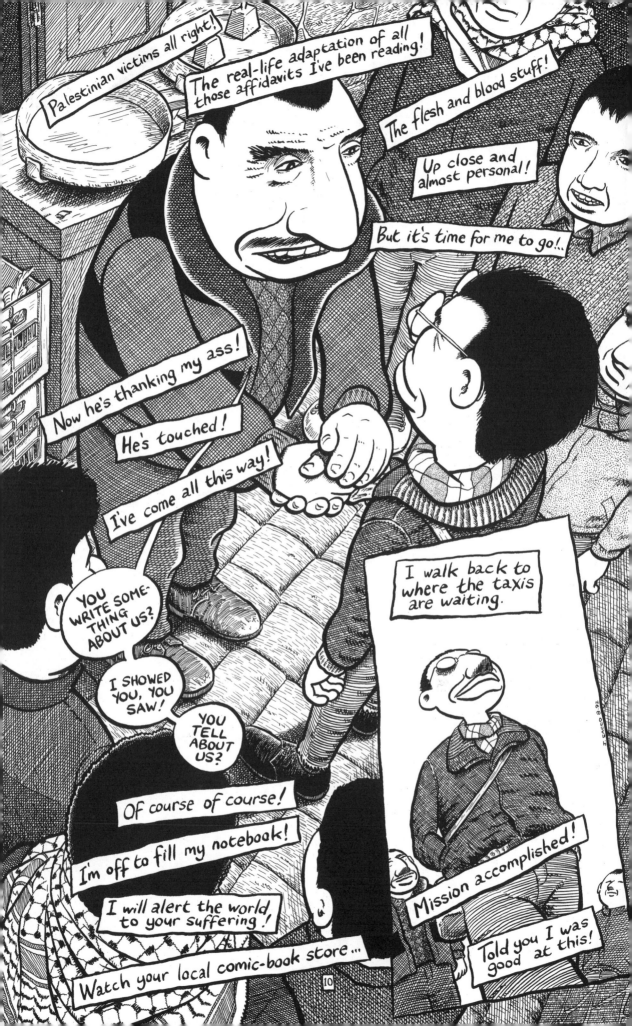

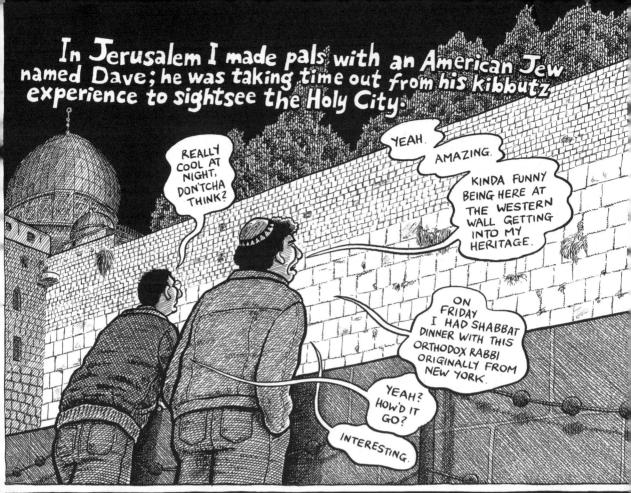

In Jerusalem I made pals with an American Jew named Dave; he was taking time out from his kibbutz experience to sightsee the Holy City.

REALLY COOL AT NIGHT, DON'TCHA THINK?

YEAH.

AMAZING.

KINDA FUNNY BEING HERE AT THE WESTERN WALL GETTING INTO MY HERITAGE.

ON FRIDAY I HAD SHABBAT DINNER WITH THIS ORTHODOX RABBI ORIGINALLY FROM NEW YORK.

YEAH? HOW'D IT GO?

INTERESTING.

RETURN

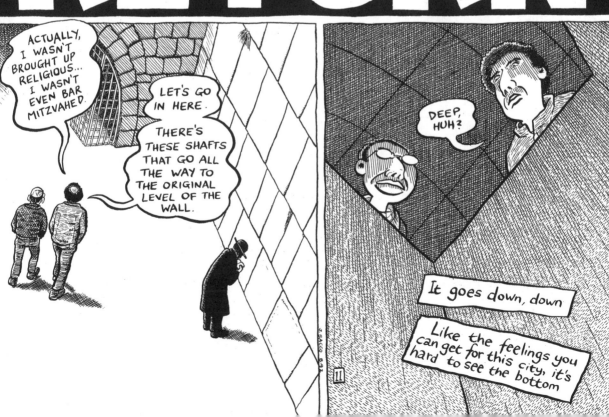

ACTUALLY, I WASN'T BROUGHT UP RELIGIOUS... I WASN'T EVEN BAR MITZVAHED.

LET'S GO IN HERE.

THERE'S THESE SHAFTS THAT GO ALL THE WAY TO THE ORIGINAL LEVEL OF THE WALL.

DEEP, HUH?

It goes down, down

Like the feelings you can get for this city; it's hard to see the bottom

J. SACCO 8.97

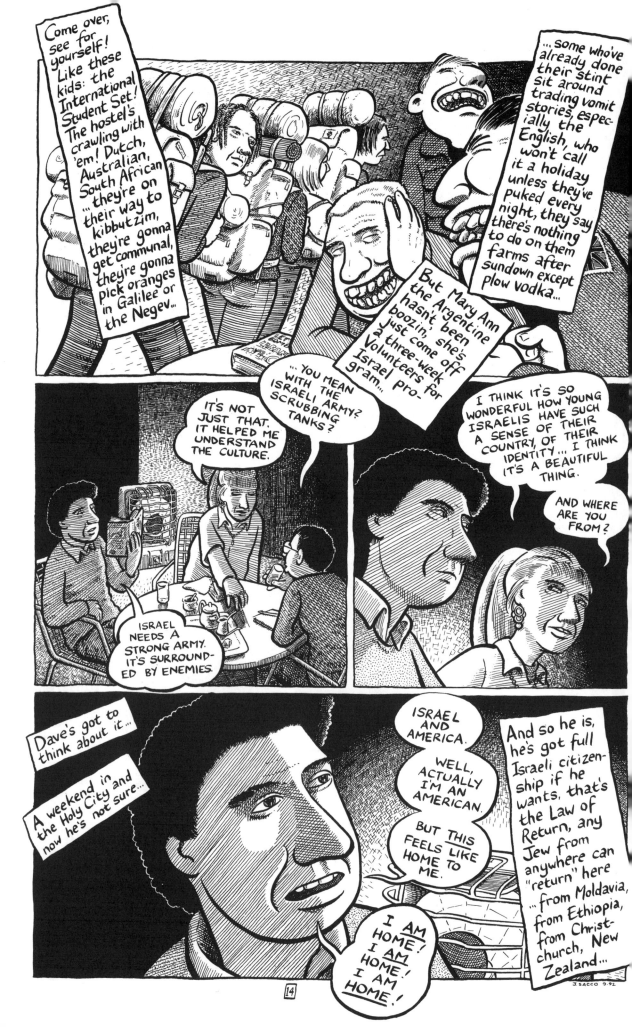

Come over, see for yourself! Like these kids: the International Student Set! The hostel's crawling with 'em! Dutch, Australian, South African ... they're on their way to kibbutzim, they're gonna get communal, they're gonna pick oranges in Galilee or the Negev...

...some who've already done their stint sit around trading vomit stories, especially the English, who won't call it a holiday unless they've puked every night, they say there's nothing to do on them farms after sundown except plow vodka...

But Mary Ann the Argentine hasn't been boozin', she's just come off a three-week Volunteers for Israel program...

"...YOU MEAN WITH THE ISRAELI ARMY? SCRUBBING TANKS?"

IT'S NOT JUST THAT. IT HELPED ME UNDERSTAND THE CULTURE.

I THINK IT'S SO WONDERFUL HOW YOUNG ISRAELIS HAVE SUCH A SENSE OF THEIR COUNTRY, OF THEIR IDENTITY... I THINK IT'S A BEAUTIFUL THING.

AND WHERE ARE YOU FROM?

ISRAEL NEEDS A STRONG ARMY. IT'S SURROUNDED BY ENEMIES.

Dave's got to think about it...

A weekend in the Holy City and now he's not sure...

ISRAEL AND AMERICA.

WELL, ACTUALLY I'M AN AMERICAN.

BUT THIS FEELS LIKE HOME TO ME.

And so he is, he's got full Israeli citizenship if he wants, that's the Law of Return, any Jew from anywhere can "return" here ...from Moldavia, from Ethiopia, from Christchurch, New Zealand...

I AM HOME! I AM HOME! I AM HOME!

14

J. SACCO 9·92

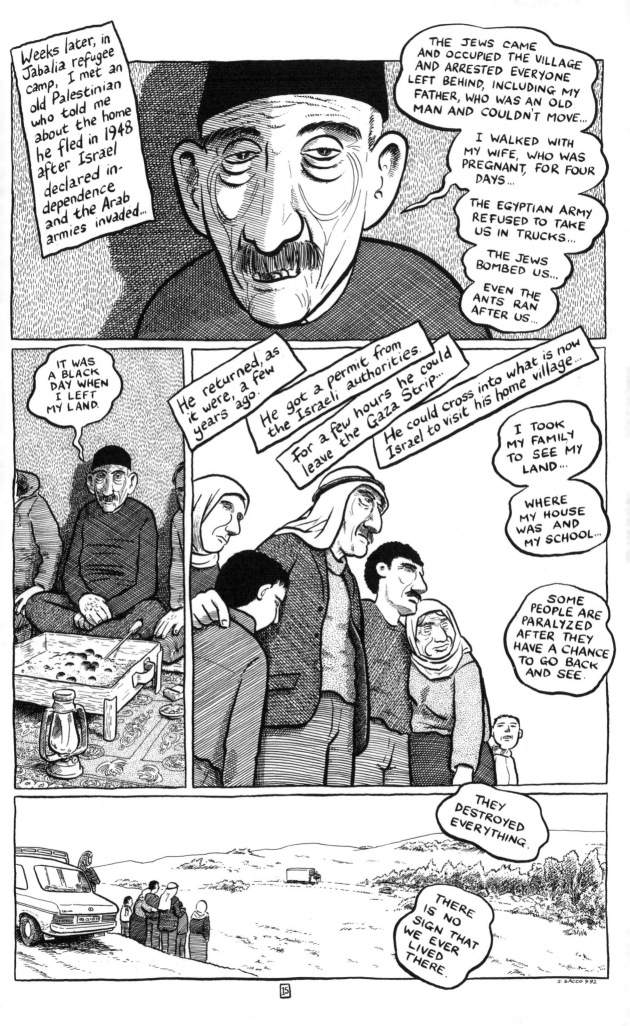

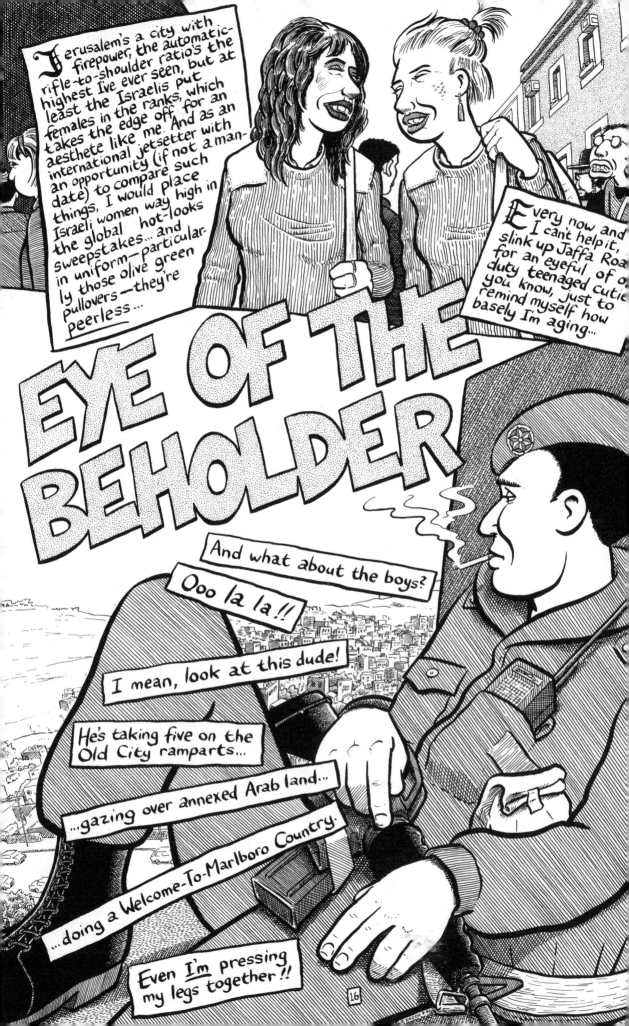

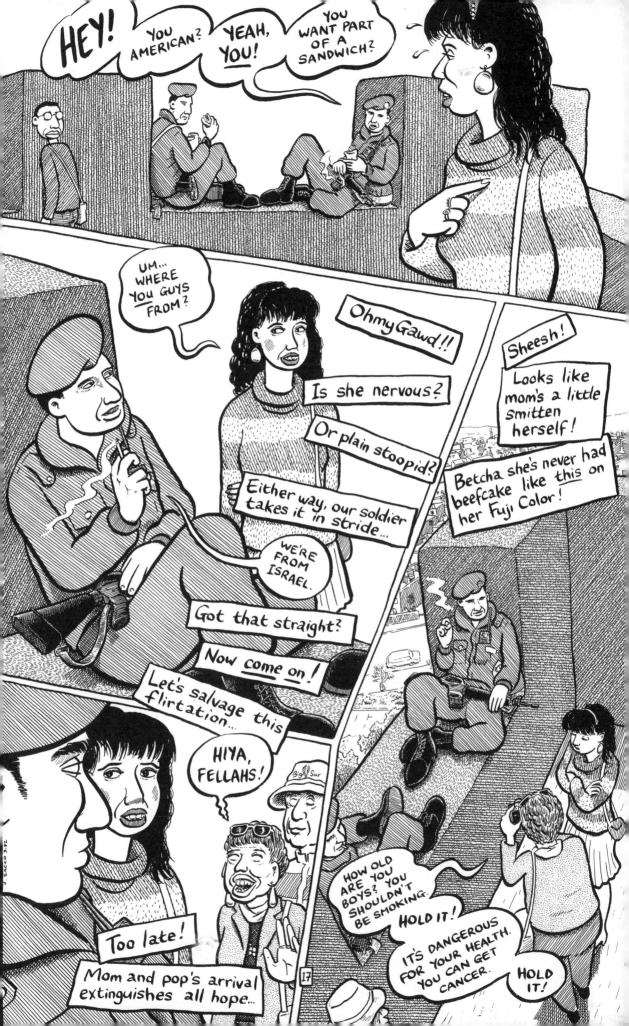

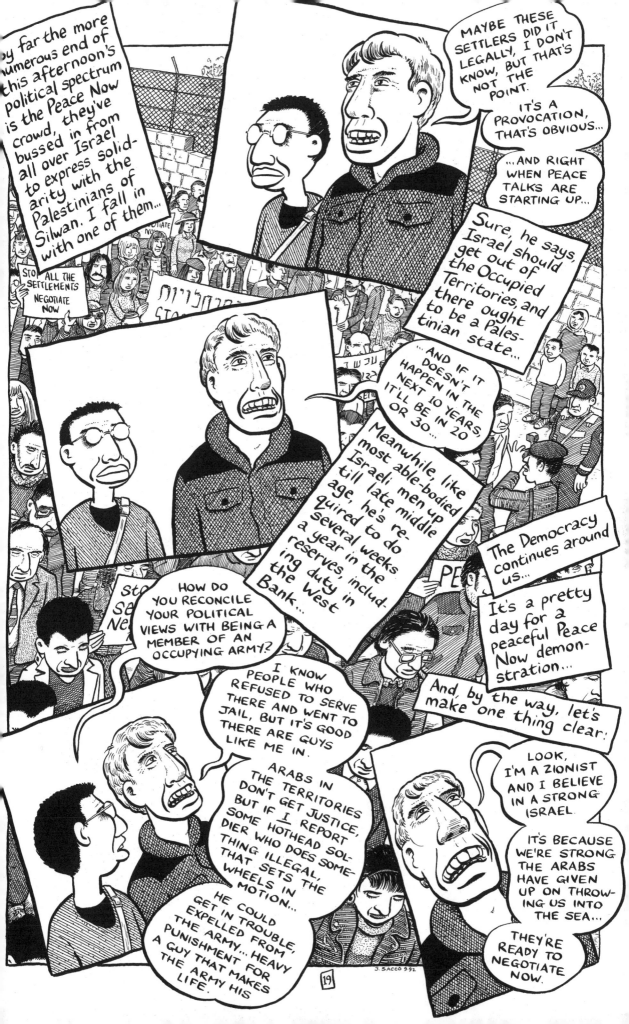

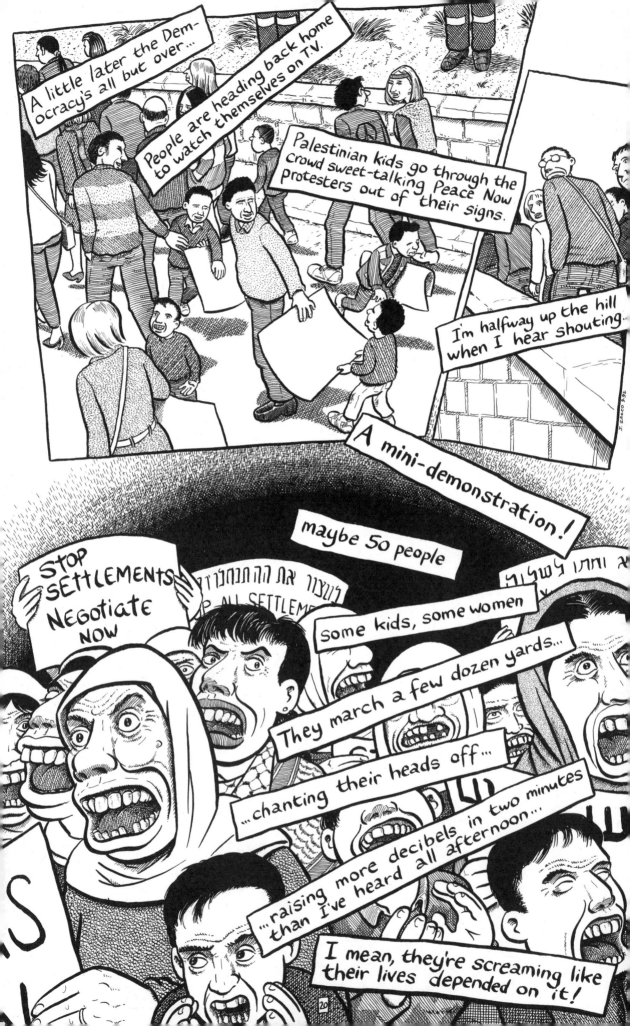

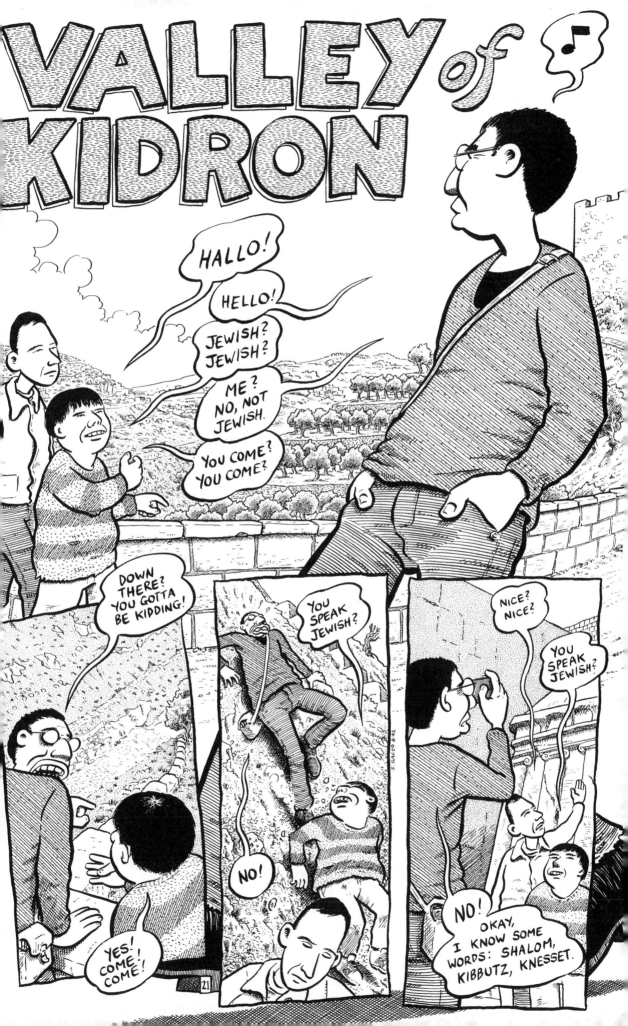

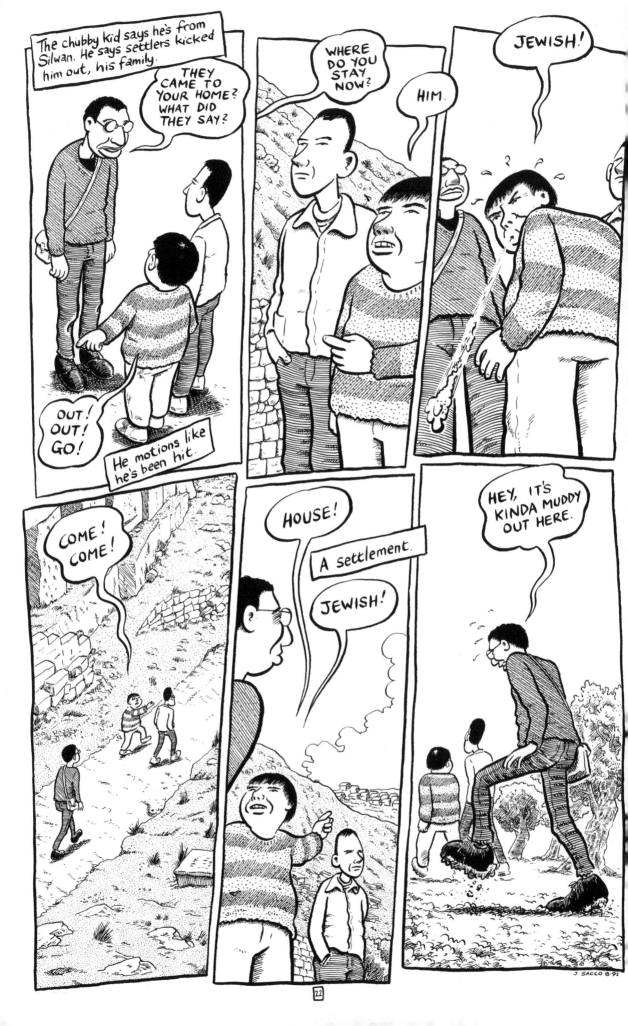

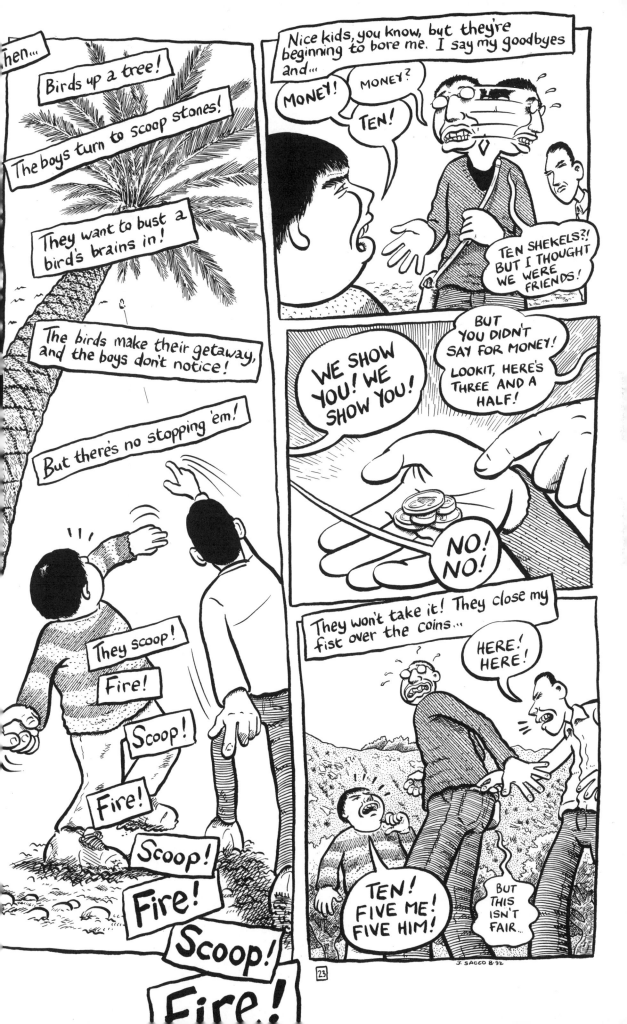

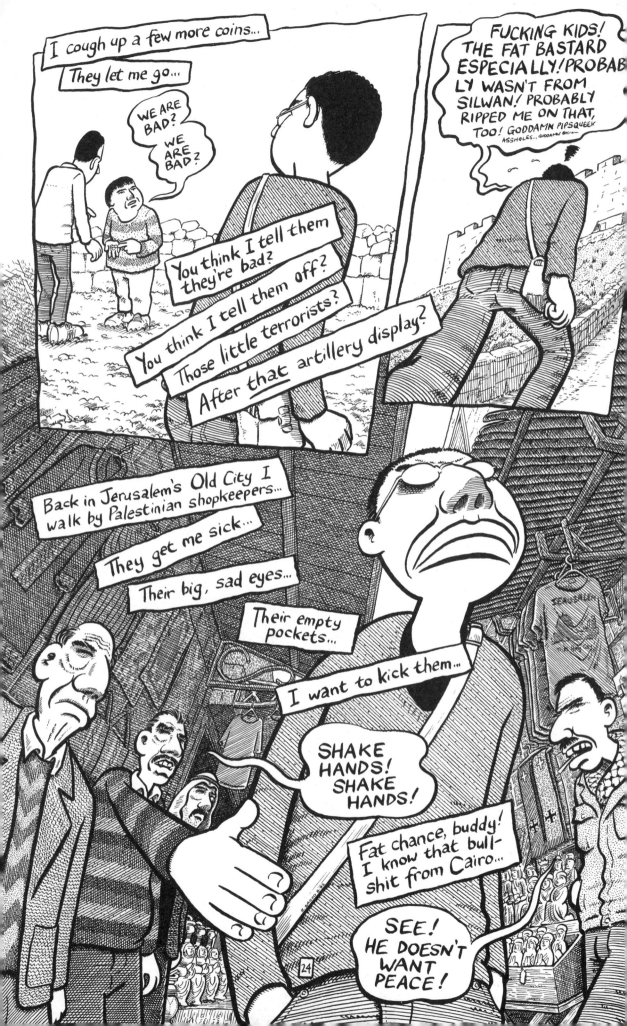

Chapter Two

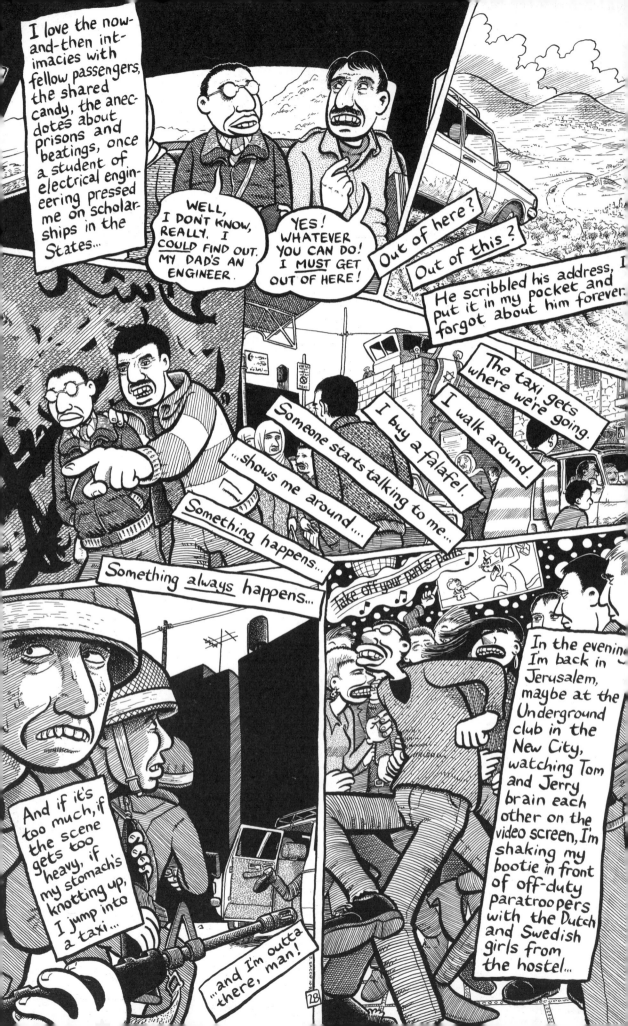

I love the now-and-then intimacies with fellow passengers, the shared candy, the anecdotes about prisons and beatings, once a student of electrical engineering pressed me on scholarships in the States...

WELL, I DON'T KNOW, REALLY. I COULD FIND OUT. MY DAD'S AN ENGINEER.

YES! WHATEVER YOU CAN DO! I MUST GET OUT OF HERE!

Out of here?

Out of this?

He scribbled his address, I put it in my pocket and forgot about him forever.

The taxi gets where we're going.

I walk around.

I buy a falafel.

Someone starts talking to me...

"...shows me around...."

Something happens...

Something always happens...

Take off your pants—pants♪

And if it's too much, if the scene gets too heavy, if my stomach's knotting up, I jump into a taxi...

"...and I'm outta there, man!

In the evening I'm back in Jerusalem, maybe at the Underground club in the New City, watching Tom and Jerry brain each other on the video screen, I'm shaking my bootie in front of off-duty paratroopers with the Dutch and Swedish girls from the hostel...

28

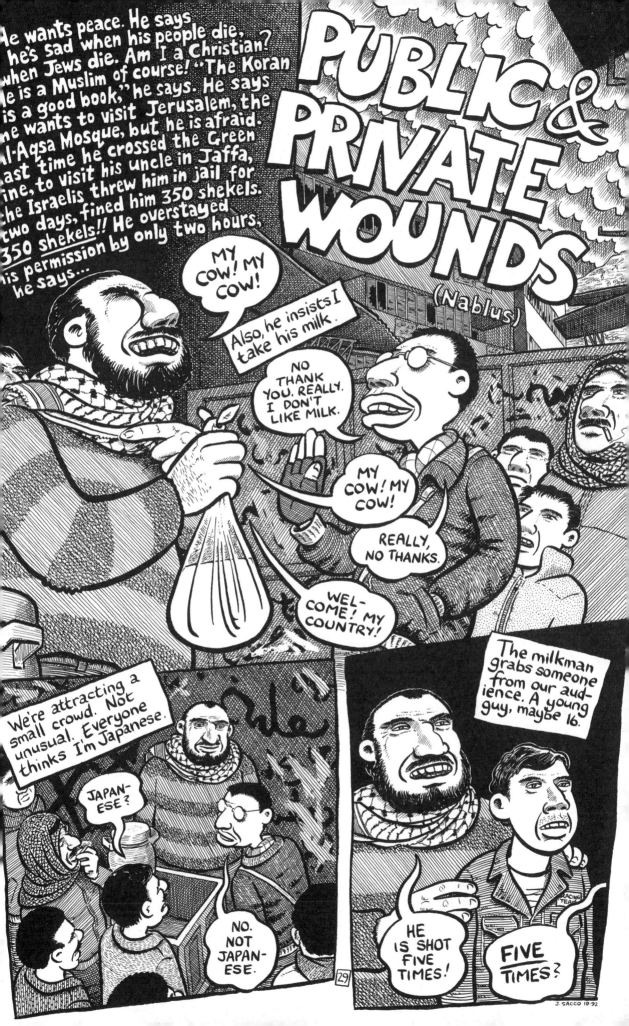

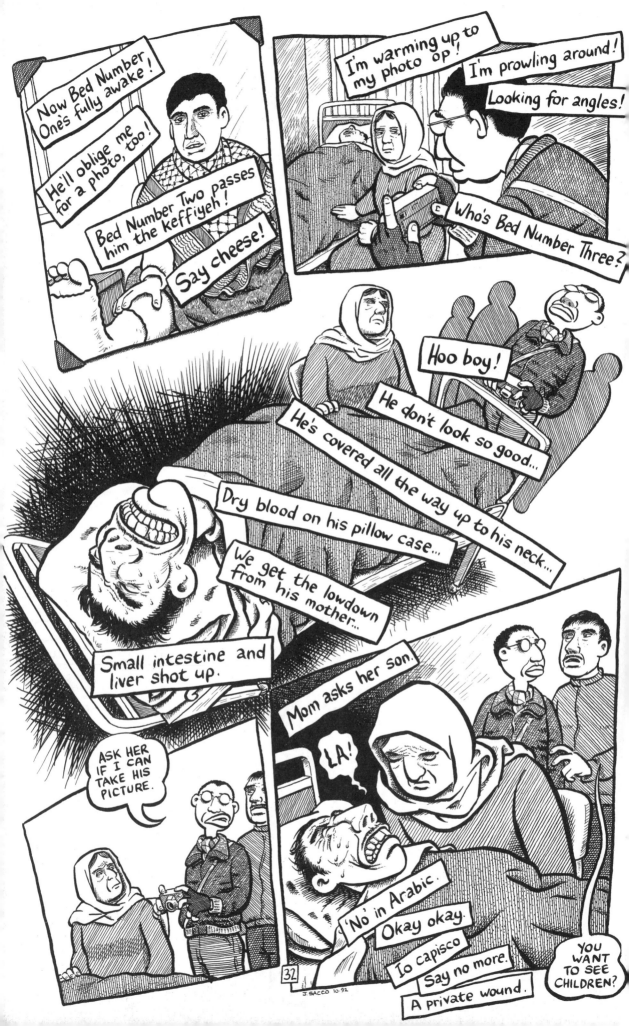

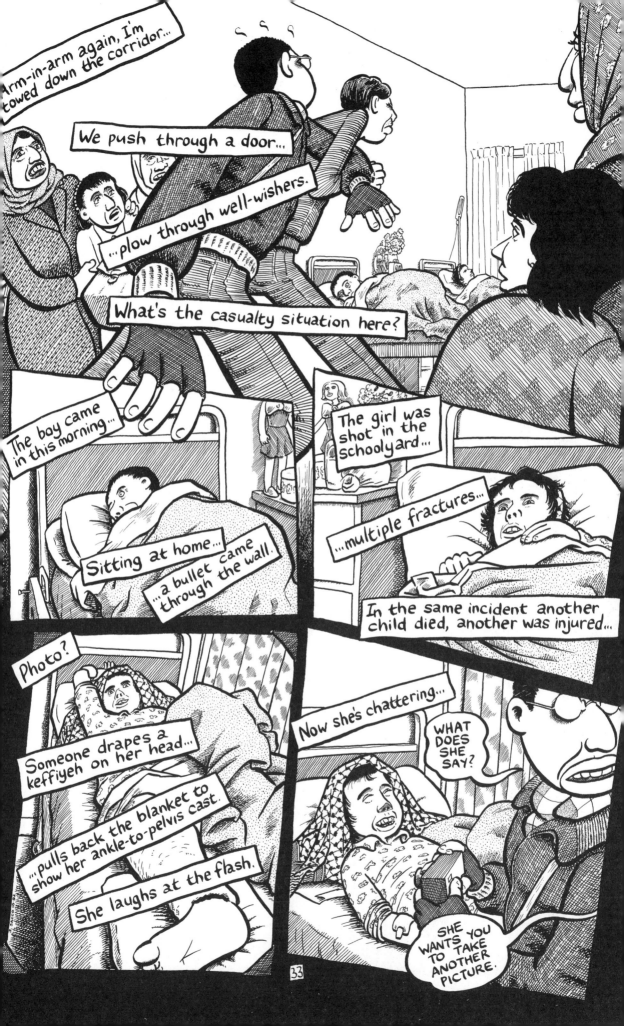

CARRY ON, DOCTOR

Okay, the 11-year-old from the last page... definitely a sweetie... my heart's still melted... But let's put the issue of cuteness aside (along with the Fourth Geneva Convention) ...it's not exactly like she was not guilty ...on a second visit, she 'fesses up...

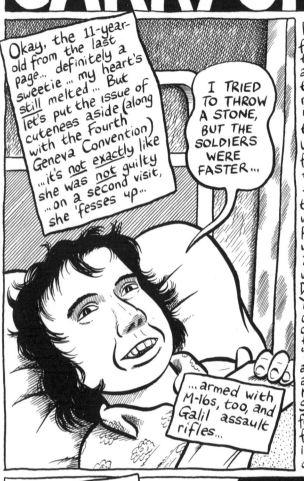

I TRIED TO THROW A STONE, BUT THE SOLDIERS WERE FASTER...

...armed with M-16s, too, and Galil assault rifles...

But there's fewer clashes these days and less of the acute-response-to-impact stuff that grabbed world attention from late '87 to '88, the first year of the intifada, when 400 Palestinians were killed, 20,000 injured, when Israeli Defense Minister Yitzhak Rabin ordered the crushing of protests with "force, might, and beatings" and Prime Minister Yitzhak Shamir called for putting "the fear of death into the Arabs of the areas..."

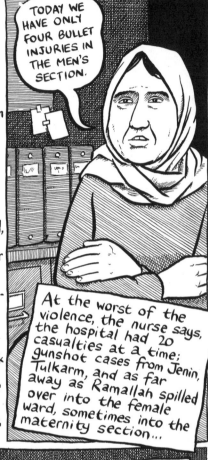

TODAY WE HAVE ONLY FOUR BULLET INJURIES IN THE MEN'S SECTION.

At the worst of the violence, the nurse says, the hospital had 20 casualties at a time; gunshot cases from Jenin, Tulkarm, and as far away as Ramallah spilled over into the female ward, sometimes into the maternity section...

In those days when the "shebab" —the youth— heard ambulances they'd come quickly from school, from university, to give blood, a medical technician tells me...

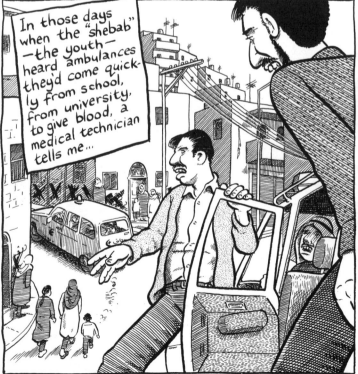

Now the hospital's got a special refrigerator for plasma, she says... it keeps for a year... they're well stocked...

BUT AS IN ALL WARS FRESH BLOOD IS BEST.

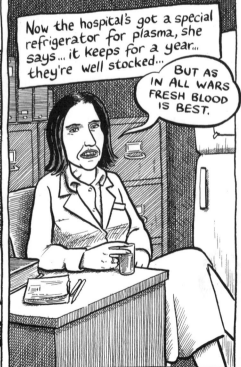

J. SACCO 11-92

And what's that scar on her neck? Oh, a bullet in the throat she picked up at Bir Zeit University while protesting a killing at Bethlehem University... three major surgeries...

Anyway, she says, after clashes soldiers often follow ambulances in, they enter the emergency room to interrogate the wounded...

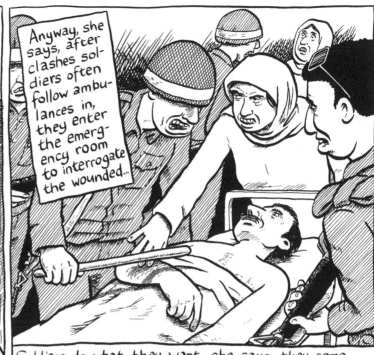

Soldiers do what they want, she says, they come into the operating theater without masks, they question visitors, they've shouted at people donating blood, they've beaten her director. Other staffers tell me of soldiers obstructing ambulances, of taking patients "right from the [operating] theater...."

IT'S AN ORDINARY CASE TO WORK UNDER TENSION.

The last incident? "Two weeks ago soldiers came in and did a quick search, not a very serious one, they checked the W.C.

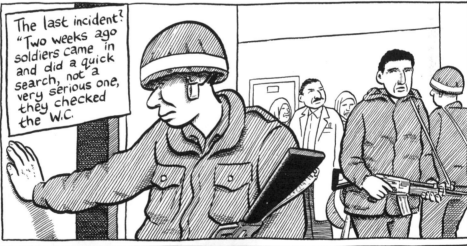

"They ordered all employees into the courtyard, except those in the operating room ... All the other patients we left unattended ...No one was allowed in or out..."

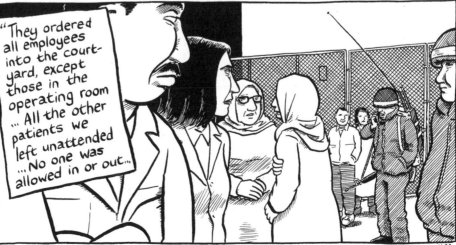

J. SACCO 11-92

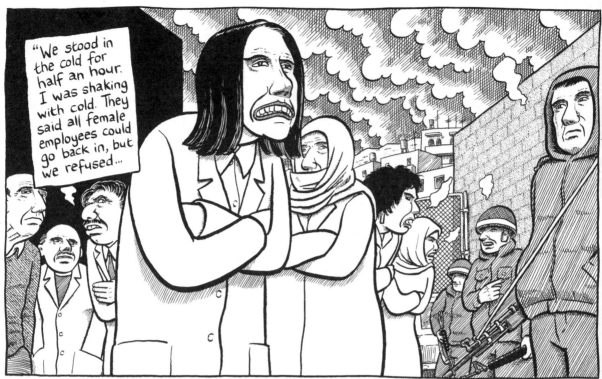

"We stood in the cold for half an hour. I was shaking with cold. They said all female employees could go back in, but we refused..."

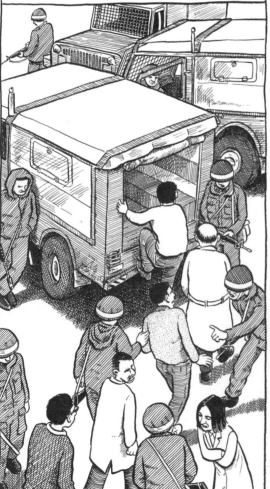

"They checked our ID cards and took five male employees in a jeep. I told the soldiers not to beat them..."

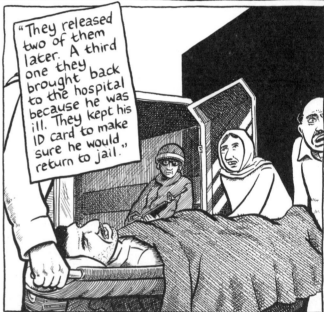

"They released two of them later. A third one they brought back to the hospital because he was ill. They kept his ID card to make sure he would return to jail."

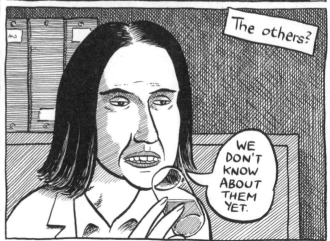

The others?

WE DON'T KNOW ABOUT THEM YET.

J. SACCO 11-92

36

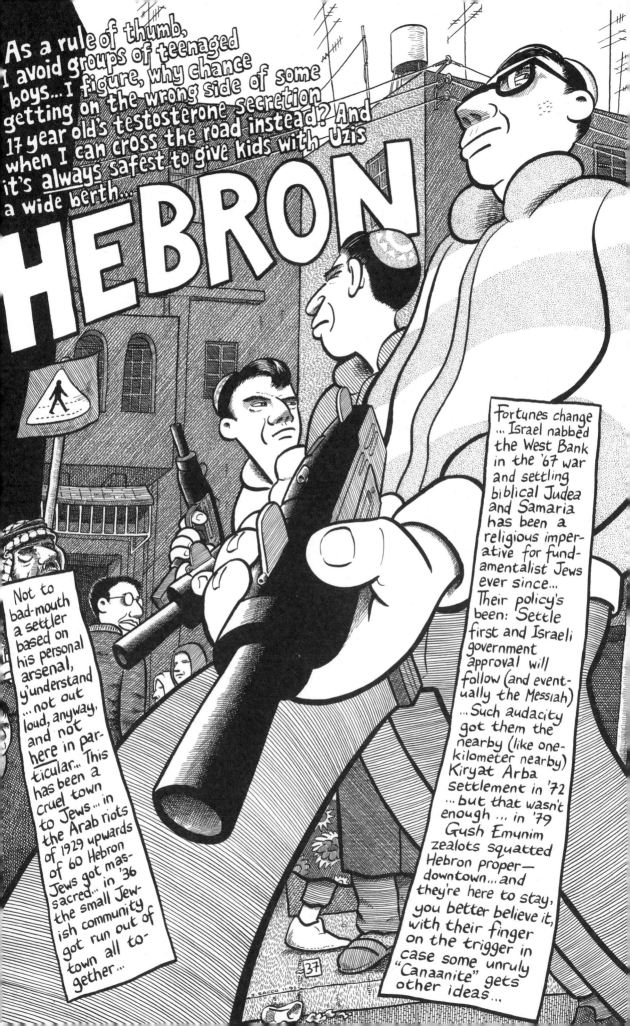

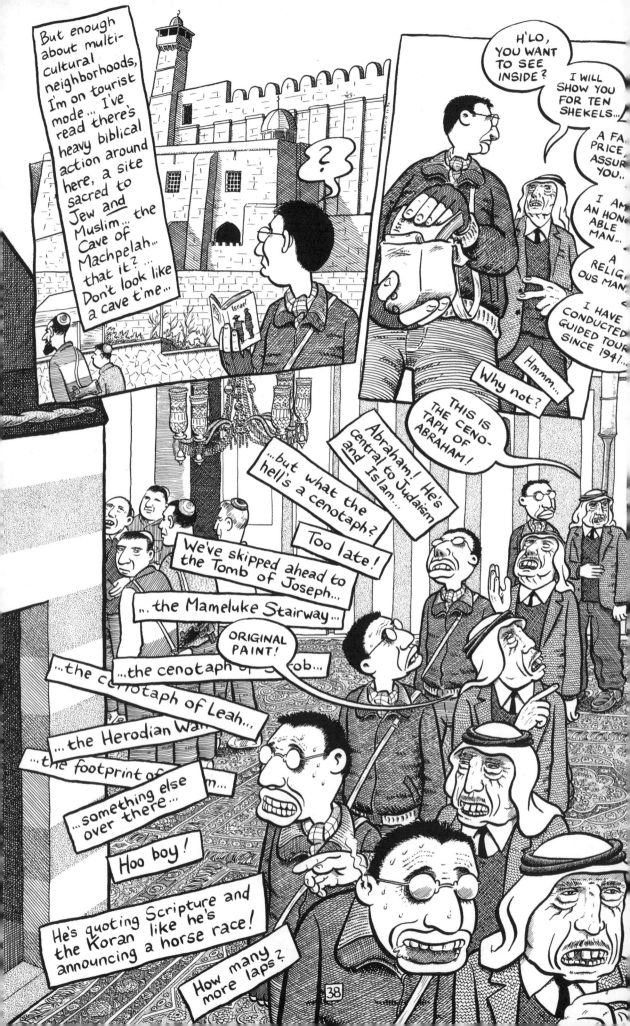

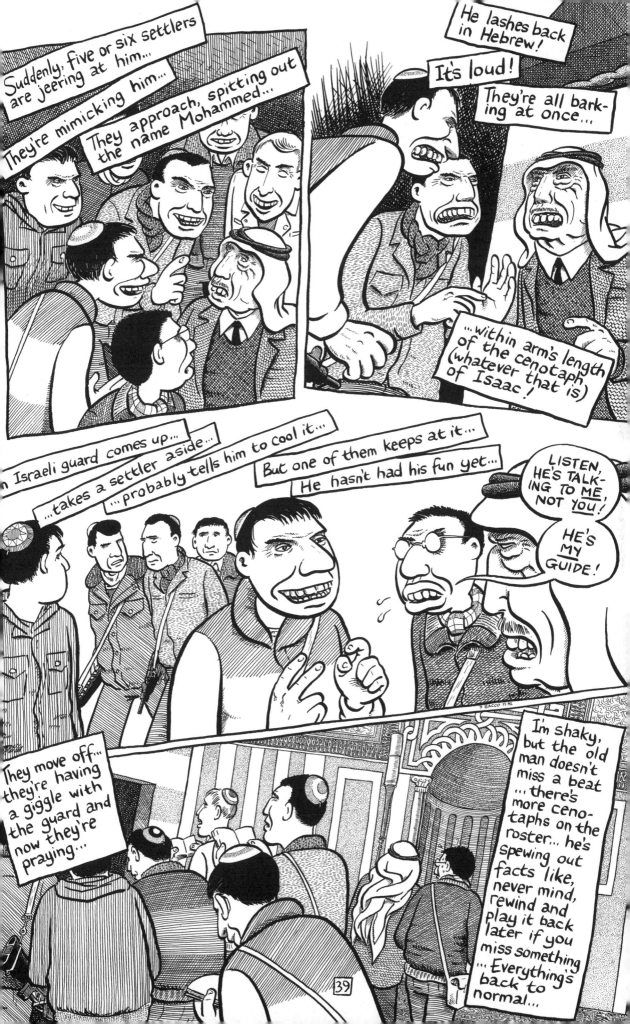

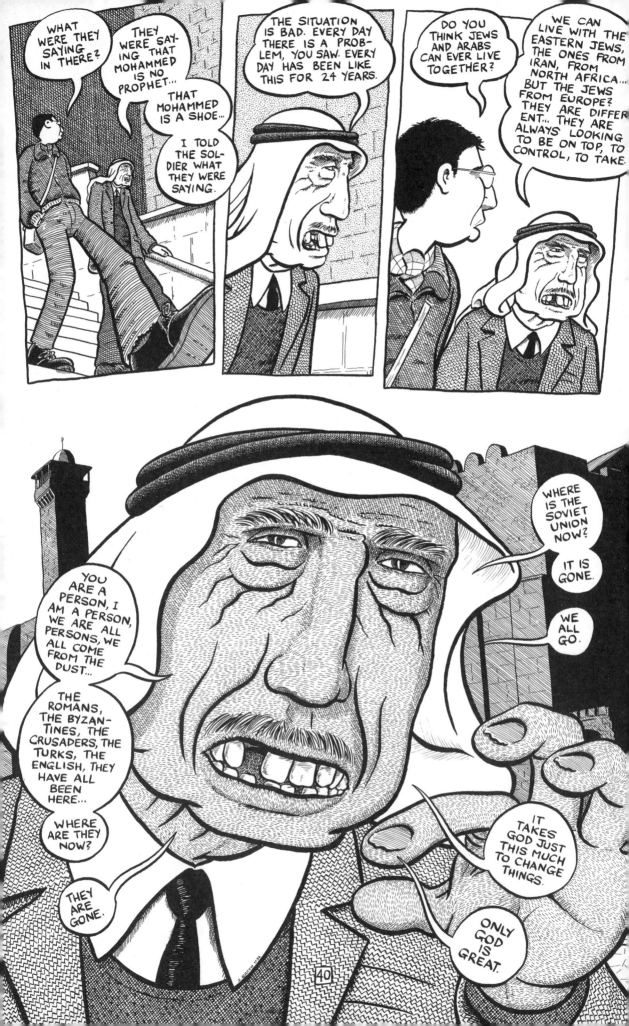

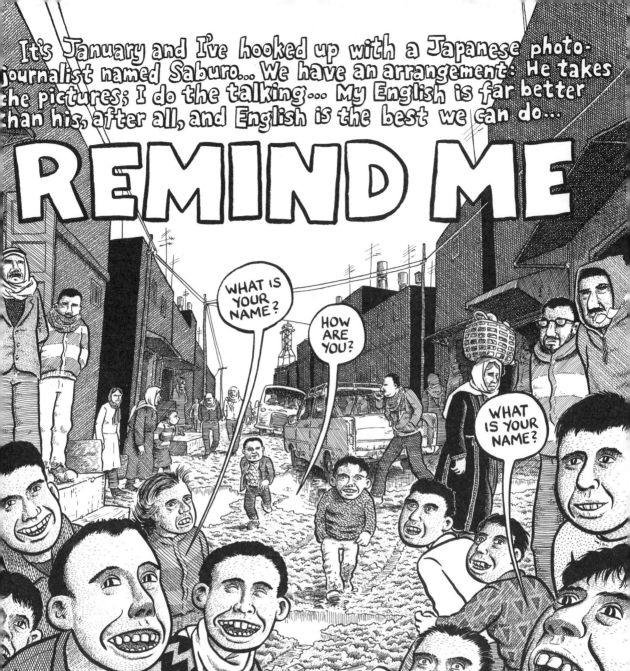

Not that English always gets you far, but the kids like the practice, and it's a good idea to get the kids on your side. I smile a lot, tell them my name is Joe, that I am fine, and that usually does the trick, though not always. Two or three times, in other places, kids have chased me off, calling out to each other that I'm a Jew, or picked up stones and fingered them till I've smiled and beamed my way into their little hearts. Kids can be exhausting...

Adults, too. Not that _they_ run after you, giggling and tugging at your sleeve. In a place like this they hang back, staring, sizing up the kind of trouble you might mean. More smiles and greetings in order here. "Salaam Aleekum!" Keep that smile going. "Salaam Aleekum!" _Now_ they're smiling back. Someone hands us a bag of tangerines.

This is Balata, the biggest refugee camp in the West Bank, practically across the road from Nablus. Some Palestinians living here were among the three-quarters of a million who fled or were forced out of what is now Israel in 1948...

Do we need to talk about 1948? It's hardly a secret how the Zionists used rumors, threats, and massacres to expel the Arabs and create new demographics that guaranteed the Jewish nature

of Israel.

Of course, it's more comfortable to think of refugees as some regrettable consequence of war, but getting rid of the Palestinians has been an idea kicking around since Theodor Herzl formulated modern Zionism in the late 1800s. "We shall have to spirit the penniless population [sic] across the border," he wrote, "by procuring employment for it in the transit countries, while denying it employment in our own country."

After all, some Zionists reasoned, Palestinians were less attached to their ancestral homeland than the Jews who hadn't lived there for centuries. According to Israel's first prime minister, David Ben-Gurion, a Palestinian "is equally at ease whether in Jordan, Lebanon or a variety of places." With war imminent, Ben-Gurion had no illusions about "spiriting" or inducing the Palestinians away. "In each attack," he wrote, "a decisive blow should be struck, resulting in the destruction of homes and the expulsion of the population." When that was basically accomplished he told an advisor, "Palestinian Arabs have only one role left — to flee."

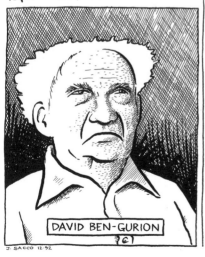
DAVID BEN-GURION

J. SACCO 12-92

But if 1948 is no secret, it's all but a non-issue, dismissed entirely by Prime Minister Golda Meir: "It was not as though there was a Palestinian people considering itself as a Palestinian people and we came and threw them out and took their country away from them. They did not exist."

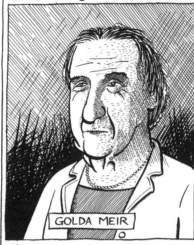
GOLDA MEIR

But they did exist, and they do, and here they are... and their children, and their children's children... and still they are refugees... stale ones, maybe, in the nightly news scheme of things, but, nonetheless, refugees... which I suppose means they're waiting to go back...

But back to what? Close to 400 Palestinian villages were razed by the Israelis during and after the '48 war... fleeing Palestinians were declared "absentees" ...their homes and lands declared "abandoned" or "uncultivated" and expropriated for settlement by Jews.

You say refugee camp and I picture tents, people lying on cots... but somewhere along the line Balata's residents figured they'd be here for the long haul, and the camp took on a sort of shabby

permanence... People live here, they watch T.V., they shop, they raise families... On first glance, sloshing down a main road, what sets Balata apart is the mud. The snows have melted and the road is mud. Everywhere, mud.

We came here to meet Saburo's friend, but he's gone to a wedding somewhere and won't be back today. Now what? I'm freezing, and I wonder how long we're going to walk around in the cold.

Fortunately someone remembers Saburo from last time he was here and invites us into his shop for tea... ah, tea... holding a cup of tea, that's the ticket for right now... I'm lost in my tea while Saburo arranges a place to spend the night.

Meanwhile, word must be out 'cause small groups of the shebab are coming and going, giving us the once over. Most of them hang out for a few minutes and leave. Foreigners? Journalists? Big deal! We're not the first and won't be the last to drop by looking under their skirts for stories...

One of them, though, maybe he's 16 or 18, takes a shining to me. It must be all my smiling. His English is piss-poor, but that doesn't stop a guy like this, pantomime's not beneath him. He makes it clear he's done some rough-and-tumble with the IDF, the Israeli Defense Forces. He takes out his ID card to prove it. Every Palestinian over 16 in the Occupied Territories has to carry one, and his is green, which means he's done a

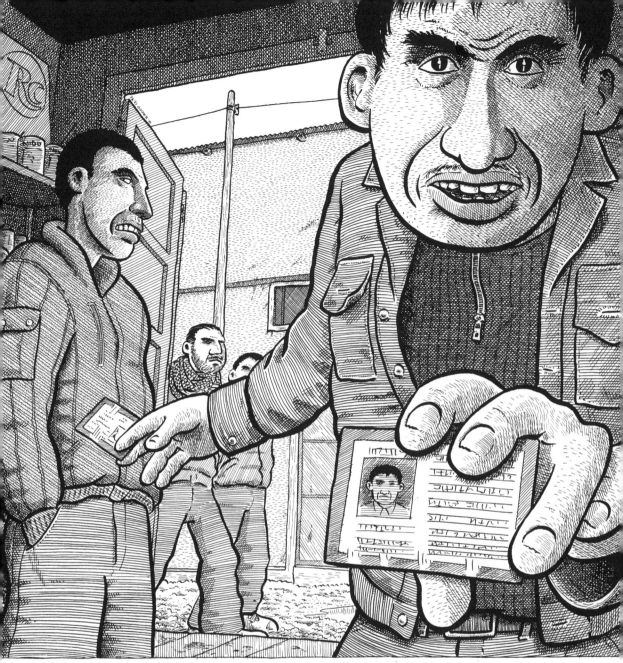

recent stint in prison. He orders over a friend who sheepishly produces an orange ID, the regular card color for West Bank residents.

"<u>Green</u> card: Intifada!" says my new pal, waving his card... "Orange card: <u>No</u> intifada," he says, holding up his friend's...

Orange Card retreats with a red face while Green Card beams proudly. I beam back, out of sympathy, really, 'cause I've got a bad feeling about a dude without discretion like this... He's destined for a casualty appendix, I'm thinking; he's probably got an appointment with a serious bullet.

Saburo's made arrangements for the night. We'll be staying with someone named Jabril, who speaks pretty good English. Jabril takes us home, sits us down in the front room, makes us comfy. There's full mobilization in the kitchen and he and his brothers bring out one plate after another. It's a regular feast! I tell you,

I eat like a king in refugee camps, they pull out all the stops, I blow kisses in the direction of the invisible womenfolk. And now we're stuffed, and Jabril sets up the kerosene heater against our toes, he wants us crispy.

"Coffee?" he asks.

Christ, they love us in Palestine!

Meanwhile, the room's filling with neighbors. They've heard about us and they don't mind answering some questions. I reach for my pad. They've been laughing

and talking amongst themselves, but now they're quiet, even the children they've brought along.

I ask where they work. "Israel! Israel!" say most. There's jobs in Israel, they say, not in the West Bank. They get up early for their jobs. It's an hour there, an hour back, and they have to be out of the country by 6 p.m. Only Jabril has a local job, in Nablus. The others are part of Israel's convenient low-wage labor pool. Israel calls the economic shots and makes rules to suit itself, as when Defense Minister Rabin said in 1985: "No permits will be given for expanding agriculture or industry [in the Territories] which may compete with the State of Israel."

Mahmoud says he hasn't worked for two years. He has a green ID card, which means he can't cross into Israel for work. Green card? He was in prison? The soldiers came to his door one day, he says, he asked why and they smashed him in the head! In front of his wife and children! The soldiers wanted to know who was throwing stones. Mahmoud told them it wasn't him, but they took him anyway. He shrugs. "If they don't take me, they'll take you."

Now they're all blurting stories about soldiers and prisons. Firas says soldiers shot him two years ago and his leg's still not right. Ahmed says soldiers raided his home at midnight, they busted down the door, they came through the roof, they destroyed furniture, they caught him. He was 16. Three years in prison. "For what?" I ask. "For throwing a Molotov cocktail," he says. "And I didn't even see where it landed." The whole crowd

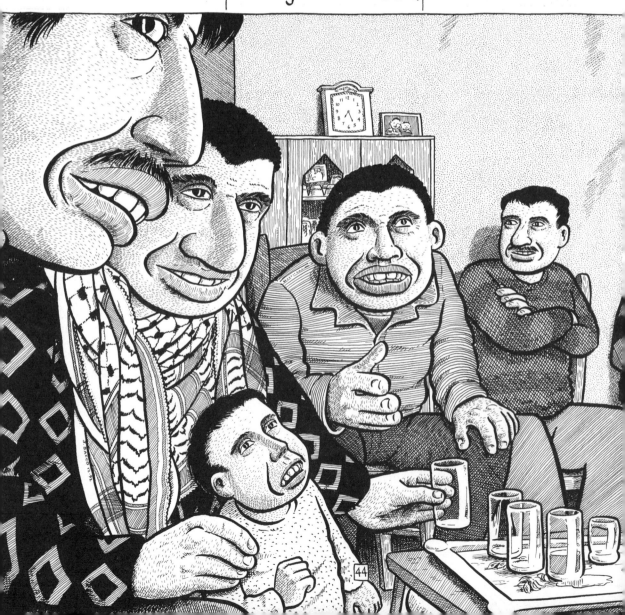

44

busts up. They think that's pretty funny.

But the Israelis take Molotovs seriously, often demolishing the homes of Molotov throwers. I ask about demolished homes in Balata. They talk it over, pointing different directions, counting on their fingers, naming names.

"Six houses destroyed by dynamite," Abu Akram announces finally. "One of them belonged to my friend, a butcher, he was a rich man. Eleven other people lived in his house. They had one hour to move." The butcher, it seems, was a collaborator who was discovered and allowed to redeem himself by killing two other collaborators, who were considered dangerous. He killed them; the Israelis put him in prison for life, blew up his home. They say five collaborators have been killed in Balata.

I ask about life in the camp. "No cinema, no garden," says Jabril. "If the soldier sees me he asks, 'Where are you going?' If I want to play football in the schoolyard, the soldier comes. So my friends visit my home. We drink tea. We drink coffee. We speak. This is my life."

Jabril says Balata has a reputation with the soldiers. The first West Bank clashes of the intifada occurred here. Jabril says he's been knocked down in Nablus by soldiers who've discovered he's from Balata.

"When I go to Nablus," says Abu Akram, "I go with a hurry and come back. If a soldier stops me, he puts me up against a wall, takes my card, he asks the computer, he asks why I was in prison. If the soldier is very bad, he takes me in a store and beats me. It is best to stay in Balata camp."

We go on the roof. It's freezing up there, but the lights from a nearby

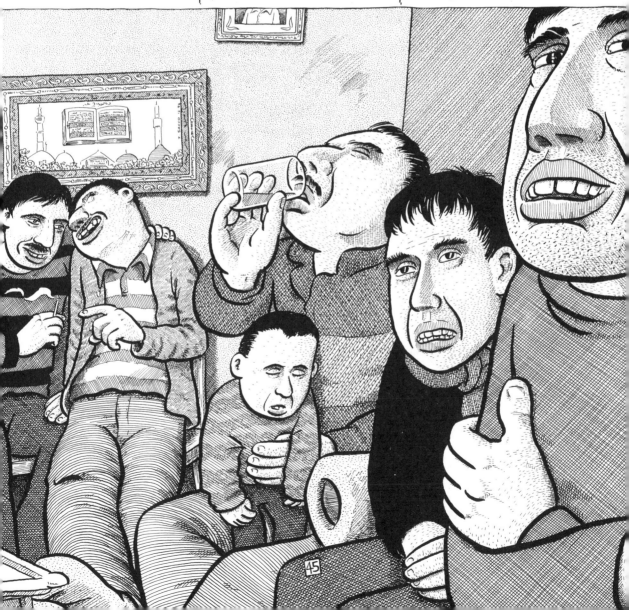

45

They ordered him to take down a picture of Arafat from a wall. Yes, but why did they beat him? "For speaking to them in English and not in Hebrew," he says.

Saburo and I make a quick visit to the local UNRWA clinic. They don't ask for authorization here. A nurse gives us a tour of the antenatal department— 50 camp births a month, she says; the laboratory; the rehabilitation unit; and (with some pride) the new X-ray room.

Now the doctor will see us. The nurse jumps us past the long line waiting at his door. The doctor greets us into his office and shoos out a couple of female patients.

Just two doctors serve the clinic, he says, one of them a relief doctor. "The main problem," he says, "is over-load." The clinic gets up to 300 patients a day. (Last night, at the roundtable discussion, the men joked about the rushed diagnoses at the clinic. "Go to the window! Go to the window!" they sang, mimicking the staff sending them away with hurried prescriptions.)

The doctor says he sees a lot of respiratory illnesses from bad ventilation and overcrowding, "from problems related to political and social conditions."

Meanwhile, there's knocking on the door! We've been too long! The women who've been kicked out want back in! Whose clinic is it, any-way?

Outside we find Green Card —Mr. Intifada from yester-day— and a friend. They've

show us the outdoor toilets whose walls have crumbled.

The headmaster appears, he has angry words for the teachers. The three of them step aside, arguing, apparently, on the advis-ability of talking to "journalists." The teachers are raising their voices. The headmaster walks off sullenly. The teachers rejoin us. "Never mind," one of them says. "We told him we take full responsibility."

They tell us their cur-riculum corresponds to Jordan's. The Israelis allow English and math books in

from Jordan, they say, but no history or geography text, for example, that mentions Palestine. Not that it matters, says one teacher. "Since the intifada it is not necessary to teach such children that this is not Israel."

They say soldiers pass by ...soldiers chase people through the school...they shoot ... it doesn't make for a good school environ-ment for the 500 boys. What about for teachers? On a recent morning, says one of them, on his way to school, soldiers beat him.

come to fetch us. For what? Their English isn't good enough to explain. We follow them. I've become familiar with Balata's main roads, but they lead us into the maze of side streets, into the back alleys, where there's hardly a couple of shoulder-widths between houses and little boys are playing marbles... We're twisting and turning... hopping over open drainage canals...going left, going right, going in circles, I can't tell. Period-ically Green Card motions for us to stop, peers around a corner, motions for us to follow. "Police danger," he informs us. He stops us again. They frisk us. They go through our belongings. Green Card turns the pages of my passport, he studies leftover bank receipts from Cairo, my air ticket, my camera... He's flipping through my journals... He's serious, grim even... Of course, I could have reams of notes about a hot-tubbing experience with Ariel Sharon and Green Card wouldn't have a clue ... In any case, they decide we're kosher... more twists and turns... we're back on a muddy main street ... whew...

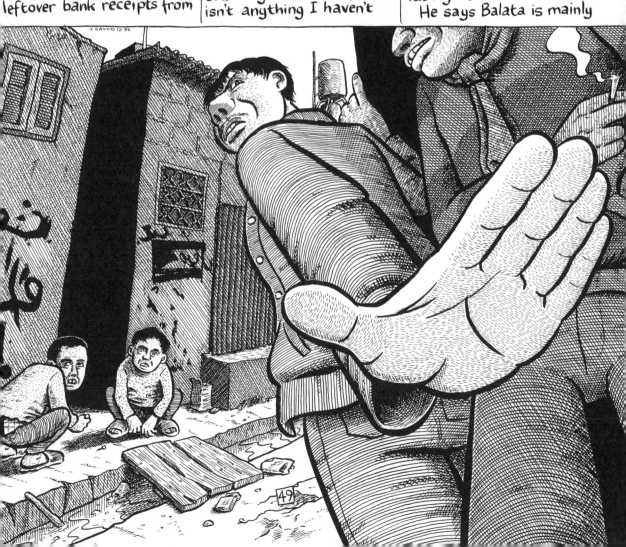Now we're in a house, the tea is coming... Jabril is there, and a few faces from the night before... but there's someone new... you'd figure after all the precautions Green Card took we'd be meeting Arafat himself or at least a Black Panthers guerrilla, but this new fellow looks pretty ordinary... and his spiel isn't anything I haven't heard before... He's vague about who he is, though, and I don't press him for a resume.

He says the uprising is the result of years of suffering, that the intifada started spontaneously but is now directed by the PLO. He says the intifada focused world attention on the Palestinians and now there's a chance for a political solution...

That's the tip-off. This guy's with Fateh, Arafat's faction of the PLO... I've made a game of guessing what PLO faction a Pales-tinian supports by his opinion of the "peace process"... Popular Front supporters, for example, oppose the talks 'cause of stiff Israeli preconditions on the Palestinian negot-iating team.

He says Balata is mainly

J. SACCO 12·92

49

with Fateh. Fateh supports the negotiations, so he supports the negotiations ...but he's a skeptic. "The majority of Israelis don't want land-for-peace," he says. "They want to make agreements with other Arab nations, but not with Palestinians." What does he see ahead? "More settlements, more soldiers, more [Jewish] immigration." And if the negotiations fail, then what? "What do you expect?" he says. "The intifada will continue."

The discussion's over. The women are sending in food. We're dipping pita bread into all kinds of stuff. We're off politics now. We're laughing. Here comes the coffee...

They're asking Saburo about Japan, and I turn his rough English into English they can understand. It comes out that Saburo is something of a spiritualist, he reads life-lines... Green Card pulls his chair up and sticks out his palm. After a little analysis, Saburo has comp-limentary words about Green Card's emotions and intelligence... Then Saburo looks hard at the palm and announces that some-thing will happen to Green Card soon. "Back in jail," says Jabril and they all laugh. "No," insists Saburo, "things will get better."

They warn us about the upcoming strikes... Hamas, the Islamic fundamentalist group, has called a general strike for tomorrow; the Unified National Leader-

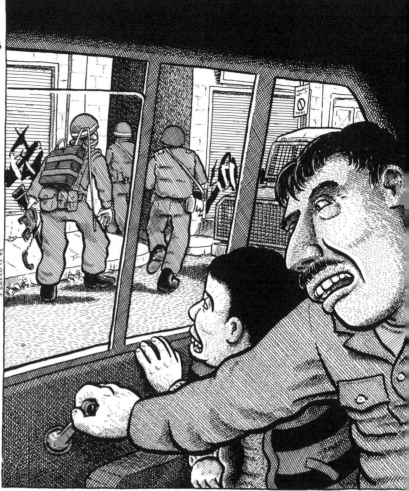

ship has called one for the day after; and both groups have called for a strike the day after that ... That's going to mess up the taxi situation. We decide to split rather than get stranded in Balata.

We take a taxi to Nablus ...the Nablus streets are all but empty; maybe there's a curfew coming up ...At the taxi stand we find a Jerusalem-bound stretch Mercedes and wait inside with a couple and their boy. The driver won't leave till he gets one or two more passengers, but we'll have to leave soon if we want to get through Ramallah before Ramallah's five o'clock curfew...

A jeep pulls up across the street. Soldiers jump out and head into a narrow Old City passageway.

There's a gunshot...Another jeep pulls up. More soldiers. A soldier with a radio drops his phone and it swings wildly out of reach below his knees. He can't seem to get at it. He's having trouble. The boy in the taxi is laughing, calling the soldier "mignoon"—crazy. His father says to roll up the windows in case there's gas...Another jeep shows up. More soldiers are piling out and ducking into the passageway.

And finally we're leaving Nablus... past the prison ...We're leaving Balata behind ...Balata is receding...I'm looking forward to the long, winding hilly stretch ahead... Jerusalem is one hour away... Jerusalem is one hour away...mean-while, I'll enjoy the scenery.

Chapter Three

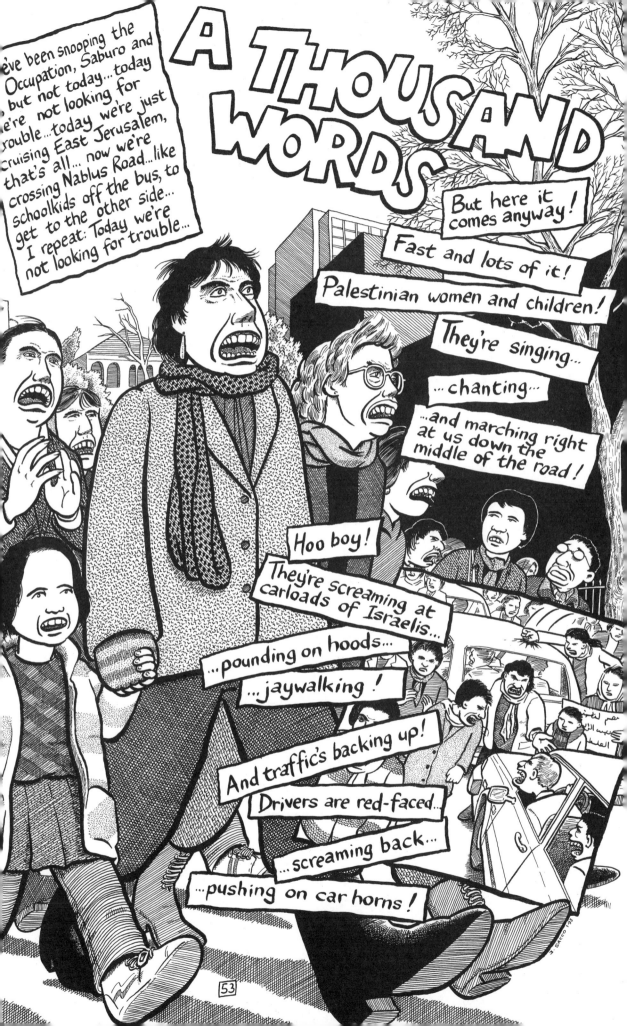

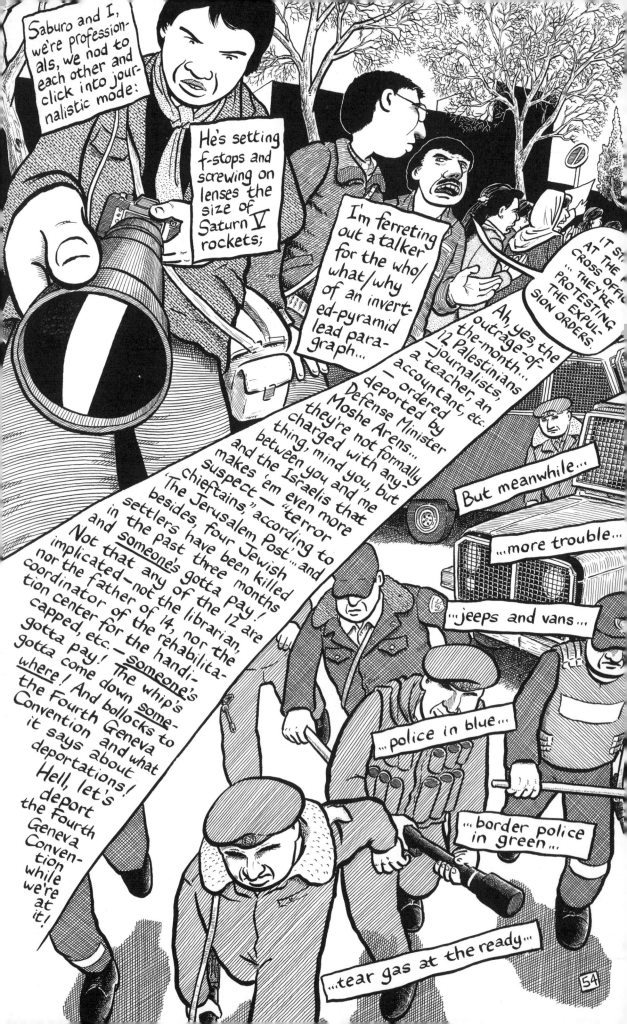

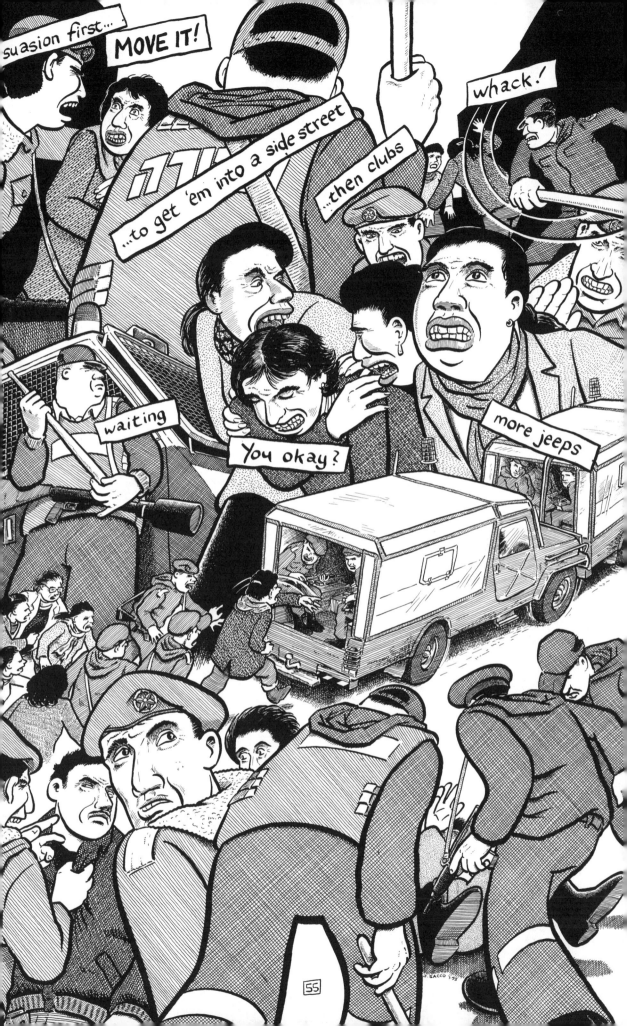

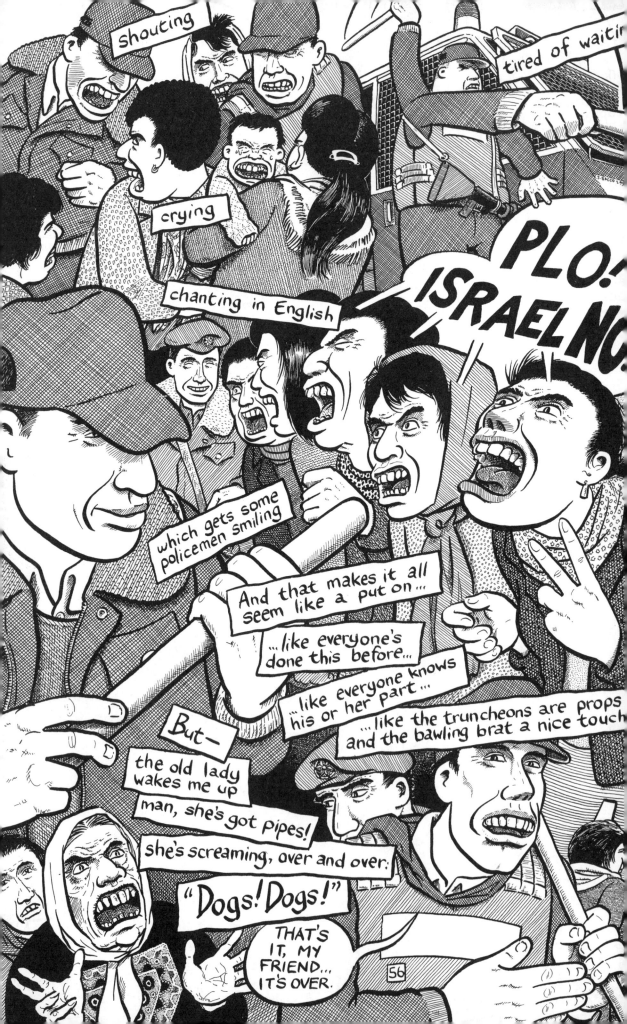

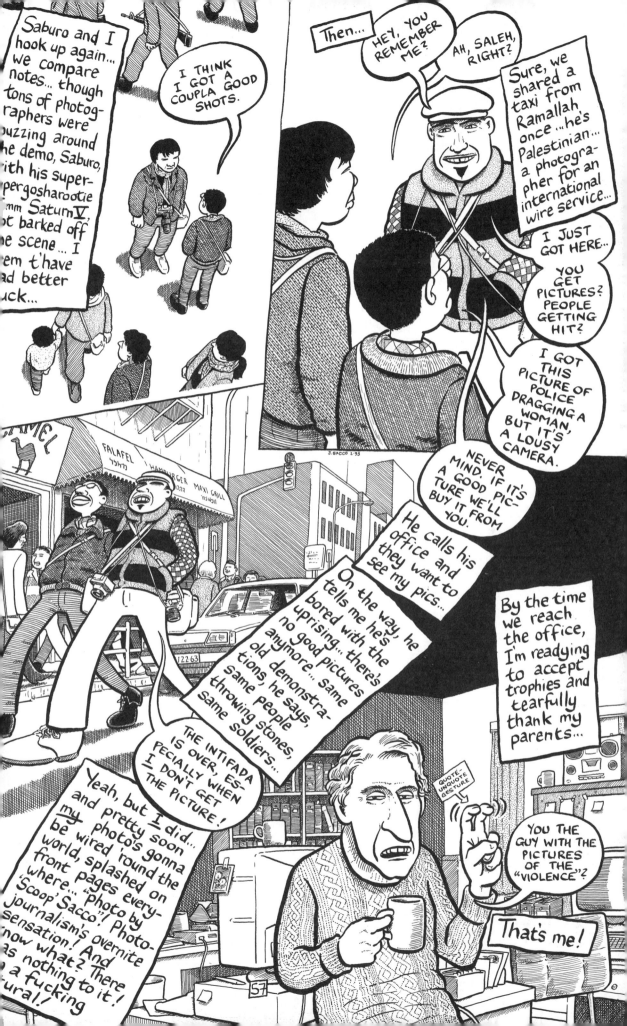

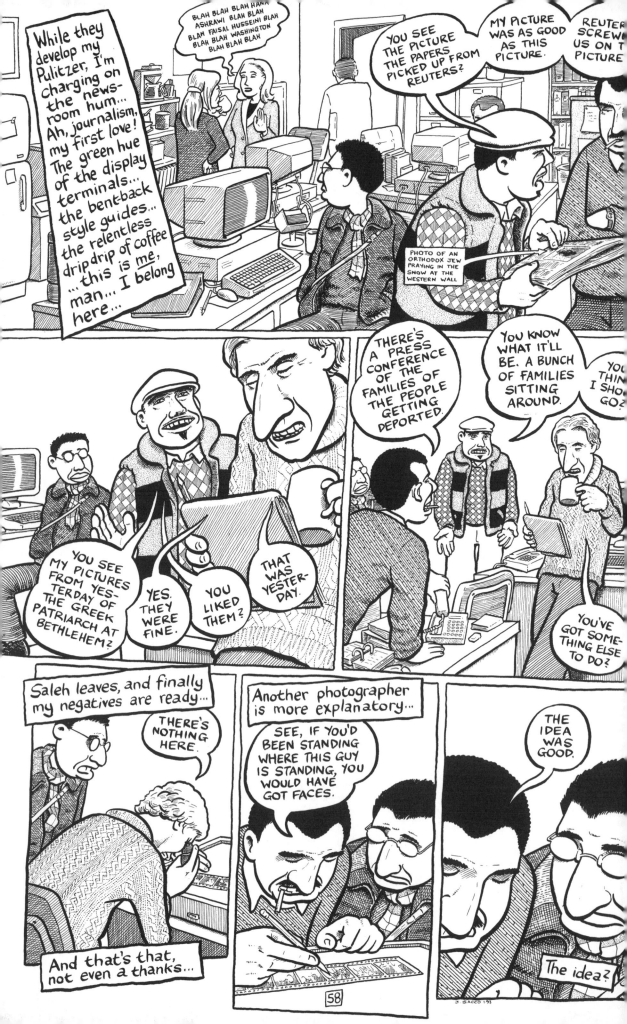

While they develop my Pulitzer, I'm charging on the newsroom hum... Ah, journalism, my first love! The green hue of the display terminals... the bentback style guides... the relentless drip drip of coffee ...this is me, man... I belong here...

BLAH BLAH BLAH HANA ASHRAWI BLAH BLAH BLAH FAISAL HUSSEINI BLAH BLAH BLAH WASHINGTON BLAH BLAH BLAH

YOU SEE THE PICTURE THE PAPERS PICKED UP FROM REUTERS?

MY PICTURE WAS AS GOOD AS THIS PICTURE.

REUTER SCREWE US ON TH PICTURE

PHOTO OF AN ORTHODOX JEW PRAYING IN THE SNOW AT THE WESTERN WALL

THERE'S A PRESS CONFERENCE OF THE FAMILIES OF THE PEOPLE GETTING DEPORTED.

YOU KNOW WHAT IT'LL BE. A BUNCH OF FAMILIES SITTING AROUND.

YOU THIN I SHO GO?

YOU SEE MY PICTURES FROM YESTERDAY OF THE GREEK PATRIARCH AT BETHLEHEM?

YES, THEY WERE FINE.

YOU LIKED THEM?

THAT WAS YESTERDAY.

YOU'VE GOT SOMETHING ELSE TO DO?

Saleh leaves, and finally my negatives are ready...

THERE'S NOTHING HERE.

Another photographer is more explanatory...

SEE, IF YOU'D BEEN STANDING WHERE THIS GUY IS STANDING, YOU WOULD HAVE GOT FACES.

THE IDEA WAS GOOD.

And that's that, not even a thanks...

The idea?

58

J. SACCO '93

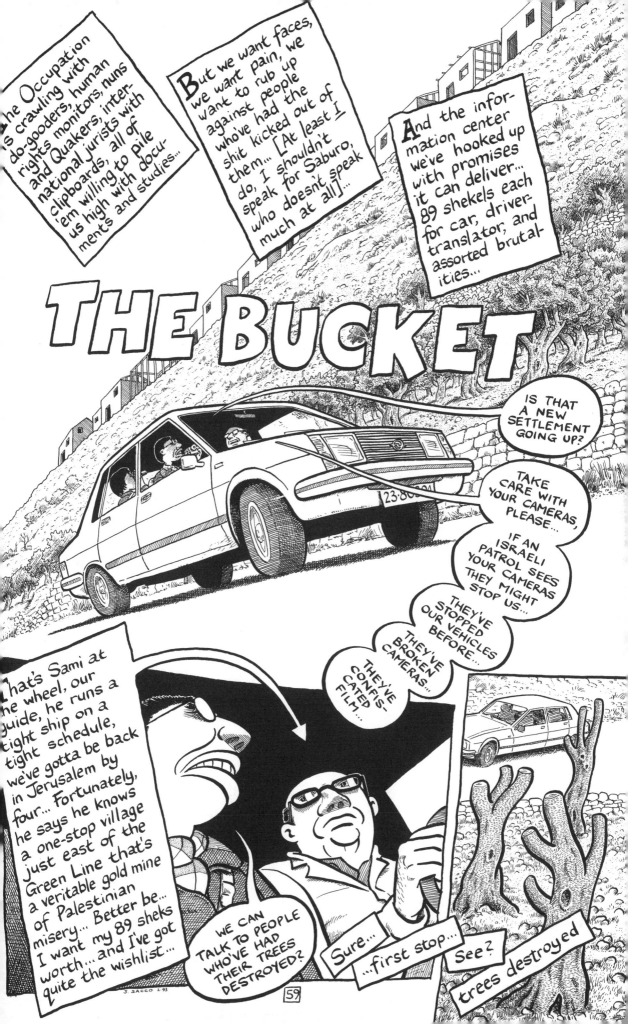

The woman of the house lets us stomp around for photos, then invites us in... As usual, all the time is teatime, and there's chocolates left over from the Greek Orthodox Christmas...

TELL US ABOUT THE TREES.

WE WERE SITTING HERE IN THE EVENING TWO WEEKS AGO WHEN WE HEARD A SOUND LIKE A BOMB...

"Somebody was wounded beyond our neighbor's house — a Palestinian who'd been preparing a Molotov cocktail. He moved into the street and signalled for cars to stop...

"A settler stopped, and then a car driven by a Palestinian. The settler took the ID card of the Palestinian driver and told him to drive the wounded man to the settlement. The settler followed in his car...

"At 4 a.m. the soldiers drove by with loudspeaker and imposed an immediate curfew on the area...

"The following day, in the afternoon, the soldiers returned and cut down the olive trees of my neighbors, the trees along the street...

"The soldiers lifted the curfew...

"The next day they came back and cut my six olive trees...

WHY ARE YOU CRYING?

BECAUSE YOU ARE CUTTING MY TREES.

THAT'S NOTHING.

"All together they cut down 70 olive trees, the trees of 13 families."

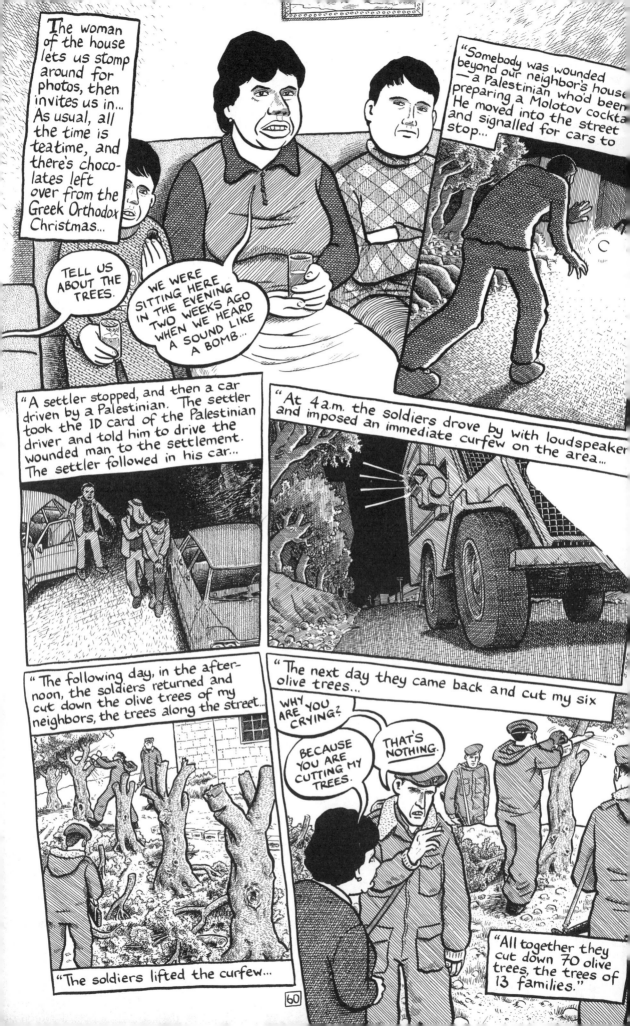

60

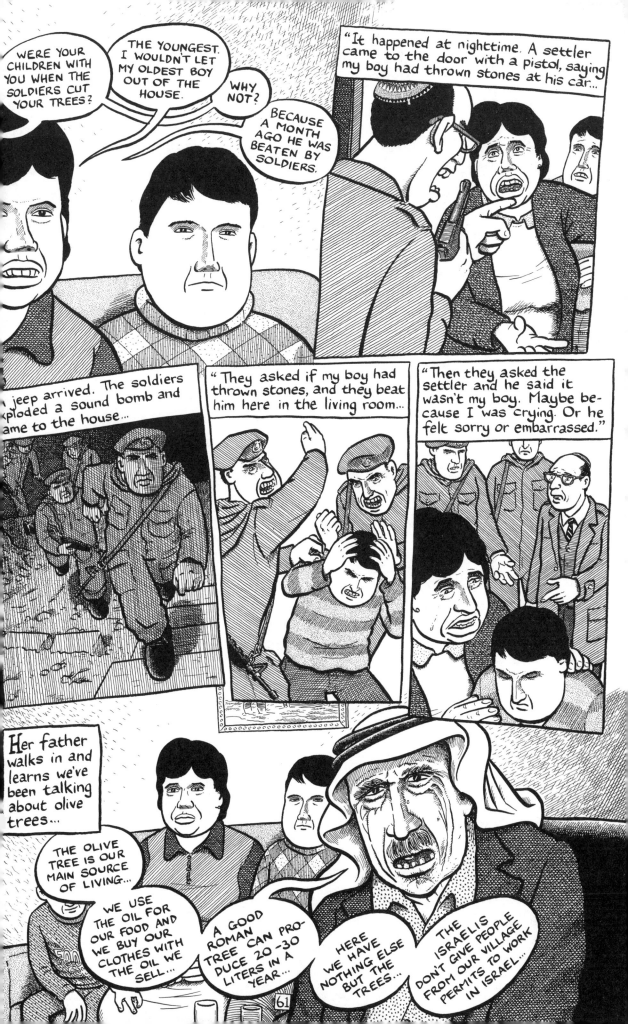

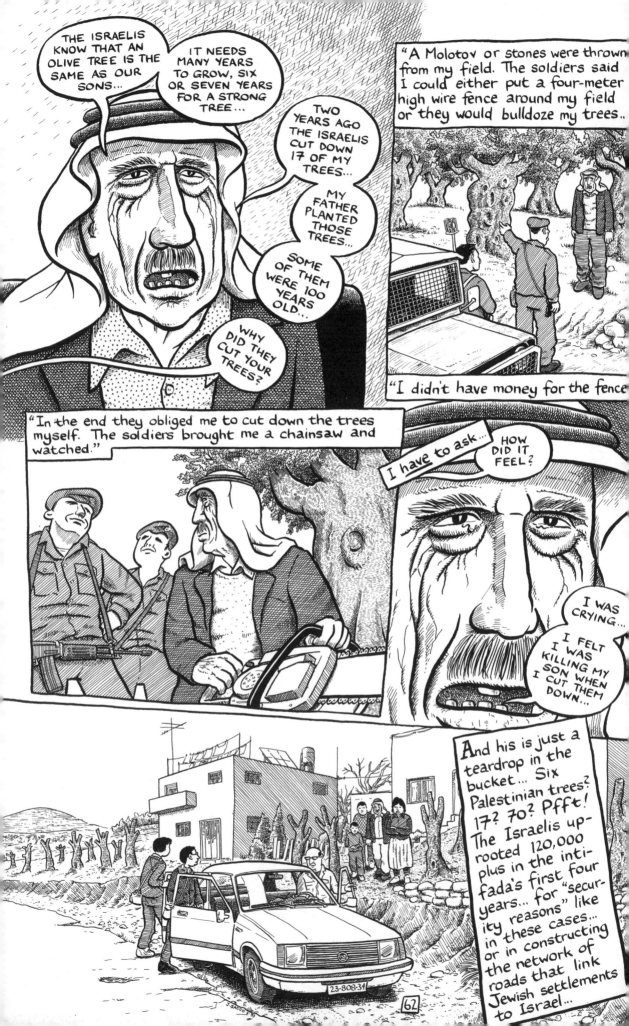

And speaking of settlements, Sami drives us to the village outskirts...

ALL THE LAND ON THIS SIDE OF THE ROAD HAS BEEN CONFISCATED BY THE ISRAELIS FOR SETTLEMENT...

It's scores of acres of farmland and pasture we're looking at... again, just drops in the bucket... Israel has expropriated two-thirds of the West Bank for its own use, including the settlement of Jews... (and I'm not counting annexed "Greater Jerusalem")...but like Prime Minister Shamir says:

IF WE ESTABLISH A SETTLEMENT HERE OR EXPAND A SETTLEMENT THERE, THIS IS ONLY NATURAL. WE ARE OPERATING ACCORDING TO THE UNDERSTANDING THAT THE LAND BELONGS TO US.

And with that "understanding" in mind, the World Zionist Organization's 'Master Plan 2010' points out that only five percent of the West Bank is "problematic for settlement..."

I suppose what makes it "problematic" is that hundreds of thousands of Palestinians still live here... in the countryside, though, they're mostly confined within village boundaries set under British rule in 1942 ... and the Israelis routinely reject rural building applications, forcing tens of thousands of Palestinians to build and live in "illegal" dwellings, hundreds of which are leveled every year... in fact, according to some official Israeli figures, in '87 and '88 the Israelis demolished more Palestinian homes than they granted building licenses...

But if a Jew wants to join a settlement on occupied Arab land, it's full steam ahead! Incentives to make your head spin! A government grant to offset moving expenses! Eligibility for higher loans at lower interest! Cheaper housing than in Israel! A seven percent income tax deduction! You get the idea — the yuppie version of the Homestead Act...

63

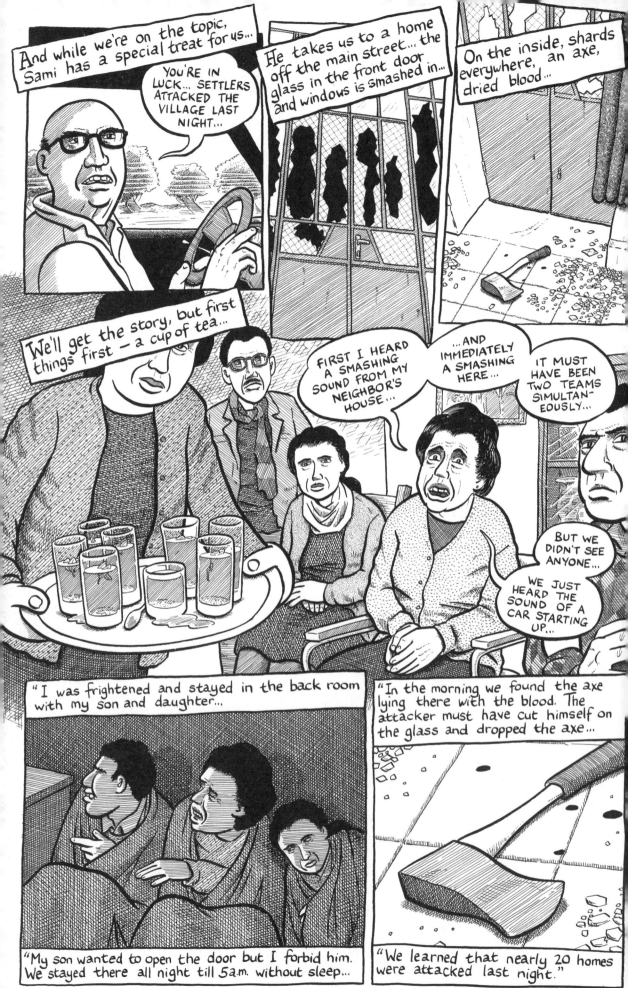

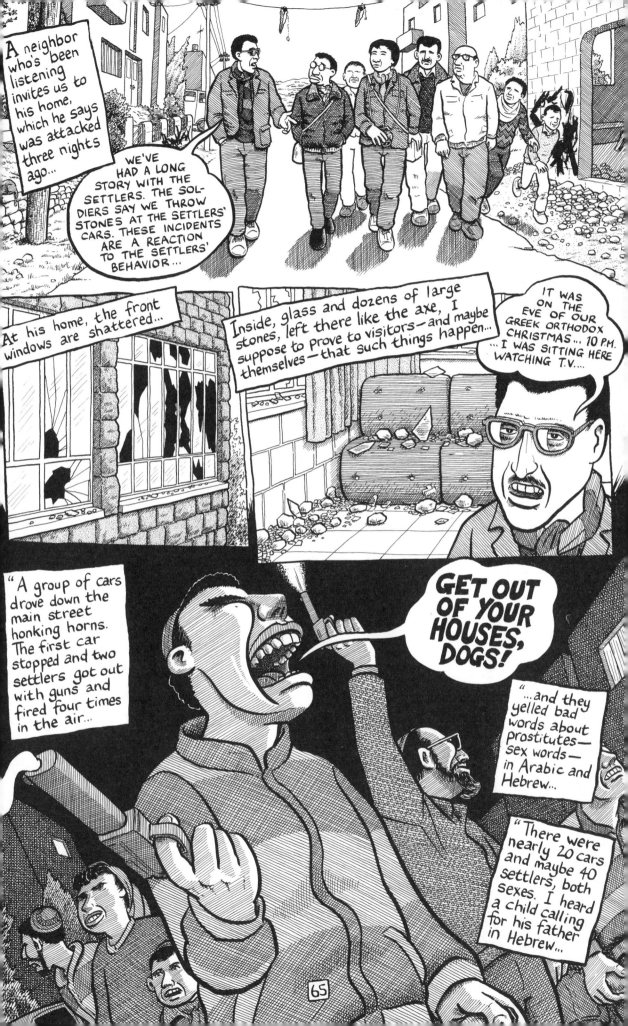

A neighbor who's been listening invites us to his home, which he says was attacked three nights ago...

WE'VE HAD A LONG STORY WITH THE SETTLERS. THE SOLDIERS SAY WE THROW STONES AT THE SETTLERS' CARS. THESE INCIDENTS ARE A REACTION TO THE SETTLERS' BEHAVIOR...

At his home, the front windows are shattered...

Inside, glass and dozens of large stones, left there like the axe, I suppose to prove to visitors—and maybe themselves—that such things happen...

IT WAS ON THE EVE OF OUR GREEK ORTHODOX CHRISTMAS... 10 P.M. ...I WAS SITTING HERE WATCHING T.V....

"A group of cars drove down the main street honking horns. The first car stopped and two settlers got out with guns and fired four times in the air...

GET OUT OF YOUR HOUSES, DOGS!

"...and they yelled bad words about prostitutes— sex words— in Arabic and Hebrew...

"There were nearly 20 cars and maybe 40 settlers, both sexes. I heard a child calling for his father in Hebrew...

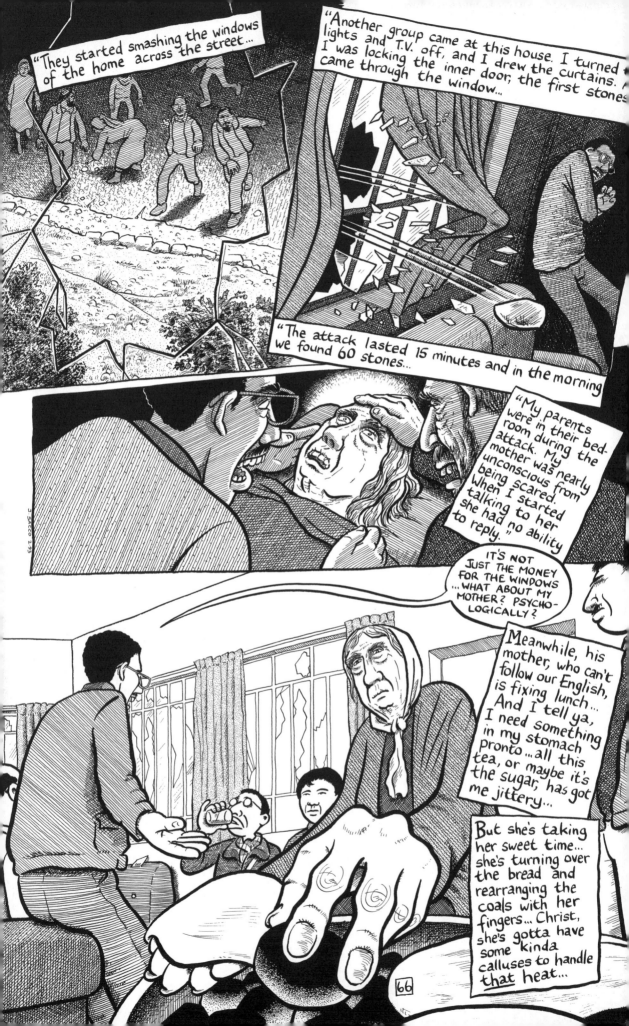

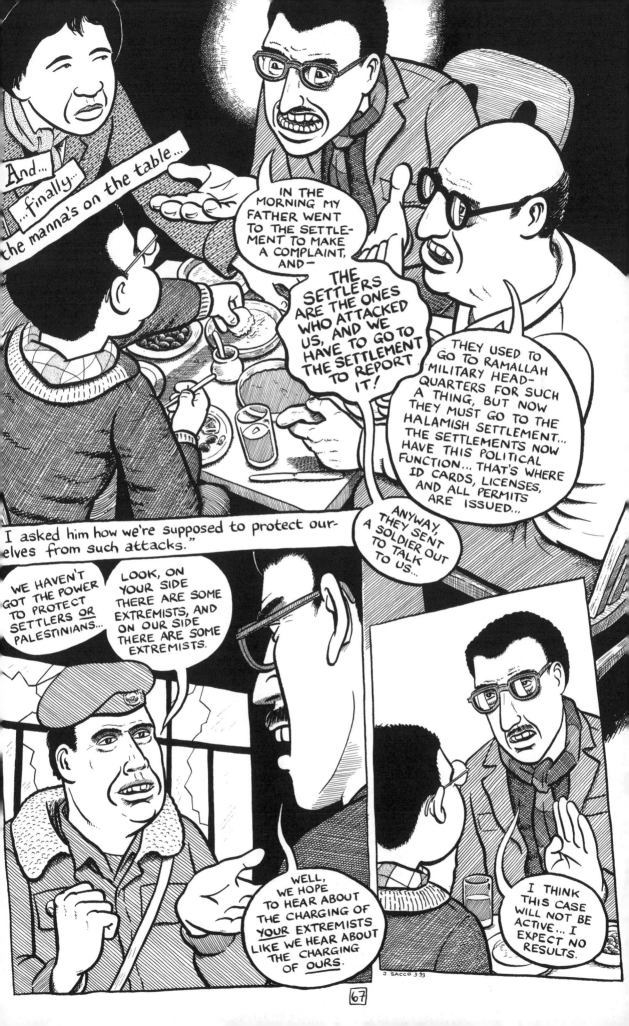

And... ...finally... the manna's on the table...

IN THE MORNING MY FATHER WENT TO THE SETTLEMENT TO MAKE A COMPLAINT, AND—

THE SETTLERS ARE THE ONES WHO ATTACKED US, AND WE HAVE TO GO TO THE SETTLEMENT TO REPORT IT!

THEY USED TO GO TO RAMALLAH MILITARY HEADQUARTERS FOR SUCH A THING, BUT NOW THEY MUST GO TO THE HALAMISH SETTLEMENT... THE SETTLEMENTS NOW HAVE THIS POLITICAL FUNCTION... THAT'S WHERE ID CARDS, LICENSES, AND ALL PERMITS ARE ISSUED...

I asked him how we're supposed to protect ourselves from such attacks."

ANYWAY, THEY SENT A SOLDIER OUT TO TALK TO US...

WE HAVEN'T GOT THE POWER TO PROTECT SETTLERS OR PALESTINIANS...

LOOK, ON YOUR SIDE THERE ARE SOME EXTREMISTS, AND ON OUR SIDE THERE ARE SOME EXTREMISTS.

WELL, WE HOPE TO HEAR ABOUT THE CHARGING OF YOUR EXTREMISTS LIKE WE HEAR ABOUT THE CHARGING OF OURS.

I THINK THIS CASE WILL NOT BE ACTIVE... I EXPECT NO RESULTS.

J. SACCO 3.93

67

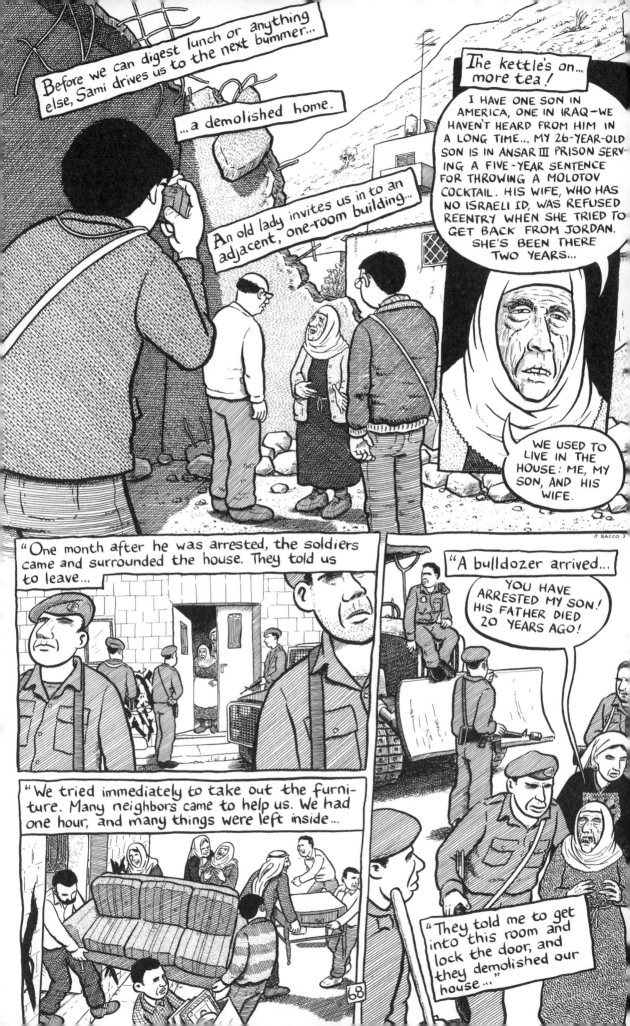

Before we can digest lunch or anything else, Sami drives us to the next bummer...

...a demolished home.

An old lady invites us in to an adjacent, one-room building...

The kettle's on... more tea!

I HAVE ONE SON IN AMERICA, ONE IN IRAQ—WE HAVEN'T HEARD FROM HIM IN A LONG TIME... MY 26-YEAR-OLD SON IS IN ANSAR III PRISON SERVING A FIVE-YEAR SENTENCE FOR THROWING A MOLOTOV COCKTAIL. HIS WIFE, WHO HAS NO ISRAELI ID, WAS REFUSED REENTRY WHEN SHE TRIED TO GET BACK FROM JORDAN. SHE'S BEEN THERE TWO YEARS...

J. SACCO 3

WE USED TO LIVE IN THE HOUSE: ME, MY SON, AND HIS WIFE.

"One month after he was arrested, the soldiers came and surrounded the house. They told us to leave...

"A bulldozer arrived...

YOU HAVE ARRESTED MY SON! HIS FATHER DIED 20 YEARS AGO!

"We tried immediately to take out the furniture. Many neighbors came to help us. We had one hour, and many things were left inside...

"They told me to get into this room and lock the door, and they demolished our house..."

68

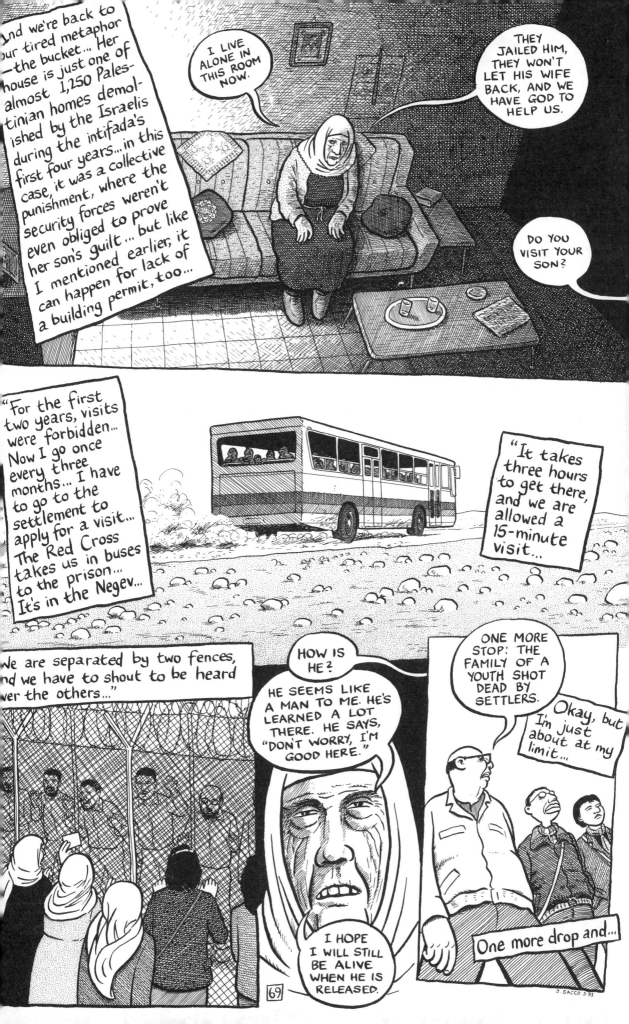

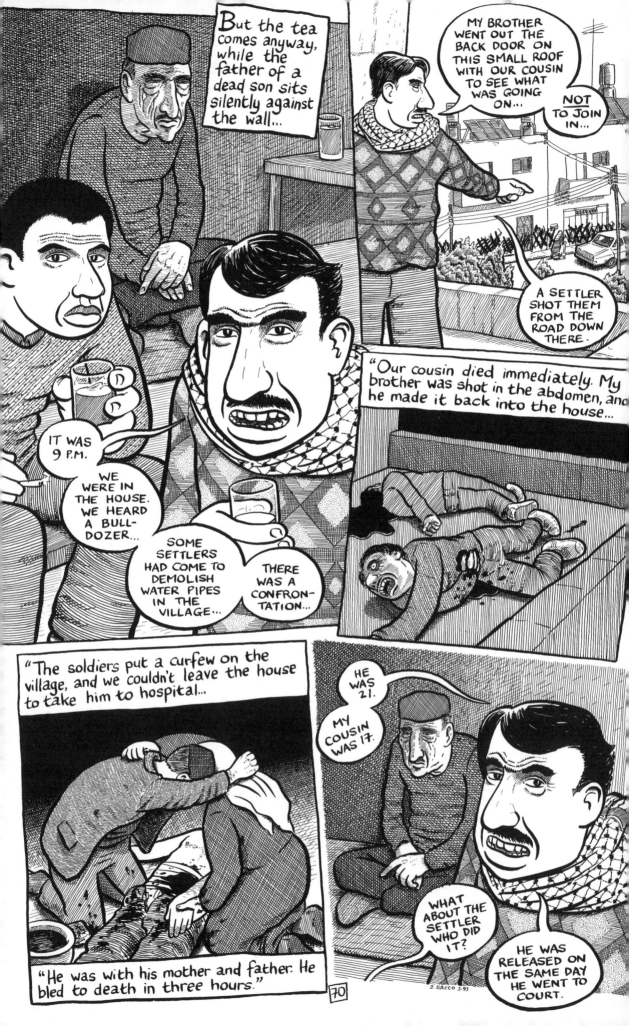

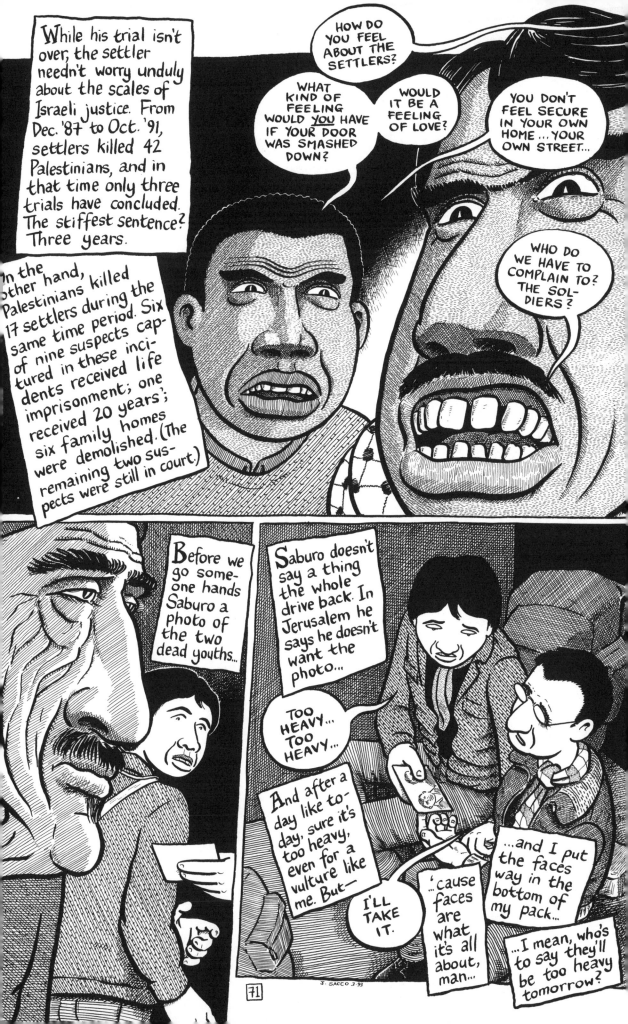

While his trial isn't over, the settler needn't worry unduly about the scales of Israeli justice. From Dec. '87 to Oct. '91, settlers killed 42 Palestinians, and in that time only three trials have concluded. The stiffest sentence? Three years.

On the other hand, Palestinians killed 17 settlers during the same time period. Six of nine suspects captured in these incidents received life imprisonment; one received 20 years; six family homes were demolished. (The remaining two suspects were still in court.)

HOW DO YOU FEEL ABOUT THE SETTLERS?

WHAT KIND OF FEELING WOULD YOU HAVE IF YOUR DOOR WAS SMASHED DOWN?

WOULD IT BE A FEELING OF LOVE?

YOU DON'T FEEL SECURE IN YOUR OWN HOME... YOUR OWN STREET...

WHO DO WE HAVE TO COMPLAIN TO? THE SOLDIERS?

Before we go someone hands Saburo a photo of the two dead youths...

Saburo doesn't say a thing the whole drive back. In Jerusalem he says he doesn't want the photo...

TOO HEAVY... TOO HEAVY...

And after a day like today, sure it's too heavy, even for a vulture like me. But—

I'LL TAKE IT.

'cause faces are what it's all about, man...

...and I put the faces way in the bottom of my pack...

...I mean, who's to say they'll be too heavy tomorrow?

J. SACCO 3·93

71

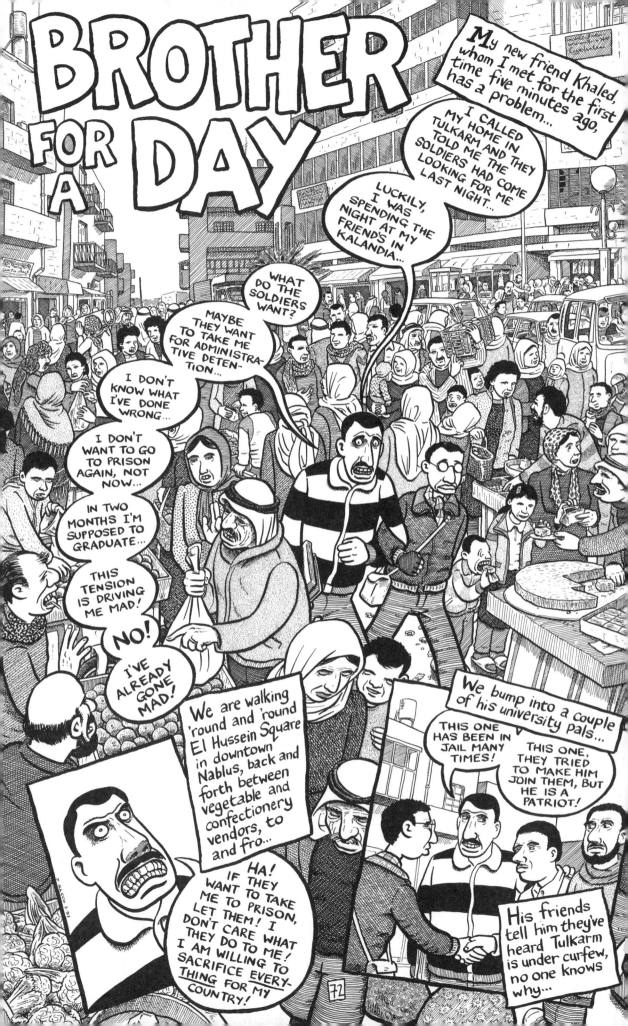

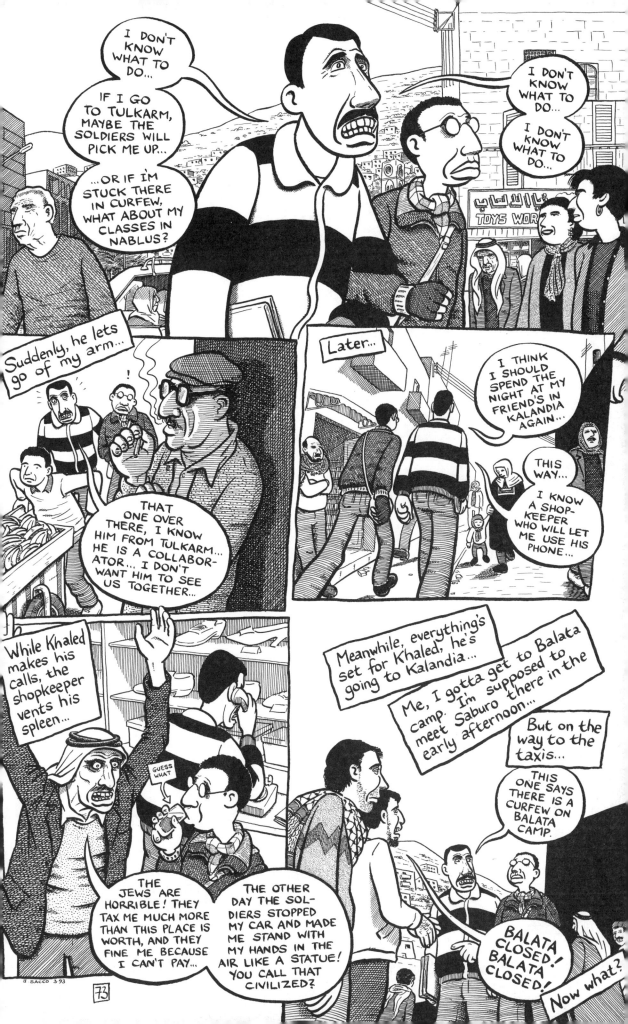

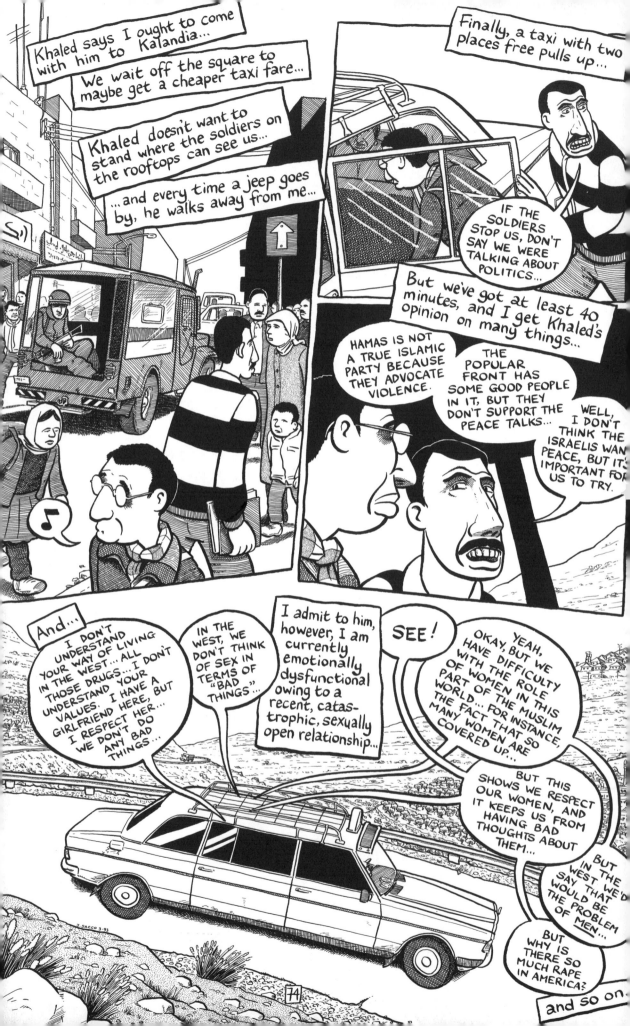

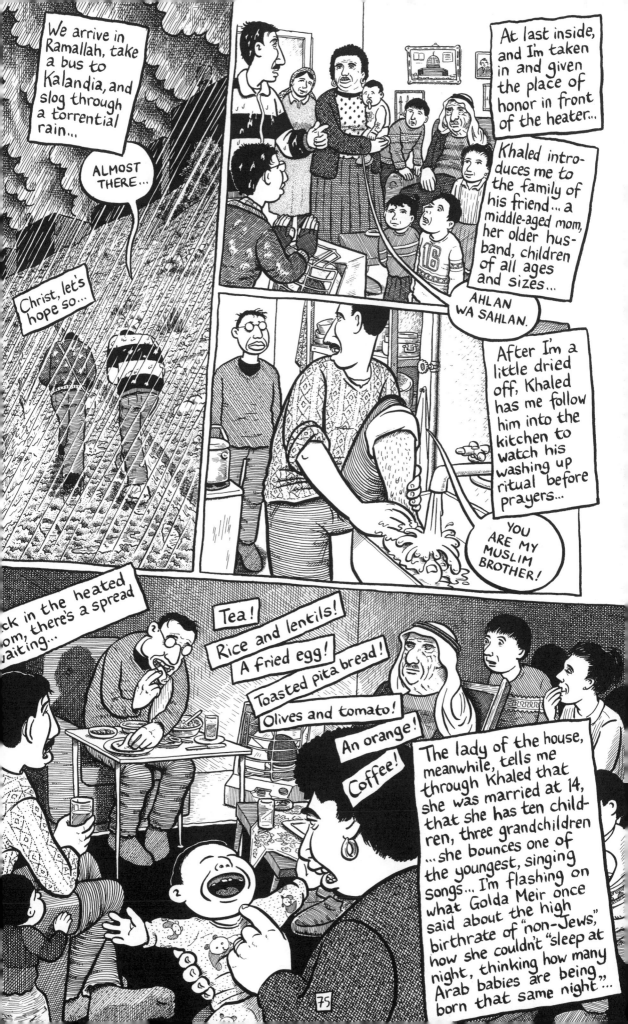

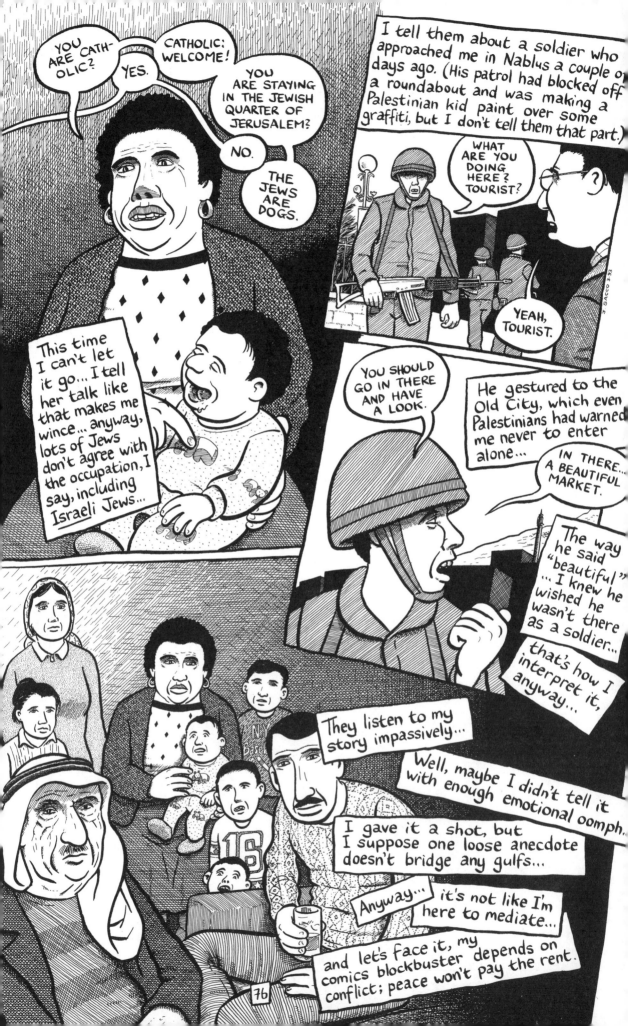

WHERE IS SABURO?

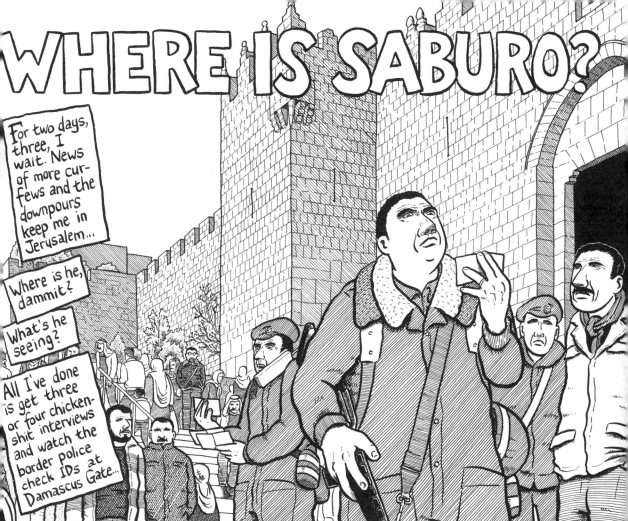

For two days, three, I wait. News of more curfews and the downpours keep me in Jerusalem...

Where is he, dammit?

What's he seeing?

All I've done is get three or four chicken-shit interviews and watch the border police check IDs at Damascus Gate...

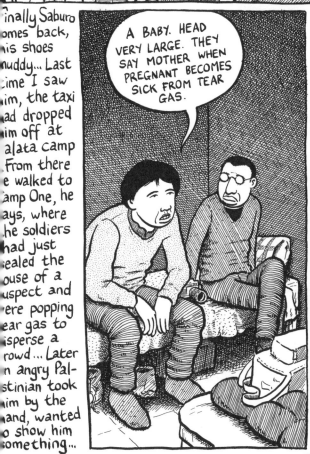

Finally Saburo comes back, his shoes muddy... Last time I saw him, the taxi had dropped him off at Balata camp. From there he walked to Camp One, he says, where the soldiers had just sealed the house of a suspect and were popping tear gas to disperse a crowd... Later an angry Palestinian took him by the hand, wanted to show him something...

A BABY. HEAD VERY LARGE. THEY SAY MOTHER WHEN PREGNANT BECOMES SICK FROM TEAR GAS.

I'm a skeptic. Journalistically speaking, you gotta be a Doubting Thomas; you gotta make sure. It's good to get your finger in the wound. Your whole head would be better.

DID YOU GET A PICTURE?

OF THE BABY?

I DON'T WANT TAKE PICTURE, BUT THEY WANT ME TAKE PICTURE.

AND?

I TAKE PICTURE... VERY HARD.

Man, I wish I'd seen the soldiers firing tear gas...

wish I'd seen that baby.

J. SACCO 4·93

Chapter Four

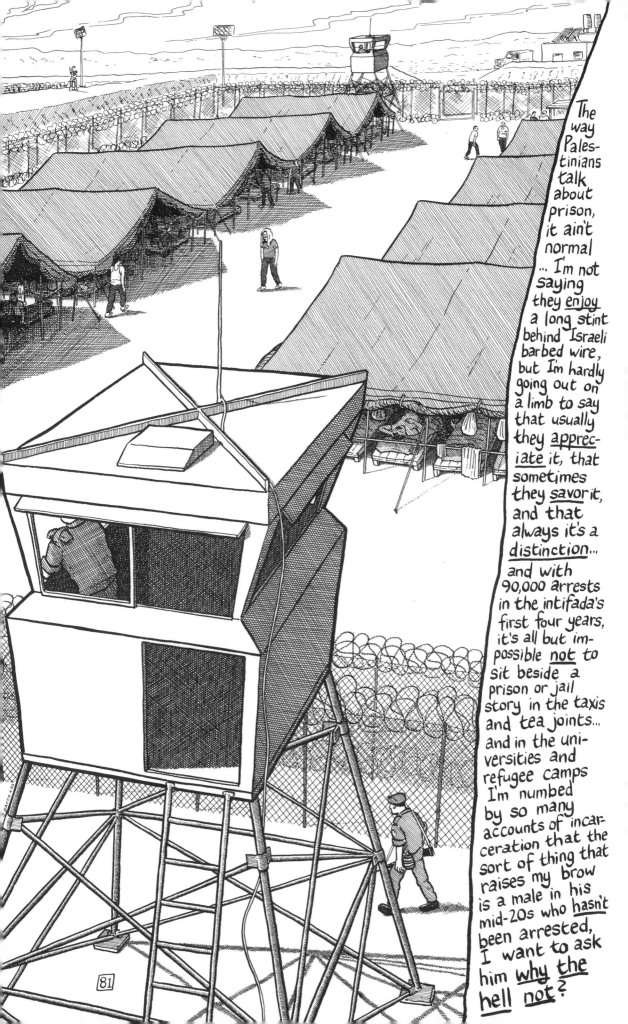

The way Palestinians talk about prison, it ain't normal ... I'm not saying they <u>enjoy</u> a long stint behind Israeli barbed wire, but I'm hardly going out on a limb to say that usually they <u>appreciate</u> it, that sometimes they <u>savor</u> it, and that always it's a <u>distinction</u>... and with 90,000 arrests in the intifada's first four years, it's all but impossible <u>not</u> to sit beside a prison or jail story in the taxis and tea joints... and in the universities and refugee camps I'm numbed by so many accounts of incarceration that the sort of thing that raises my brow is a male in his mid-20s who <u>hasn't</u> been arrested, I want to ask him <u>why the hell not</u>?

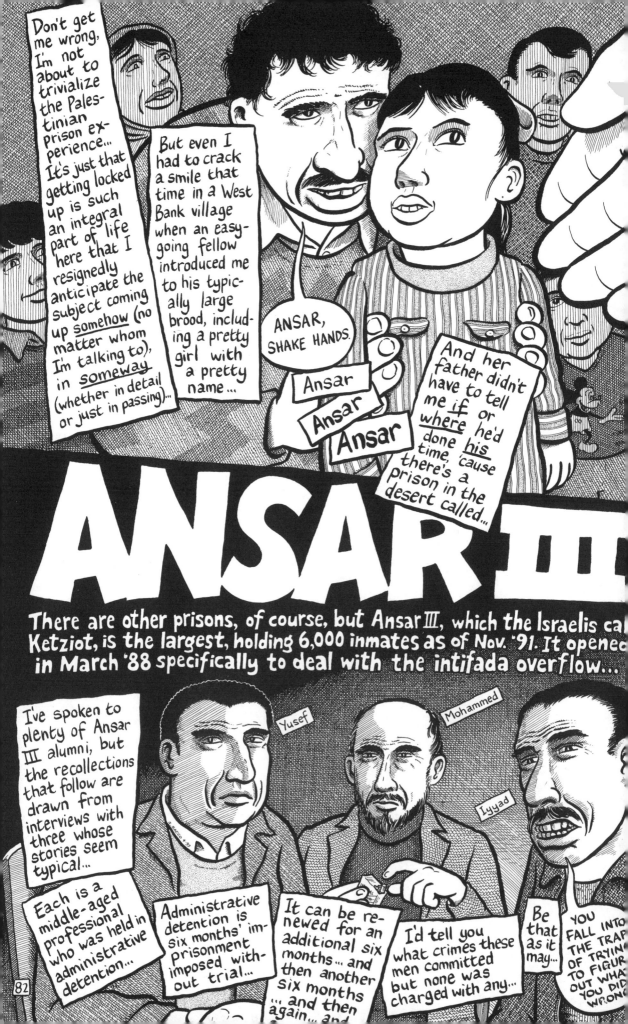

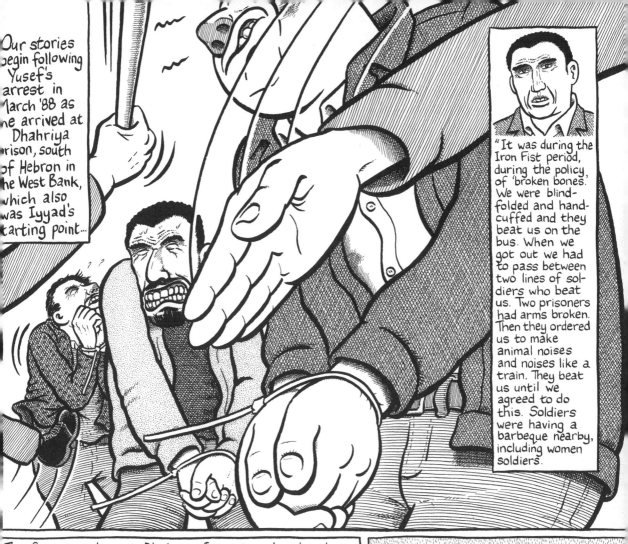

Our stories begin following Yusef's arrest in March '88 as he arrived at Dhahriya prison, south of Hebron in the West Bank, which also was Iyyad's starting point...

"It was during the Iron Fist period, during the policy of 'broken bones.' We were blindfolded and handcuffed and they beat us on the bus. When we got out we had to pass between two lines of soldiers who beat us. Two prisoners had arms broken. Then they ordered us to make animal noises and noises like a train. They beat us until we agreed to do this. Soldiers were having a barbeque nearby, including women soldiers."

The first two days at Dhahriya I spent under the sky... Then I spent 11 days in a cell. There were 35 of us. There was a barrel toilet and it was full. We told the soldiers, but it was during the night and raining so they didn't want to empty it right then. A fat prisoner had to go. He climbed onto the toilet, lost his balance, and the whole thing tipped over.

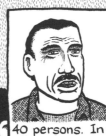

"I spent 18 days at Dhahriya before receiving an administrative detention order for six months. I was placed in a room of 4x6 meters with about 40 persons. In ten days they allowed us out of the room only twice, for 15 minutes each time."

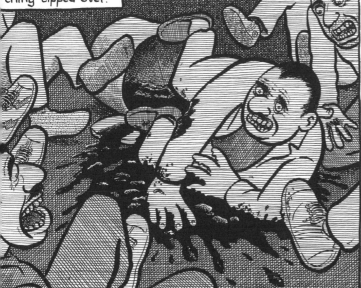

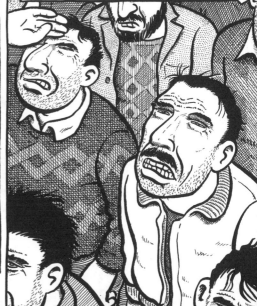

"The room was full of shit. We were shouting. We carried our shoes in our hands and our socks in our shoes. The soldiers came after half an hour, and they gave us soap and water to clean with, but we spent five days with the smell."

SACCO 4-93

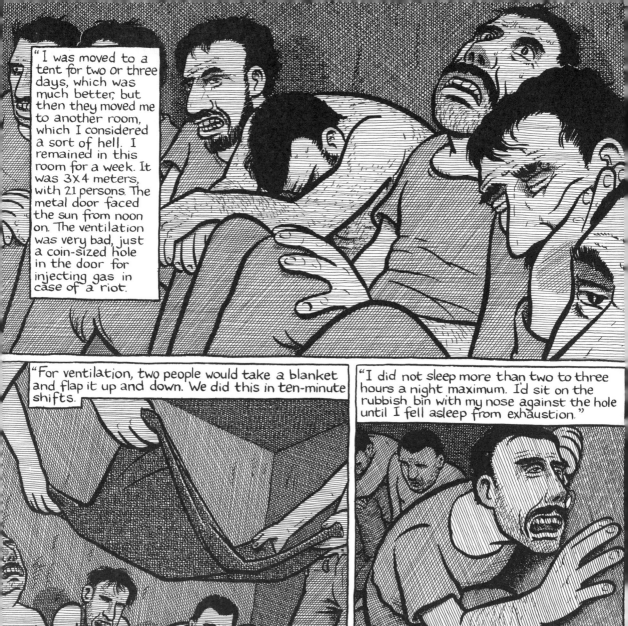

"I was moved to a tent for two or three days, which was much better, but then they moved me to another room, which I considered a sort of hell. I remained in this room for a week. It was 3x4 meters, with 21 persons. The metal door faced the sun from noon on. The ventilation was very bad, just a coin-sized hole in the door for injecting gas in case of a riot.

"For ventilation, two people would take a blanket and flap it up and down. We did this in ten-minute shifts.

"I did not sleep more than two to three hours a night maximum. I'd sit on the rubbish bin with my nose against the hole until I fell asleep from exhaustion."

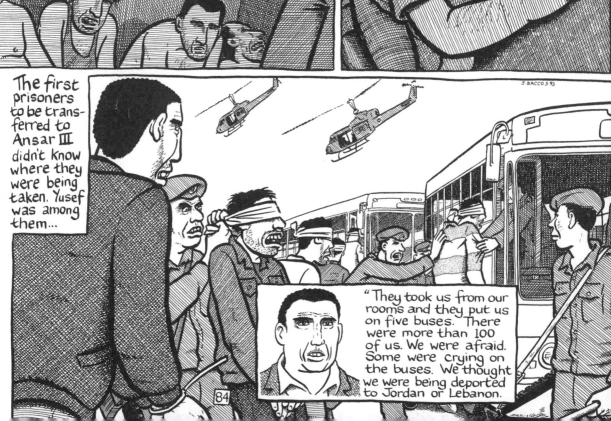

The first prisoners to be transferred to Ansar III didn't know where they were being taken. Yusef was among them...

J. SACCO 5-93

"They took us from our rooms and they put us on five buses. There were more than 100 of us. We were afraid. Some were crying on the buses. We thought we were being deported to Jordan or Lebanon.

84

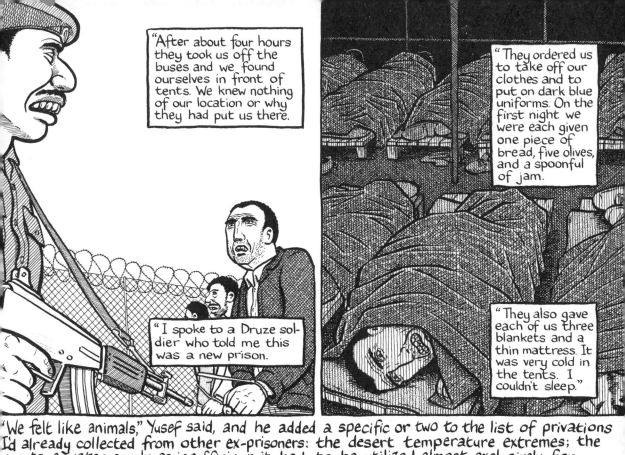

"After about four hours they took us off the buses and we found ourselves in front of tents. We knew nothing of our location or why they had put us there.

"I spoke to a Druze soldier who told me this was a new prison.

"They ordered us to take off our clothes and to put on dark blue uniforms. On the first night we were each given one piece of bread, five olives, and a spoonful of jam.

"They also gave each of us three blankets and a thin mattress. It was very cold in the tents. I couldn't sleep."

"We felt like animals," Yusef said, and he added a specific or two to the list of privations I'd already collected from other ex-prisoners: the desert temperature extremes; the insects; a water supply so insufficient it had to be utilized almost exclusively for drinking; a bland, inadequate diet; no change of clothes; little medical care... enough stuff, in other words, for another comics series... but let's not get bogged down by the bummed-behind-barbed-wire material 'cause, anyway, some things have improved with time and pressure... water, for example, is more readily available... writing implements are allowed, newspapers, too... and in Oct. '91 — three and a half years after Ansar III opened for business — regular family visits were arranged. In the meantime, the prison expanded to keep up with the growing number of intifada arrests...

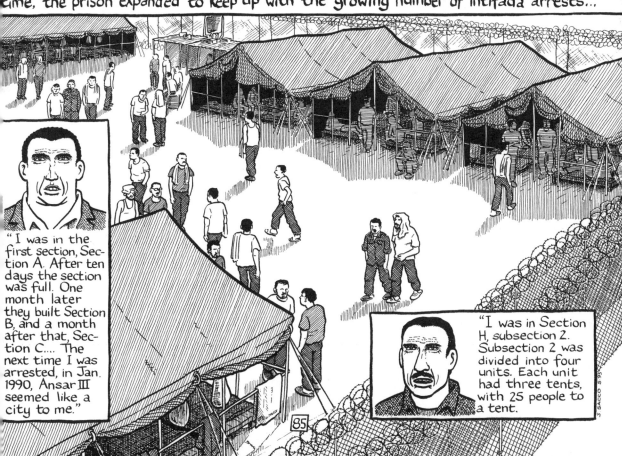

" I was in the first section, Section A. After ten days the section was full. One month later they built Section B, and a month after that, Section C.... The next time I was arrested, in Jan. 1990, Ansar III seemed like a city to me."

"I was in Section H, subsection 2. Subsection 2 was divided into four units. Each unit had three tents, with 25 people to a tent.

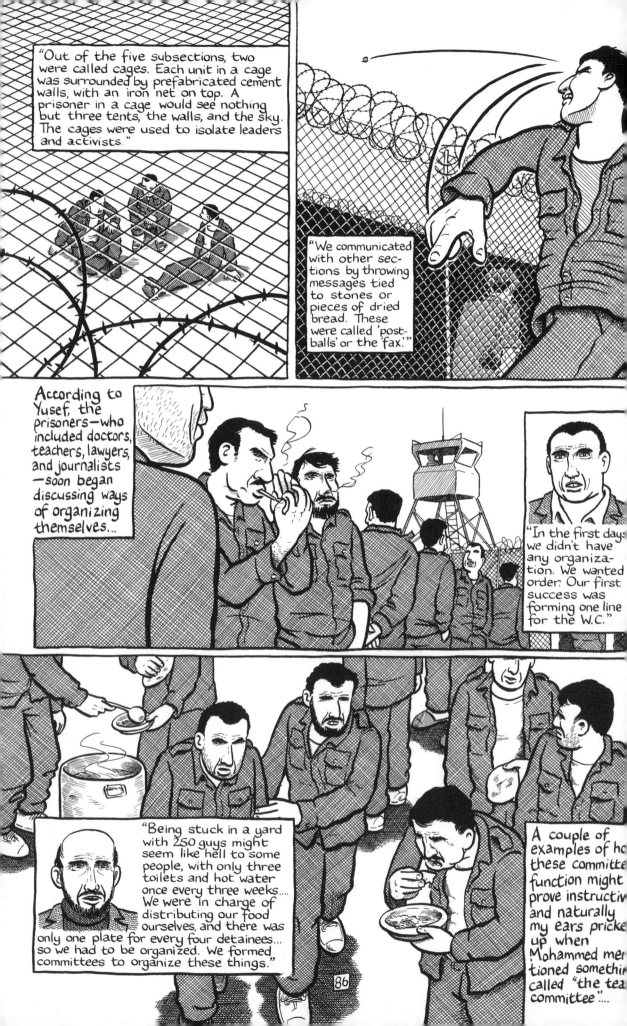

"Out of the five subsections, two were called cages. Each unit in a cage was surrounded by prefabricated cement walls, with an iron net on top. A prisoner in a cage would see nothing but three tents, the walls, and the sky. The cages were used to isolate leaders and activists."

"We communicated with other sections by throwing messages tied to stones or pieces of dried bread. These were called 'postballs' or the 'fax.'"

According to Yusef, the prisoners—who included doctors, teachers, lawyers, and journalists—soon began discussing ways of organizing themselves...

"In the first days we didn't have any organization. We wanted order. Our first success was forming one line for the W.C."

"Being stuck in a yard with 250 guys might seem like hell to some people, with only three toilets and hot water once every three weeks.... We were in charge of distributing our food ourselves, and there was only one plate for every four detainees... so we had to be organized. We formed committees to organize these things."

A couple of examples of how these committees function might prove instructive, and naturally my ears pricked up when Mohammed mentioned something called "the tea committee"....

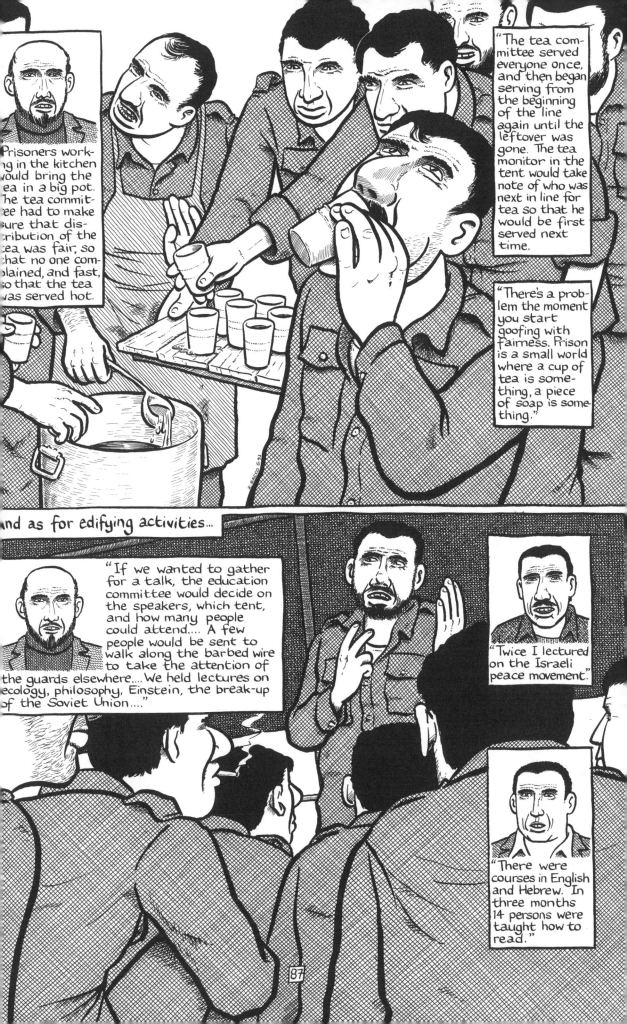

Prisoners working in the kitchen would bring the tea in a big pot. The tea committee had to make sure that distribution of the tea was fair, so that no one complained, and fast, so that the tea was served hot.

"The tea committee served everyone once, and then began serving from the beginning of the line again until the leftover was gone. The tea monitor in the tent would take note of who was next in line for tea so that he would be first served next time.

"There's a problem the moment you start goofing with fairness. Prison is a small world where a cup of tea is something, a piece of soap is something."

and as for edifying activities...

"If we wanted to gather for a talk, the education committee would decide on the speakers, which tent, and how many people could attend.... A few people would be sent to walk along the barbed wire to take the attention of the guards elsewhere.... We held lectures on ecology, philosophy, Einstein, the break-up of the Soviet Union...."

"Twice I lectured on the Israeli peace movement."

"There were courses in English and Hebrew. In three months 14 persons were taught how to read."

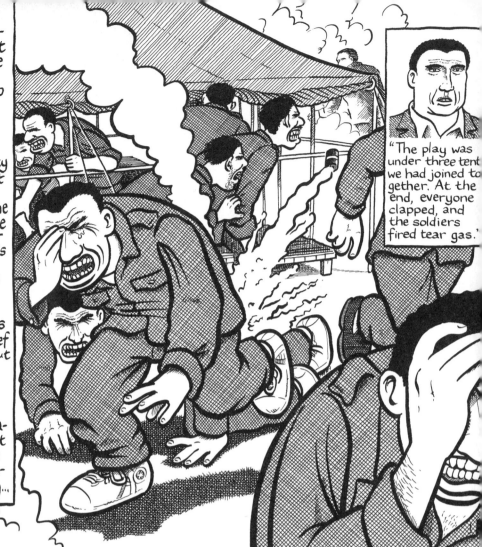

"Ansar is our university," a student in Bethlehem once told me, and he added a story so tidy I chalked it up to apocrypha (but who knows?): A Bir Zeit University professor was sent to Ansar III and found himself in the same tent as some of his students—so he continued his course and even administered an exam...

Besides lectures and studies, Yusef said, prisoners put on skits that demonstrated Israeli interrogation methods and on one occasion a play that dramatized the death of a Palestinian in custody...

"The play was under three tent we had joined to gether. At the end, everyone clapped, and the soldiers fired tear gas."

All the activities and organizational structures mentioned here, as well as prison discipline, were controlled by political committees representing the various faction of the PLO – Fateh, the Popular Front, the Democratic Front, the Communists, etc.

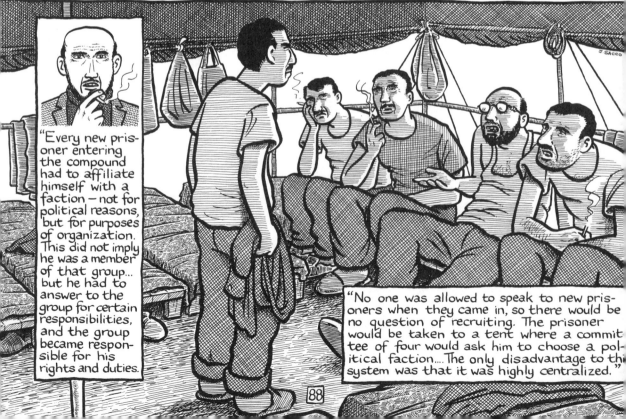

"Every new prisoner entering the compound had to affiliate himself with a faction – not for political reasons, but for purposes of organization. This did not imply he was a member of that group... but he had to answer to the group for certain responsibilities, and the group became responsible for his rights and duties.

"No one was allowed to speak to new prisoners when they came in, so there would be no question of recruiting. The prisoner would be taken to a tent where a committee of four would ask him to choose a political faction.... The only disadvantage to the system was that it was highly centralized."

The extent of prisoner solidarity, despite diverse political views, is well demonstrated by an event that took place early in the history of Ansar III...

"I hid the newspaper and took it to a friend from Jenin who could read Hebrew. When he read it he began crying."

THEY'VE KILLED ABU JIHAD*!

"I worked in the kitchen with three others. We used to take the rubbish from the kitchen to dump with the soldiers' rubbish, and I found a Hebrew newspaper in there.

*Abu Jihad (Khalil Al-Wazir) — formed the Palestinian revolutionary group Fateh with his close friend Yasser Arafat. Assassinated by Israeli commandoes in Tunis, April 16, 1988. "We were one spirit in two bodies," Arafat said of him.

As part of the kitchen staff distributing food, Yusef helped spread the news, which was already six days old...

"We spoke with prisoners and told them what we had learned ...slowly, slowly, so not to start a riot."

Abu Jihad belonged to Fateh, but the other factions wanted to commemorate him, too. Section A's political committee decided to pay tribute to him the next morning...

"We weren't allowed watches, so we decided to leave our tents during prayers.... After the third 'Allah Aqbar' all of us went out and stood in line for one minute.

J. SACCO 5·93

89

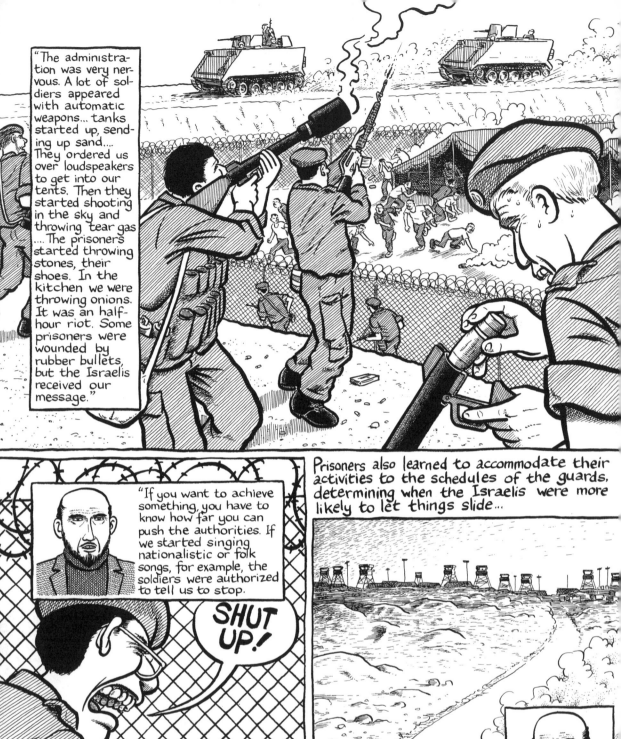

"The administration was very nervous. A lot of soldiers appeared with automatic weapons... tanks started up, sending up sand.... They ordered us over loudspeakers to get into our tents. Then they started shooting in the sky and throwing tear gas.... The prisoners started throwing stones, their shoes. In the kitchen we were throwing onions. It was an half-hour riot. Some prisoners were wounded by rubber bullets, but the Israelis received our message."

"If you want to achieve something, you have to know how far you can push the authorities. If we started singing nationalistic or folk songs, for example, the soldiers were authorized to tell us to stop.

SHUT UP!

"We ignore him, and he might tell us three times. He tells an officer, and the officer comes to warn our subsection, next time there might be tear gas. As soon as we see it's serious, we stop.... Half an hour later we start up again."

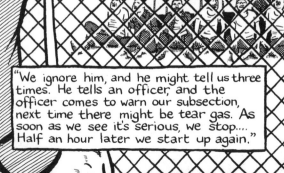

Prisoners also learned to accommodate their activities to the schedules of the guards, determining when the Israelis were more likely to let things slide...

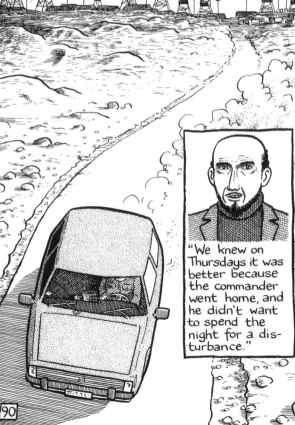

"We knew on Thursdays it was better because the commander went home, and he didn't want to spend the night for a disturbance."

90

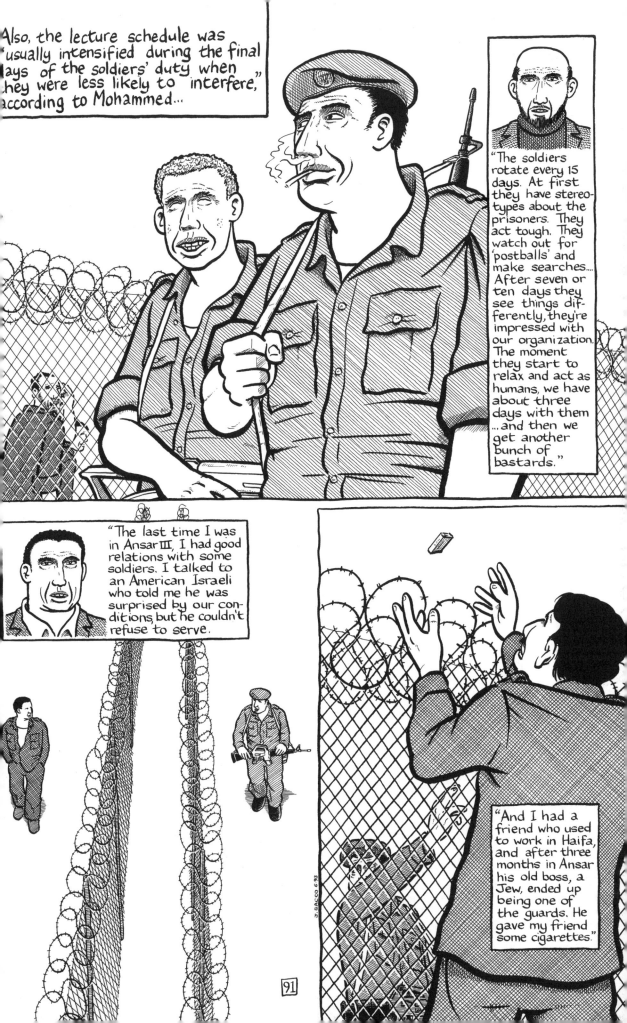

Also, the lecture schedule was usually intensified during the final days of the soldiers' duty when they were less likely to interfere," according to Mohammed...

"The soldiers rotate every 15 days. At first they have stereotypes about the prisoners. They act tough. They watch out for 'postballs' and make searches.... After seven or ten days they see things differently, they're impressed with our organization. The moment they start to relax and act as humans, we have about three days with them ...and then we get another bunch of bastards."

"The last time I was in Ansar III, I had good relations with some soldiers. I talked to an American Israeli who told me he was surprised by our conditions, but he couldn't refuse to serve.

"And I had a friend who used to work in Haifa, and after three months in Ansar his old boss, a Jew, ended up being one of the guards. He gave my friend some cigarettes."

J. SACCO 6-93

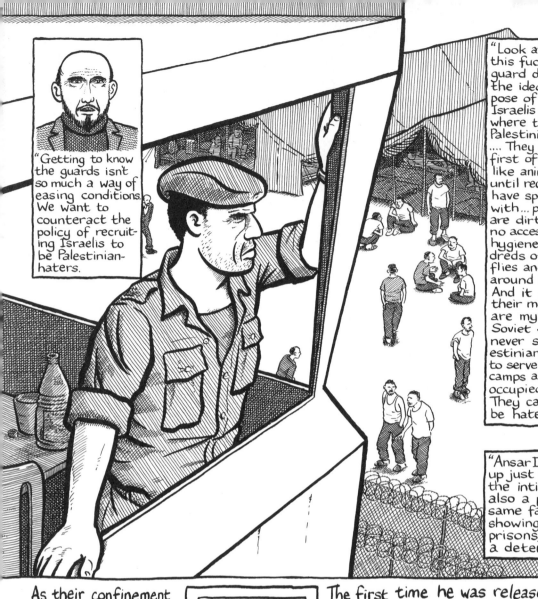

"Getting to know the guards isn't so much a way of easing conditions. We want to counteract the policy of recruiting Israelis to be Palestinian-haters."

"Look at how it works, this fucking Israeli guard duty. It serves the ideological purpose of exposing Israelis to conditions where they don't see Palestinians as humans.... They see people, first of all, dressed like animals, who, until recently, didn't have spoons to eat with... people who are dirty, who have no access to proper hygiene, with hundreds of different flies and mosquitoes around their faces. And it sticks in their minds — 'Those are my enemies'.... Soviet Jews who've never seen a Palestinian are taken to serve in detention camps and in the occupied territories. They can learn to be haters, too.

"Ansar III wasn't set up just to counteract the intifada; it's also a policy.... The same faces keep showing up in the prisons, so it's not a deterrence."

As their confinement comes to an end, prisoners often have one last obligation to the comrades they're leaving behind — getting messages to friends and loved ones on the outside...

"It's the usual routine.... You swallow capsules with messages. They're plastic with the ends melted to form a seal.... I swallowed at least 14 such messages. On the day you are released, people come up to you and ask if you have a message for them. You say, "Yes, but maybe tomorrow.""

The first time he was released from Ansar III, Yusef told me, was the happiest moment of his life. Many people, journalists, came to greet him. When the Israelis arrested him again, four months later, he was here in his office, where we sipped tea...

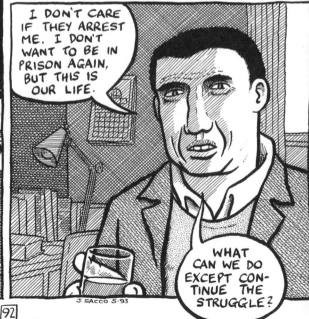

I DON'T CARE IF THEY ARREST ME. I DON'T WANT TO BE IN PRISON AGAIN, BUT THIS IS OUR LIFE.

WHAT CAN WE DO EXCEPT CONTINUE THE STRUGGLE?

J. SACCO 5·93

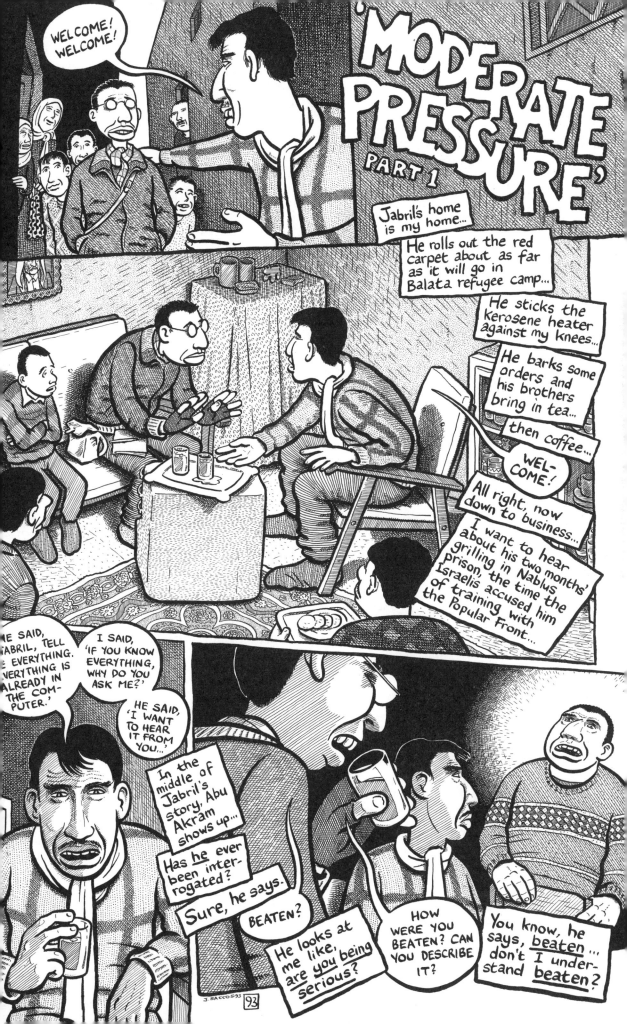

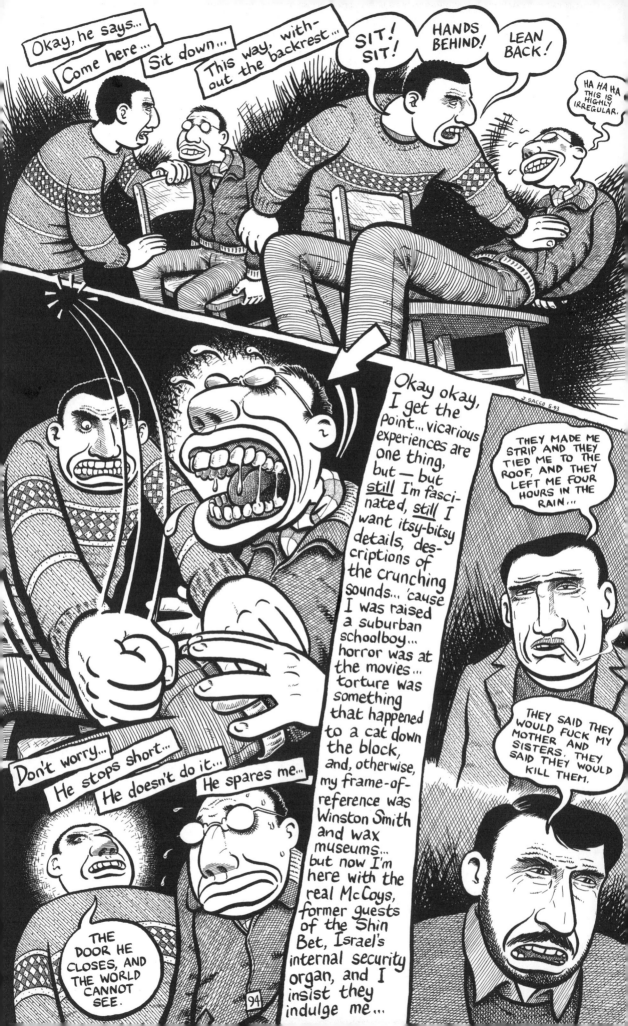

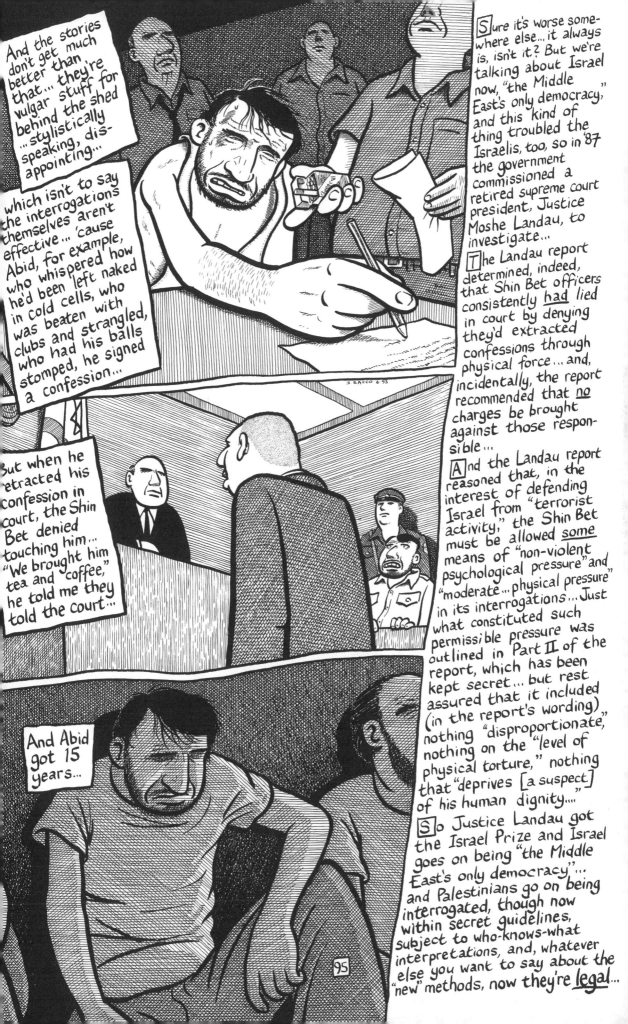

And the stories don't get much better than that... they're vulgar stuff for behind the shed ... stylistically speaking, disappointing...

which isn't to say the interrogations themselves aren't effective... 'cause Abid, for example, who whispered how he'd been left naked in cold cells, who was beaten with clubs and strangled, who had his balls stomped, he signed a confession...

But when he retracted his confession in court, the Shin Bet denied touching him... "We brought him tea and coffee," he told me they told the court...

And Abid got 15 years...

Sure it's worse somewhere else... it always is, isn't it? But we're talking about Israel now, "the Middle East's only democracy," and this kind of thing troubled the Israelis, too, so in '87 the government commissioned a retired supreme court president, Justice Moshe Landau, to investigate...

The Landau report determined, indeed, that Shin Bet officers consistently had lied in court by denying they'd extracted confessions through physical force... and, incidentally, the report recommended that no charges be brought against those responsible...

And the Landau report reasoned that, in the interest of defending Israel from "terrorist activity," the Shin Bet must be allowed some means of "non-violent psychological pressure" and "moderate... physical pressure" in its interrogations... Just what constituted such permissible pressure was outlined in Part II of the report, which has been kept secret... but rest assured that it included (in the report's wording) nothing "disproportionate," nothing on the "level of physical torture," nothing that "deprives [a suspect] of his human dignity...."

So Justice Landau got the Israel Prize and Israel goes on being "the Middle East's only democracy"... and Palestinians go on being interrogated, though now within secret guidelines, subject to who-knows-what interpretations, and, whatever else you want to say about the "new" methods, now they're legal...

J. SACCO 6 93

95

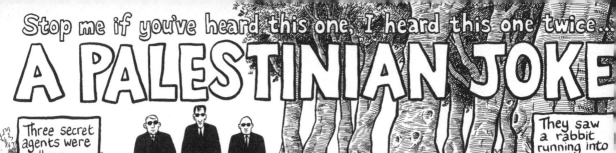

Stop me if you've heard this one, I heard this one twice...
A PALESTINIAN JOKE

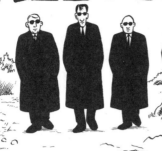

Three secret agents were walking along the edge of a forest. One was CIA, one was KGB, one was Shin Bet...

They saw a rabbit running into the trees and they decided to see how fast each of them could capture it...

The CIA man went first and returned with the rabbit in ten minutes...

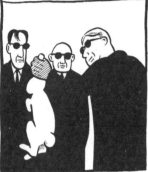

They let the rabbit go again...

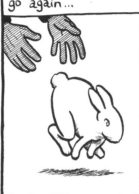

The KGB agent returned with the rabbit in only five minutes...

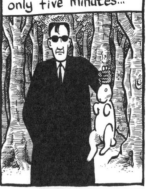

The Shin Bet fellow was not impressed...

THAT'S NOTHING.

LET THE RABBIT GO AGAIN.

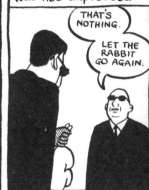

The Shin Bet officer went after the rabbit...

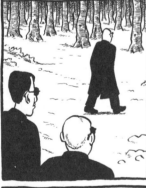

The other two agents waited... five minutes passed... ten minutes... 20... 40...

SOMETHING'S GONE WRONG.

They entered the forest to look for their Israeli colleague...

They walked for a long time... going deeper and deeper into the woods...

Finally, they heard noise — yelling and screaming...

...and they followed the sound to a clearing...

ADMIT YOU'RE THE RABBIT!

ADMIT YOU'RE THE RABBIT!

J. SACCO 6-91

96

Someone in the Gaza Strip once told me, "When you are under interrogation, you forget the name of your father." Me? I wonder how long I'd last getting the business behind a closed door... Not long I bet, but I'm a Pussy First Class... a harsh word and a dirty look and I'd be screaming for Amnesty Int'l....

THE TOUGH AND THE DEAD

I meet a Palestinian woman about my age, though, who is one tough cookie...

Two years ago she did 18 days in Jerusalem's notorious Russian Compound, courtesy of the Shin Bet...

And still she's bitter about the guys who squealed on her, who named her for something she says she didn't do — underwriting nationalistic pamphlets...

SOME OF THEM WERE ARRESTED IN THE MORNING AND DENOUNCED ME IN THE AFTERNOON...

THEY COULDN'T TOLERATE ONE DAY OF PAIN...

NOT ONLY WERE THEIR BODIES WEAK, BUT THEIR MINDS WERE WEAK, THEIR COMMITMENT TO THE NATIONAL CAUSE WAS WEAK...

"The Shin Bet confronted me with one of them, and when I asked him if he even knew me, he said no..."

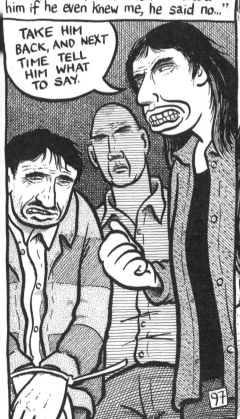

TAKE HIM BACK, AND NEXT TIME TELL HIM WHAT TO SAY.

EVEN IF THEY BEAT HIM ON THE GENITALS, IT HURTS ONCE, IT HURTS TWICE...

And after that, she says, you don't feel it so much...

I beg to differ, of course, but who am I to take issue with a person of her mettle... she's done months in prison, she's been arrested four times...

And in the Russian Compound the Shin Bet stood her up in the "coffin" half a day after she'd undergone a liver biopsy...

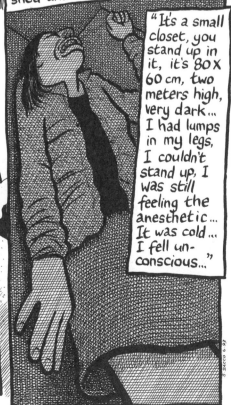

"It's a small closet, you stand up in it, it's 80 X 60 cm, two meters high, very dark... I had lumps in my legs, I couldn't stand up, I was still feeling the anesthetic... It was cold... I fell unconscious..."

97

Some time later the door opened, the air revived her...

YOU'RE NOT DEAD YET?

I WANT TO VOMIT.

And they tied her and hooded her —the Palestinians call this technique "Al-Shabah"— "sometimes four hours, sometimes the whole day ... sometimes they take you in the middle of the night for this."

They made her sit up straight with a metal bar pressing down the center of her back, she says, they hit her when she leaned against the wall...

But worst of all was isolation, her cell, which was besmirched with filth, she says, and where she was left without toilet paper and sanitary napkins...

She longed for the interrogations, when she'd have someone to talk to... "I'd have fun with them"... she says she'd figured out the Shin Bet...

"They have some information against you. First they want you to confirm the information. Second, they want you to provide additional information, to implicate others..."

The Shin Bet reckoned they could play the twin cards of gender and Arab culture against her... They implied a long imprisonment would ruin her marriage prospects...

WE DON'T ARREST GIRLS. WE KNOW YOUR SITUATION AS A GIRL IN YOUR SOCIETY. NO ONE WILL MARRY YOU.

IN 25 YEARS I'LL BE OUT, THEY'LL BE STANDING IN LINE FOR ME, BUT YOU MAY BE DEAD.

98

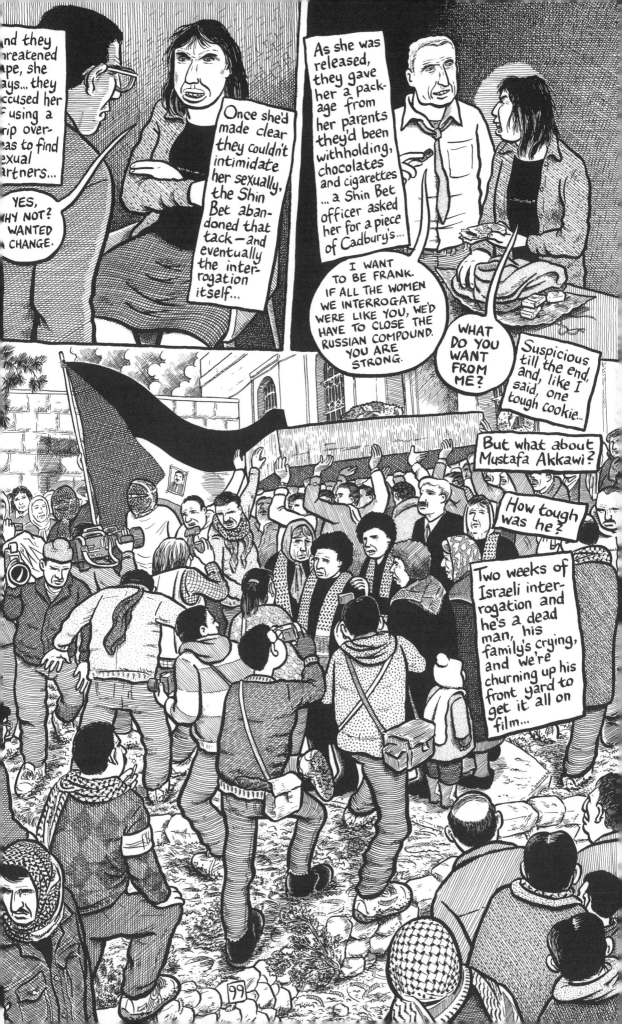

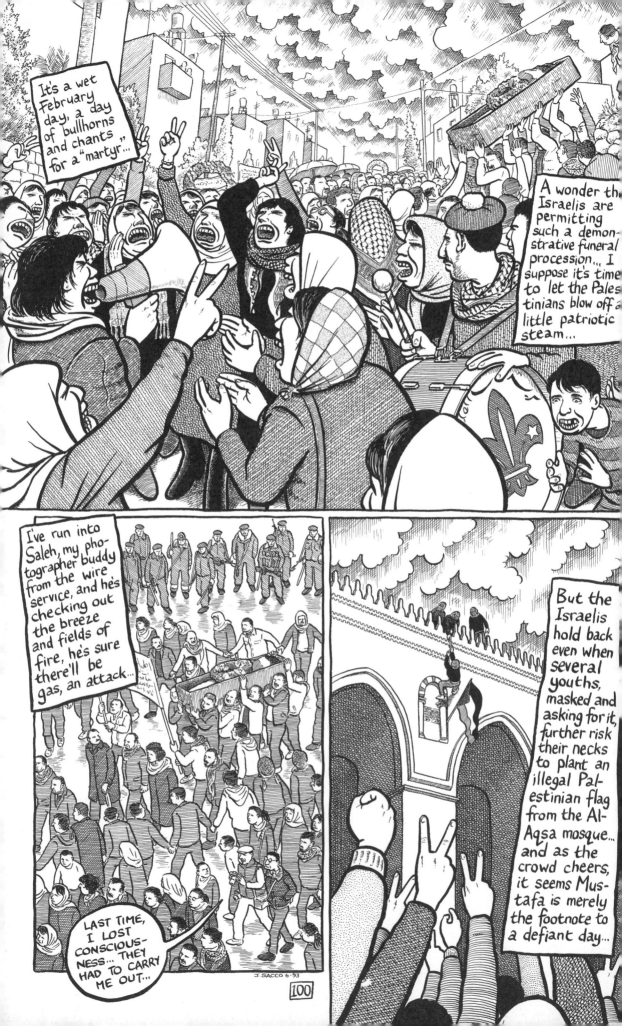

It's a wet February day, a day of bullhorns and chants for a "martyr"...

A wonder the Israelis are permitting such a demonstrative funeral procession... I suppose it's time to let the Palestinians blow off a little patriotic steam...

I've run into Saleh, my photographer buddy from the wire service, and he's checking out the breeze and fields of fire, he's sure there'll be gas, an attack...

LAST TIME, I LOST CONSCIOUSNESS... THEY HAD TO CARRY ME OUT...

But the Israelis hold back even when several youths, masked and asking for it, further risk their necks to plant an illegal Palestinian flag from the Al-Aqsa mosque... and as the crowd cheers, it seems Mustafa is merely the footnote to a defiant day...

J. SACCO 6·93

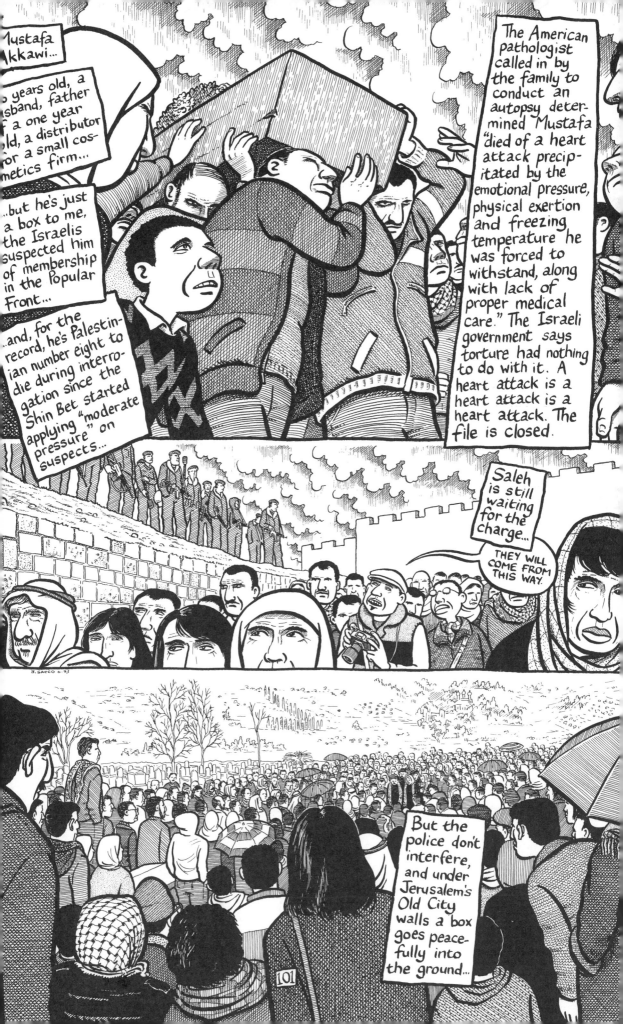

Mustafa Akkawi...

...years old, a [hu]sband, father [of] a one year [o]ld, a distributor [f]or a small cosmetics firm...

...but he's just a box to me, the Israelis suspected him of membership in the Popular Front...

...and, for the record, he's Palestinian number eight to die during interrogation since the Shin Bet started applying "moderate pressure" on suspects...

The American pathologist called in by the family to conduct an autopsy determined Mustafa "died of a heart attack precipitated by the emotional pressure, physical exertion and freezing temperature he was forced to withstand, along with lack of proper medical care." The Israeli government says torture had nothing to do with it. A heart attack is a heart attack is a heart attack. The file is closed.

Saleh is still waiting for the charge...

THEY WILL COME FROM THIS WAY.

But the police don't interfere, and under Jerusalem's Old City walls a box goes peacefully into the ground...

J. SACCO 6.95

101

'MODERATE PRESSURE' PART 2

Make no mistake, everywhere you go, not just in Marvel Comics, there's parallel universes... Here? On the surface streets: traffic, couples in love, falafel-to-go, tourists in jogging suits licking stamps for postcards... And over the wall behind closed doors: other things — people strapped to chairs, sleep deprivation, the smell of piss... other things happenning for "reasons of national security" ...for "security reasons"...to combat "terrorist activity"...they were happening to Ghassan a week and a half ago, he shows me his back and wrists, he's still got the marks... he's a fresh case, all right ... right off the rack...

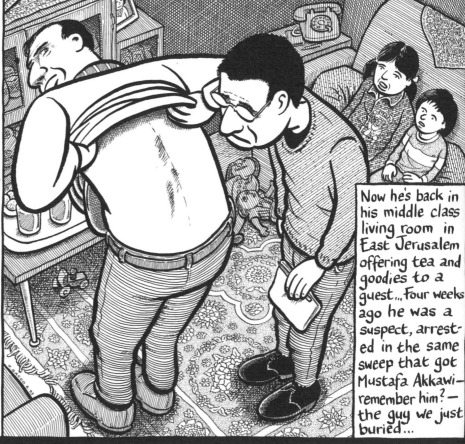

Now he's back in his middle class living room in East Jerusalem offering tea and goodies to a guest...Four weeks ago he was a suspect, arrested in the same sweep that got Mustafa Akkawi— remember him? — the guy we just buried...

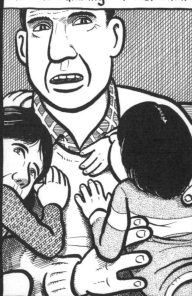

Ghassan tells me his story, his kids climbing all over him.

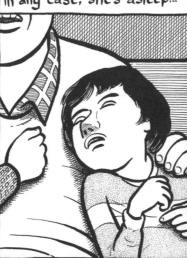

And soon his little girl is fast asleep... Probably she's too young to understand, or else she's heard it all before..., in any case, she's asleep...

And sleep is where Ghassan's story starts... where stories like this always start... when people are asleep...

And then the door gets bashed down...

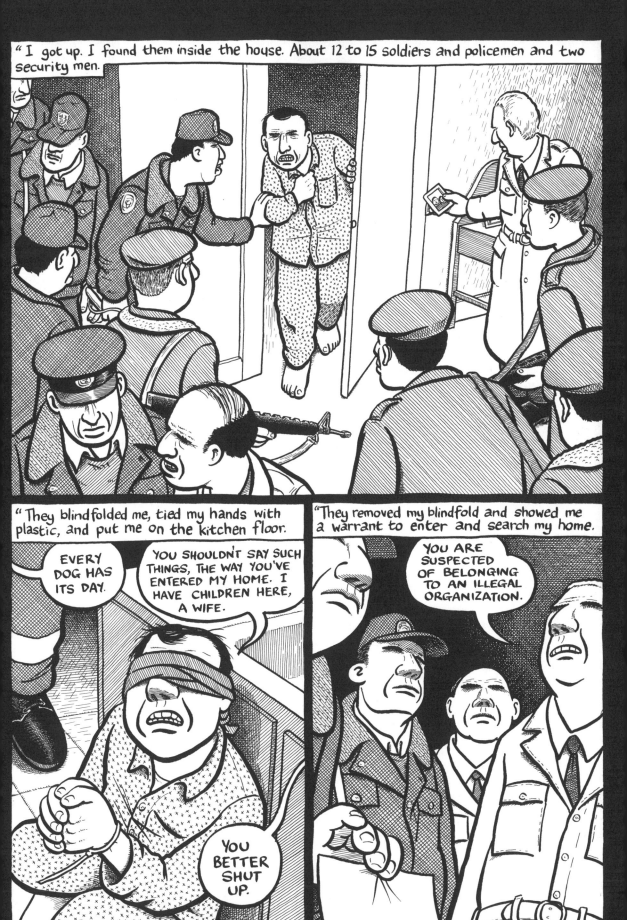

"A man with a camera took two or three photos.

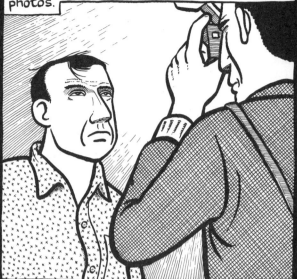

"They blindfolded me again... We were going outside. My wife insisted they take some clothes for me.

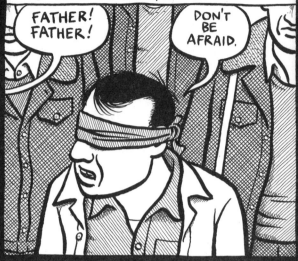

FATHER! FATHER!

DON'T BE AFRAID.

"They put me in a car and we drove for five or ten minutes.

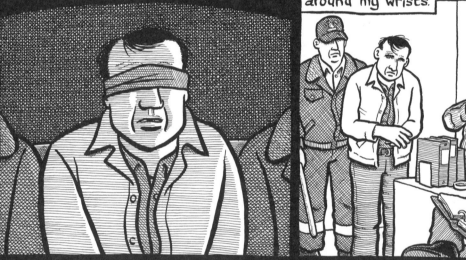

"They pulled me into a police station... They untied the blindfold and the plastic around my wrists.

"They took my ID and everything from my pockets and made a list of it.

"After more photos they took me to a police clinic.

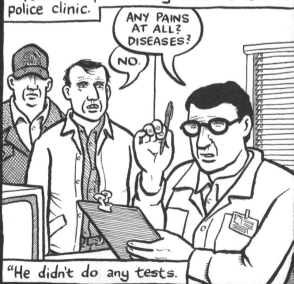

ANY PAINS AT ALL? DISEASES?

NO.

"He didn't do any tests.

"A policeman put a sack on my head and tied my hands behind me... The sack had a dirty smell, like urine.

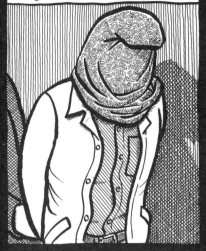

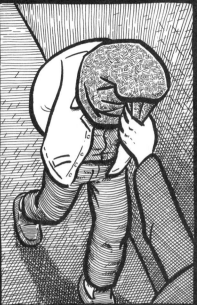

"He told me to sit in a small chair. He tied my hands very tight, my left hand to an iron bar or pipe and my right hand to the back of the chair.

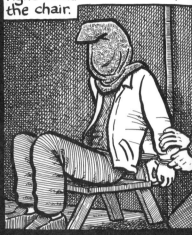

"After an hour I began to feel a pain in my shoulders.

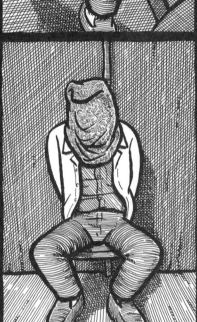

"After six or seven hours a policeman came for me.

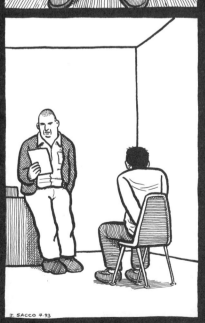

YOU'RE SUSPECTED OF BELONGING TO AN ILLEGAL ORGANIZATION.

J. SACCO 7.93

I DON'T KNOW WHAT YOU'RE TALKING ABOUT. I'M NOT A MEMBER OF ANYTHING. I DON'T HAVE ANYTHING TO SAY.

IF YOU WANT TO CONFESS, OKAY. IF NOT, WE'LL DO SOMETHING ELSE.

"After one or two hours, a policeman came for me.

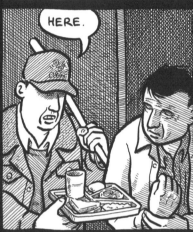

HERE.

"I was in a cell with a dirty toilet. I had to eat and drink quickly. I had an egg, four pieces of bread, a bit of yogurt, and a piece of tomato. After 10 or 15 minutes, the policeman returned.

"Once I moved to get more comfortable and fell.

HEY.

HEY, SOMEONE.

IDIOT, WHY DON'T YOU SIT STILL?

SIT DOWN.

"I felt I was in a yard with a corrugated zinc roof. It was very cold.

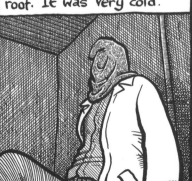

"I could feel other people there. I could hear the police coming and going.

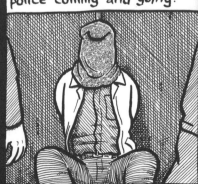

"One time I heard someone talking. I felt once the police come and hit someone."

"Tapes were playing from speakers...very loud... Hebrew songs, English, some Arabic.

"They played three or four cassettes, the same songs, 24 hours a day.

ARE YOU READY TO TALK NOW?

"After about 30 hours from my arrest, the police came for me.

"I felt this time they'll take me to court.

"They took the sack from my head and untied me and left me four or five hours in an office."

"My hands were swollen. The color of my skin was reddish blue."

"I was taken to a court. My lawyer was present but I wasn't allowed to speak to him.

YOUR HONOR, WE BELIEVE THE SUSPECT BELONGS TO AN ILLEGAL ORGANIZATION.

THAT'S NOT TRUE. WHAT EVIDENCE DO YOU HAVE?

WE FOUND DOCUMENTS IN HIS HOME. HE IS PHONING THE TERRORIST LEADERSHIP ABROAD. WE FOUND THIS LIST OF PHONE NUMBERS.

THIS IS THE NUMBER OF MY BROTHER-IN-LAW, OTHER RELATIVES OF MY WIFE... WHERE I WORK... A HOSPITAL... NUMBERS OF MY RELATIVES...

"The judge could read Arabic. He looked at the list himself.

YOUR HONOR, WE NEED 15 MORE DAYS TO FIND ADDITIONAL EVIDENCE.

YOUR HONOR, THERE IS NO EVIDENCE. MY CLIENT SHOULD BE RELEASED IMMEDIATELY.

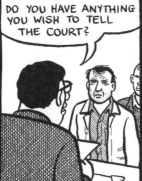

I'LL EXTEND CUSTODY AN ADDITIONAL EIGHT DAYS FROM THE INITIAL 48-HOUR PERIOD.

"The lawyers left the room.

DO YOU HAVE ANYTHING YOU WISH TO TELL THE COURT?

"I described the attack on my home. I described the treatment I was getting.

"I said this in front of my jailors. They heard everything.

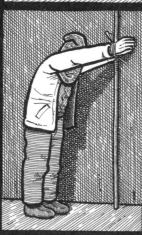

"They tied me tighter than before.

"I was in a different sort of chair... I had a lot of pain in my back, my shoulders, my knees, my wrists... I couldn't lean against the wall.

DO YOU HAVE ANYTHING TO TELL US?

STAND LIKE THIS. DON'T MOVE.

"They changed my position every four or five hours.

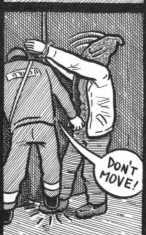

DON'T MOVE!

"They returned me to a chair.

"With this new chair, I could lean my head against the wall but the sack would collapse on my face and I couldn't breathe.

"After four days without sleep, I began to have hallucinations.

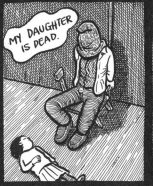
MY DAUGHTER IS DEAD.

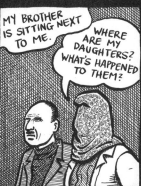
MY BROTHER IS SITTING NEXT TO ME.

WHERE ARE MY DAUGHTERS? WHAT'S HAPPENED TO THEM?

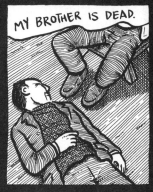
MY BROTHER IS DEAD.

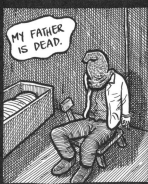
MY FATHER IS DEAD.

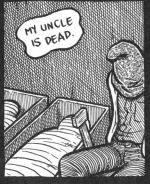
MY UNCLE IS DEAD.

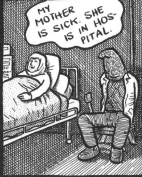
MY MOTHER IS SICK. SHE IS IN HOSPITAL.

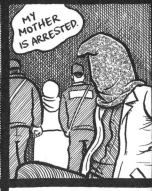
MY MOTHER IS ARRESTED.

"I had hallucinations till about the 15th day. They would stop when they took me to eat or to be interrogated...

...or when they tapped me on the head so I wouldn't sleep or made me sit up straight.

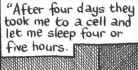
"After four days they took me to a cell and let me sleep four or five hours.

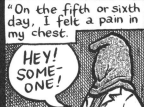
"On the fifth or sixth day, I felt a pain in my chest.

HEY! SOMEONE!

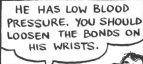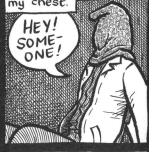

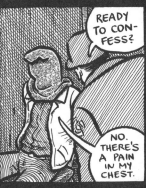
READY TO CONFESS?

NO. THERE'S A PAIN IN MY CHEST.

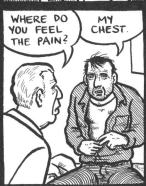
WHERE DO YOU FEEL THE PAIN?

MY CHEST.

TAKE THIS PILL.

J. SACCO 7-93

HE HAS LOW BLOOD PRESSURE. YOU SHOULD LOOSEN THE BONDS ON HIS WRISTS.

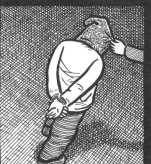

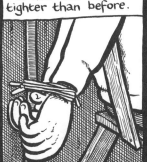
"I was tied even tighter than before.

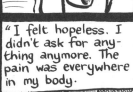
"I felt hopeless. I didn't ask for anything anymore. The pain was everywhere in my body.

"Someone came by and pulled my hands up and tightened the plastic even more.

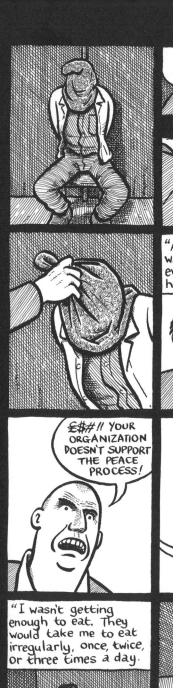

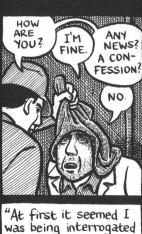
HOW ARE YOU? I'M FINE. ANY NEWS? A CONFESSION? NO.

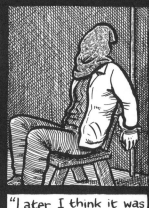

"Then I stopped feeling pain second-by-second."

"At first it seemed I was being interrogated every seven or eight hours." TELL US ABOUT YOUR FAMILY.

"Later, I think it was every 24 to 30 hours." I THINK YOU SHOULD CONFESS. WE HAVE ALL THE INFORMATION WE NEED ALREADY. JUST SIGN.

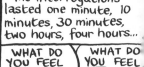
"The interrogations lasted one minute, 10 minutes, 30 minutes, two hours, four hours... WHAT DO YOU FEEL ABOUT THE PEACE PROCESS? WHAT DO YOU FEEL ABOUT THE PEACE PROCESS?

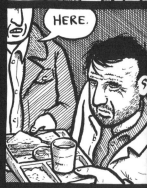

£$#!! YOUR ORGANIZATION DOESN'T SUPPORT THE PEACE PROCESS!

I DON'T BELONG TO ANY ORGANIZATION. YOU ARE LYING!

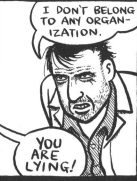

HERE.

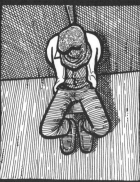
"I wasn't getting enough to eat. They would take me to eat irregularly, once, twice, or three times a day."

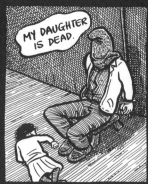
MY DAUGHTER IS DEAD.

YOU WANT TO SLEEP NOW? YES, IF THERE'S A POSSIBILITY.

YOU HAVE TO TALK A LITTLE. YOU HAVE TO COOPERATE WITH US. AND IF I DON'T? YOU'LL BE HERE FOR A LONG TIME.

"On the ninth day they let me sleep five or six hours."

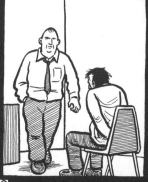

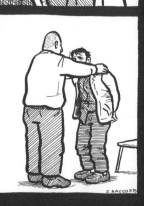

110

"He punched me with his shoulder...

"...then shook me...

"...and threw me back in the chair.

NOW YOU'LL HAVE A HEART ATTACK!

WE HAVEN'T FOUND ANY NEW DOCUMENTS, YOUR HONOR...

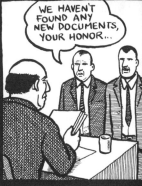

...BUT WE'LL HAVE OUR EVIDENCE IF YOU GRANT US ANOTHER 15 DAYS.

YOUR HONOR, THERE IS NO EVIDENCE. THE COURT SHOULD RELEASE MY CLIENT IMMEDIATELY.

"The judge agreed to another seven days.

"The lawyers left the room.

DO YOU HAVE ANYTHING TO SAY TO THE COURT?

NO.

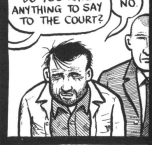

I DON'T WANT TO PUT YOU IN THIS CELL...YOU'RE A PROFESSIONAL MAN..., BUT YOU'RE NOT COOPERATING.

"It was a small dark cell, about 1.2 meters square, full of urine.

"I decided I wasn't going to sit in the urine.

"I was hallucinating I was in a big cell.

"I'd start walking and hit the wall after one step.

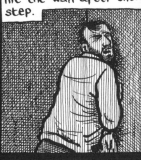

"I decided it was better to sit. There was a small dry area on the step.

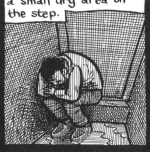

ANYTHING TO TELL US? IF NOT, YOU'LL HAVE TO STAY IN HERE.

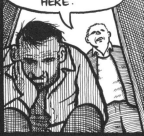

MY DAUGHTER IS DEAD.

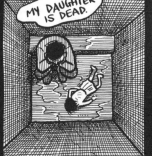

"After one or one and a half days, they returned me to the chairs.

"It was very, very cold. On the 12th day, the night of the Feb. 4 storm, they took me to another place.

111

"It might have been a corridor.

"The wind was blowing hard down the corridor. It felt like the roof was falling.

"The rain was dripping down, the floor was full of water. My socks and shoes were soaked.

"I lost all feeling.

WELL?

"At my third court appearance, the judge decided I should be held an additional four days.

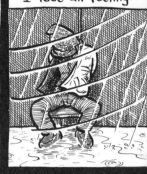

"After four or five hours a policeman asked if I wanted a bath.

IF THERE'S HOT WATER.

HERE'S SOME CLOTHES FROM YOUR FAMILY, SOMETHING TO SHAVE WITH.

"It was the first time I'd washed in 15 days.

"I didn't know then that Mustafa Akkawi had just been killed.

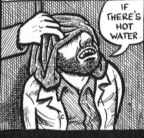

"After only two hours in the chair, I was taken to a nice cell to sleep.

"They changed me from one cell to another four or five times, every four or five hours.

"I was allowed to sleep.

"I was in the last cell for two days. It was Saturday, the Sabbath, and they didn't interrogate me.

"On the 19th day I had another court appearance.

YOUR HONOR, WE NEED ANOTHER TEN DAYS TO GATHER EVIDENCE IN THIS CASE.

YOUR HONOR, THERE IS NO EVIDENCE, THERE HAS BEEN NO CONFESSION, MY CLIENT SHOULD BE RELEASED TODAY.

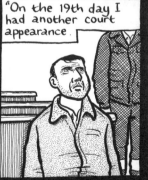

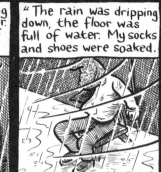

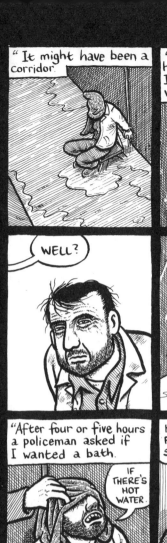

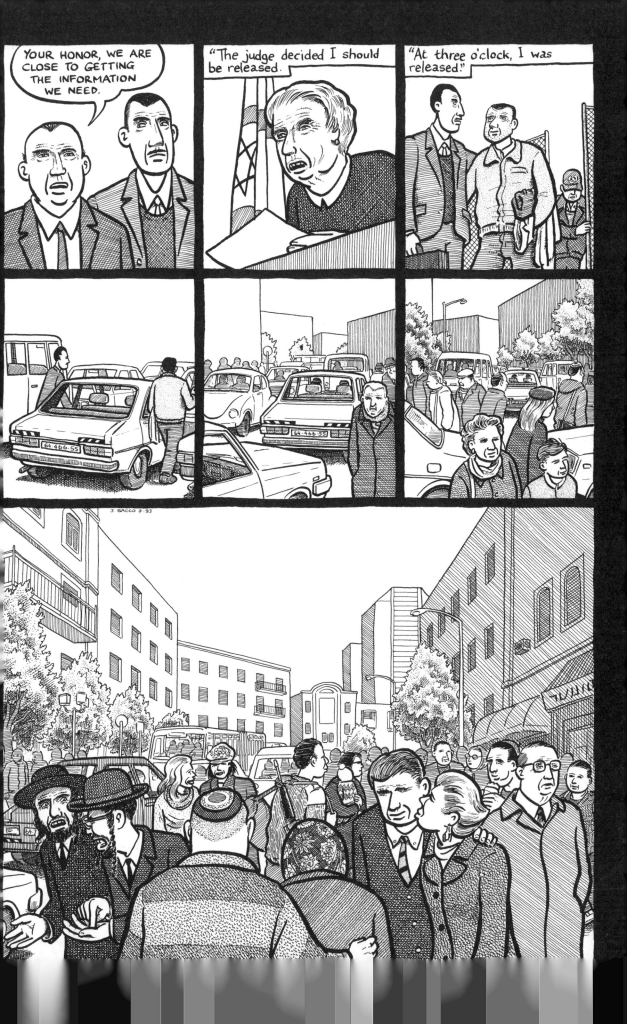

Chapter Five

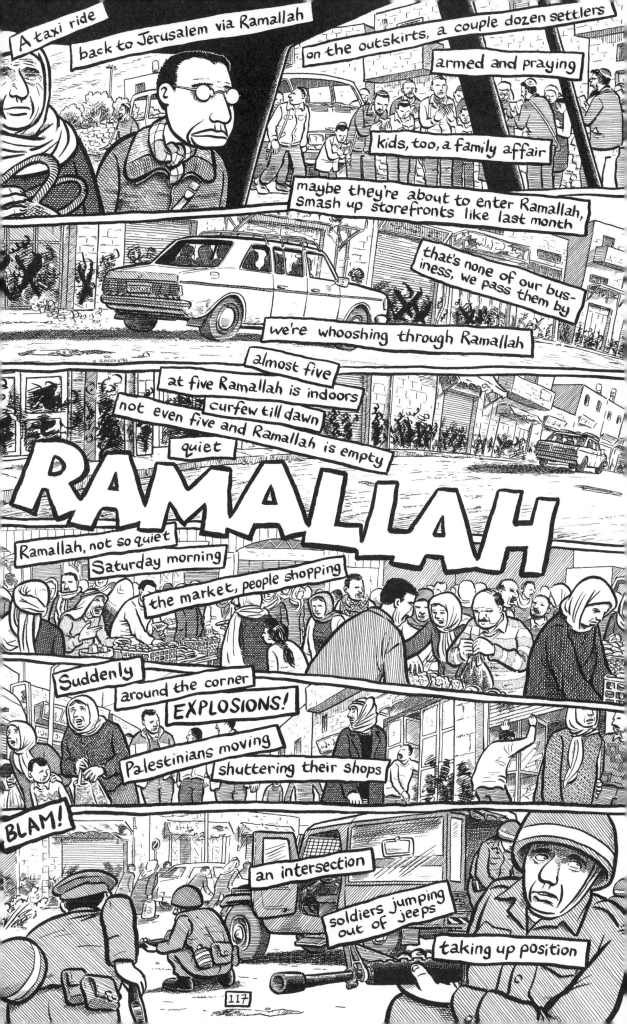

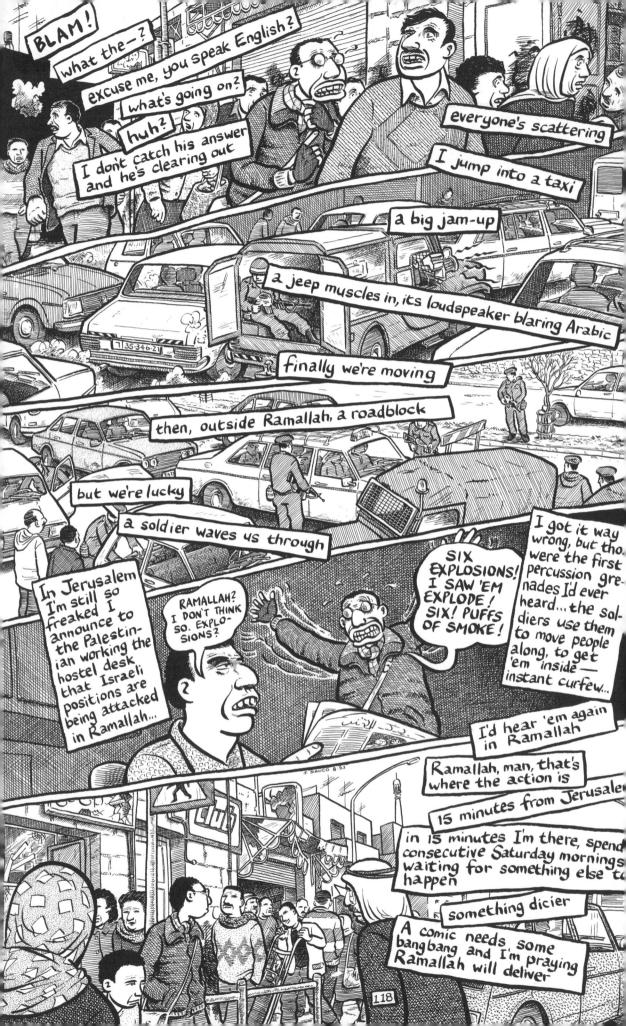

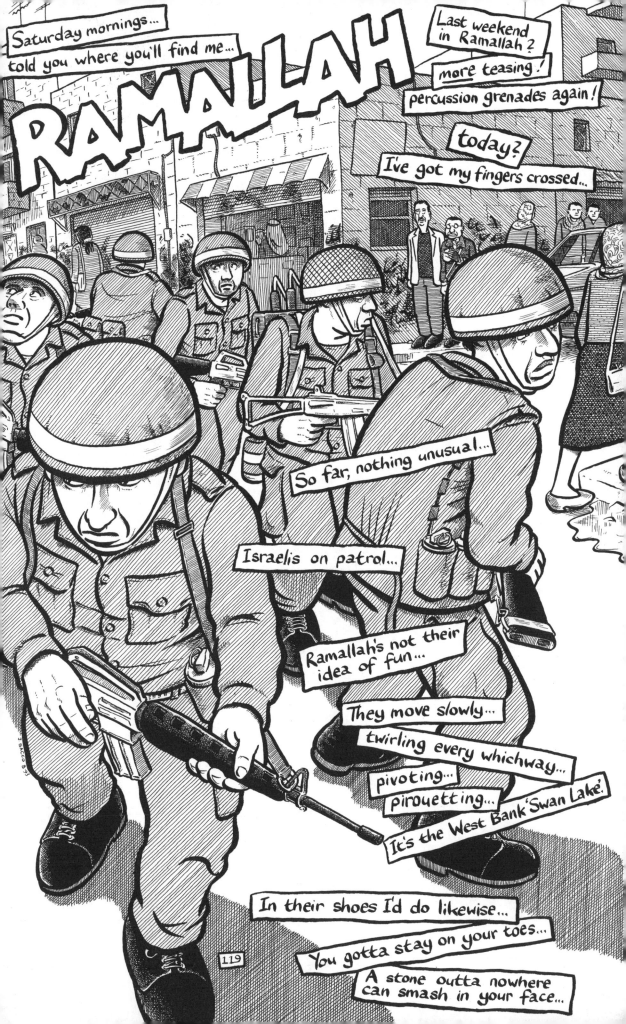

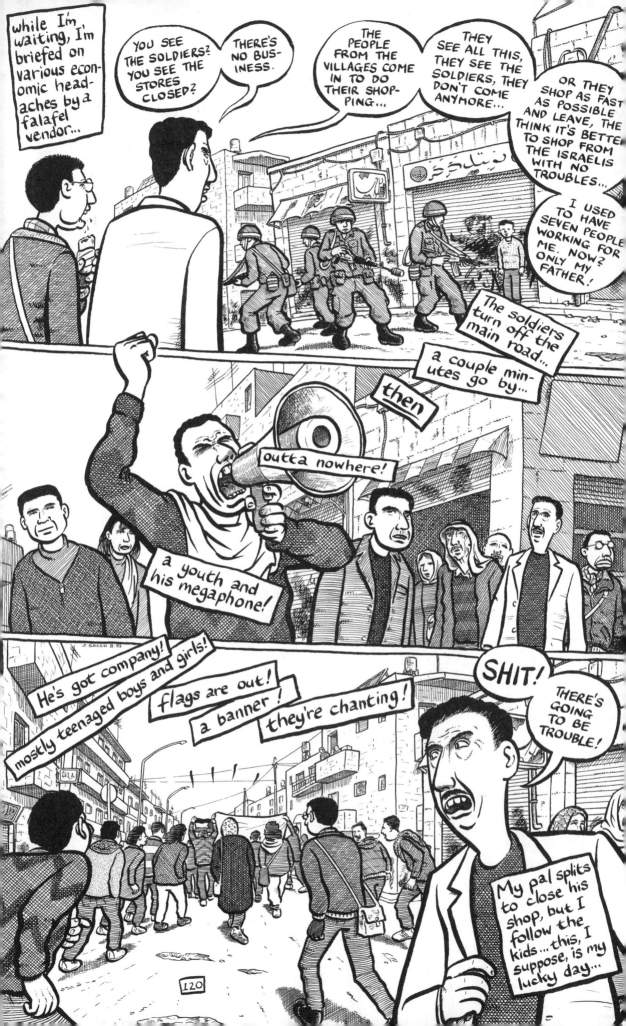

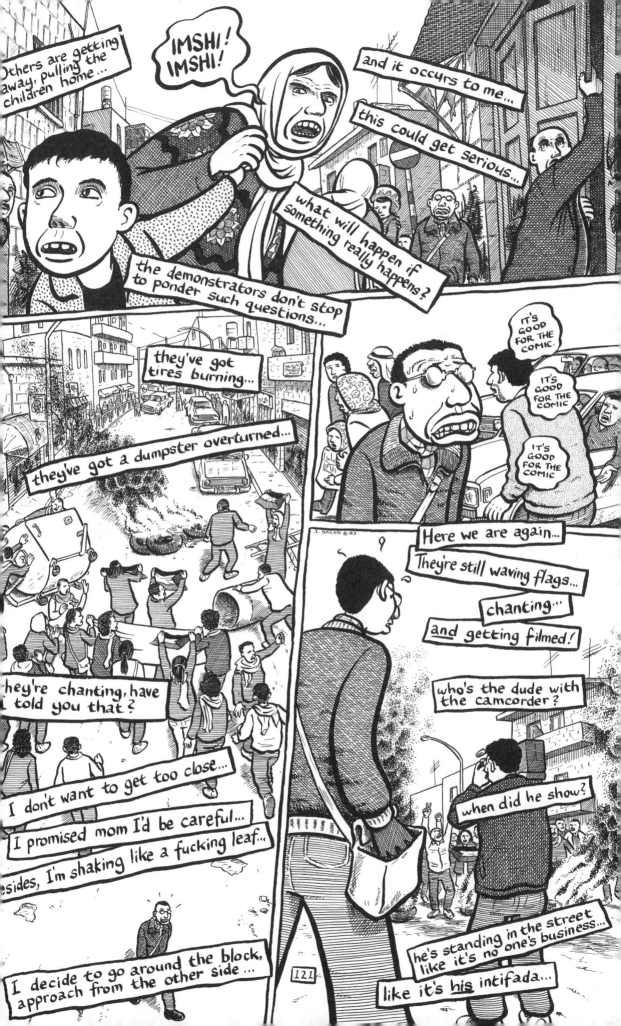

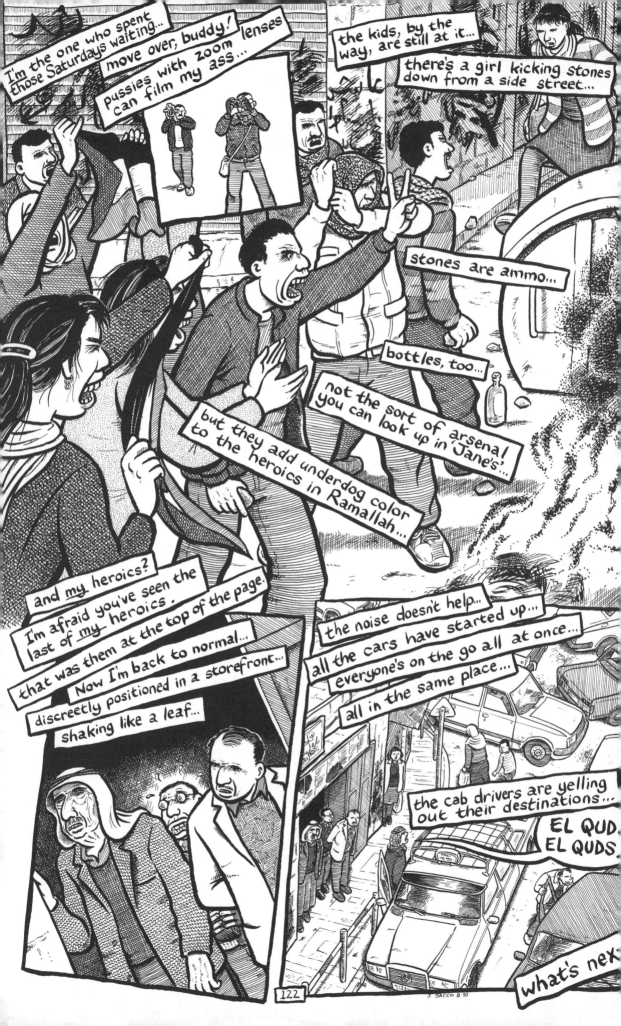

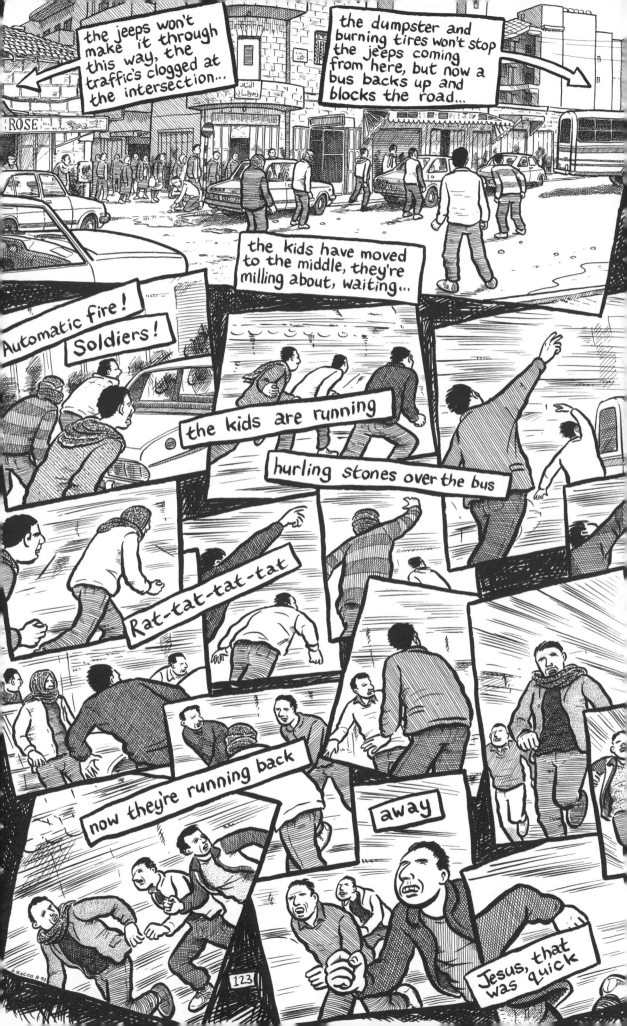

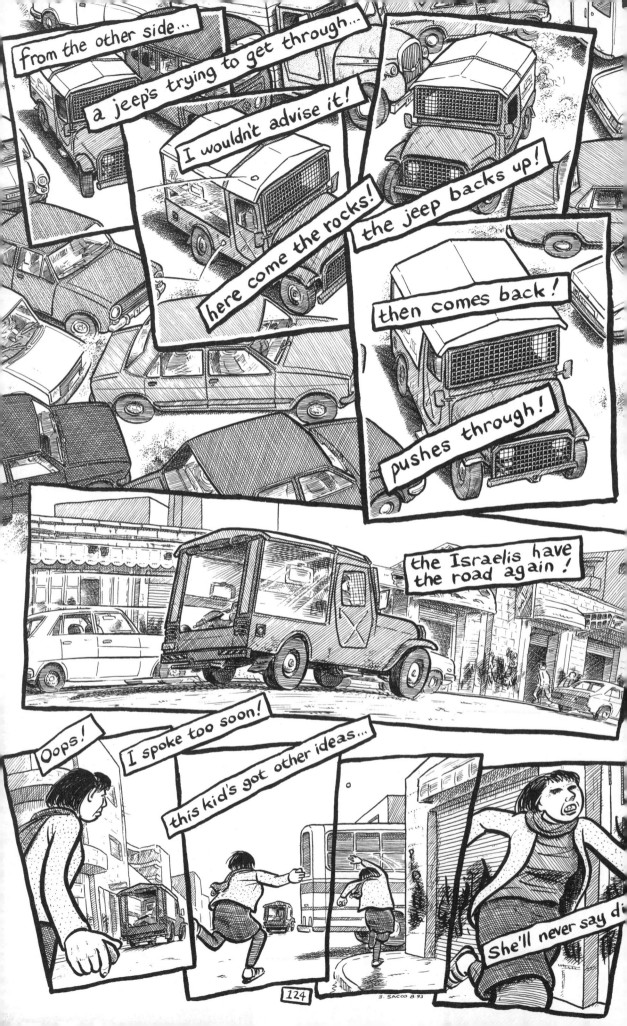

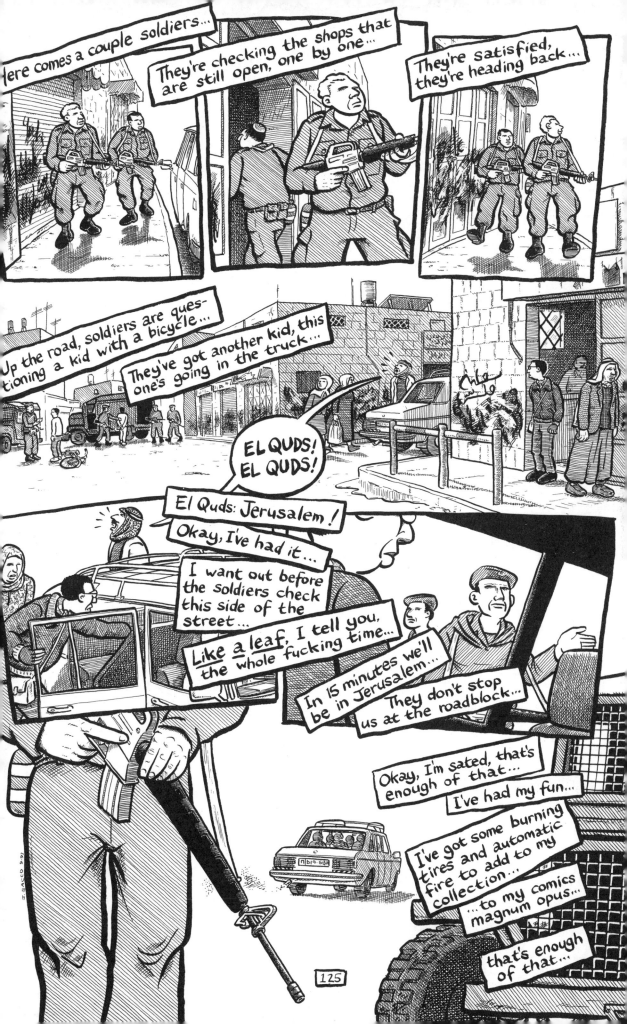

Here comes a couple soldiers...

They're checking the shops that are still open, one by one...

They're satisfied, they're heading back...

Up the road, soldiers are questioning a kid with a bicycle...

They've got another kid, this one's going in the truck...

EL QUDS! EL QUDS!

El Quds: Jerusalem!

Okay, I've had it...

I want out before the soldiers check this side of the street...

Like a leaf, I tell you, the whole fucking time...

In 15 minutes we'll be in Jerusalem...

They don't stop us at the roadblock...

Okay, I'm sated, that's enough of that...

I've had my fun...

I've got some burning tires and automatic fire to add to my collection...

...to my comics magnum opus...

that's enough of that...

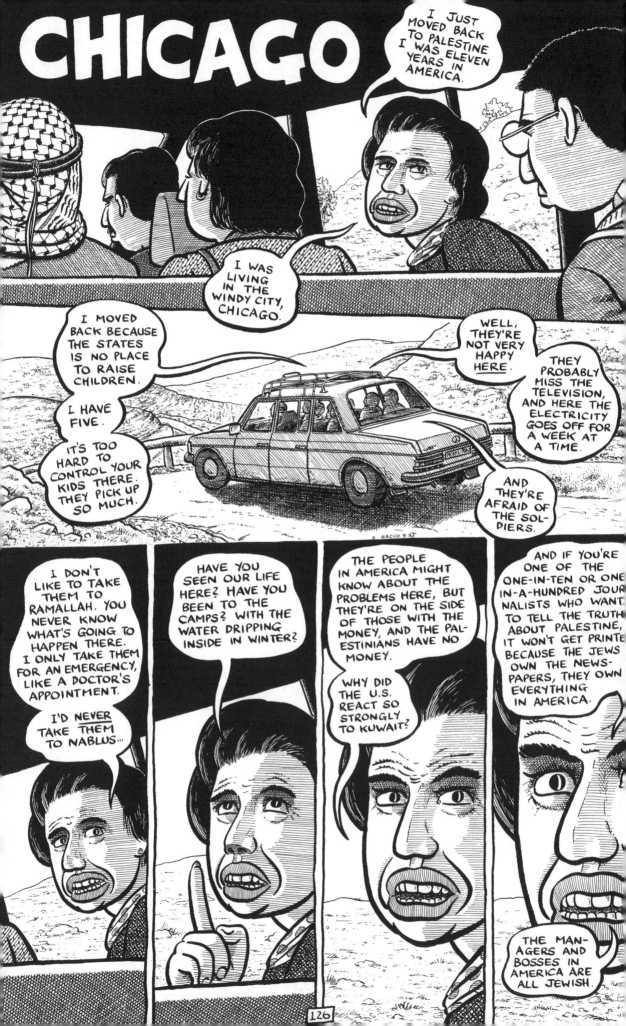

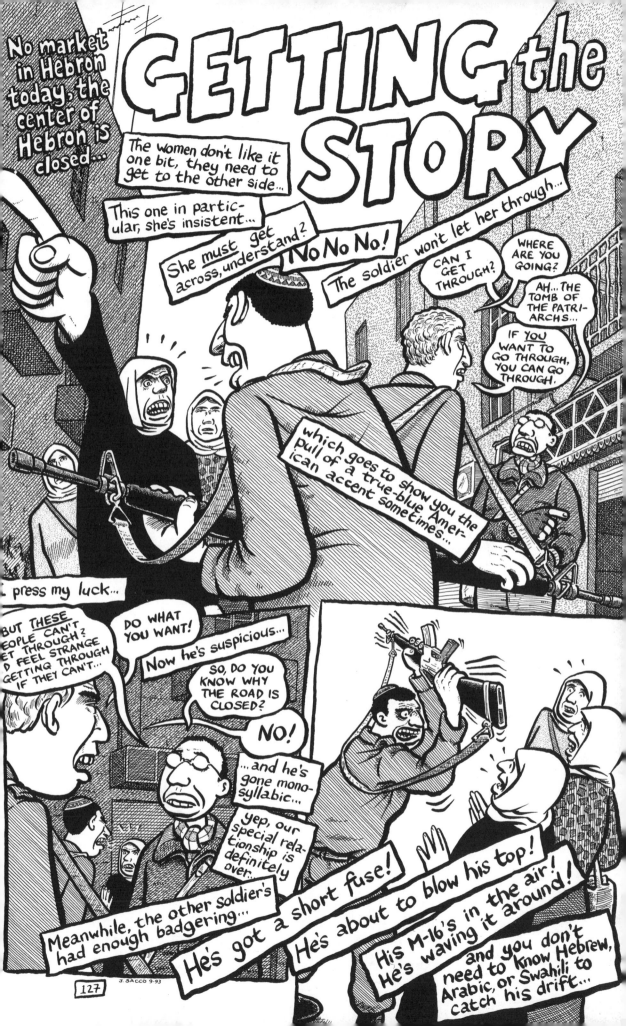

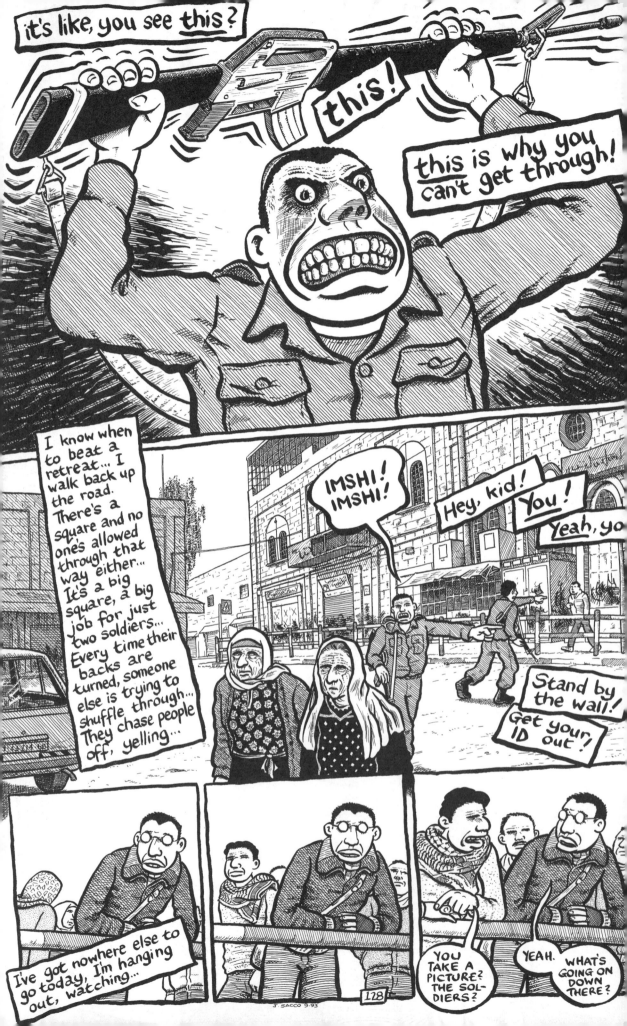

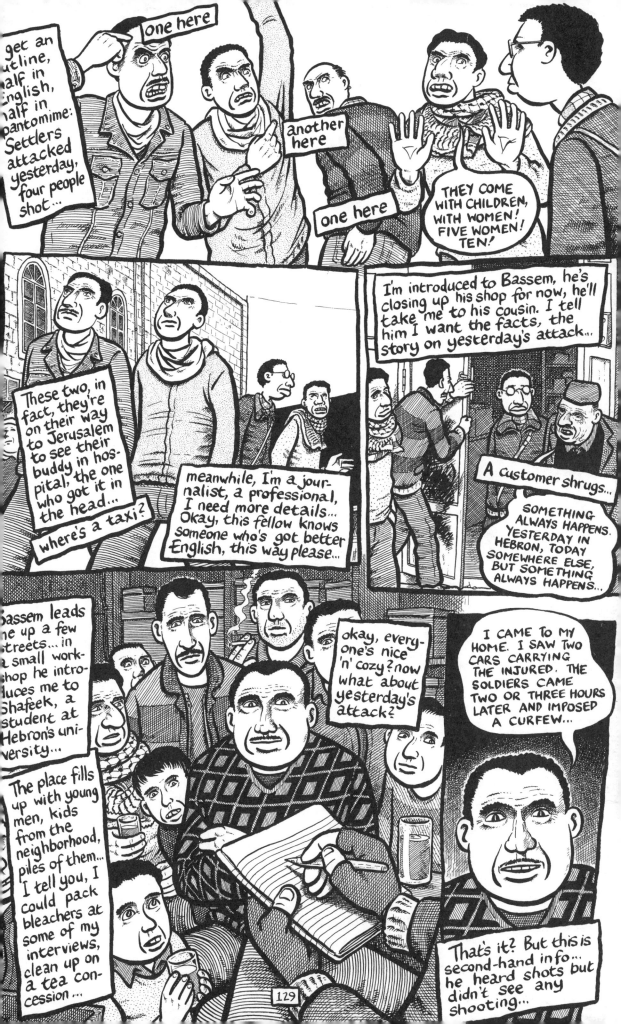

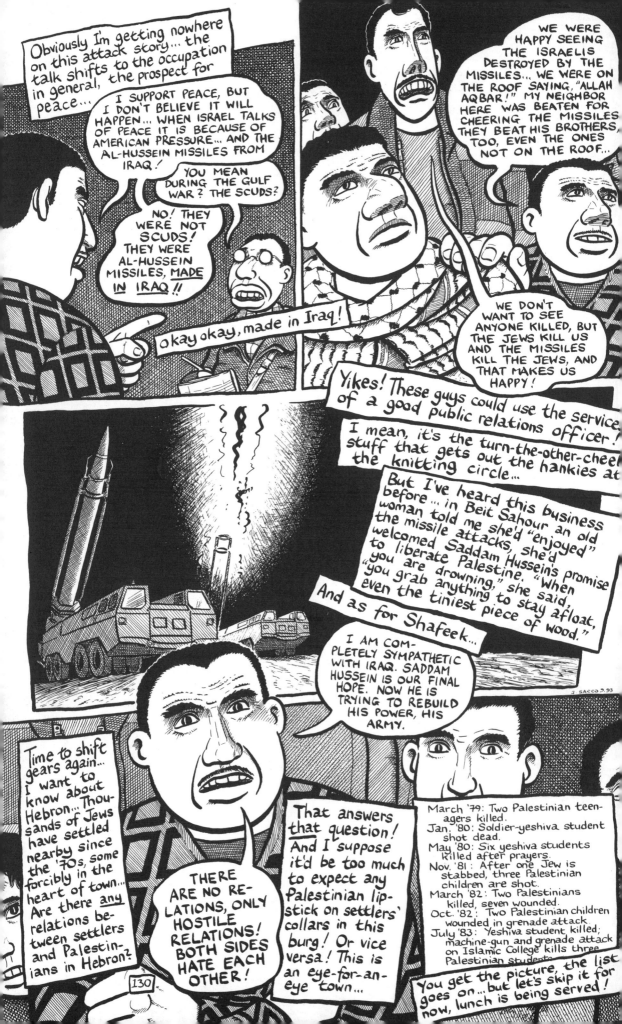

Obviously I'm getting nowhere on this attack story... the talk shifts to the occupation in general, the prospect for peace...

I SUPPORT PEACE, BUT I DON'T BELIEVE IT WILL HAPPEN... WHEN ISRAEL TALKS OF PEACE IT IS BECAUSE OF AMERICAN PRESSURE... AND THE AL-HUSSEIN MISSILES FROM IRAQ!

YOU MEAN DURING THE GULF WAR? THE SCUDS?

NO! THEY WERE NOT SCUDS! THEY WERE AL-HUSSEIN MISSILES, MADE IN IRAQ!!

okay okay, made in Iraq!

WE WERE HAPPY SEEING THE ISRAELIS DESTROYED BY THE MISSILES... WE WERE ON THE ROOF SAYING, "ALLAH AQBAR!" MY NEIGHBOR HERE WAS BEATEN FOR CHEERING THE MISSILES THEY BEAT HIS BROTHERS TOO, EVEN THE ONES NOT ON THE ROOF...

WE DON'T WANT TO SEE ANYONE KILLED, BUT THE JEWS KILL US AND THE MISSILES KILL THE JEWS, AND THAT MAKES US HAPPY!

Yikes! These guys could use the service of a good public relations officer!

I mean, it's the turn-the-other-cheek stuff that gets out the hankies at the knitting circle...

But I've heard this business before... in Beit Sahour an old woman told me she'd "enjoyed" the missile attacks, she'd welcomed Saddam Hussein's promise to liberate Palestine. "When you are drowning," she said, "you grab anything to stay afloat, even the tiniest piece of wood."

And as for Shafeek...

I AM COMPLETELY SYMPATHETIC WITH IRAQ. SADDAM HUSSEIN IS OUR FINAL HOPE. NOW HE IS TRYING TO REBUILD HIS POWER, HIS ARMY.

J. SACCO 3.93

Time to shift gears again... I want to know about Hebron... Thousands of Jews have settled nearby since the '70s, some forcibly in the heart of town... Are there any relations between settlers and Palestinians in Hebron?

130

THERE ARE NO RELATIONS, ONLY HOSTILE RELATIONS! BOTH SIDES HATE EACH OTHER!

That answers that question! And I suppose it'd be too much to expect any Palestinian lipstick on settlers' collars in this burg! Or vice versa! This is an eye-for-an-eye town...

March '79: Two Palestinian teenagers killed.
Jan. '80: Soldier-yeshiva student shot dead.
May '80: Six yeshiva students killed after prayers.
Nov. '81: After one Jew is stabbed, three Palestinian children are shot.
March '82: Two Palestinians killed, seven wounded.
Oct. '82: Two Palestinian children wounded in grenade attack.
July '83: Yeshiva student killed; machine-gun and grenade attack on Islamic College kills three Palestinian students.

You get the picture, the list goes on... but let's skip it for now, lunch is being served!

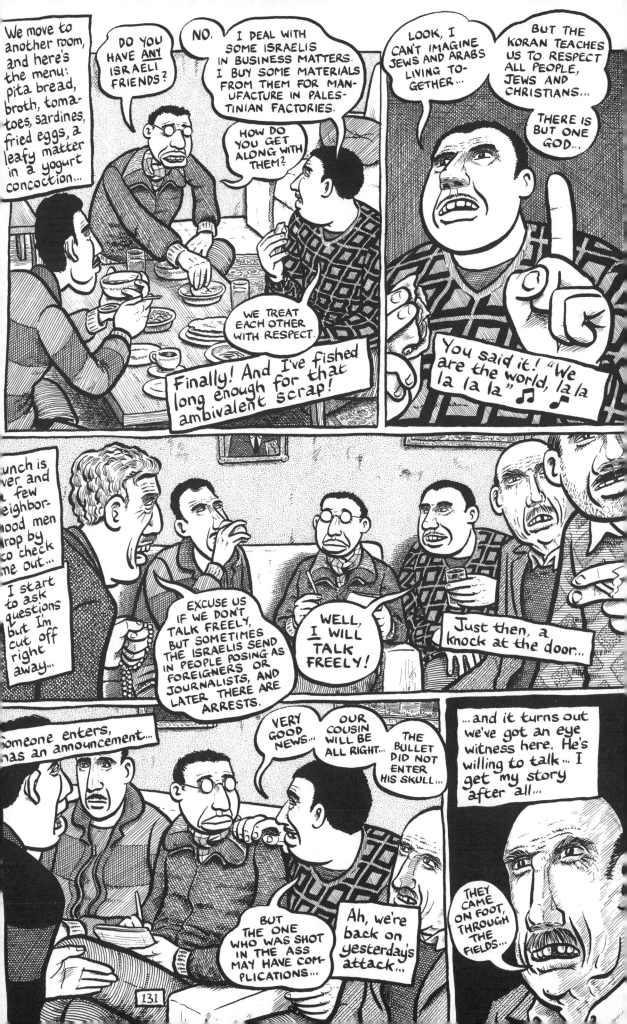

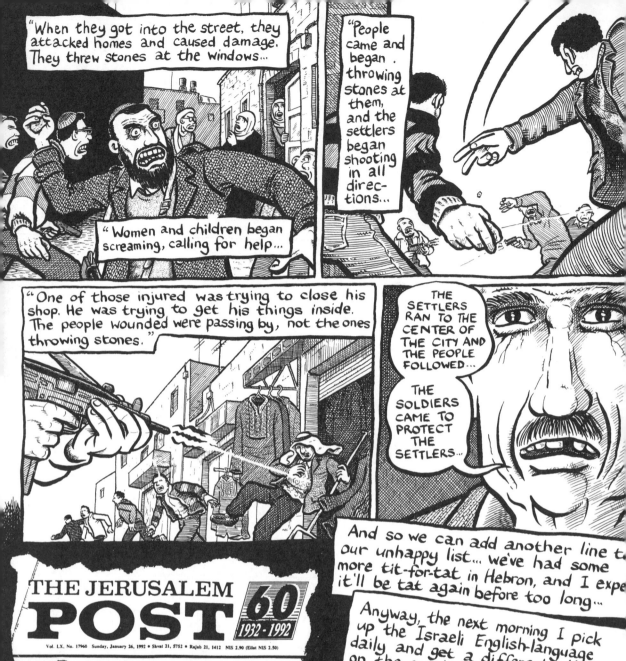

THE JERUSALEM POST

60 1932-1992

Vol. LX, No. 17960 Sunday, January 26, 1992 • Shvat 21, 5752 • Rajab 21, 1412 NIS 2.90 (Eilat NIS 2.50)

...aims fe...

major factor in de....
for elections.

government legalized all private transactions, ...

Seven hurt in Hebron shooting incident

Three Kiryat A'rba residents were lightly injured and four Hebron Arabs critically, seriously, and lightly hurt in an incident yesterday afternoon.

A group of Jewish families, members of the Kach-affiliated Committee for Safety on the Roads, were patrolling in the Harat a-Sheikh section of Hebron, when they were attacked by several hundred Arabs. They said they were pelted with rocks and bottles from rooftops and alleys.

Two children and a woman were injured.

Two escape, the settlers fired in the air, and when that had no effect, they said they fired at the legs of the rock-throwers.

Last night, four wounded Arabs were brought to Mokassad Hospital in East Jerusalem. One, the hospital reported, was in critical condition with a bullet wound in the abdomen. Two others were seriously wounded in the head and chest, and a third lightly wounded in the leg.

The IDF relayed a report on the incident to the Hebron police, who have opened an investigation.

The Committee for Safety on the Roads said it would continue to patrol Arab neighborhoods which Jews have previously preferred not to enter.

On Friday, some 150 settlers from Kiryat Arba and Hebron had blocked the road to Kiryat Arba where it passes through the Tark section of Hebron. They charged that cars and buses were constantly being stoned there.

After two hours, the IDF convinced the settlers to open the road.

(Itim)

Moslem fundamentalists

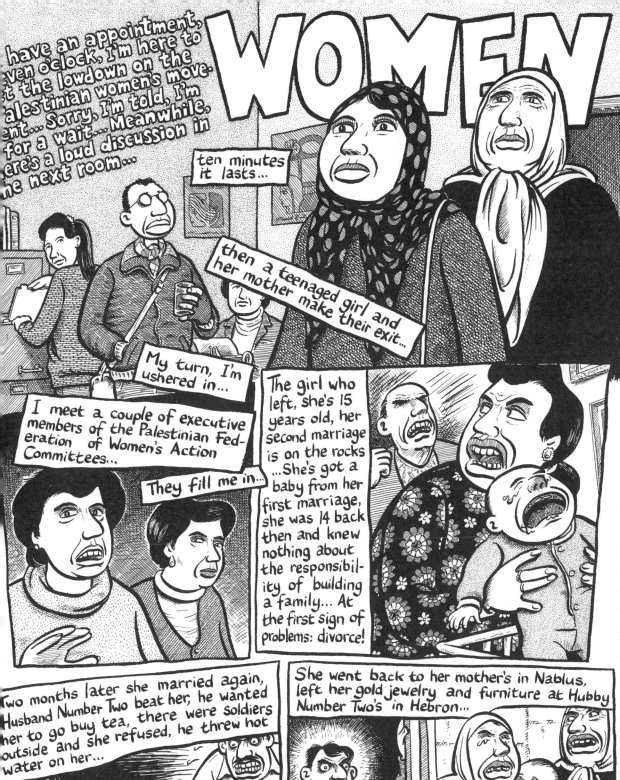

WOMEN

I have an appointment, seven oclock, I'm here to get the lowdown on the Palestinian women's movement... Sorry, I'm told, I'm in for a wait... Meanwhile, there's a loud discussion in the next room...

ten minutes it lasts...

then a teenaged girl and her mother make their exit...

My turn, I'm ushered in...

I meet a couple of executive members of the Palestinian Federation of Women's Action Committees...

They fill me in...

The girl who left, she's 15 years old, her second marriage is on the rocks ...She's got a baby from her first marriage, she was 14 back then and knew nothing about the responsibility of building a family... At the first sign of problems: divorce!

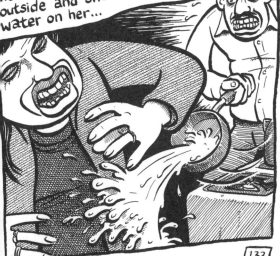

Two months later she married again, Husband Number Two beat her, he wanted her to go buy tea, there were soldiers outside and she refused, he threw hot water on her...

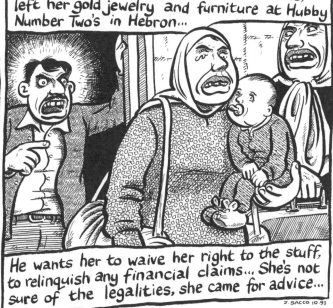

She went back to her mother's in Nablus, left her gold jewelry and furniture at Hubby Number Two's in Hebron...

He wants her to waive her right to the stuff, to relinquish any financial claims... She's not sure of the legalities, she came for advice...

J. SACCO 10.93

133

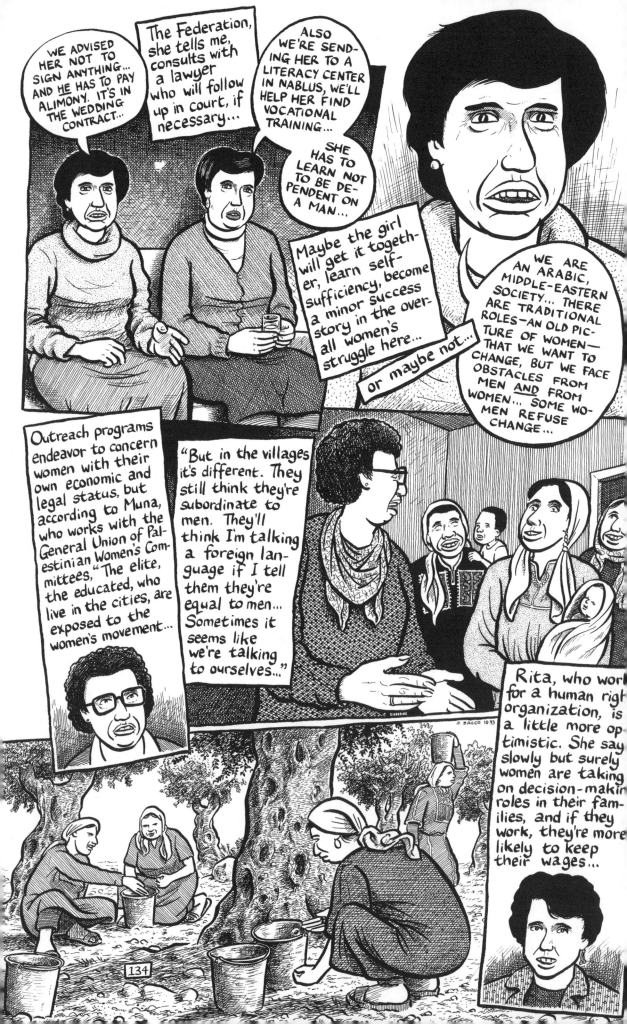

WE ADVISED HER NOT TO SIGN ANYTHING... AND _HE_ HAS TO PAY ALIMONY. IT'S IN THE WEDDING CONTRACT...

The Federation, she tells me, consults with a lawyer who will follow up in court, if necessary...

ALSO WE'RE SENDING HER TO A LITERACY CENTER IN NABLUS, WE'LL HELP HER FIND VOCATIONAL TRAINING...

SHE HAS TO LEARN NOT TO BE DEPENDENT ON A MAN...

Maybe the girl will get it together, learn self-sufficiency, become a minor success story in the overall women's struggle here...

or maybe not...

WE ARE AN ARABIC, MIDDLE-EASTERN SOCIETY... THERE ARE TRADITIONAL ROLES—AN OLD PICTURE OF WOMEN—THAT WE WANT TO CHANGE, BUT WE FACE OBSTACLES FROM MEN _AND_ FROM WOMEN... SOME WOMEN REFUSE CHANGE...

Outreach programs endeavor to concern women with their own economic and legal status, but according to Muna, who works with the General Union of Palestinian Women's Committees, "The elite, the educated, who live in the cities, are exposed to the women's movement...

"But in the villages it's different. They still think they're subordinate to men. They'll think I'm talking a foreign language if I tell them they're equal to men... Sometimes it seems like we're talking to ourselves..."

Rita, who works for a human rights organization, is a little more optimistic. She says slowly but surely women are taking on decision-making roles in their families, and if they work, they're more likely to keep their wages...

J. SACCO 10.93

134

...e says Islam and the vast majority of Palestinian women are Muslim—grants women property rights, and Islamic law can be interpreted to the advantage of women... Marriage contracts, for example, are a feature of Islam...

"A woman getting married can put conditions on her husband, and if these are not met, she can ask for a divorce... A woman might stipulate that if her husband takes a second wife, that is grounds for a divorce, or if he prevents her from working or leaves to go abroad..."

Polygamy, she says, can be curtailed by a strict reading of Islamic law, which says a man must treat each wife equally—all but an impossibility, she argues...

So, in theory, Islam offers avenues by which women can press for their rights...

BUT IN PRACTICE, THIS IS A GREAT DIFFICULTY...

And we're back to square one, raising the political self-awareness of women in the context of certain cultural and religious realities...

Rita is philosophical about the slow road to societal change...

LOOK, I'M A CATHOLIC... THREE YEARS AGO I WAS ALL FOR SECULAR LAWS TO PROTECT WOMEN, I WOULDN'T GIVE THE IDEA UP, BUT WE CAN'T ACHIEVE THAT NOW...

Muna, a non-practising Muslim, is more skeptical about using Islamic law to advance women's rights... she sees some irreconcilable differences...

WE HAVE A BIG PROBLEM WITH BATTERED WOMEN... THE KORAN PERMITS A MAN TO BEAT A WOMAN ...WOMEN HERE ARE TAUGHT THEY CAN BE SLAPPED, EVEN THE CHRISTIANS... IT'S PART OF THE ARAB CULTURE... WOMEN HERE DON'T COMPLAIN, THEY DON'T CALL THEM-SELVES BATTERED... AND IT'S NOT JUST A CHAR-ACTERISTIC OF THE POOR...

EDUCATE MEN? WE'RE NOT DOING ENOUGH TO EDUCATE WOMEN !

135

J SACCO 10-93

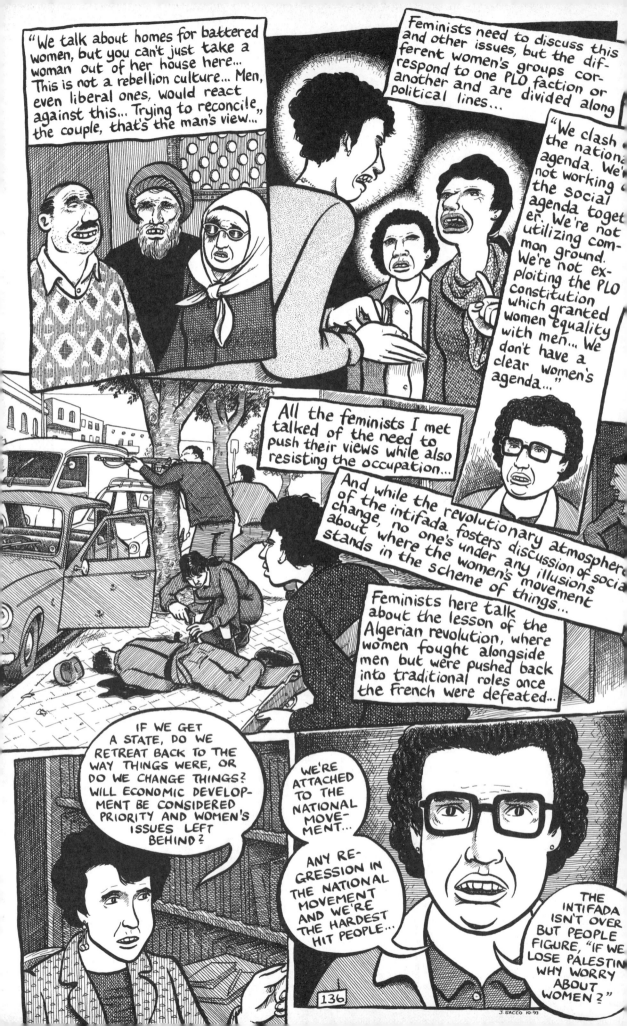

"We talk about homes for battered women, but you can't just take a woman out of her house here... This is not a rebellion culture... Men, even liberal ones, would react against this... Trying to reconcile the couple, that's the man's view..."

Feminists need to discuss this and other issues, but the different women's groups correspond to one PLO faction or another and are divided along political lines...

"We clash the nation agenda. We' not working the social agenda toget er. We're not utilizing common ground. We're not exploiting the PLO constitution which granted women equality with men... We don't have a clear women's agenda..."

All the feminists I met talked of the need to push their views while also resisting the occupation...

And while the revolutionary atmosphere of the intifada fosters discussion of social change, no one's under any illusions about where the women's movement stands in the scheme of things...

Feminists here talk about the lesson of the Algerian revolution, where women fought alongside men but were pushed back into traditional roles once the French were defeated...

IF WE GET A STATE, DO WE RETREAT BACK TO THE WAY THINGS WERE, OR DO WE CHANGE THINGS? WILL ECONOMIC DEVELOPMENT BE CONSIDERED PRIORITY AND WOMEN'S ISSUES LEFT BEHIND?

WE'RE ATTACHED TO THE NATIONAL MOVEMENT...

ANY REGRESSION IN THE NATIONAL MOVEMENT AND WE'RE THE HARDEST HIT PEOPLE...

THE INTIFADA ISN'T OVER BUT PEOPLE FIGURE, "IF WE LOSE PALESTIN WHY WORRY ABOUT WOMEN?"

136

J. SACCO 10-93

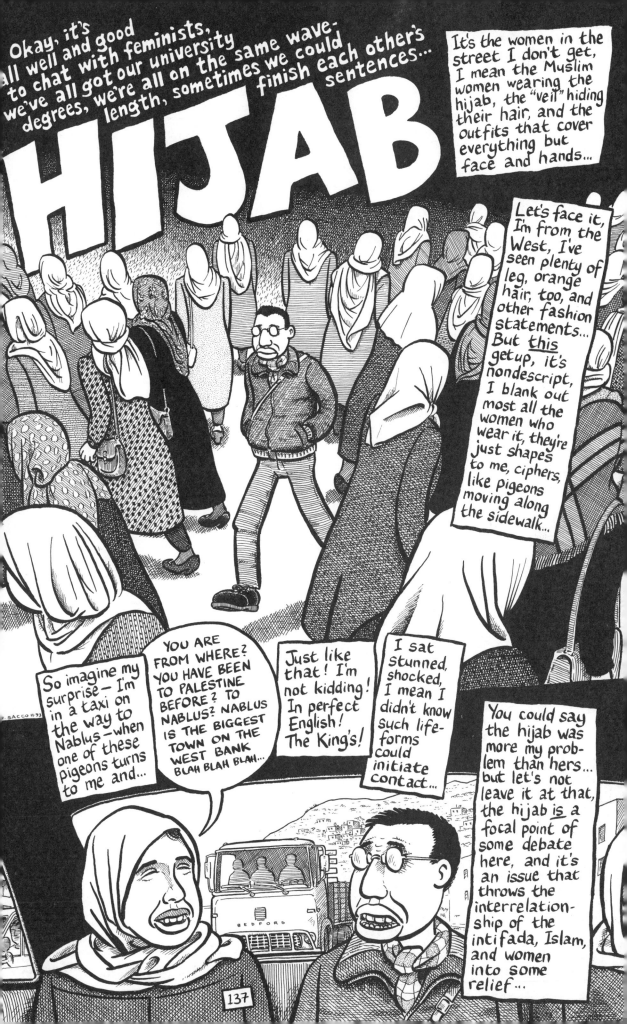

The way Muna tells the story, at the beginning of the uprising the Unified Leadership—which includes the main PLO factions—called for traditional dress as a way of emphasizing Palestinian identity...

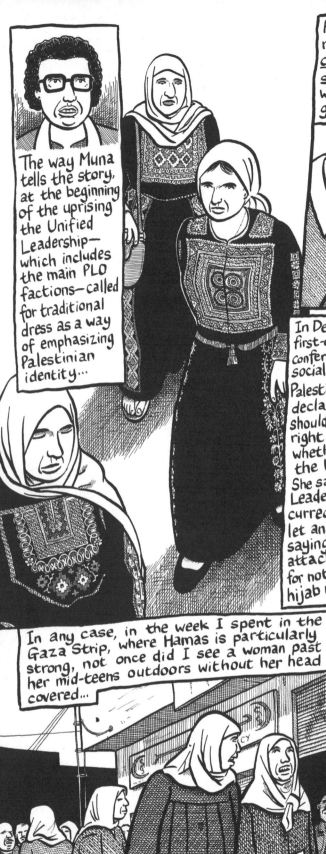

Hamas, the extremist Islamic group which rivals the secular PLO, then called for the compulsory wearing of the hijab. She says Hamas followers began threatening women and sometimes beating them for going outside without a head covering...

In Dec. 1990 a first-of-its-kind conference on the social problems of Palestinian women declared women should have the right to choose whether to wear the hijab or not... She says the Unified Leadership concurred with a leaflet and messages saying anyone who attacked a woman for not wearing the hijab was a traitor...

In any case, in the week I spent in the Gaza Strip, where Hamas is particularly strong, not once did I see a woman past her mid-teens outdoors without her head covered...

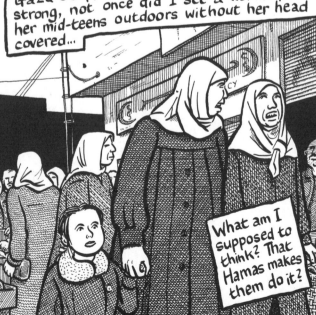

What am I supposed to think? That Hamas makes them do it?

I meet with a few Gazan women to get some handle on the subject... The first two, ages 19 and 20, live just outside Jabalia refugee camp and say they've worn the hijab since their early teens...

WE BELIEVE WE HAVE TO. AFTER SIX YEARS OF WEARING IT, IT SEEMS LIKE A HABIT TO ME...

IT IS WRITTEN IN THE KORAN.

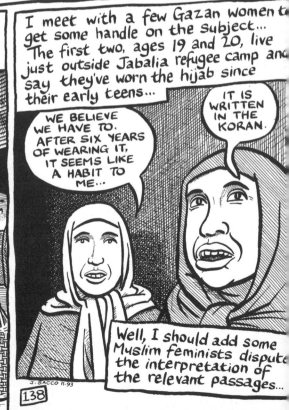

Well, I should add some Muslim feminists dispute the interpretation of the relevant passages...

J. SACCO 11.93

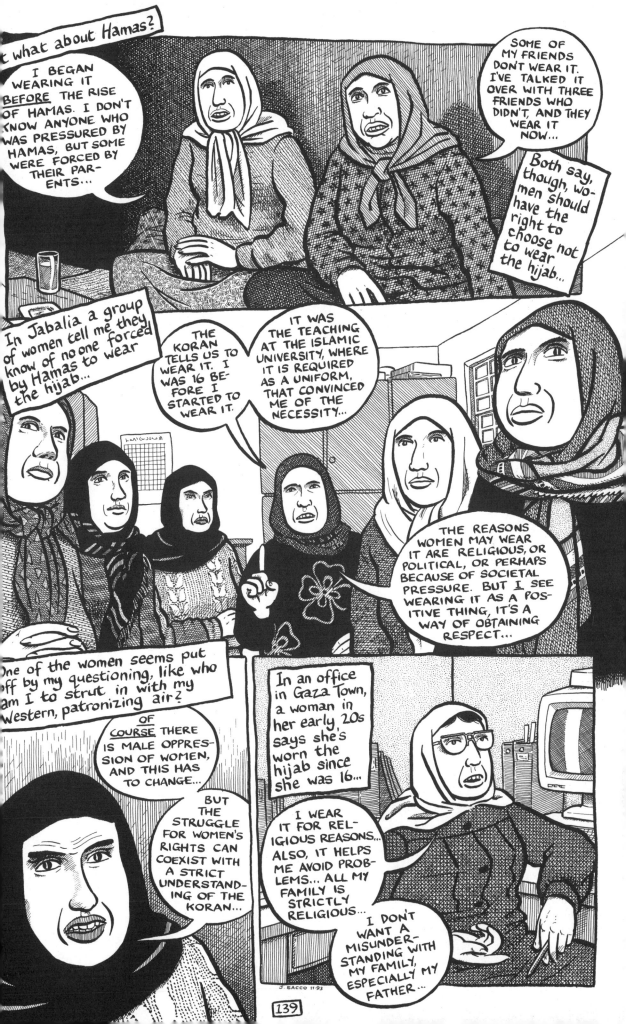

t what about Hamas?

I BEGAN WEARING IT BEFORE THE RISE OF HAMAS. I DON'T KNOW ANYONE WHO WAS PRESSURED BY HAMAS, BUT SOME WERE FORCED BY THEIR PARENTS...

SOME OF MY FRIENDS DON'T WEAR IT. I'VE TALKED IT OVER WITH THREE FRIENDS WHO DIDN'T, AND THEY WEAR IT NOW...

Both say, though, women should have the right to choose not to wear the hijab...

In Jabalia a group of women tell me they know of no one forced by Hamas to wear the hijab...

THE KORAN TELLS US TO WEAR IT. I WAS 16 BEFORE I STARTED TO WEAR IT.

IT WAS THE TEACHING AT THE ISLAMIC UNIVERSITY, WHERE IT IS REQUIRED AS A UNIFORM, THAT CONVINCED ME OF THE NECESSITY...

THE REASONS WOMEN MAY WEAR IT ARE RELIGIOUS, OR POLITICAL, OR PERHAPS BECAUSE OF SOCIETAL PRESSURE. BUT I SEE WEARING IT AS A POSITIVE THING, IT'S A WAY OF OBTAINING RESPECT...

One of the women seems put off by my questioning, like who am I to strut in with my Western, patronizing air?

OF COURSE THERE IS MALE OPPRESSION OF WOMEN, AND THIS HAS TO CHANGE...

BUT THE STRUGGLE FOR WOMEN'S RIGHTS CAN COEXIST WITH A STRICT UNDERSTANDING OF THE KORAN...

In an office in Gaza Town, a woman in her early 20s says she's worn the hijab since she was 16...

I WEAR IT FOR RELIGIOUS REASONS... ALSO, IT HELPS ME AVOID PROBLEMS... ALL MY FAMILY IS STRICTLY RELIGIOUS...

I DON'T WANT A MISUNDERSTANDING WITH MY FAMILY, ESPECIALLY MY FATHER...

J. SACCO 11-93

139

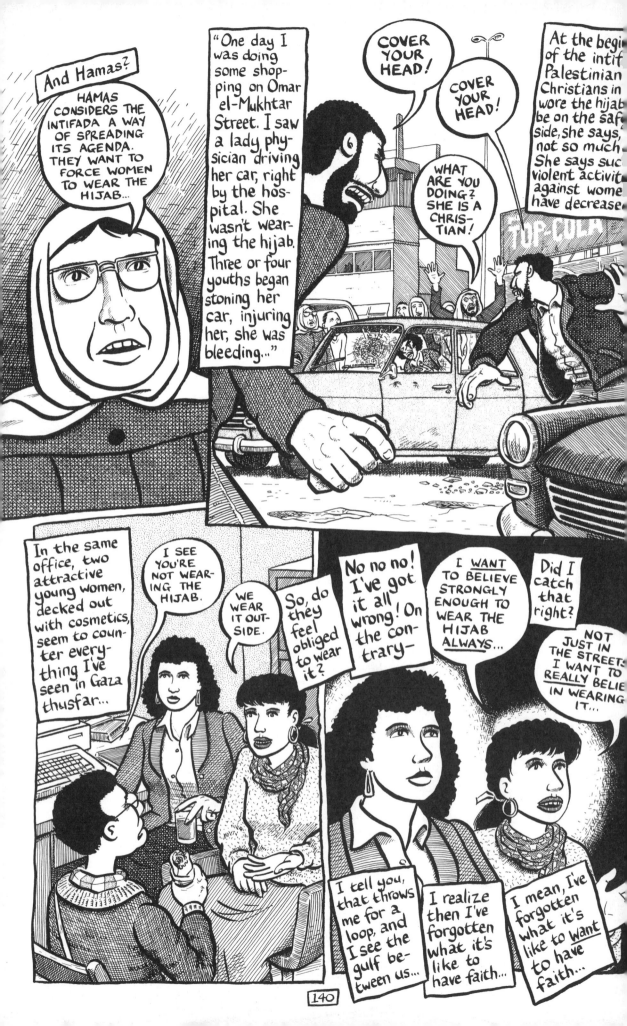

And Hamas?

HAMAS CONSIDERS THE INTIFADA A WAY OF SPREADING ITS AGENDA. THEY WANT TO FORCE WOMEN TO WEAR THE HIJAB...

"One day I was doing some shopping on Omar el-Mukhtar Street. I saw a lady physician driving her car, right by the hospital. She wasn't wearing the hijab. Three or four youths began stoning her car, injuring her, she was bleeding..."

COVER YOUR HEAD!

COVER YOUR HEAD!

WHAT ARE YOU DOING? SHE IS A CHRISTIAN!

At the begi of the intif Palestinian Christians in wore the hijab be on the safe side, she says, not so much She says suc violent activiti against wome have decrease

TOP-COLA

In the same office, two attractive young women, decked out with cosmetics, seem to counter everything I've seen in Gaza thusfar...

I SEE YOU'RE NOT WEARING THE HIJAB.

WE WEAR IT OUTSIDE.

So, do they feel obliged to wear it?

No no no! I've got it all wrong! On the contrary—

I WANT TO BELIEVE STRONGLY ENOUGH TO WEAR THE HIJAB ALWAYS...

Did I catch that right?

NOT JUST IN THE STREET I WANT TO REALLY BELIE IN WEARING IT...

I tell you, that throws me for a loop, and I see the gulf between us...

I realize then I've forgotten what it's like to have faith...

I mean, I've forgotten what it's like to want to have faith...

140

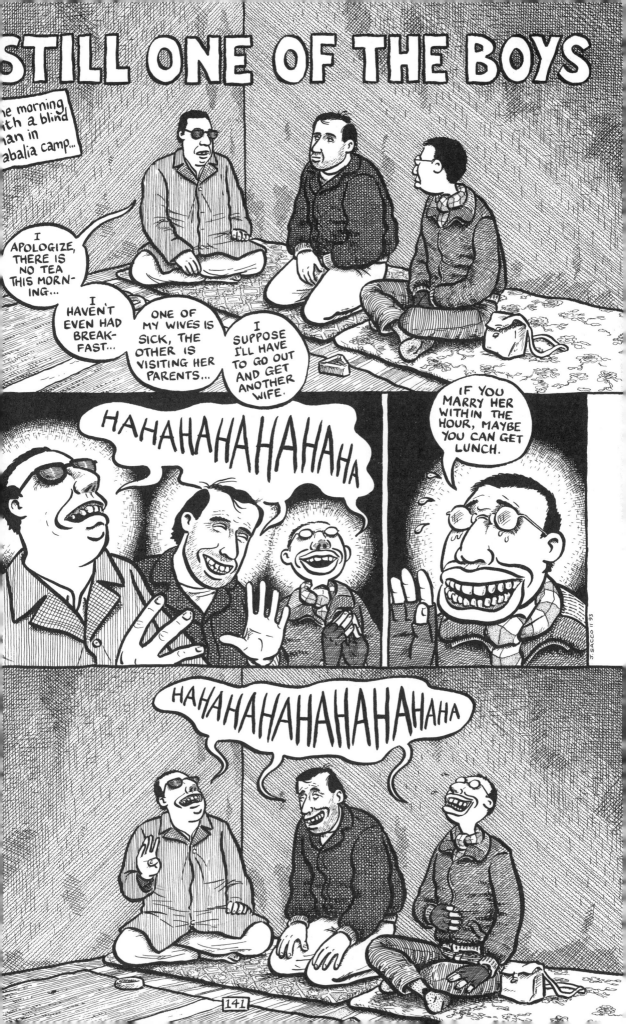

Chapter Six

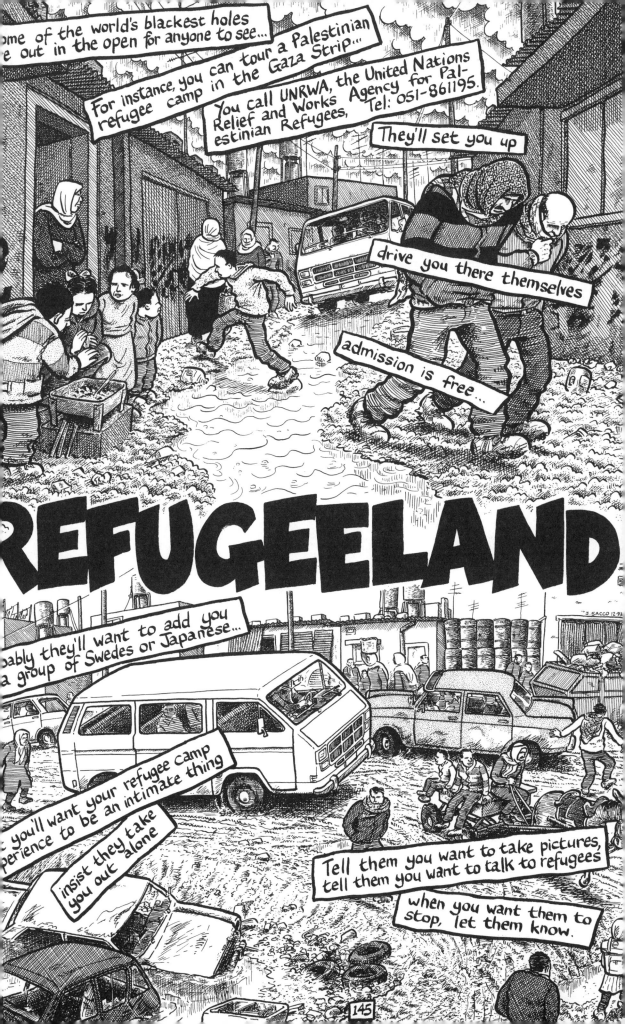

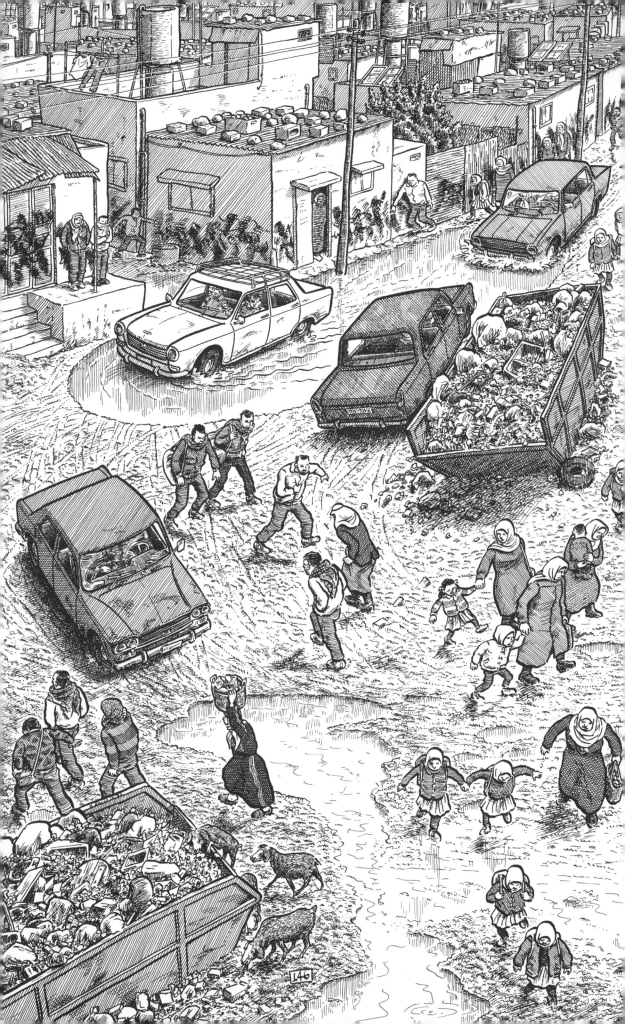

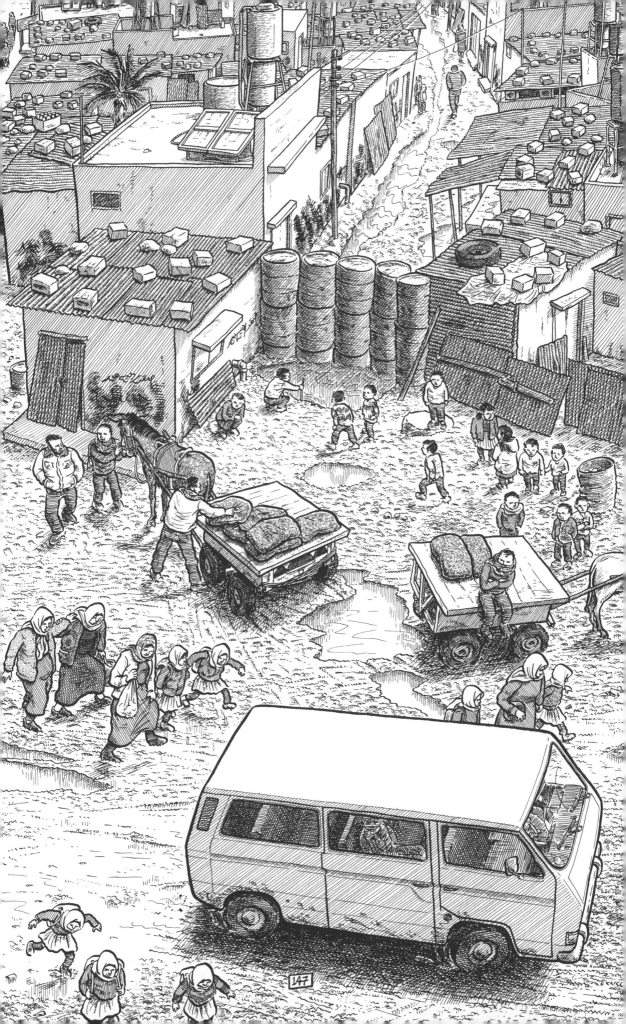

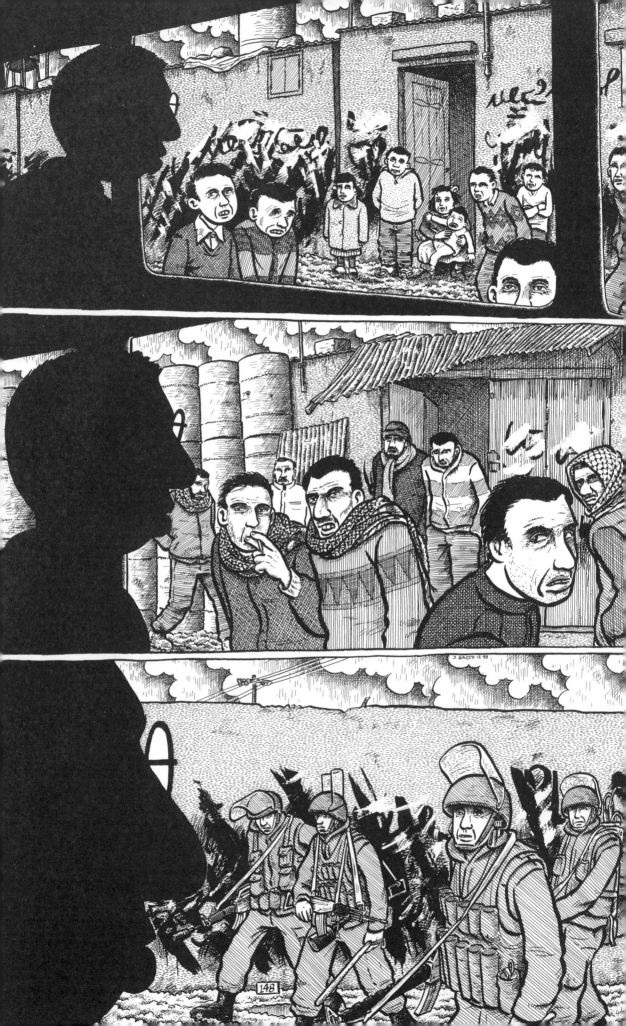

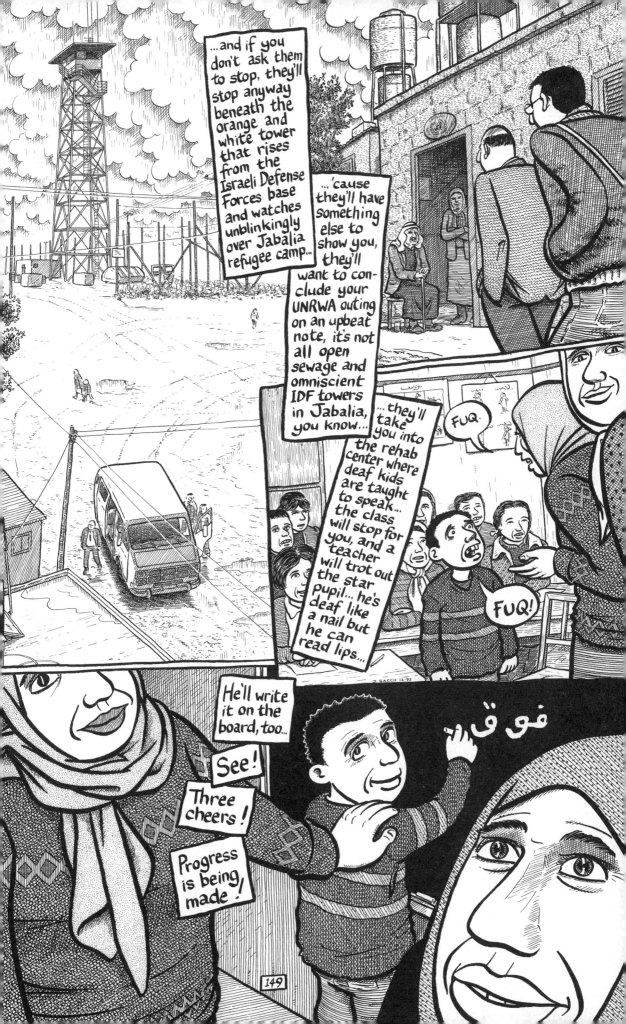

...and if you don't ask them to stop, they'll stop anyway beneath the orange and white tower that rises from the Israeli Defense Forces base and watches unblinkingly over Jabalia refugee camp...

...'cause they'll have something else to show you, they'll want to conclude your UNRWA outing on an upbeat note, it's not all open sewage and omniscient IDF towers in Jabalia, you know...

...they'll take you into the rehab center where deaf kids are taught to speak... the class will stop for you, and a teacher will trot out the star pupil... he's deaf like a nail but he can read lips...

FUQ

FUQ!

J. SACCO 12-93

He'll write it on the board, too...

See!

Three cheers!

Progress is being made!

فوق

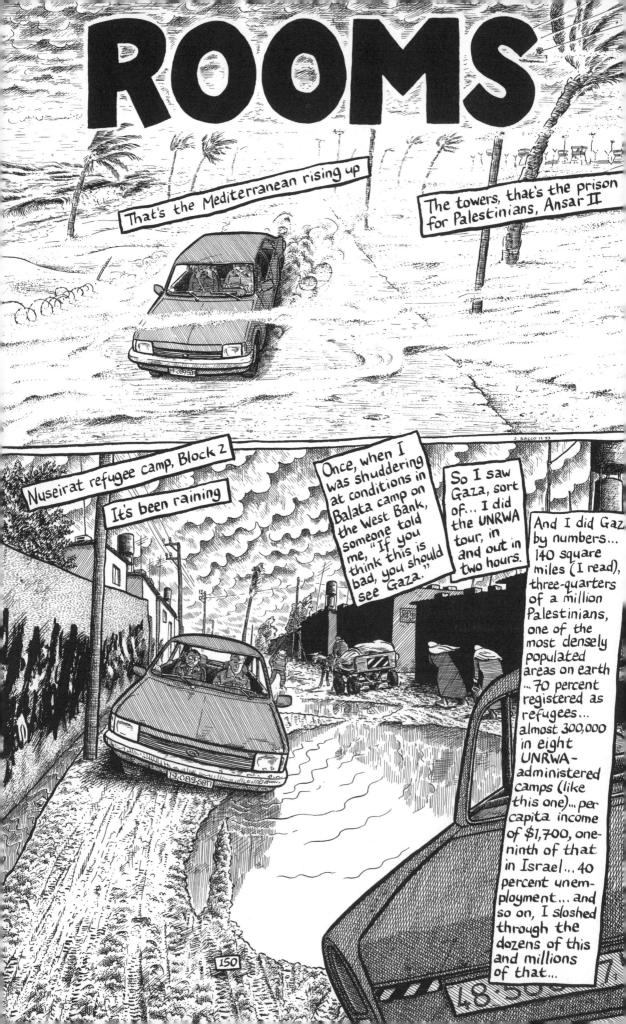

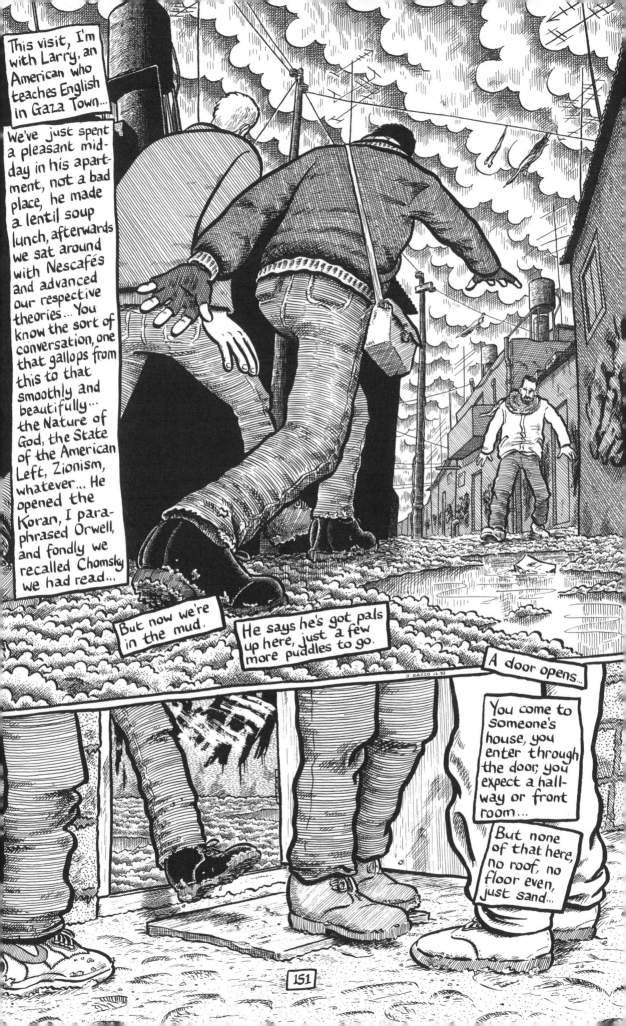

This visit, I'm with Larry, an American who teaches English in Gaza Town...

We've just spent a pleasant mid-day in his apartment, not a bad place, he made a lentil soup lunch, afterwards we sat around with Nescafés and advanced our respective theories... You know the sort of conversation, one that gallops from this to that smoothly and beautifully... the Nature of God, the State of the American Left, Zionism, whatever... He opened the Koran, I paraphrased Orwell, and fondly we recalled Chomsky we had read...

But now we're in the mud.

He says he's got pals up here, just a few more puddles to go.

A door opens...

You come to someone's house, you enter through the door, you expect a hallway or front room...

But none of that here, no roof, no floor even, just sand...

J. SACCO 12-93

151

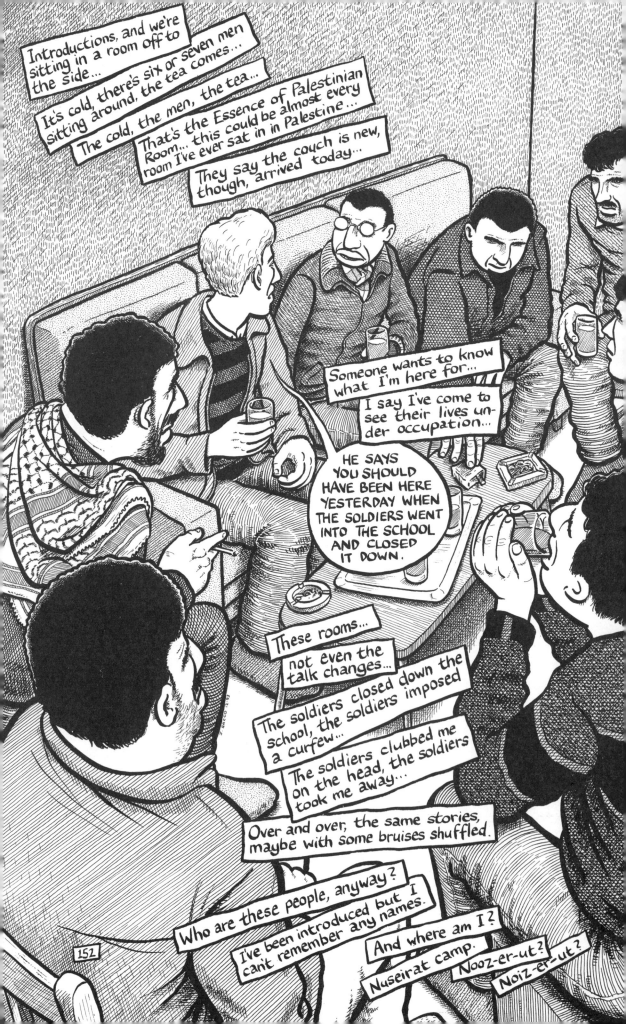

Someone's showing me his permit to work in Israel, he's doctored it, see? He's extended his permit by scratching off a zero. "He does it because he must work," someone explains, "The Israelis take so long to renew his papers"... Nuseirat camp, the Gaza Strip, unemployment 40 percent, a job in Israel is a prized thing even though

the average daily wage for Palestinian workers is just $20, even if transportation to work costs more than half that, even if it means four hours travelling time to and from Tel Aviv every day... This guy's a lucky one, too, he works, he teaches locally, over in Khan Younis... What's his name again? Masud? Masud. Masud who teaches

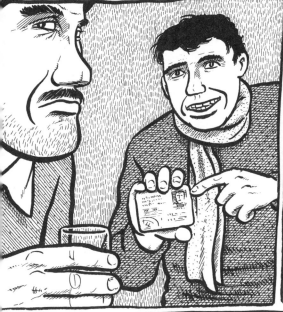

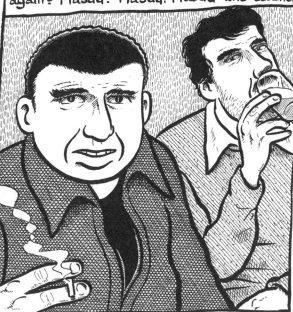

in Khan Younis... He tells me why the school, two schools, were closed in Nuseirat yesterday. What happened? "The soldiers come," he says, "two Thursdays in a row, they park near the school. It's a provocation and someone throws a stone. The soldiers go in with tear gas, shooting rubber and live bullets." Once, Masud says, a student

where he teaches, an eight year old, was killed by a rubber bullet, it entered the boy's head... The Gaza Strip, lots of kids get shot here... in '89, for example, of 3,779 live-round casualties, 1,506 were children under 15, 33 were five years old or younger... Masud, though, doesn't seem too bitter. So, does he have hopes for

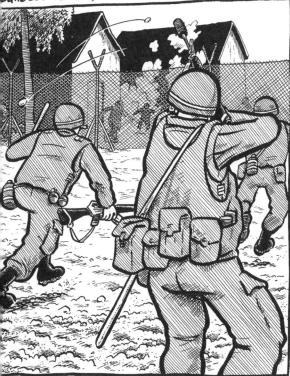

peace with Israel? "No," he says, "I have no hope. Things won't change." But that seems almost beside the point to Masud. "We Arabs have tried nationalism," he says, "but what the people must do is return to their Muslim roots. Fundamentalism is on the rise and that's a good thing. Now it is the turn of Islam." The turn of Islam?

Fundamentalism? That's the cue for all true white men to form a perimeter around the women and children!... But Masud's brand of fundamentalism doesn't sound like the militancy of Hamas, the resistance movement which emphasizes a forceful liberation of Palestine as it moves to Islamize Palestinian society. And someone—

his name is Ibrahim, and this is his room, I take it, his couch — says he believes in the armed struggle all right. "The Israelis only understand force," he says. How? What force? "There are ways. So far it's been stones, but there are guns." Yes yes, I've heard this before, Palestinians stewing in rooms like this one, raising a finger in

warning and the specter of shooting Israelis... The intifada thusfar, they say, has been an exercise in restraint... But the Israelis are exponentially more powerful than the Palestinians, does Ibrahim expect a hand (or a tank corps) from the Arab states? "The other Arabs are worthless," he says. "They're talk talk talk. Where was

J. SACCO 1·94

154

Qaddafi during the Gulf War? Only Saddam Hussein attacked Israel. He kept his word. Was he a man or was he a man?" Ibrahim's on a roll now about Palestinian military prowess, his commando raid Top Ten... Did I hear about the shebab who seized the bus and made a seven-kilometer run attacking Israeli positions until a

helicopter got them? And what about Leila Khaled?! A PFLP guerilla, she helped hijack those airliners to Jordan, the ones blown up after being emptied of passengers and crew... "I don't agree with those tactics," says a man with a beard. "They didn't get us anywhere." And Masud, the fundamentalist, agrees... Probably they've talked this

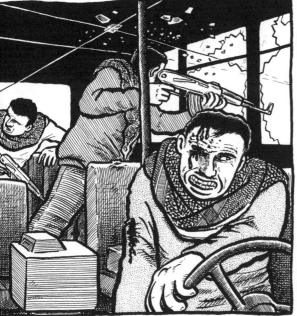

through a hundred times before in Nuseirat, in other camps, in villages and towns, in rooms just like this one, with the tea coming and coming, year after year... And it was a young man from Nuseirat, married, with a newborn baby, and one of the lucky ones, too, with a job, who forced an Israeli bus into a

ravine, killing 15, and he wasn't under orders from Fateh or the PFLP or Hamas, his was a personal explosion, maybe he'd been dwelling on his best friend, whose spine had been cut through by an Israeli bullet... And someone asks me what Americans think of Palestinians, and I try to answer, throwing in that the killing of collaborators hasn't gone over

J. SACCO 1·94

too well, from mid '90 to mid '91 83 alleged collaborators were killed in Gaza by other Palestinians, which is more than two and a half times those killed here by Israeli security forces in the same period...And Ibrahim says he doesn't care about American public opinion, he says, "We can't have these collaborators among us, assassinating us, telling

the Israelis what they know," and someone else says before the intifada the collaborators did as they pleased, now they're paying, he says maybe ten have been killed in Nuseirat, and someone recalls one collaborator being shoved down a street, the people beating him with their shoes, then a couple of cars drove

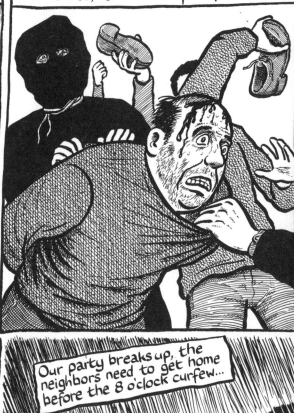

up with members of the Unified Leadership and Hamas, they took him to an orange grove and killed him. And they say sometimes the suspect's confession is taped and then played in cassette shops for everyone to hear, and, yes, they admit some suspects may be tortured, but Ibrahim says, "We have no jails, no imprisonment. There is no other way to deal with these people."

J. SACCO 1·94

Our party breaks up, the neighbors need to get home before the 8 o'clock curfew...

the rest of us cross the sandy area to a new room...

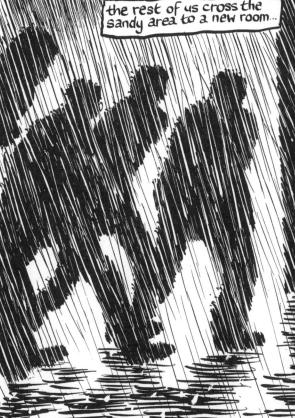

We settle in... Ibrahim tends to the coals while the rain beats hard on the corrugated asbestos roof...

This is the room of Ibrahim's brother...

Ibrahim's brother has been pretty quiet most of the evening...

I've been told his name two or three times... what was it?... Ammar

Ammar's wife and children have been sent elsewhere to make room for us...

Ibrahim's family lives in the other part of the house, the part with the new couch...

And by the way Ibrahim is telling us about Abu Jihad, how the PLO fighters held off the Israelis in Beirut — and with the jets dropping their phosphorous bombs!

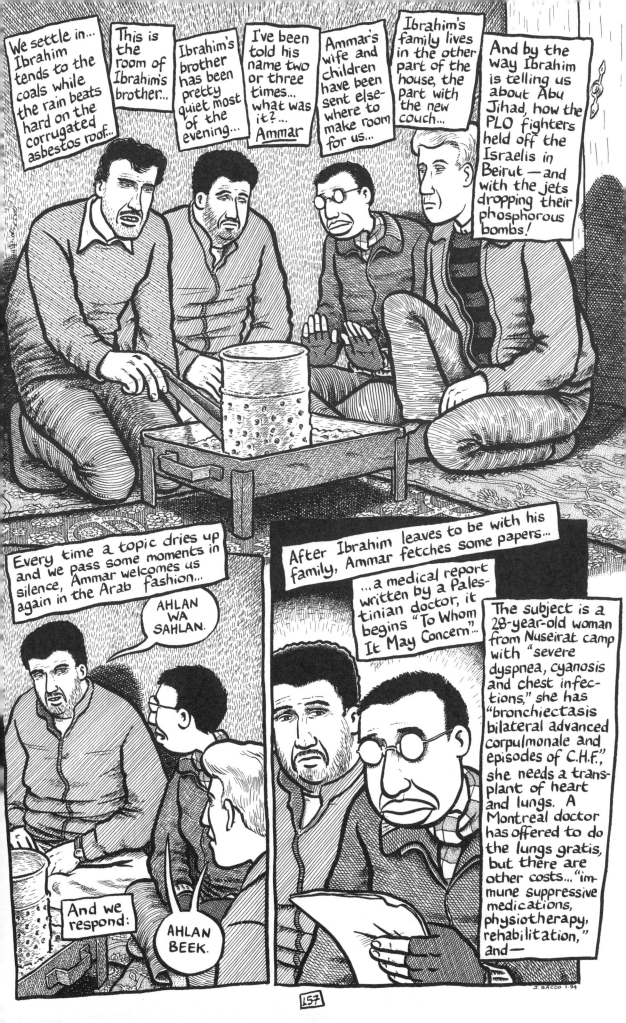

Every time a topic dries up and we pass some moments in silence, Ammar welcomes us again in the Arab fashion...

AHLAN WA SAHLAN.

And we respond:

AHLAN BEEK.

After Ibrahim leaves to be with his family, Ammar fetches some papers...

...a medical report written by a Palestinian doctor, it begins "To Whom It May Concern"...

The subject is a 28-year-old woman from Nuseirat camp with "severe dyspnea, cyanosis and chest infections," she has "bronchiectasis bilateral advanced corpulmonale and episodes of C.H.F.," she needs a transplant of heart and lungs. A Montreal doctor has offered to do the lungs gratis, but there are other costs... "immune suppressive medications, physiotherapy, rehabilitation," and—

J. SACCO 1-94

Ammar wants to know if I can get the report to someone in the West...

if I can find another doctor or hospital that would help her...

if there's something I can do...

Now Ammar and Larry are talking amongst themselves in Arabic...

and then...

I DON'T—

I—

TELL HIM I'LL TRY TO TAKE THIS TO A DOCTOR.

HE SAYS HE HASN'T WORKED IN TWO YEARS.

HE TRIED TO START A BUSINESS REPAIRING REFRIGERATORS BUT IT NEVER GOT OFF THE GROUND.

HE SAYS THERE'S NO WORK IN GAZA...

HE'S ASKING ME?

I—

YOU KNOW I THINK IT'S PRETTY HARD TO ARRANGE WORK IN THE U.S.... EUROPE I'M NOT SO SURE ABOUT BUT I THINK IT'D BE HARD THERE, TOO...

I DON'T KNOW...

HE SAYS THE ISRAELIS ISSUE FEW PERMITS TO WORK IN ISRAEL...

HE SAYS IT'S NOT POSSIBLE FOR PALESTINIANS TO WORK IN THE GULF STATES SINCE THE WAR...

HE WANTS TO KNOW IF IT'S POSSIBLE FOR HIM TO GET WORK IN THE WEST...

Larry tells him...

AHLAN WA SAHLAN.

AHLAN BEEK.

J. SACCO 1·94

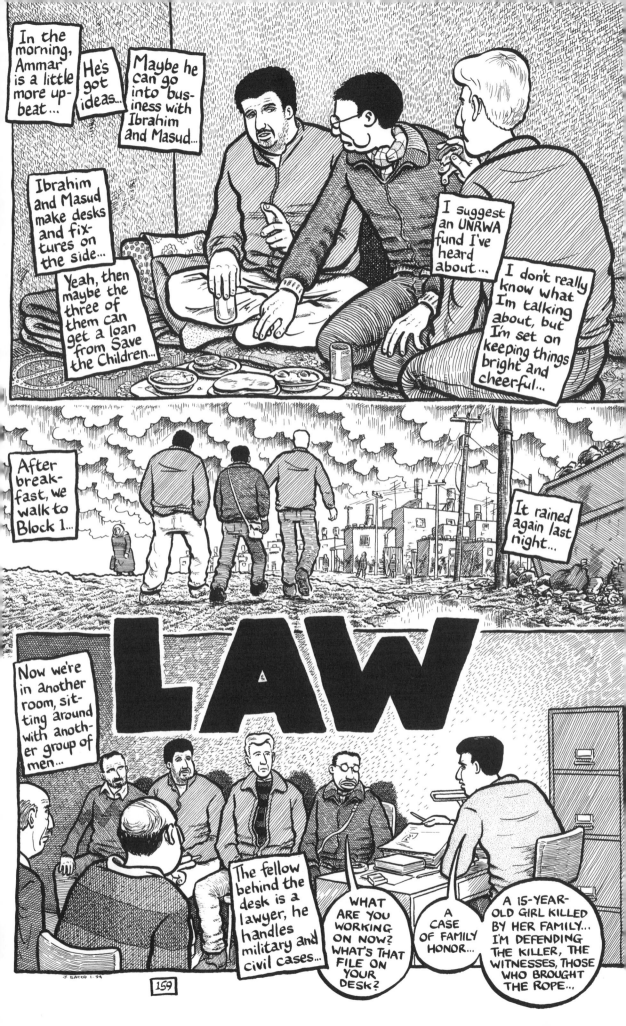

In the morning, Ammar is a little more up-beat...

He's got ideas...

Maybe he can go into business with Ibrahim and Masud...

Ibrahim and Masud make desks and fixtures on the side...

Yeah, then maybe the three of them can get a loan from Save the Children...

I suggest an UNRWA fund I've heard about...

I don't really know what I'm talking about, but I'm set on keeping things bright and cheerful...

After breakfast, we walk to Block 1...

It rained again last night...

LAW

Now we're in another room, sitting around with another group of men...

The fellow behind the desk is a lawyer, he handles military and civil cases...

WHAT ARE YOU WORKING ON NOW? WHAT'S THAT FILE ON YOUR DESK?

A CASE OF FAMILY HONOR...

A 15-YEAR-OLD GIRL KILLED BY HER FAMILY... I'M DEFENDING THE KILLER, THE WITNESSES, THOSE WHO BROUGHT THE ROPE...

J. SACCO 1-94

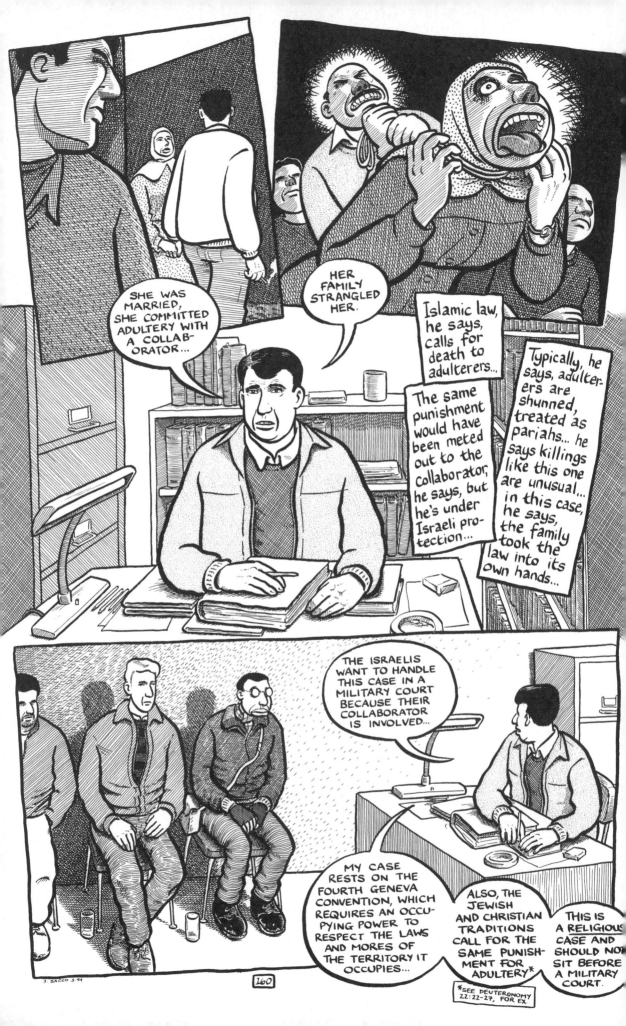

SHE WAS MARRIED, SHE COMMITTED ADULTERY WITH A COLLABORATOR...

HER FAMILY STRANGLED HER.

Islamic law, he says, calls for death to adulterers...

The same punishment would have been meted out to the collaborator, he says, but he's under Israeli protection...

Typically, he says, adulterers are shunned, treated as pariahs... he says killings like this one are unusual... in this case, he says, the family took the law into its own hands...

THE ISRAELIS WANT TO HANDLE THIS CASE IN A MILITARY COURT BECAUSE THEIR COLLABORATOR IS INVOLVED...

MY CASE RESTS ON THE FOURTH GENEVA CONVENTION, WHICH REQUIRES AN OCCU-PYING POWER TO RESPECT THE LAWS AND MORES OF THE TERRITORY IT OCCUPIES...

ALSO, THE JEWISH AND CHRISTIAN TRADITIONS CALL FOR THE SAME PUNISH-MENT FOR ADULTERY*

THIS IS A RELIGIOUS CASE AND SHOULD NOT SIT BEFORE A MILITARY COURT.

*SEE DEUTERONOMY 22:22-27, FOR EX.

J. SACCO 3-94

160

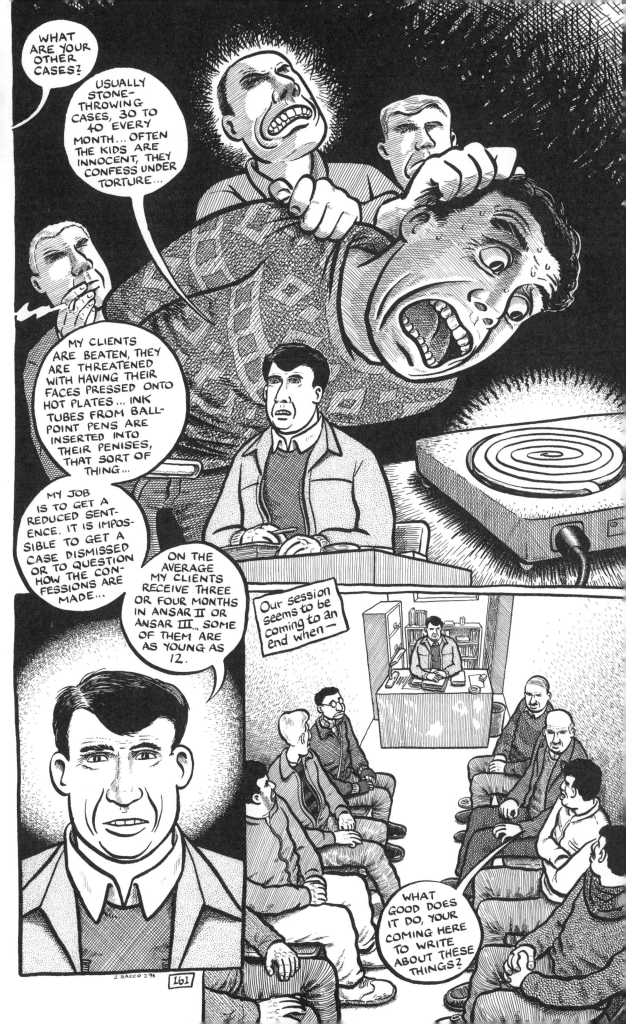

WHAT ARE YOUR OTHER CASES?

USUALLY STONE-THROWING CASES, 30 TO 40 EVERY MONTH... OFTEN THE KIDS ARE INNOCENT, THEY CONFESS UNDER TORTURE...

MY CLIENTS ARE BEATEN, THEY ARE THREATENED WITH HAVING THEIR FACES PRESSED ONTO HOT PLATES... INK TUBES FROM BALL-POINT PENS ARE INSERTED INTO THEIR PENISES, THAT SORT OF THING...

MY JOB IS TO GET A REDUCED SENT-ENCE. IT IS IMPOS-SIBLE TO GET A CASE DISMISSED OR TO QUESTION HOW THE CON-FESSIONS ARE MADE...

ON THE AVERAGE MY CLIENTS RECEIVE THREE OR FOUR MONTHS IN ANSAR II OR ANSAR III... SOME OF THEM ARE AS YOUNG AS 12.

Our session seems to be coming to an end when—

WHAT GOOD DOES IT DO, YOUR COMING HERE TO WRITE ABOUT THESE THINGS?

J. SACCO 2·94 161

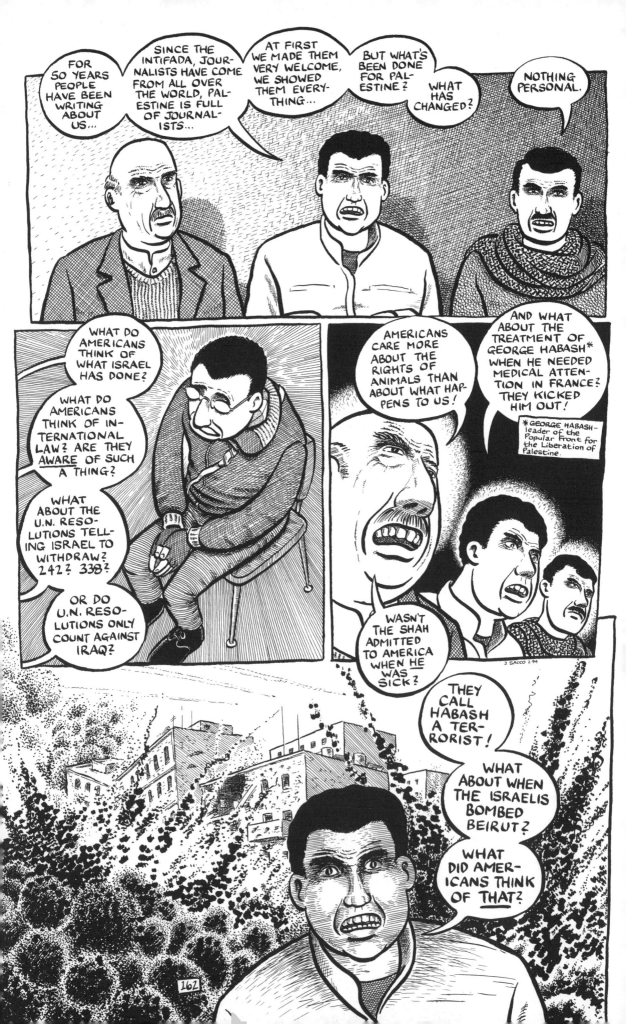

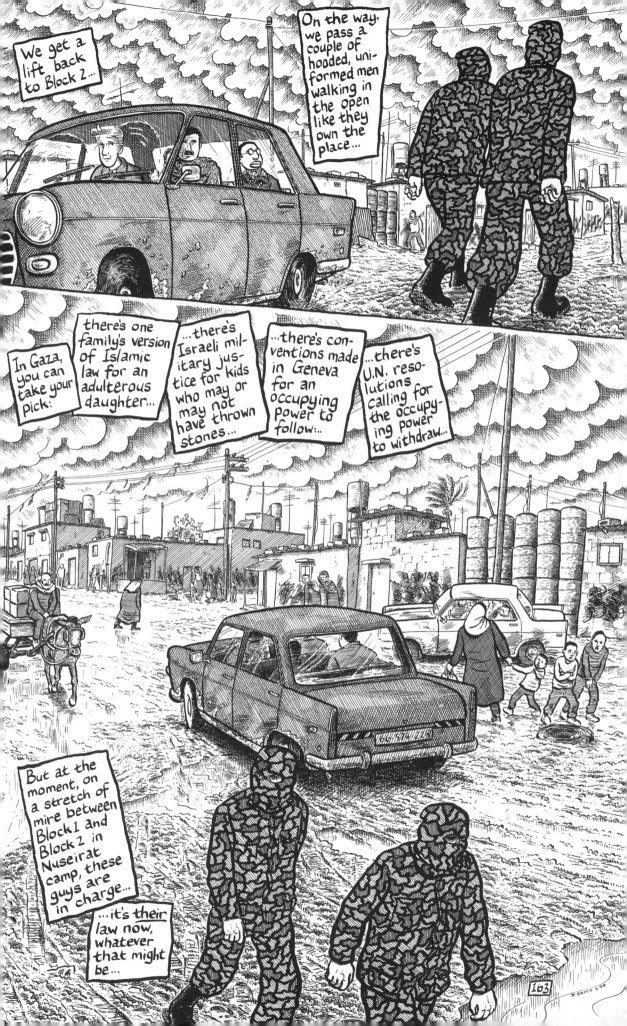

We get a lift back to Block 2...

On the way, we pass a couple of hooded, uniformed men walking in the open like they own the place...

In Gaza, you can take your pick:

...there's one family's version of Islamic law for an adulterous daughter...

...there's Israeli military justice for kids who may or may not have thrown stones...

...there's conventions made in Geneva for an occupying power to follow...

...there's U.N. resolutions calling for the occupying power to withdraw...

But at the moment, on a stretch of mire between Block 1 and Block 2 in Nuseirat camp, these guys are in charge...

...it's *their* law now, whatever that might be...

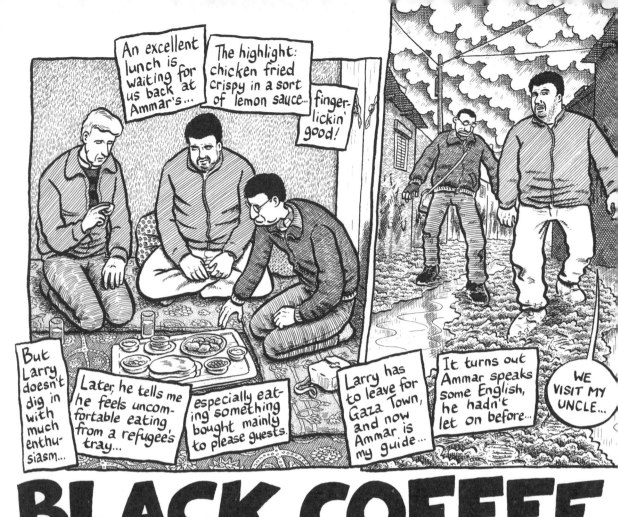

An excellent lunch is waiting for us back at Ammar's...

The highlight: chicken fried crispy in a sort of lemon sauce... finger-lickin' good!

But Larry doesn't dig in with much enthusiasm...

Later, he tells me he feels uncomfortable eating from a refugee's tray...

especially eating something bought mainly to please guests.

Larry has to leave for Gaza Town, and now Ammar is my guide...

It turns out Ammar speaks some English, he hadn't let on before...

WE VISIT MY UNCLE...

BLACK COFFEE

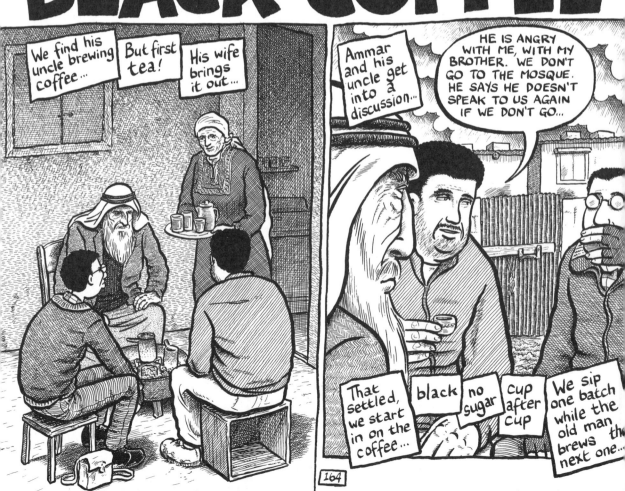

We find his uncle brewing coffee...

But first tea!

His wife brings it out...

Ammar and his uncle get into a discussion...

HE IS ANGRY WITH ME, WITH MY BROTHER. WE DON'T GO TO THE MOSQUE. HE SAYS HE DOESN'T SPEAK TO US AGAIN IF WE DON'T GO...

That settled, we start in on the coffee...

black

no sugar

cup after cup

We sip one batch while the old man brews the next one...

164

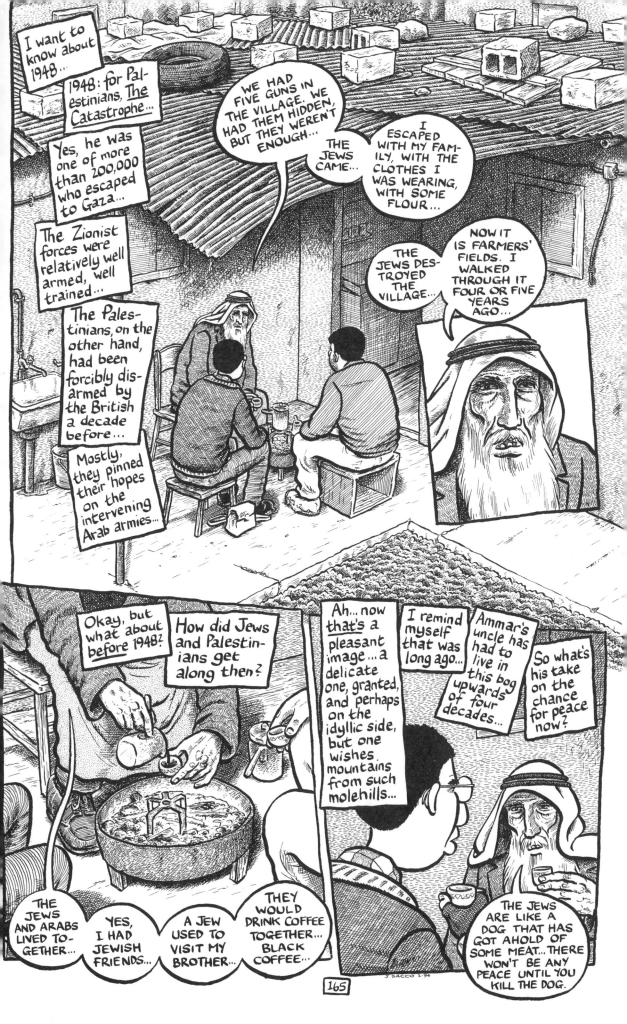

I want to know about 1948...

1948: for Palestinians, The Catastrophe...

Yes, he was one of more than 200,000 who escaped to Gaza...

The Zionist forces were relatively well armed, well trained...

The Palestinians, on the other hand, had been forcibly disarmed by the British a decade before...

Mostly, they pinned their hopes on the intervening Arab armies...

WE HAD FIVE GUNS IN THE VILLAGE. WE HAD THEM HIDDEN, BUT THEY WEREN'T ENOUGH...

THE JEWS CAME...

I ESCAPED WITH MY FAMILY, WITH THE CLOTHES I WAS WEARING, WITH SOME FLOUR...

THE JEWS DESTROYED THE VILLAGE...

NOW IT IS FARMERS' FIELDS. I WALKED THROUGH IT FOUR OR FIVE YEARS AGO...

Okay, but what about before 1948?

How did Jews and Palestinians get along then?

Ah...now that's a pleasant image...a delicate one, granted, and perhaps on the idyllic side, but one wishes mountains from such molehills...

I remind myself that was long ago...

Ammar's uncle has had to live in this bog upwards of four decades...

So what's his take on the chance for peace now?

THE JEWS AND ARABS LIVED TOGETHER...

YES, I HAD JEWISH FRIENDS...

A JEW USED TO VISIT MY BROTHER...

THEY WOULD DRINK COFFEE TOGETHER... BLACK COFFEE...

THE JEWS ARE LIKE A DOG THAT HAS GOT AHOLD OF SOME MEAT...THERE WON'T BE ANY PEACE UNTIL YOU KILL THE DOG.

165

J. SACCO 2-94

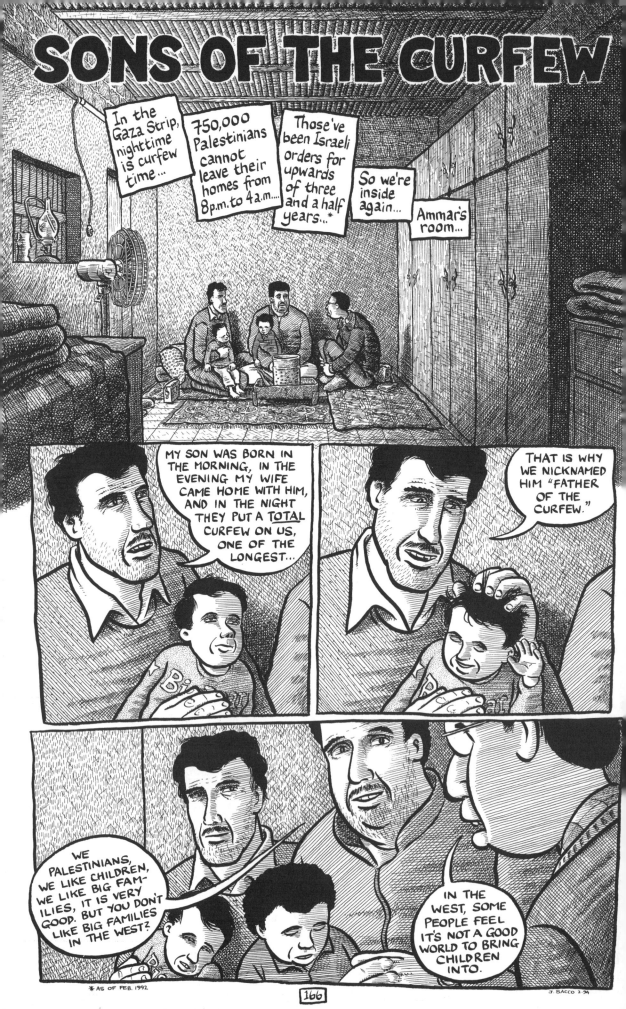

SONS OF THE CURFEW

In the Gaza Strip, nighttime is curfew time...

750,000 Palestinians cannot leave their homes from 8 p.m. to 4 a.m.....

Those've been Israeli orders for upwards of three and a half years...*

So we're inside again...

Ammar's room...

MY SON WAS BORN IN THE MORNING, IN THE EVENING MY WIFE CAME HOME WITH HIM, AND IN THE NIGHT THEY PUT A TOTAL CURFEW ON US, ONE OF THE LONGEST...

THAT IS WHY WE NICKNAMED HIM "FATHER OF THE CURFEW."

WE PALESTINIANS, WE LIKE CHILDREN, WE LIKE BIG FAMILIES, IT IS VERY GOOD. BUT YOU DON'T LIKE BIG FAMILIES IN THE WEST?

IN THE WEST, SOME PEOPLE FEEL IT'S NOT A GOOD WORLD TO BRING CHILDREN INTO.

* AS OF FEB. 1992

166

J. SACCO 2-94

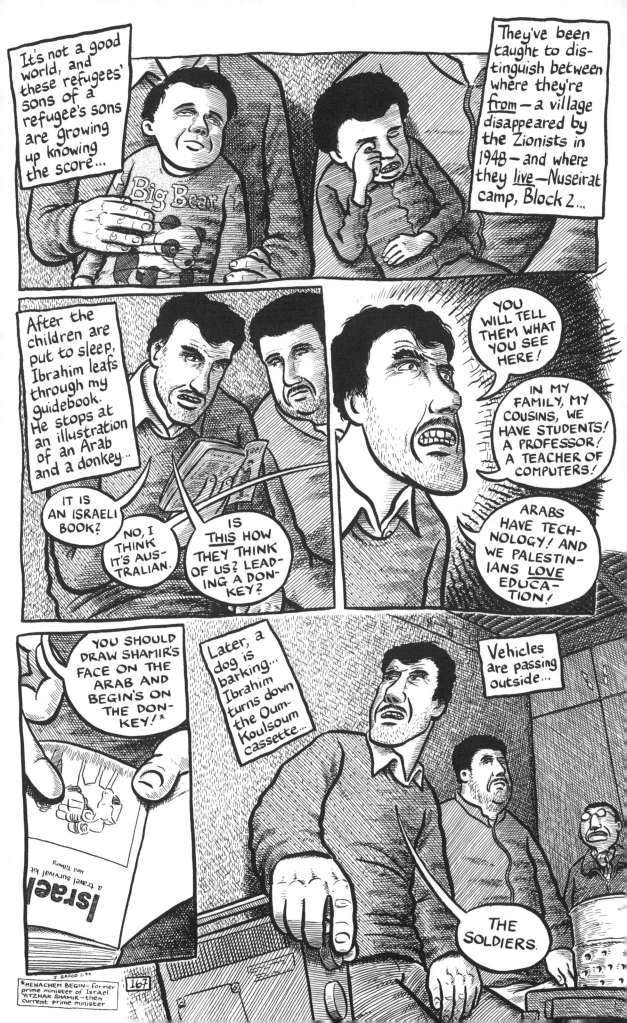

It's not a good world, and these refugees' sons of a refugee's sons are growing up knowing the score...

They've been taught to distinguish between where they're _from_ — a village disappeared by the Zionists in 1948 — and where they _live_ — Nuseirat camp, Block 2...

After the children are put to sleep, Ibrahim leafs through my guidebook. He stops at an illustration of an Arab and a donkey...

IT IS AN ISRAELI BOOK?

NO, I THINK IT'S AUSTRALIAN.

IS _THIS_ HOW THEY THINK OF US? LEADING A DONKEY?

YOU WILL TELL THEM WHAT YOU SEE HERE!

IN MY FAMILY, MY COUSINS, WE HAVE STUDENTS! A PROFESSOR! A TEACHER OF COMPUTERS!

ARABS HAVE TECHNOLOGY! AND WE PALESTINIANS LOVE EDUCATION!

YOU SHOULD DRAW SHAMIR'S FACE ON THE ARAB AND BEGIN'S ON THE DONKEY!*

Later, a dog is barking... Ibrahim turns down the Oum Koulsoum cassette...

Vehicles are passing outside...

THE SOLDIERS.

Israel a travel survival kit Neil Tilbury

J. SACCO L-94 167

*MENACHEM BEGIN — former prime minister of Israel. YITZHAK SHAMIR — then current prime minister.

TOMATOES

In the morning, we visit the workshop where Ibrahim and Masud make the desks...

Masud explains the set-up, how the operation works...

Ammar would like to work here, too...

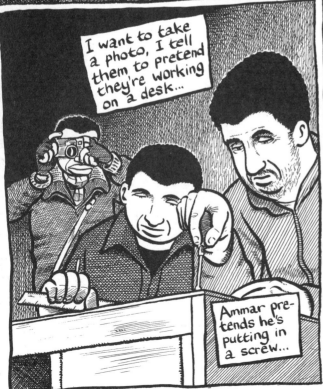

I want to take a photo, I tell them to pretend they're working on a desk...

Ammar pretends he's putting in a screw...

The make-believe is over, it's time to head out...

J. SACCO 3-94

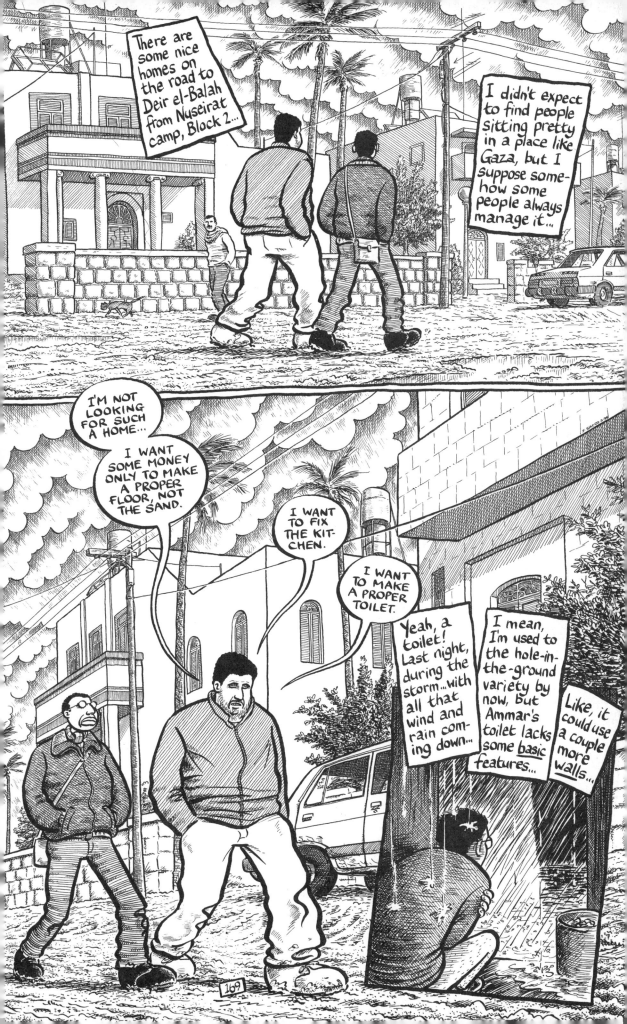

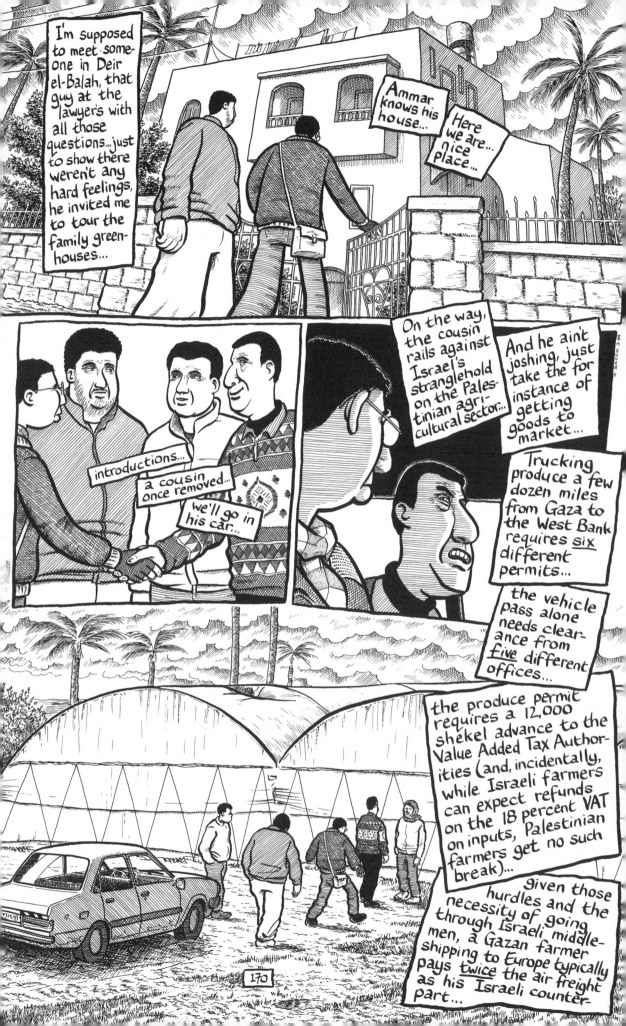

I'm supposed to meet someone in Deir el-Balah, that guy at the lawyer's with all those questions...just to show there weren't any hard feelings, he invited me to tour the family greenhouses...

Ammar knows his house...

Here we are... nice place...

On the way, the cousin rails against Israel's stranglehold on the Palestinian agricultural sector...

introductions...

a cousin once removed...

we'll go in his car...

And he ain't joshing, just take the for instance of getting goods to market...

Trucking produce a few dozen miles from Gaza to the West Bank requires six different permits...

the vehicle pass alone needs clearance from five different offices...

the produce permit requires a 12,000 shekel advance to the Value Added Tax Authorities (and, incidentally, while Israeli farmers can expect refunds on the 18 percent VAT on inputs, Palestinian farmers get no such break)...

given those hurdles and the necessity of going through Israeli middlemen, a Gazan farmer shipping to Europe typically pays twice the air freight as his Israeli counterpart...

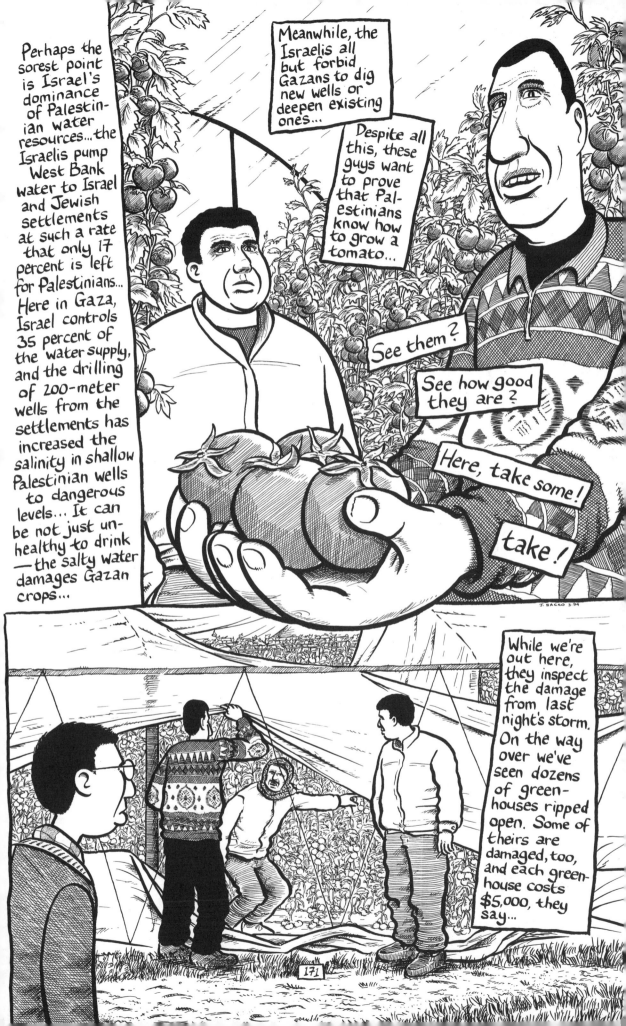

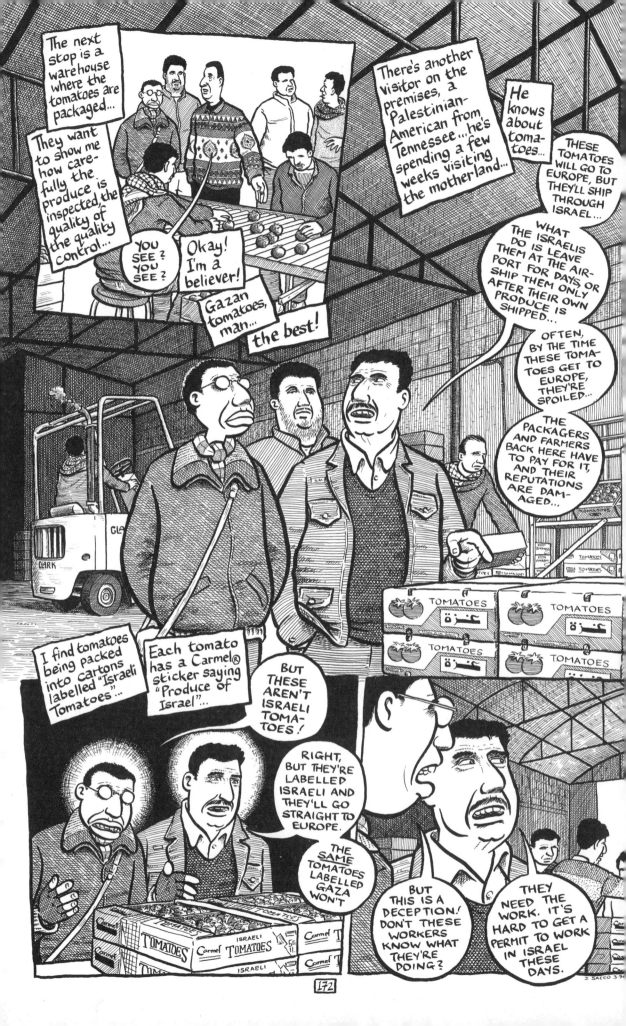

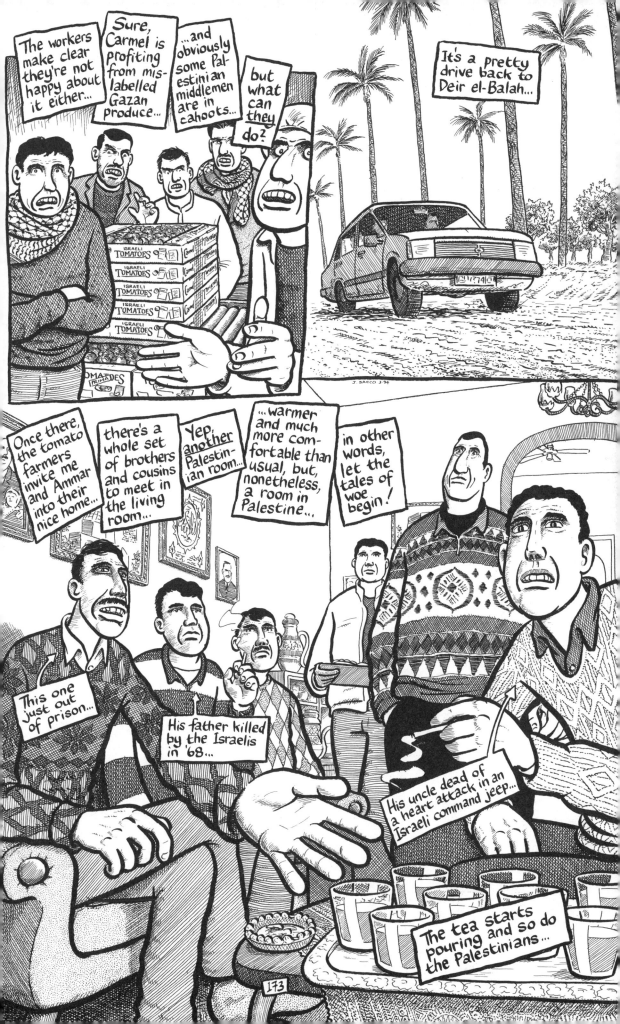

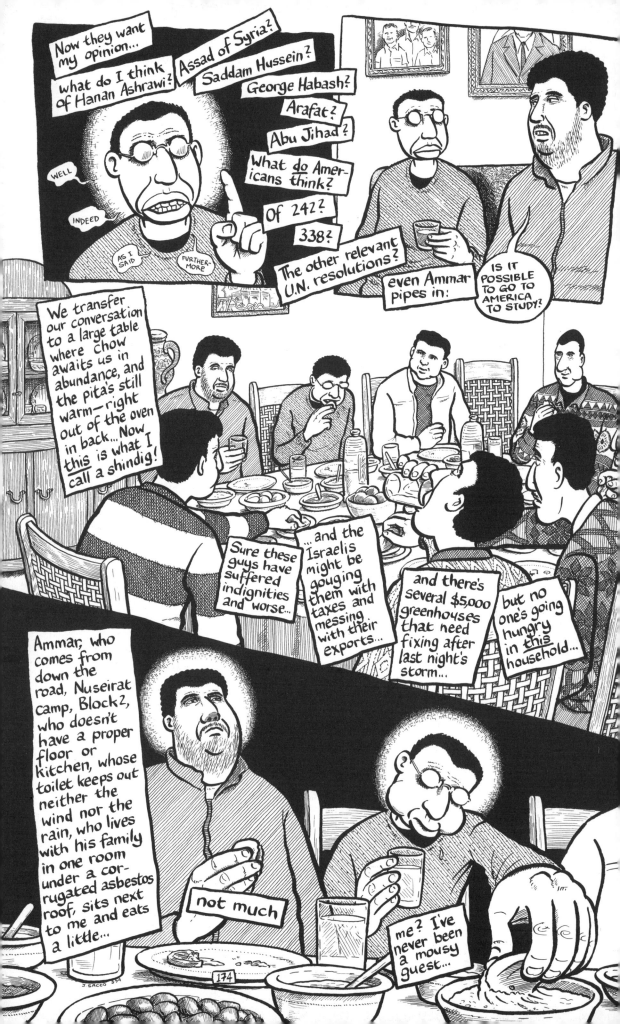

Now they want my opinion...

What do I think of Hanan Ashrawi? Assad of Syria? Saddam Hussein? George Habash? Arafat? Abu Jihad? What do Americans think? Of 242? 338? The other relevant U.N. resolutions?

WELL

INDEED

AS I SAID

FURTHER- MORE

even Ammar pipes in:

IS IT POSSIBLE TO GO TO AMERICA TO STUDY?

We transfer our conversation to a large table where chow awaits us in abundance, and the pita's still warm—right out of the oven in back... Now this is what I call a shindig!

Sure these guys have suffered indignities and worse...

...and the Israelis might be gouging them with taxes and messing with their exports...

and there's several $5,000 greenhouses that need fixing after last night's storm...

but no one's going hungry in this household...

Ammar, who comes from down the road, Nuseirat camp, Block 2, who doesn't have a proper floor or kitchen, whose toilet keeps out neither the wind nor the rain, who lives with his family in one room under a corrugated asbestos roof, sits next to me and eats a little...

not much

me? I've never been a mousy guest...

J SACCO '94

174

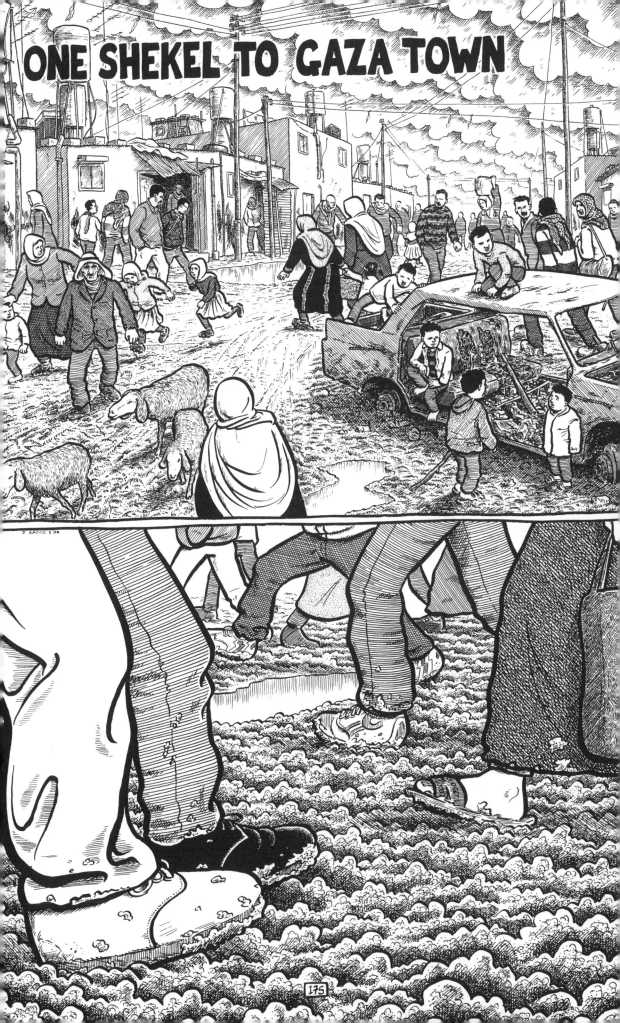

ONE SHEKEL TO GAZA TOWN

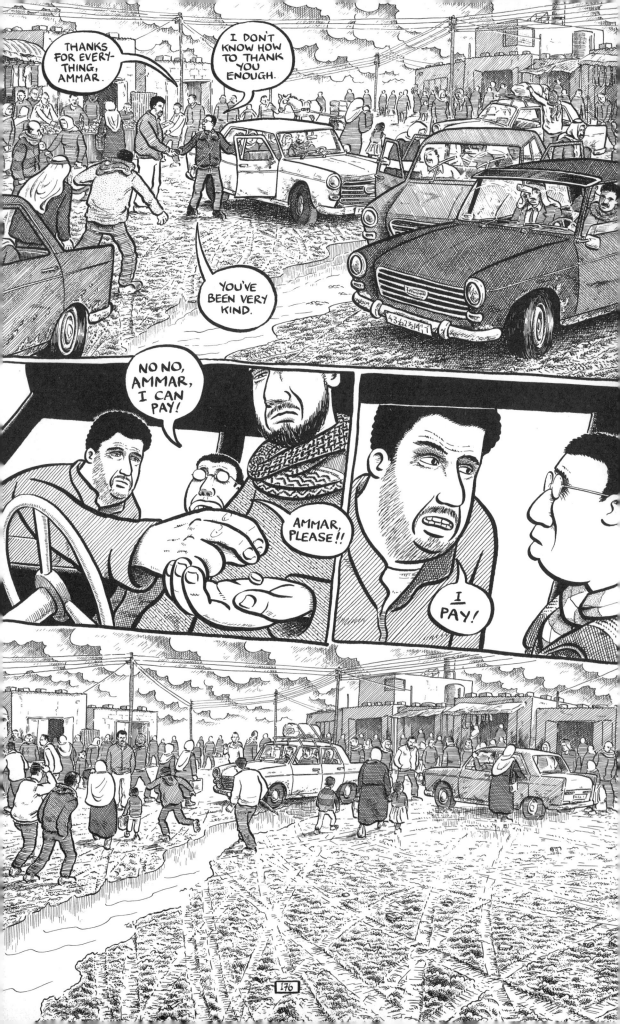

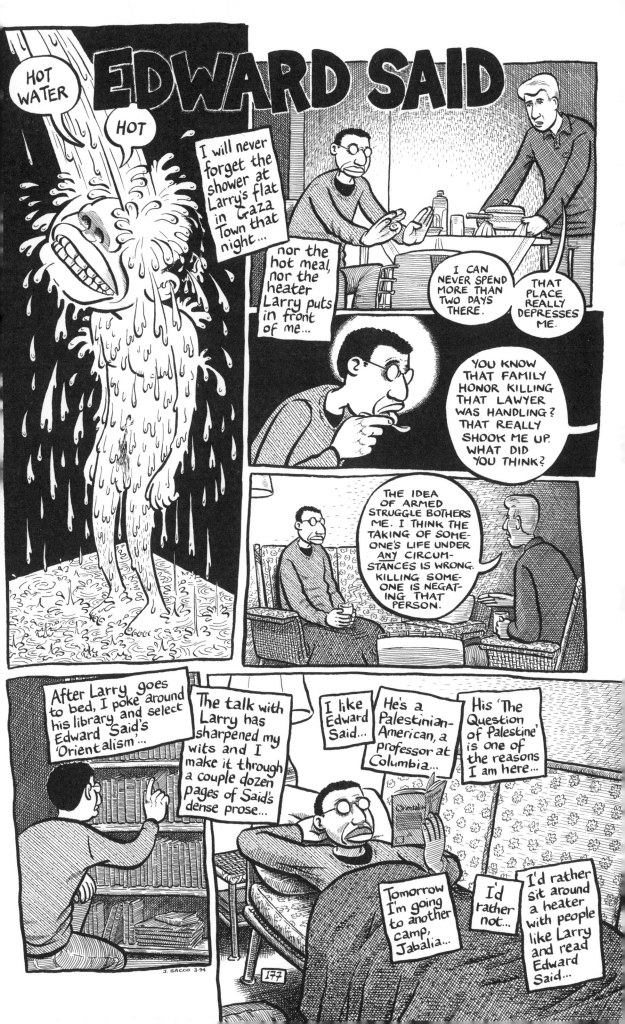

Chapter Seven

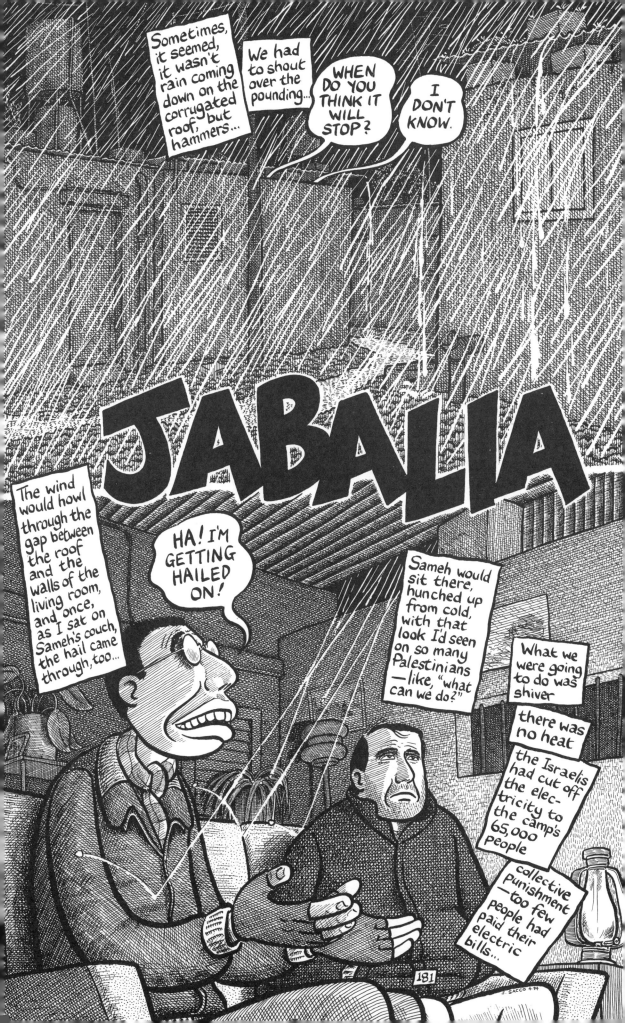

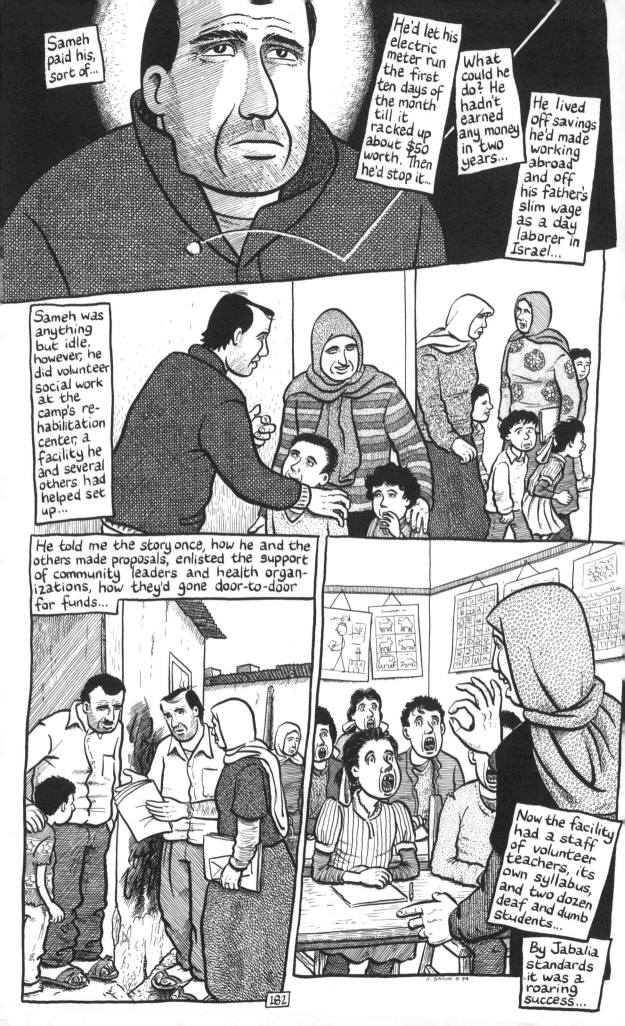

Sameh paid his, sort of...

He'd let his electric meter run the first ten days of the month till it racked up about $50 worth. Then he'd stop it...

What could he do? He hadn't earned any money in two years...

He lived off savings he'd made working abroad and off his father's slim wage as a day laborer in Israel...

Sameh was anything but idle, however; he did volunteer social work at the camp's re-habilitation center, a facility he and several others had helped set up...

He told me the story once, how he and the others made proposals, enlisted the support of community leaders and health organ-izations, how they'd gone door-to-door for funds...

Now the facility had a staff of volunteer teachers, its own syllabus, and two dozen deaf and dumb students...

By Jabalia standards it was a roaring success...

J. SACCO 5·94

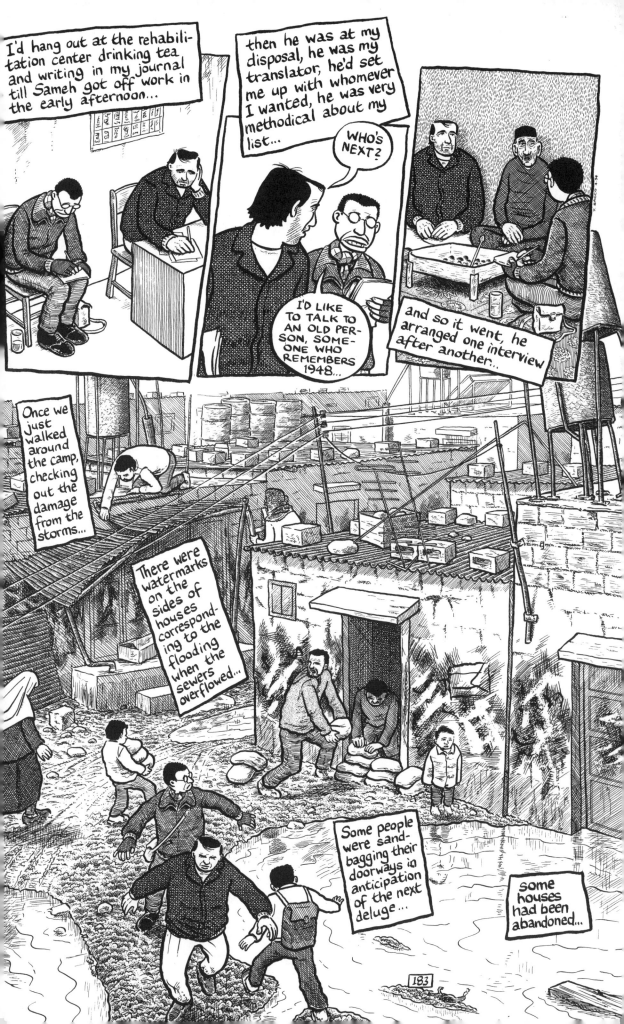

I'd hang out at the rehabilitation center drinking tea and writing in my journal till Sameh got off work in the early afternoon...

then he was at my disposal, he was my translator, he'd set me up with whomever I wanted, he was very methodical about my list...

WHO'S NEXT?

I'D LIKE TO TALK TO AN OLD PERSON, SOMEONE WHO REMEMBERS 1948...

and so it went, he arranged one interview after another...

Once we just walked around the camp, checking out the damage from the storms...

There were watermarks on the sides of houses corresponding to the flooding when the sewers overflowed...

Some people were sandbagging their doorways in anticipation of the next deluge...

Some houses had been abandoned...

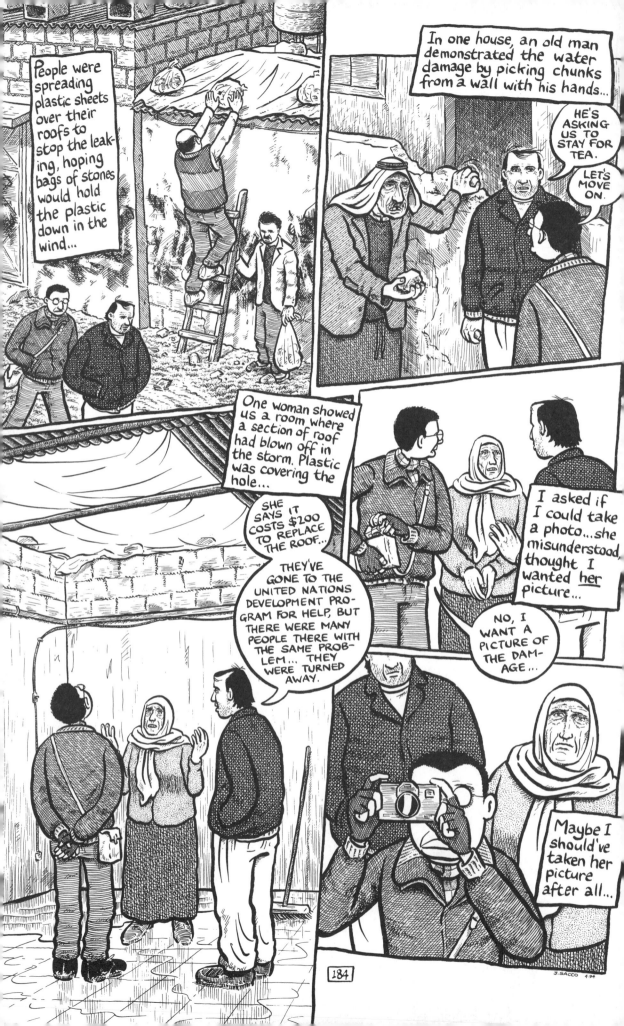

People were spreading plastic sheets over their roofs to stop the leaking, hoping bags of stones would hold the plastic down in the wind...

In one house, an old man demonstrated the water damage by picking chunks from a wall with his hands...

HE'S ASKING US TO STAY FOR TEA.

LET'S MOVE ON.

One woman showed us a room where a section of roof had blown off in the storm. Plastic was covering the hole...

SHE SAYS IT COSTS $200 TO REPLACE THE ROOF...

THEY'VE GONE TO THE UNITED NATIONS DEVELOPMENT PROGRAM FOR HELP, BUT THERE WERE MANY PEOPLE THERE WITH THE SAME PROBLEM... THEY WERE TURNED AWAY.

I asked if I could take a photo...she misunderstood, thought I wanted her picture...

NO, I WANT A PICTURE OF THE DAMAGE...

Maybe I should've taken her picture after all...

184

J. SACCO 4.94

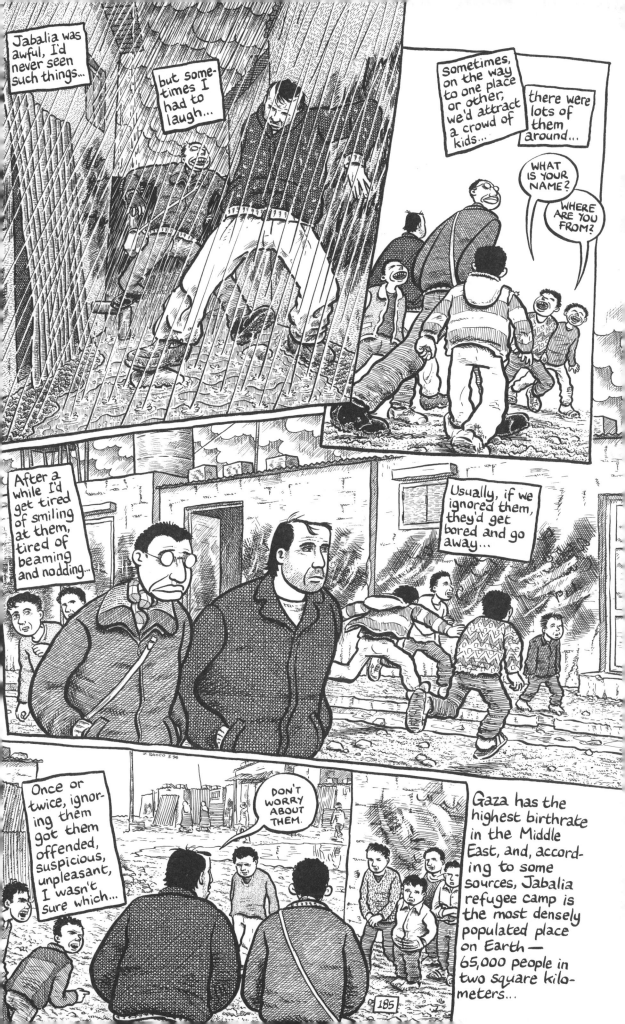

Jabalia was awful, I'd never seen such things...

but sometimes I had to laugh...

Sometimes, on the way to one place or other, we'd attract a crowd of kids...

there were lots of them around...

WHAT IS YOUR NAME?

WHERE ARE YOU FROM?

After a while I'd get tired of smiling at them, tired of beaming and nodding...

Usually, if we ignored them, they'd get bored and go away...

Once or twice, ignoring them got them offended, suspicious, unpleasant, I wasn't sure which...

DON'T WORRY ABOUT THEM.

Gaza has the highest birthrate in the Middle East, and, according to some sources, Jabalia refugee camp is the most densely populated place on Earth — 65,000 people in two square kilometers...

185

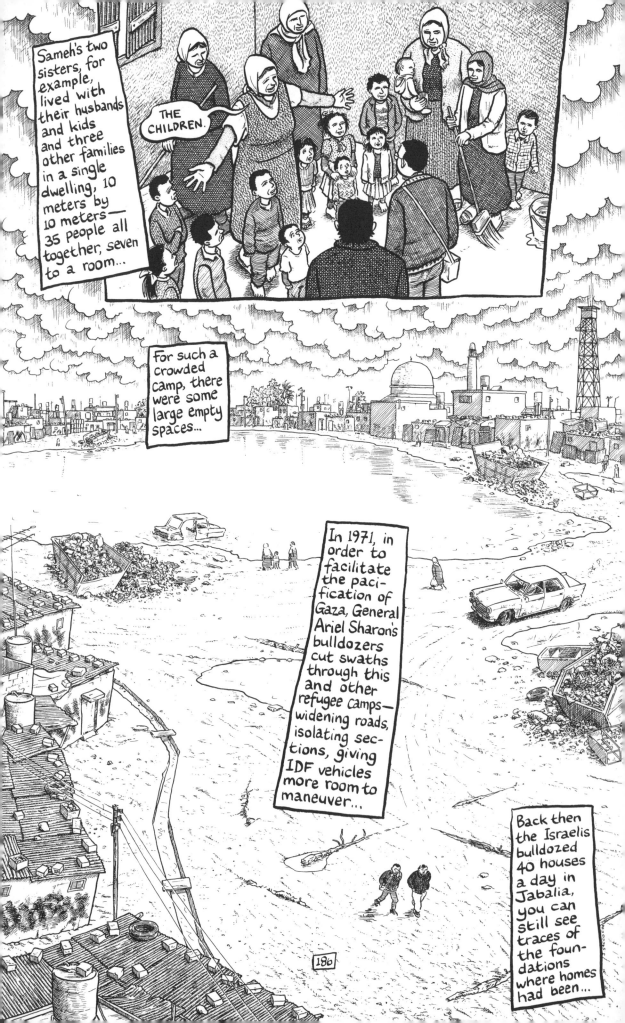

Sameh's two sisters, for example, lived with their husbands and kids and three other families in a single dwelling, 10 meters by 10 meters—35 people all together, seven to a room...

THE CHILDREN.

For such a crowded camp, there were some large empty spaces...

In 1971, in order to facilitate the pacification of Gaza, General Ariel Sharon's bulldozers cut swaths through this and other refugee camps—widening roads, isolating sections, giving IDF vehicles more room to maneuver...

Back then the Israelis bulldozed 40 houses a day in Jabalia, you can still see traces of the foundations where homes had been...

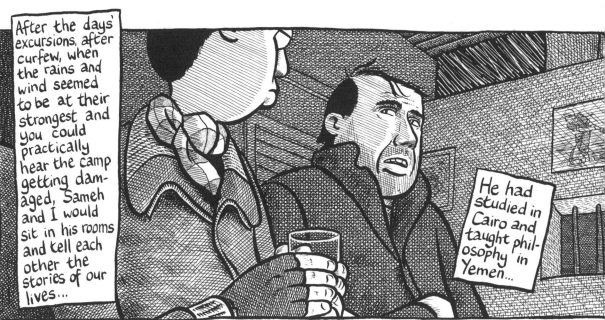

After the days' excursions, after curfew, when the rains and wind seemed to be at their strongest and you could practically hear the camp getting damaged, Sameh and I would sit in his rooms and tell each other the stories of our lives...

He had studied in Cairo and taught philosophy in Yemen...

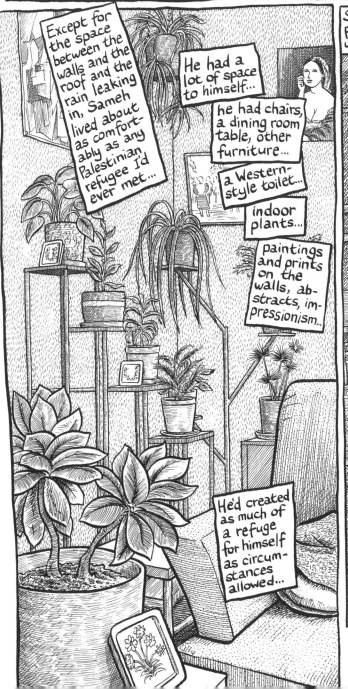

Except for the space between the walls and the roof and the rain leaking in, Sameh lived about as comfortably as any Palestinian refugee I'd ever met...

He had a lot of space to himself...

he had chairs, a dining room table, other furniture...

a Western-style toilet...

indoor plants...

paintings and prints on the walls, abstracts, impressionism...

He'd created as much of a refuge for himself as circumstances allowed...

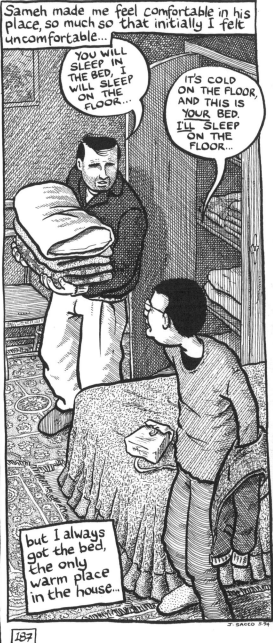

Sameh made me feel comfortable in his place, so much so that initially I felt uncomfortable...

YOU WILL SLEEP IN THE BED, I WILL SLEEP ON THE FLOOR...

IT'S COLD ON THE FLOOR, AND THIS IS YOUR BED. I'LL SLEEP ON THE FLOOR...

but I always got the bed, the only warm place in the house...

J. SACCO 5-94

187

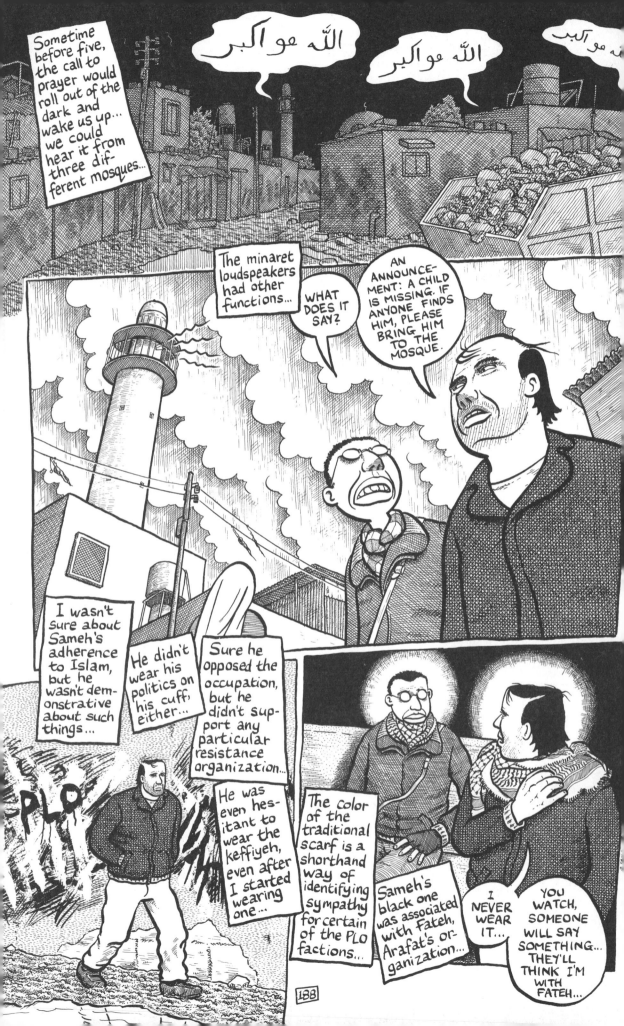

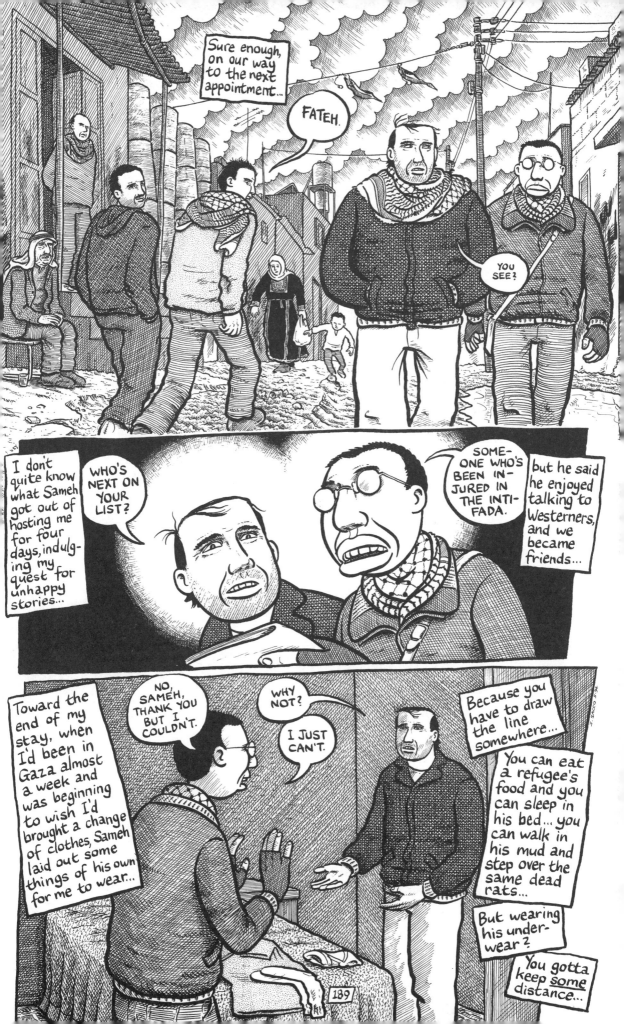

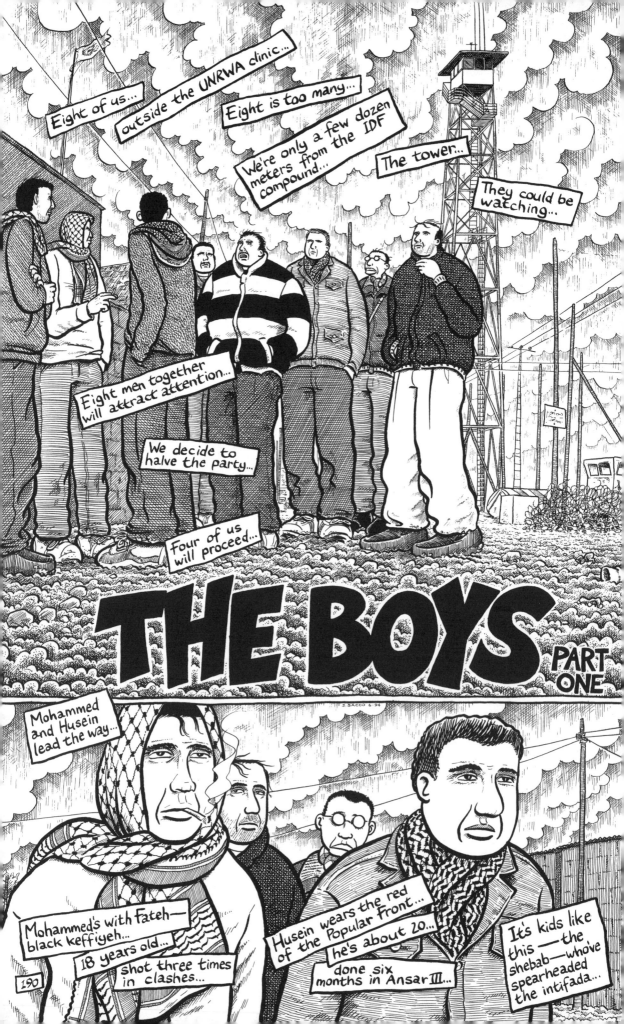

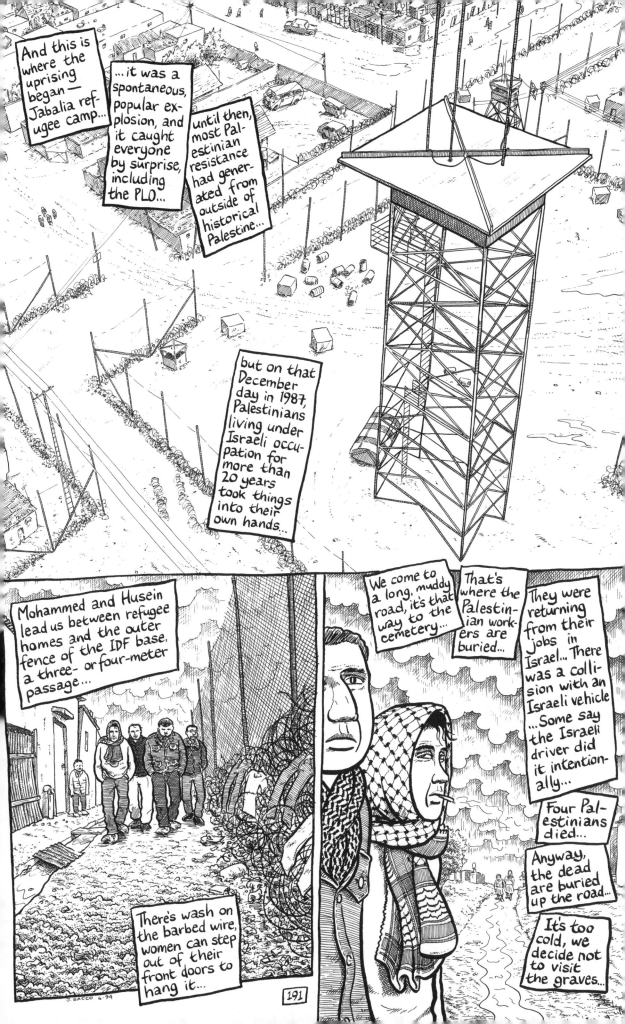

And this is where the uprising began — Jabalia refugee camp...

...it was a spontaneous, popular explosion, and it caught everyone by surprise, including the PLO...

until then, most Palestinian resistance had generated from outside of historical Palestine...

but on that December day in 1987, Palestinians living under Israeli occupation for more than 20 years took things into their own hands...

Mohammed and Husein lead us between refugee homes and the outer fence of the IDF base, a three- or four-meter passage...

We come to a long, muddy road, it's that way to the cemetery...

That's where the Palestinian workers are buried...

They were returning from their jobs in Israel... There was a collision with an Israeli vehicle ...Some say the Israeli driver did it intentionally...

Four Palestinians died...

Anyway, the dead are buried up the road...

It's too cold, we decide not to visit the graves...

There's wash on the barbed wire, women can step out of their front doors to hang it...

191

J. SACCO 6-94

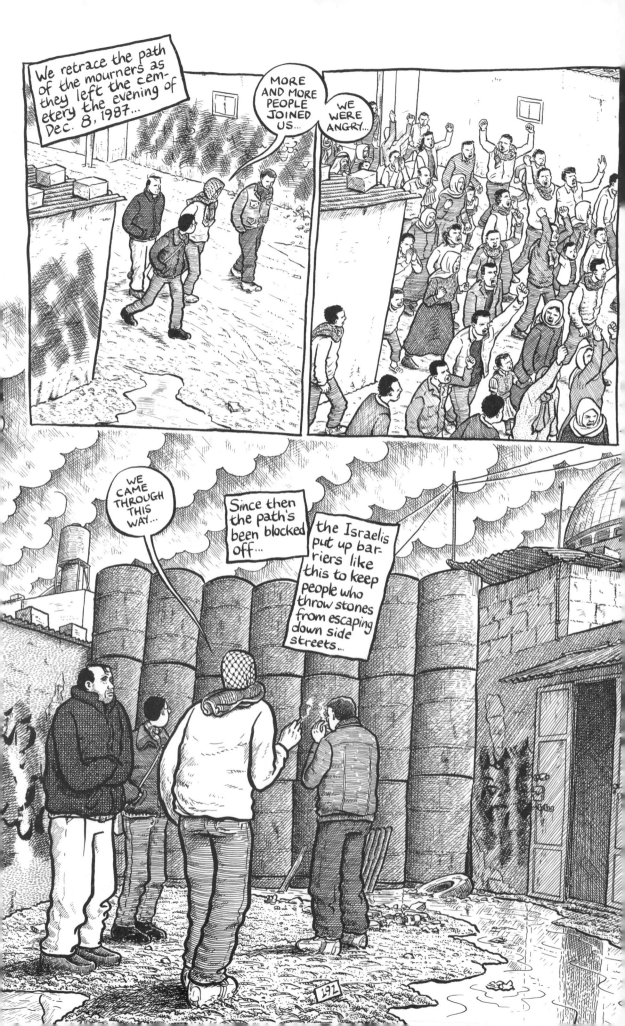

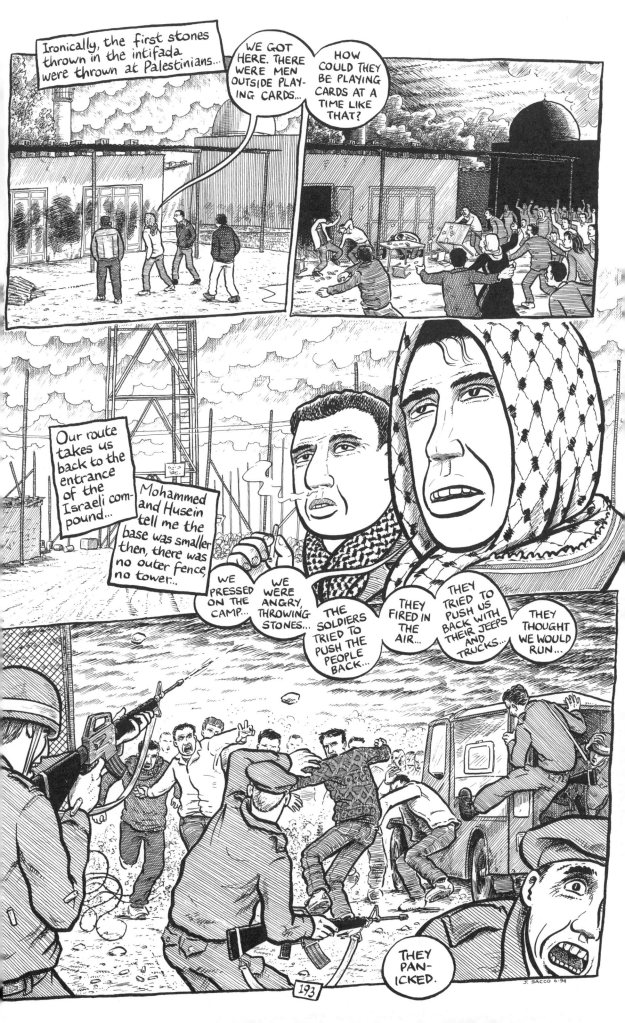

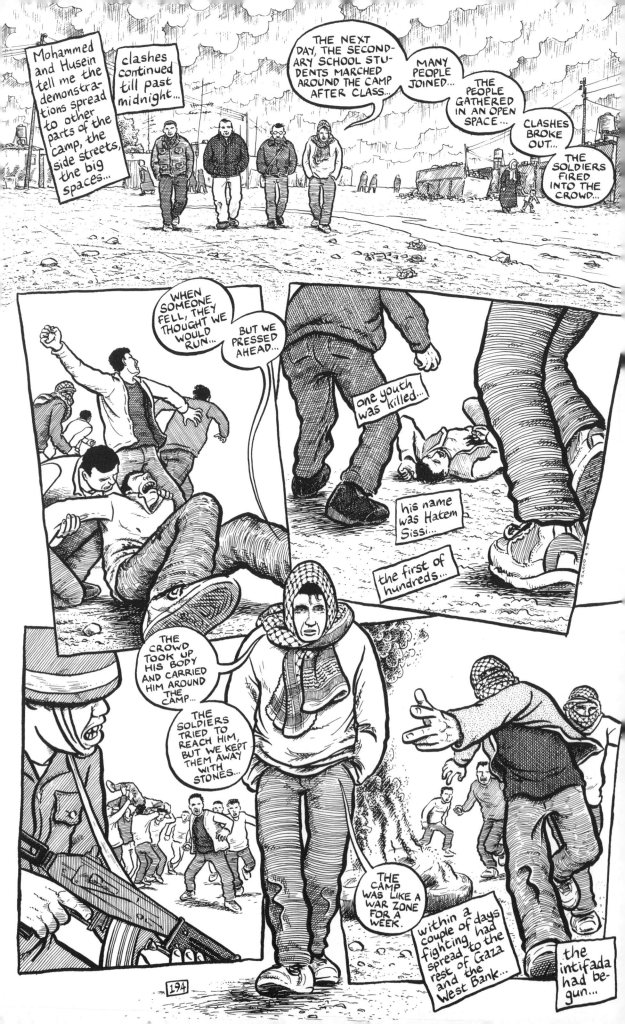

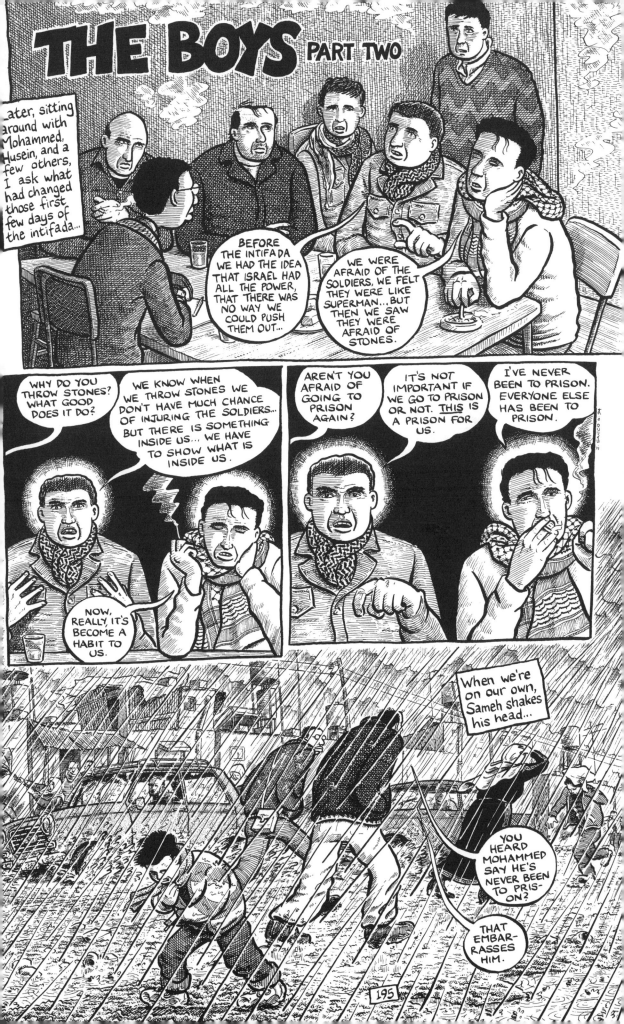

THE BOYS

PART THREE

Firas is 15 years old and works for the Popular Front for the Liberation of Palestine, one of the resistance groups that began influencing the uprising within weeks of the initial unrest...

WHY ARE YOU INVOLVED IN THE INTIFADA?

FOR ME IT IS A WAY OF TAKING BACK MY COUNTRY, TO BE FREE OF THE OCCUPATION, TO LET THE PEOPLE OF THE WORLD KNOW ABOUT US...

I SEE HOW THE SOLDIERS TREAT MY PARENTS. THEY BEAT MY BROTHERS. ONE OF MY BROTHERS IS IN JAIL...

HOW WERE YOU RECRUITED BY THE POPULAR FRONT?

"My neighbor came to me... He asked about my politics, whether I agreed with the policies of Hamas or the other groups. He left me for a couple of days. He was examining me, seeing who my friends are, where I'd go...

"When he decided I might be the right man, he asked whether I wanted to work with the Popular Front. He said I should consider it if I cared about myself and my country, about our problems here and the life we live. I said I'd think about it. He didn't force me. I sat with him and some others six times before deciding. Other groups approached me, but I'd already decided on the Popular Front..."

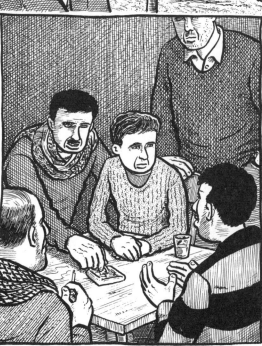

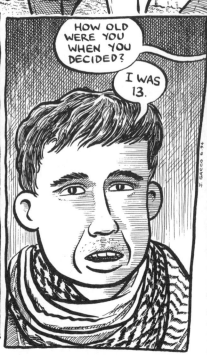

HOW OLD WERE YOU WHEN YOU DECIDED?

I WAS 13.

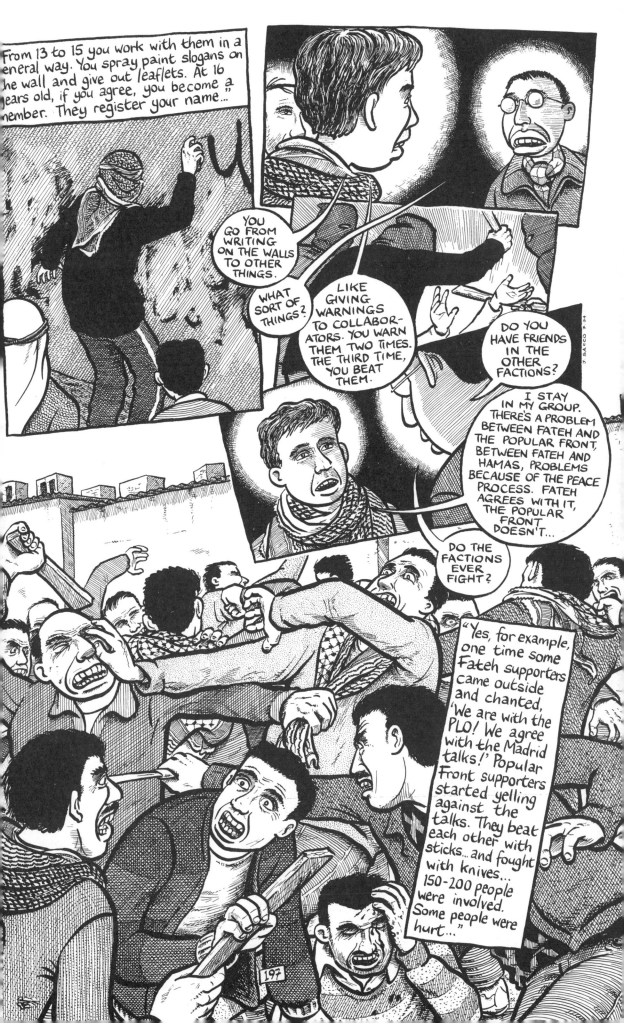

From 13 to 15 you work with them in a general way. You spray paint slogans on the wall and give out leaflets. At 16 years old, if you agree, you become a member. They register your name...

YOU GO FROM WRITING ON THE WALLS TO OTHER THINGS.

WHAT SORT OF THINGS?

LIKE GIVING WARNINGS TO COLLABORATORS. YOU WARN THEM TWO TIMES. THE THIRD TIME, YOU BEAT THEM.

DO YOU HAVE FRIENDS IN THE OTHER FACTIONS?

I STAY IN MY GROUP. THERE'S A PROBLEM BETWEEN FATEH AND THE POPULAR FRONT, BETWEEN FATEH AND HAMAS, PROBLEMS BECAUSE OF THE PEACE PROCESS. FATEH AGREES WITH IT, THE POPULAR FRONT DOESN'T...

DO THE FACTIONS EVER FIGHT?

"Yes, for example, one time some Fateh supporters came outside and chanted, 'We are with the PLO! We agree with the Madrid talks!' Popular Front supporters started yelling against the talks. They beat each other with sticks...and fought with knives... 150-200 people were involved. Some people were hurt..."

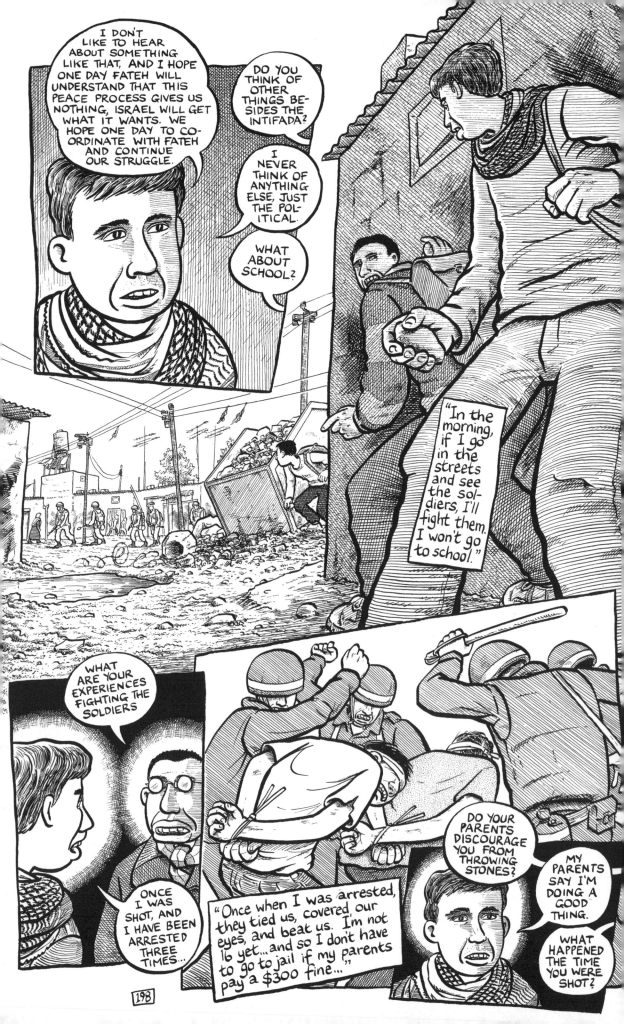

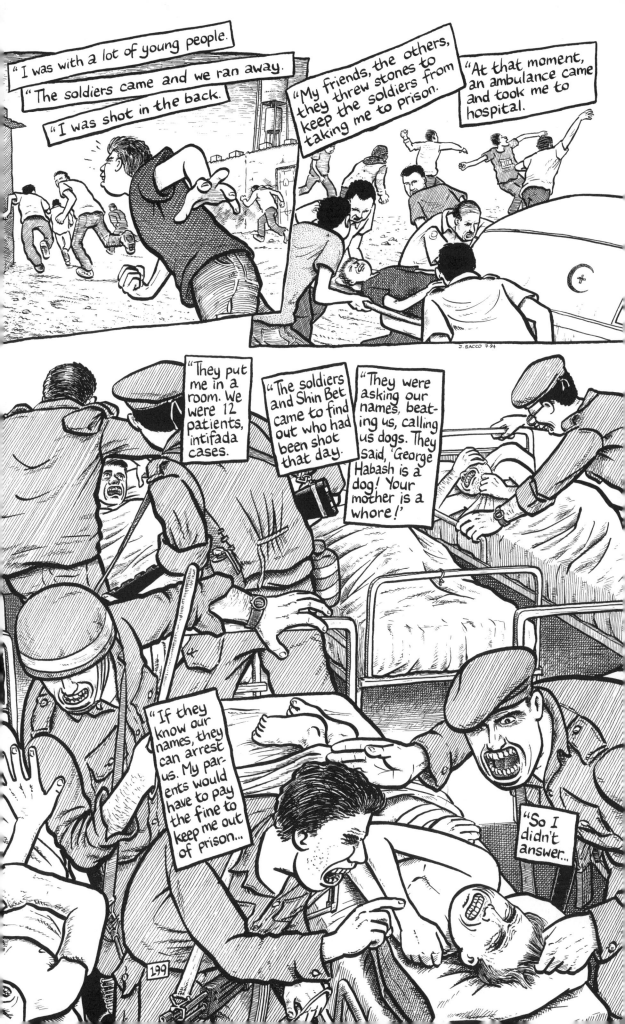

"Five soldiers took me from my bed and threw me to the ground... The fall broke my arm...

When they saw me clutching my arm, they started kicking it... Doctors and nurses tried to stop

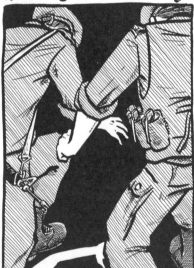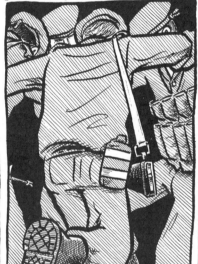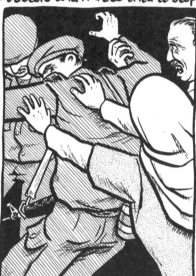

them, but they were pushed away... The soldiers broke the arm of a hospital employee, too...

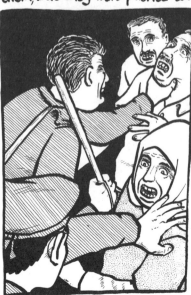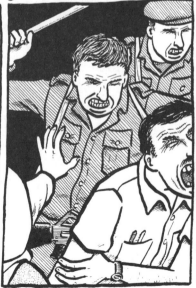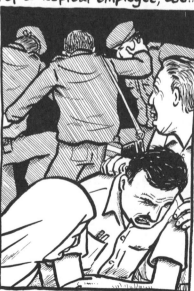

I couldn't count how many times I was beaten... Blood was coming from my mouth

and nose... They broke a tooth..."

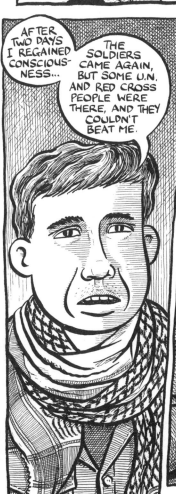

AFTER TWO DAYS I REGAINED CONSCIOUSNESS...

THE SOLDIERS CAME AGAIN, BUT SOME U.N. AND RED CROSS PEOPLE WERE THERE, AND THEY COULDN'T BEAT ME.

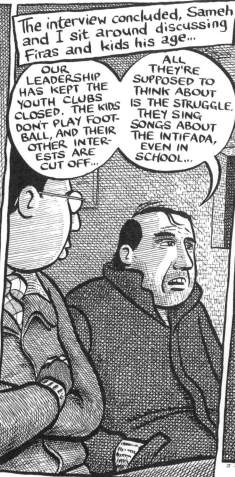

The interview concluded, Sameh and I sit around discussing Firas and kids his age...

OUR LEADERSHIP HAS KEPT THE YOUTH CLUBS CLOSED. THE KIDS DON'T PLAY FOOTBALL, AND THEIR OTHER INTERESTS ARE CUT OFF...

ALL THEY'RE SUPPOSED TO THINK ABOUT IS THE STRUGGLE. THEY SING SONGS ABOUT THE INTIFADA, EVEN IN SCHOOL...

J SACCO 7.94

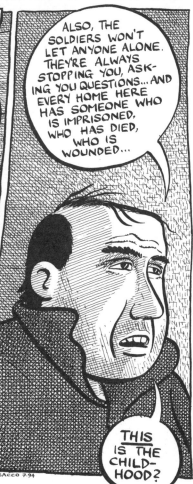

ALSO, THE SOLDIERS WON'T LET ANYONE ALONE. THEY'RE ALWAYS STOPPING YOU, ASKING YOU QUESTIONS... AND EVERY HOME HERE HAS SOMEONE WHO IS IMPRISONED, WHO HAS DIED, WHO IS WOUNDED...

THIS IS THE CHILDHOOD?

THE BOYS
PART FOUR

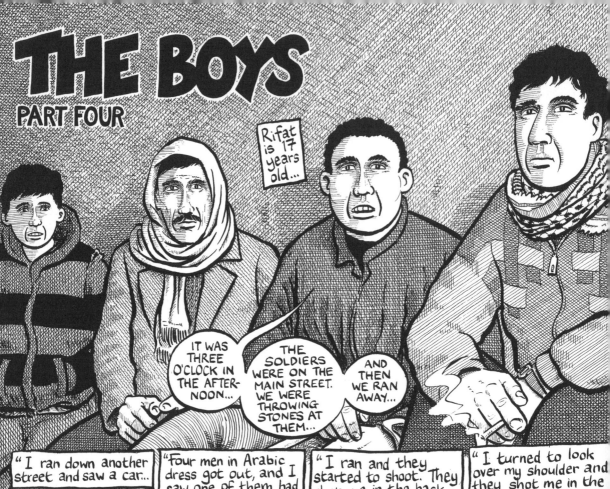

Rifat is 17 years old...

IT WAS THREE O'CLOCK IN THE AFTERNOON...

THE SOLDIERS WERE ON THE MAIN STREET. WE WERE THROWING STONES AT THEM...

AND THEN WE RAN AWAY...

"I ran down another street and saw a car...

"Four men in Arabic dress got out, and I saw one of them had a gun...

"I ran and they started to shoot. They shot me in the back, but I didn't feel it...

"I turned to look over my shoulder and they shot me in the stomach...

J. SACCO 7-94

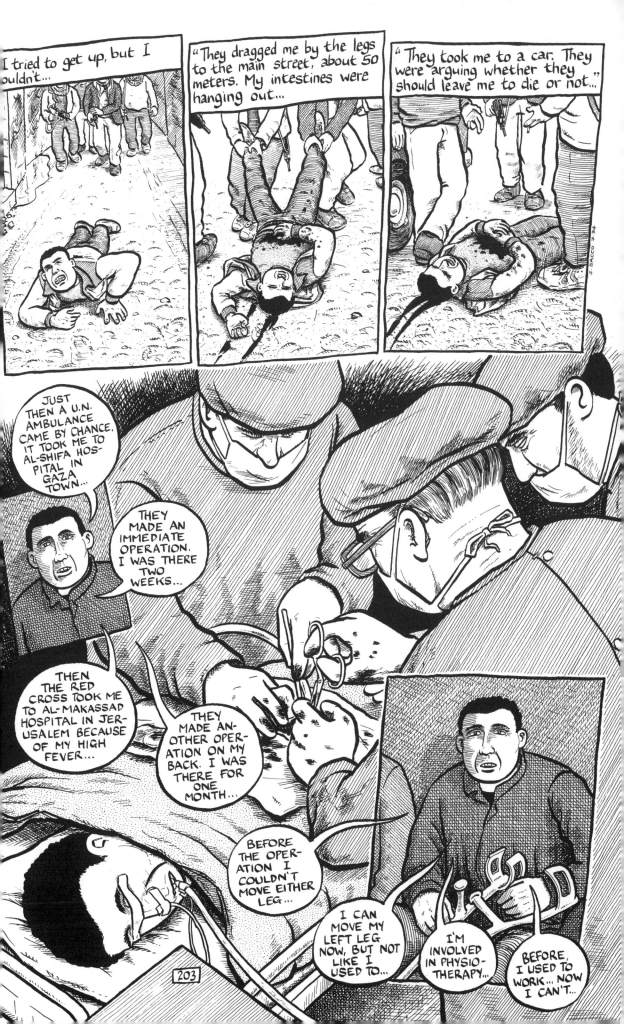

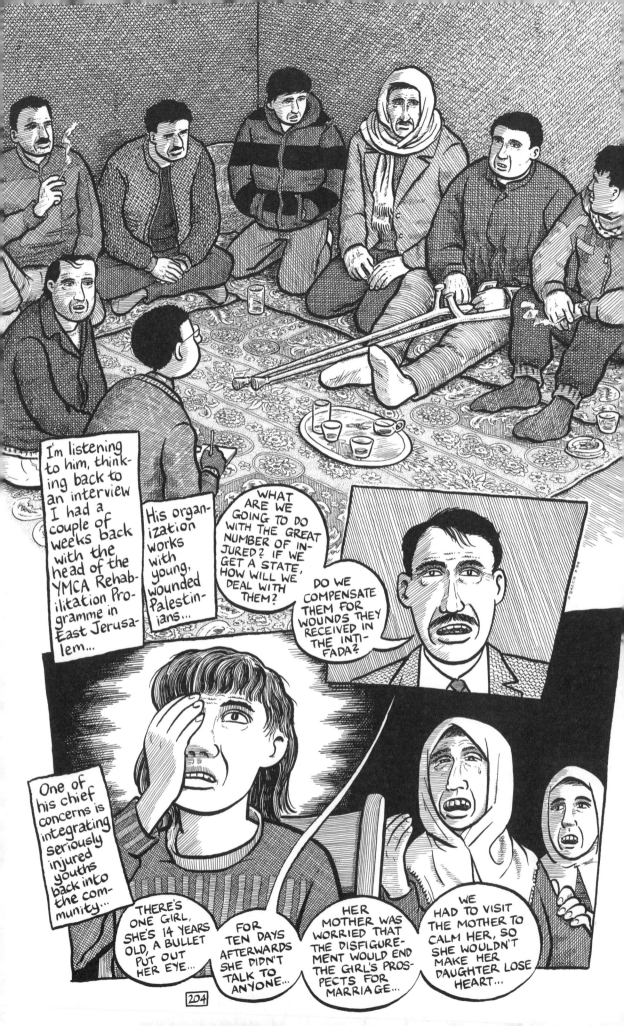

I'm listening to him, thinking back to an interview I had a couple of weeks back with the head of the YMCA Rehabilitation Programme in East Jerusalem...

His organization works with young, wounded Palestinians...

WHAT ARE WE GOING TO DO WITH THE GREAT NUMBER OF INJURED? IF WE GET A STATE, HOW WILL WE DEAL WITH THEM?

DO WE COMPENSATE THEM FOR WOUNDS THEY RECEIVED IN THE INTIFADA?

One of his chief concerns is integrating seriously injured youths back into the community...

THERE'S ONE GIRL, SHE'S 14 YEARS OLD, A BULLET PUT OUT HER EYE...

FOR TEN DAYS AFTERWARDS SHE DIDN'T TALK TO ANYONE...

HER MOTHER WAS WORRIED THAT THE DISFIGUREMENT WOULD END THE GIRL'S PROSPECTS FOR MARRIAGE...

WE HAD TO VISIT THE MOTHER TO CALM HER, SO SHE WOULDN'T MAKE HER DAUGHTER LOSE HEART...

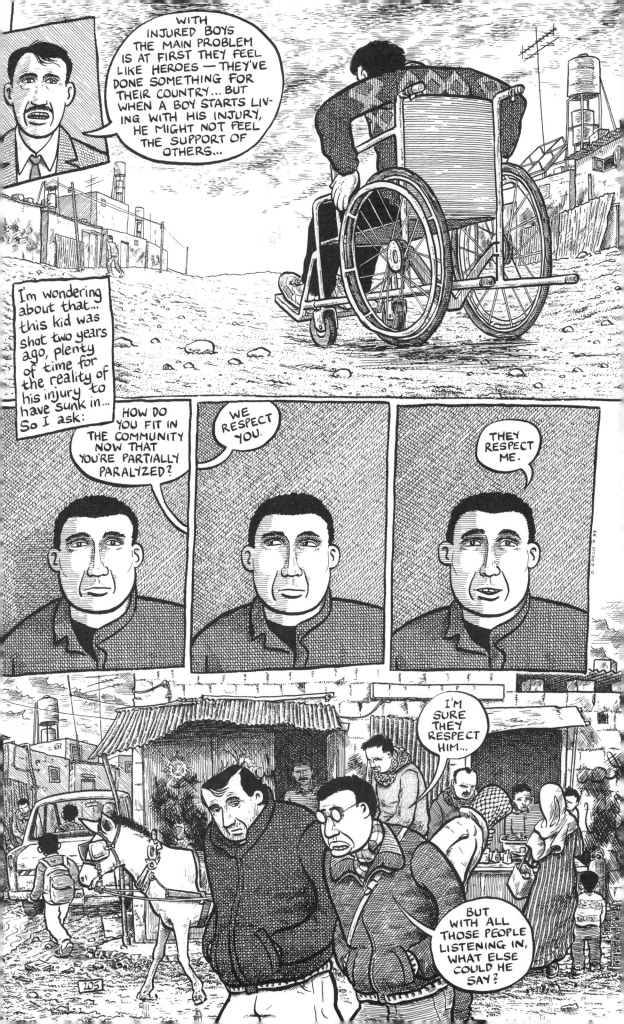

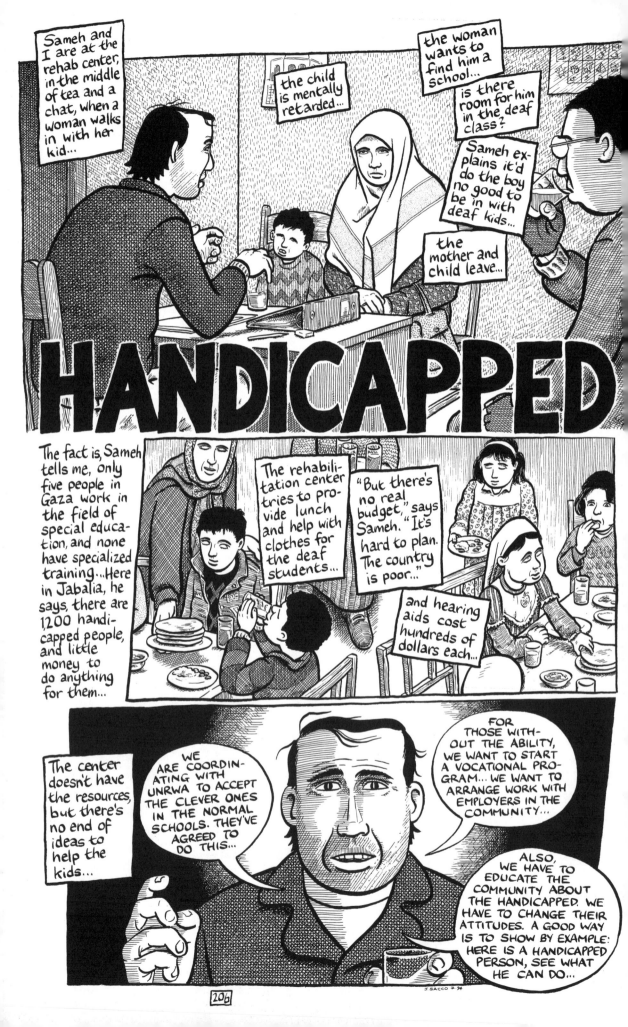

Sameh and I are at the rehab center, in the middle of tea and a chat, when a woman walks in with her kid...

the child is mentally retarded...

the woman wants to find him a school...

is there room for him in the deaf class?

Sameh explains it'd do the boy no good to be in with deaf kids...

the mother and child leave...

HANDICAPPED

The fact is, Sameh tells me, only five people in Gaza work in the field of special education, and none have specialized training...Here in Jabalia, he says, there are 1,200 handicapped people, and little money to do anything for them...

The rehabilitation center tries to provide lunch and help with clothes for the deaf students...

"But there's no real budget," says Sameh. "It's hard to plan. The country is poor..."

and hearing aids cost hundreds of dollars each...

The center doesn't have the resources, but there's no end of ideas to help the kids...

WE ARE COORDINATING WITH UNRWA TO ACCEPT THE CLEVER ONES IN THE NORMAL SCHOOLS. THEY'VE AGREED TO DO THIS...

FOR THOSE WITHOUT THE ABILITY, WE WANT TO START A VOCATIONAL PROGRAM... WE WANT TO ARRANGE WORK WITH EMPLOYERS IN THE COMMUNITY...

ALSO, WE HAVE TO EDUCATE THE COMMUNITY ABOUT THE HANDICAPPED. WE HAVE TO CHANGE THEIR ATTITUDES. A GOOD WAY IS TO SHOW BY EXAMPLE: HERE IS A HANDICAPPED PERSON, SEE WHAT HE CAN DO...

J SACCO 7 94

Sameh talks of developing a professional program here, but I've been told that certain of the center's directors owe their positions <u>not</u> to professional qualifications, but to factional loyalties...Fateh, this source said, got involved only <u>after</u> the center had already established itself and now enjoys the PR windfall of association with a successful program while providing little in promised material support...

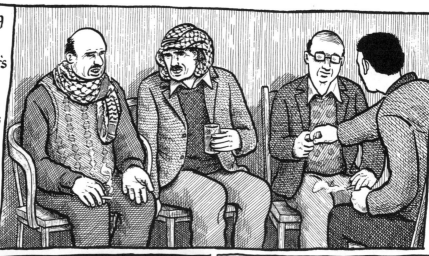

In addition to those problems, Sameh admits that neither he nor the teachers are professionally trained to work with the handicapped... he <u>wants</u> training... in fact, UNRWA had just nominated him to Bethlehem University for a four-month course that seems right up his alley—Developing Skills for Those Working with Persons with Disabilities...

but Bethlehem is in the West Bank and Sameh lives in Gaza, and travelling back and forth requires Israeli permission...

THEY SAID NO? WHY?

BECAUSE IT'S NOT A PROGRAM AFFILIATED WITH UNRWA...

Still, Sameh dreams about furthering his education...

I'D LIKE TO GO FOR A MASTER'S DEGREE ... I WANT TO STUDY IN EUROPE, WHERE THEY HAVE A HUMANE UNDERSTANDING OF THE HANDICAPPED...

I WANT TO GET ANOTHER NATIONALITY SO I CAN TRAVEL ABROAD FREELY AND COME AND WORK IN PALESTINE WITH NO PROBLEM...

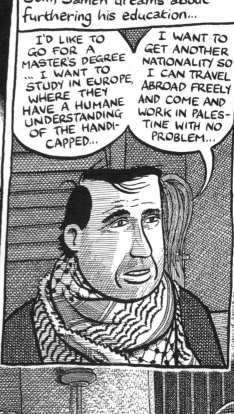

But it's the Israelis who'll decide whether Sameh can travel or not... and, in any case, the center doesn't have the money to send someone abroad for two or three years...

Hell, the center can't even afford a wage for him or its six teachers... they get nothing for full-time work...

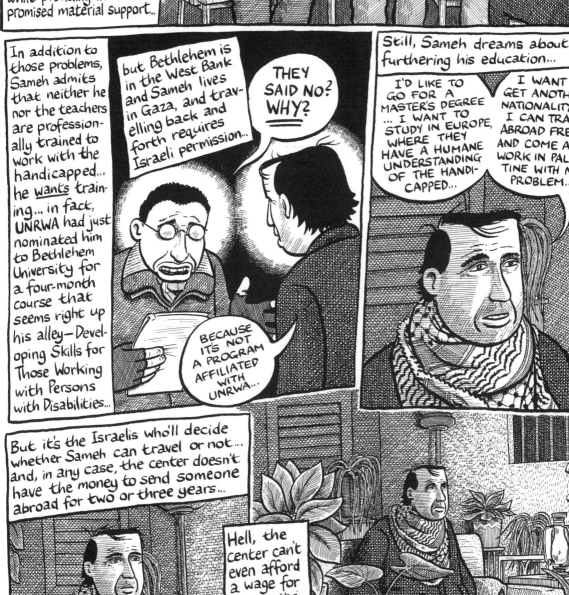

Meanwhile, the $5,000 Sameh saved while teaching in Yemen is about to run out...

then what?

I'm blinking fast, snapping mental pictures and thinking, "This'll make a great couple of pages in the comic" —a weird scene of a pitching car with the rain going torrential while Sameh strains to see over his shoulder into the dark and fumbles with the gears to back us out of another washed-out path... and that's me next to him and this is my happiest moment... I've made it, you understand, I've come hundreds of miles via planes and buses and taxis to be precisely here: Jabalia, the must-see refugee camp of the Gaza Strip, the intifada's ground zero, a Disneyland of refuse and squalor... and here I am, brushing up against the Palestinian experience, a goddamn adventure cartoonist who hasn't changed his clothes in days, who's stepped over a few dead rats and shivered from the cold, who's bullshitted with the boys and nodded knowingly at their horrible narratives... and I'm pinching myself in a car in the dark in a flood, giddy from the ferocity outside, thinking, "Throw it at me, baby, I can take it," but I've got the window rolled up tight...

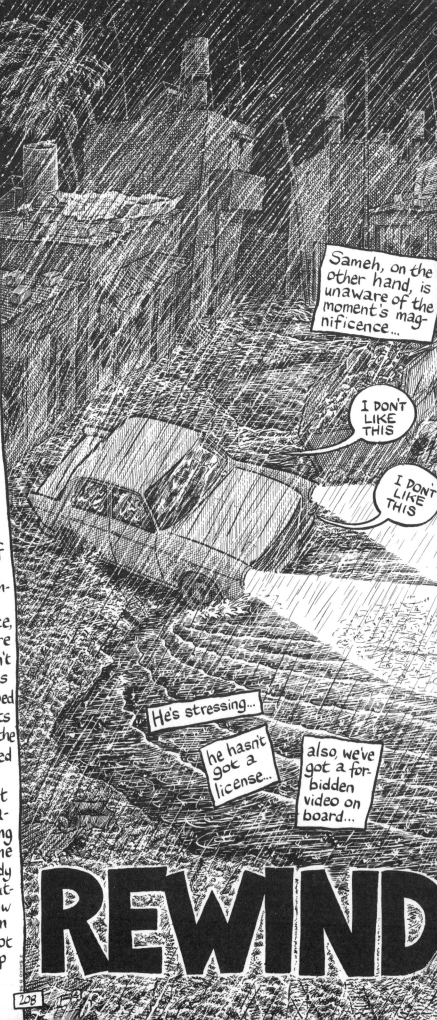

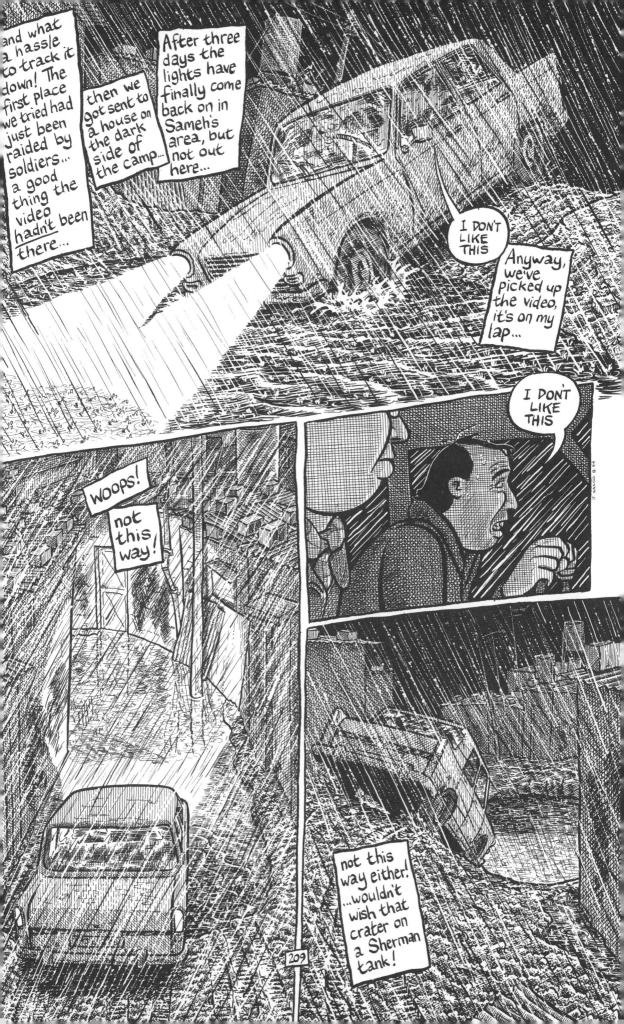

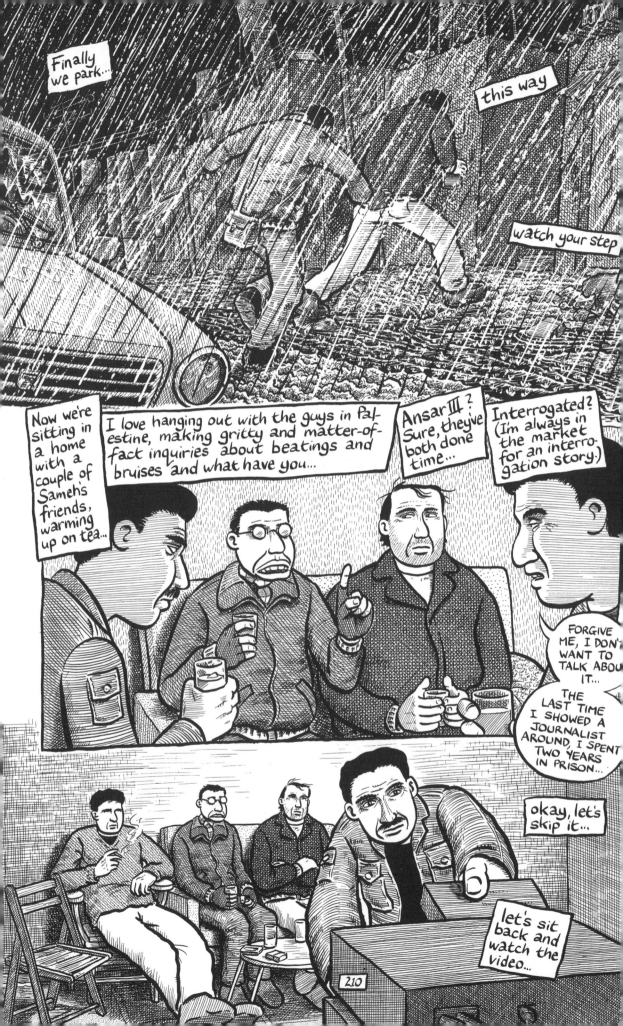

Amateur footage... battles with soldiers... wounded youths, blood, gore...

IN THE FIRST WEEKS OF THE INTIFADA, I ALMOST QUIT BECAUSE OF THAT KIND OF THING...

[He's a nurse.]

Next, the infamous CBS spot of soldiers beating a couple of kids they'd just arrested, methodically breaking their arms. I've read about this, but never seen it... it goes on a little too long...

After some rah-rah Palestine stuff — film of PLO guerrillas training and some MTV-style anthems — we get to a home video... a burial of a youth... he's just been shot dead in a clash ... the mourners are quick... tense... they're on the lookout ... Some Palestinians are convinced the Israelis use the bodies of the fallen shebab as a source of human organs... it's jerky footage... hand-held... they're tense, have I said that? watching out for soldiers, afraid soldiers will come...

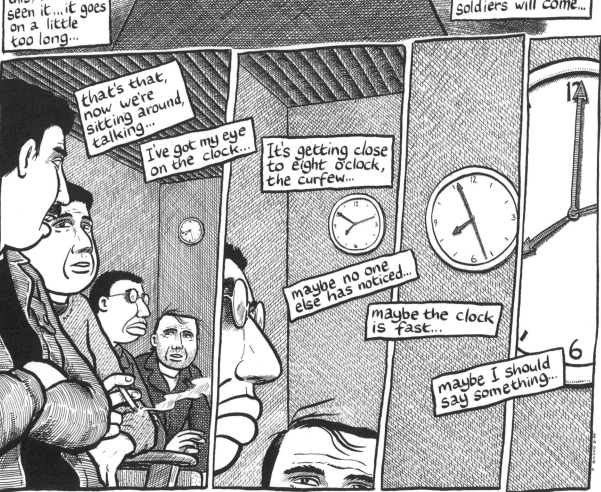

that's that, now we're sitting around, talking...

I've got my eye on the clock...

It's getting close to eight o'clock, the curfew...

maybe no one else has noticed...

maybe the clock is fast...

maybe I should say something...

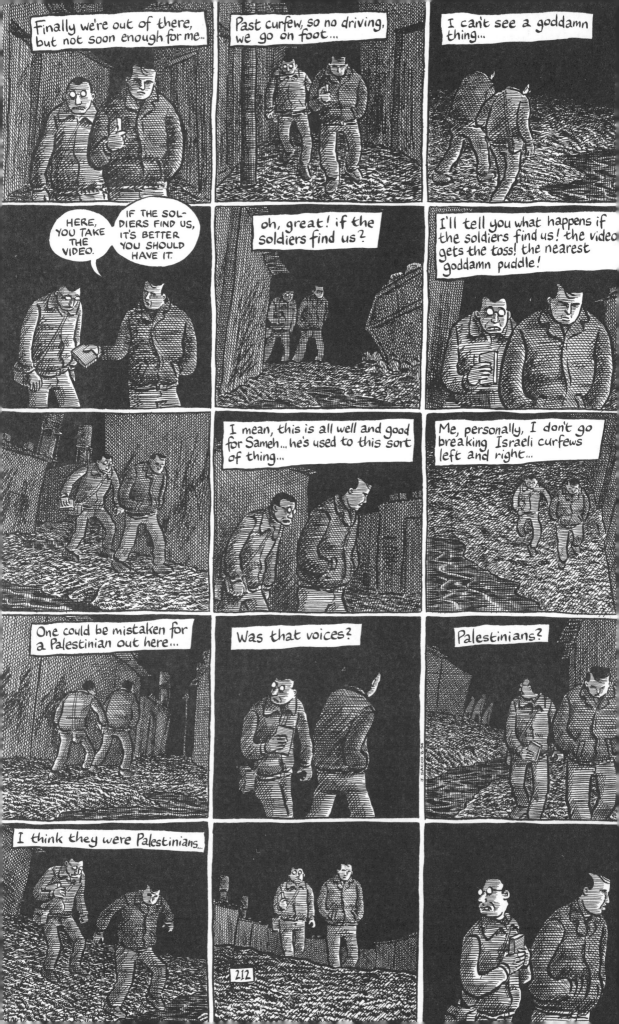

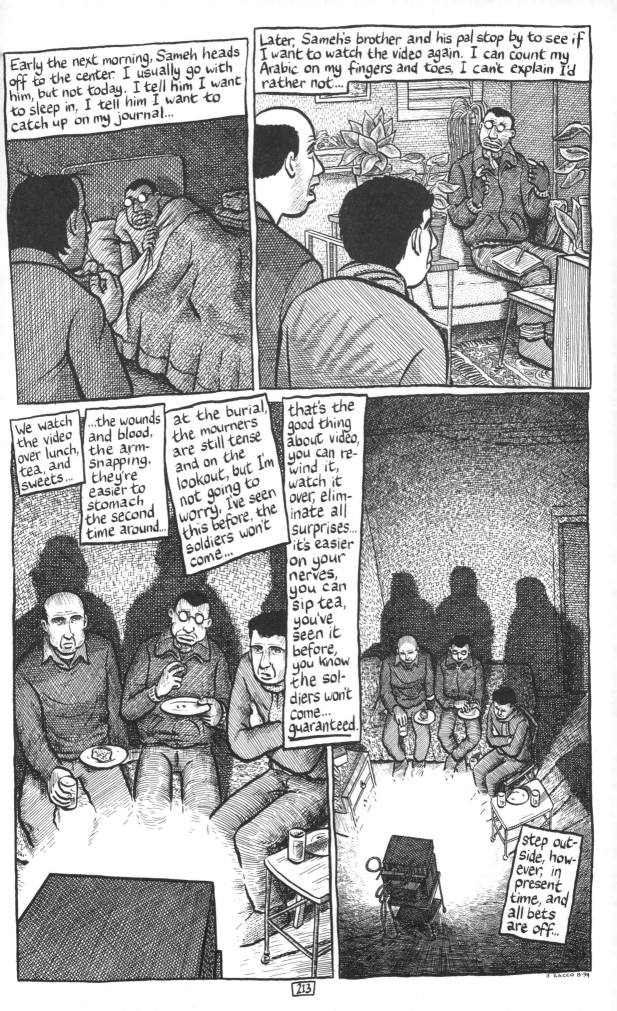

Early the next morning, Sameh heads off to the center. I usually go with him, but not today. I tell him I want to sleep in, I tell him I want to catch up on my journal...

Later, Sameh's brother and his pal stop by to see if I want to watch the video again. I can count my Arabic on my fingers and toes, I can't explain I'd rather not...

We watch the video over lunch, tea, and sweets...

...the wounds and blood, the arm-snapping, they're easier to stomach the second time around...

at the burial, the mourners are still tense and on the lookout, but I'm not going to worry, I've seen this before, the soldiers won't come...

that's the good thing about video, you can re-wind it, watch it over, eliminate all surprises... it's easier on your nerves, you can sip tea, you've seen it before, you know the soldiers won't come... guaranteed.

step outside, however, in present time, and all bets are off...

J. SACCO 8·94

Chapter Eight

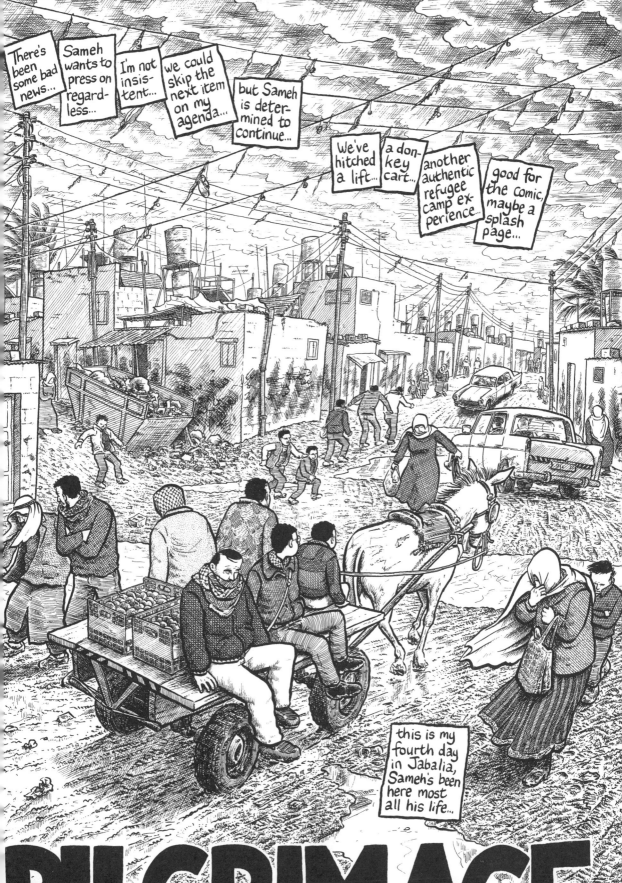

PILGRIMAGE

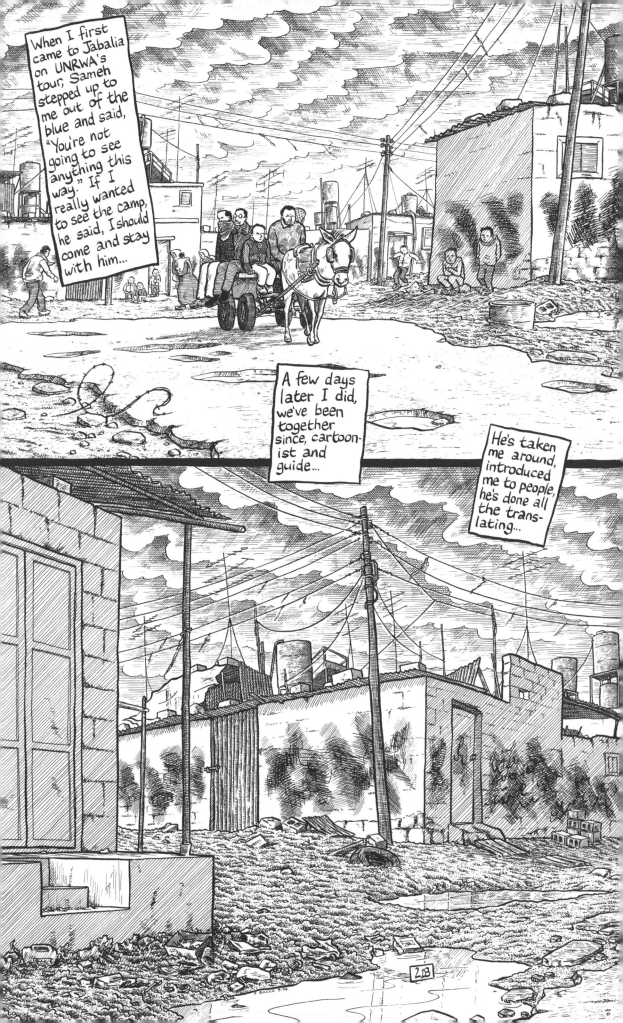

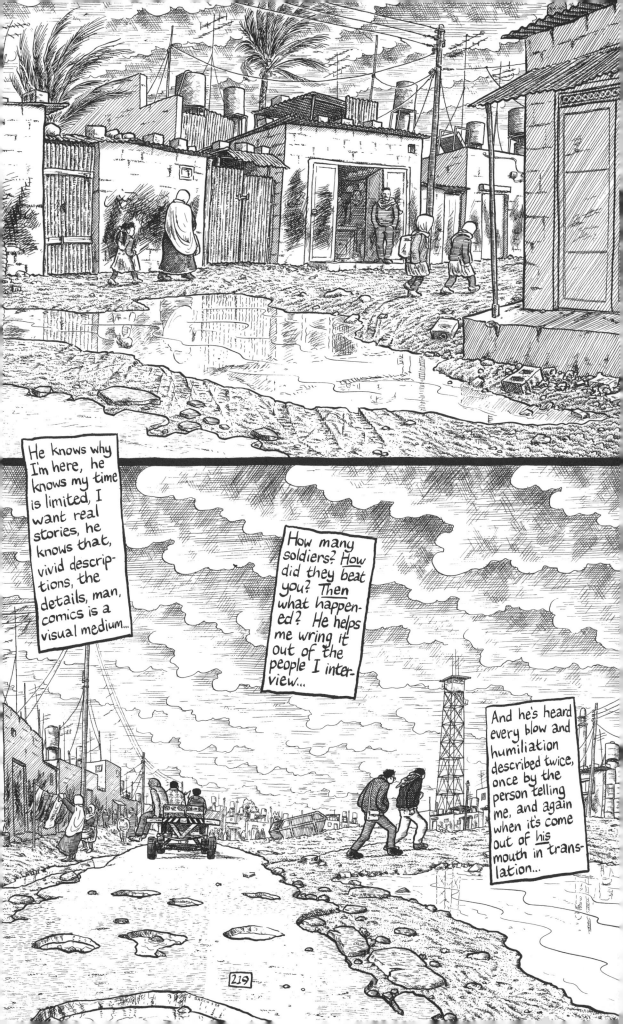

He knows why I'm here, he knows my time is limited, I want real stories, he knows that, vivid descriptions, the details, man, comics is a visual medium...

How many soldiers? How did they beat you? Then what happened? He helps me wring it out of the people I interview...

And he's heard every blow and humiliation described twice, once by the person telling me, and again when it's come out of his mouth in translation...

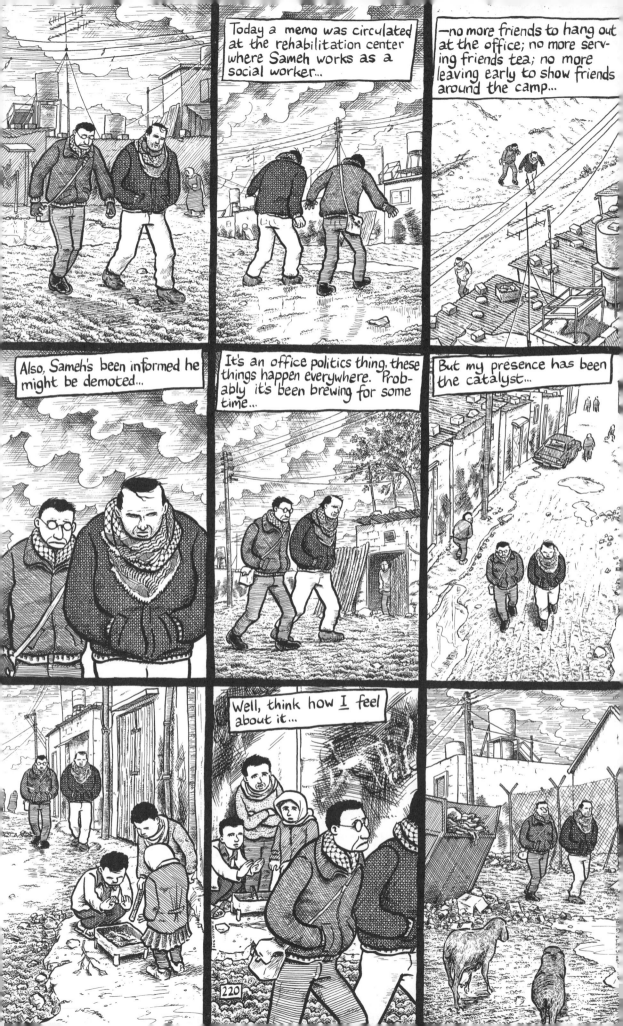

Today a memo was circulated at the rehabilitation center where Sameh works as a social worker...

—no more friends to hang out at the office; no more serving friends tea; no more leaving early to show friends around the camp...

Also, Sameh's been informed he might be demoted...

It's an office politics thing, these things happen everywhere. Probably it's been brewing for some time...

But my presence has been the catalyst...

Well, think how I feel about it...

220

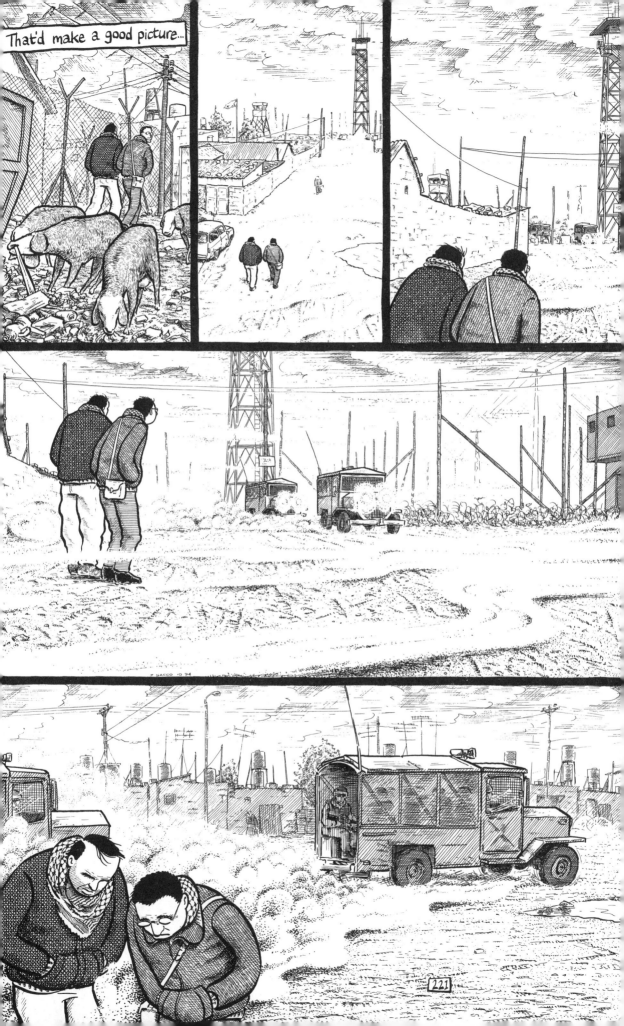

That'd make a good picture...

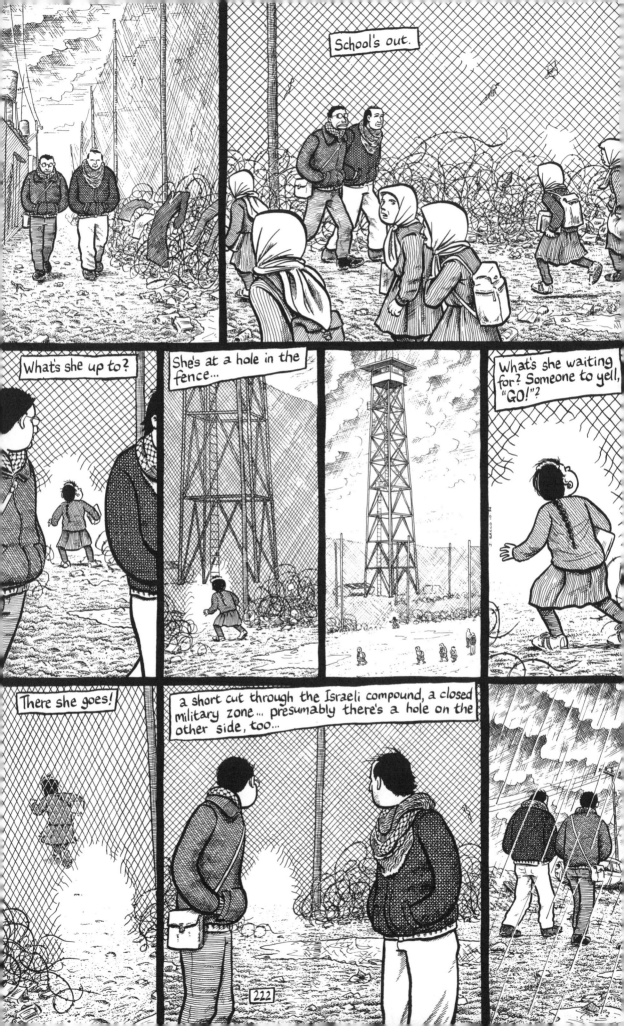

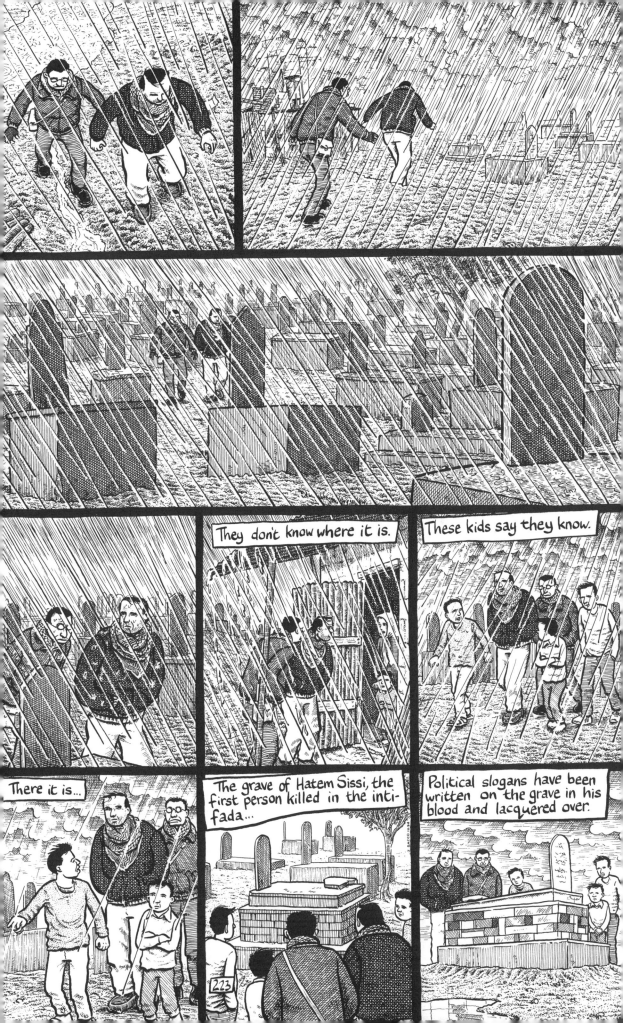

They don't know where it is.

These kids say they know.

There it is...

The grave of Hatem Sissi, the first person killed in the intifada...

223

Political slogans have been written on the grave in his blood and lacquered over.

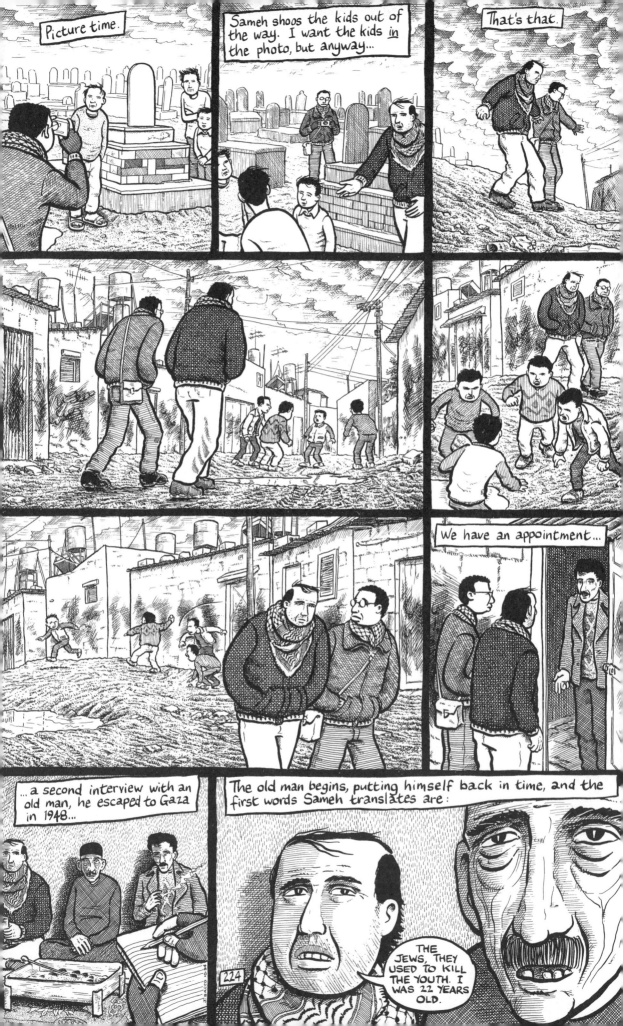

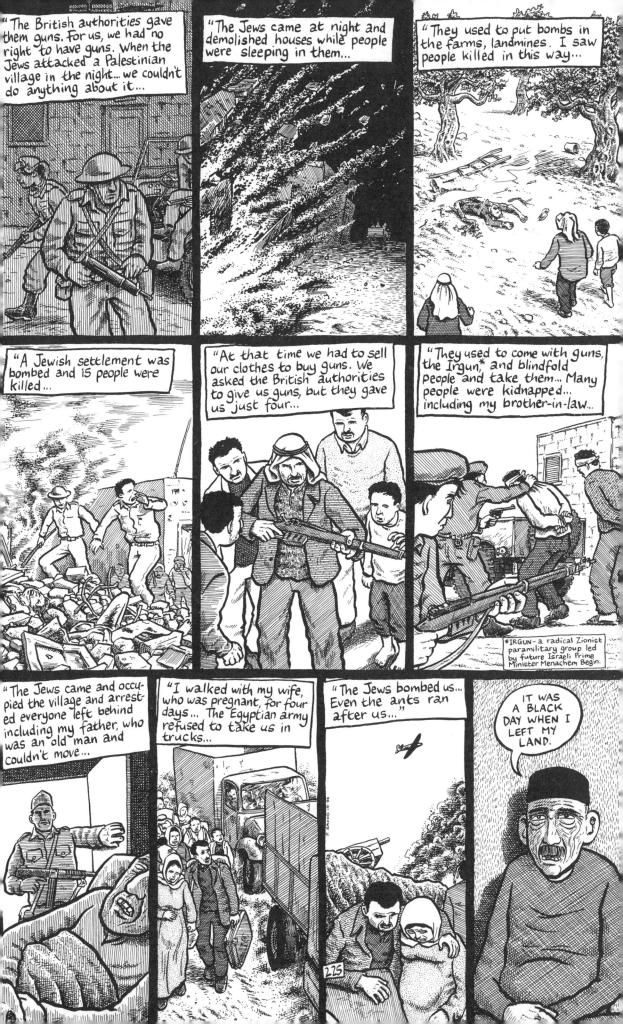

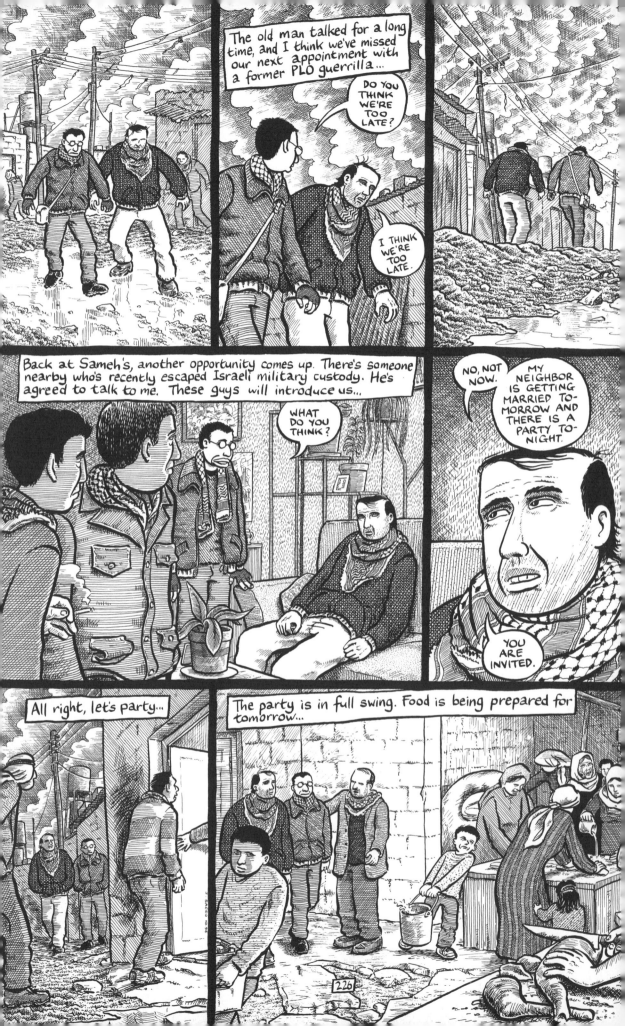

The old man talked for a long time, and I think we've missed our next appointment with a former PLO guerrilla...

DO YOU THINK WE'RE TOO LATE?

I THINK WE'RE TOO LATE.

Back at Sameh's, another opportunity comes up. There's someone nearby who's recently escaped Israeli military custody. He's agreed to talk to me. These guys will introduce us...

WHAT DO YOU THINK?

NO, NOT NOW. MY NEIGHBOR IS GETTING MARRIED TOMORROW AND THERE IS A PARTY TONIGHT.

YOU ARE INVITED.

All right, let's party...

The party is in full swing. Food is being prepared for tomorrow...

226

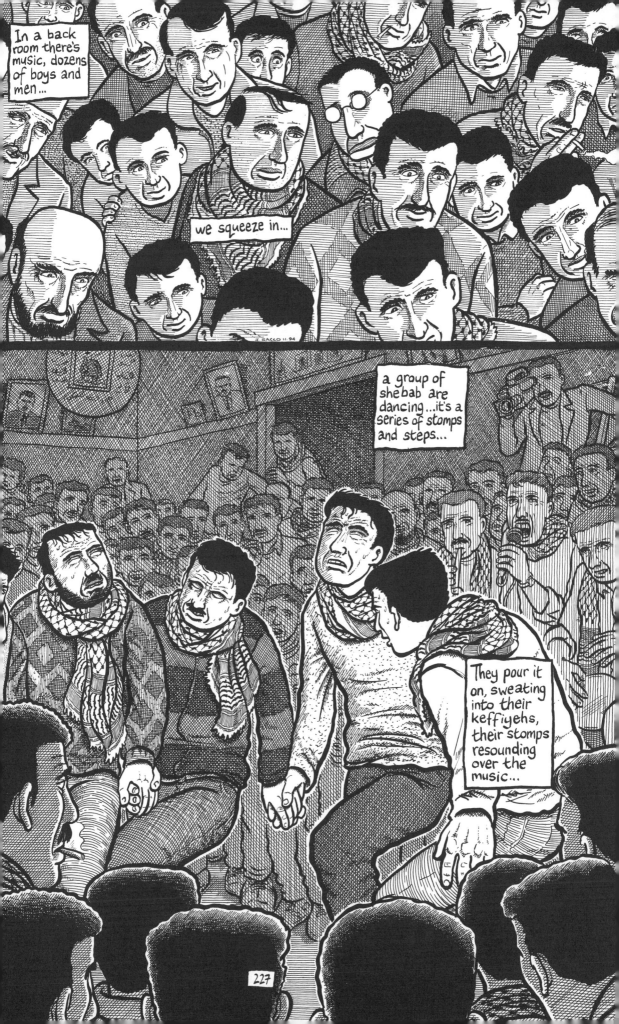

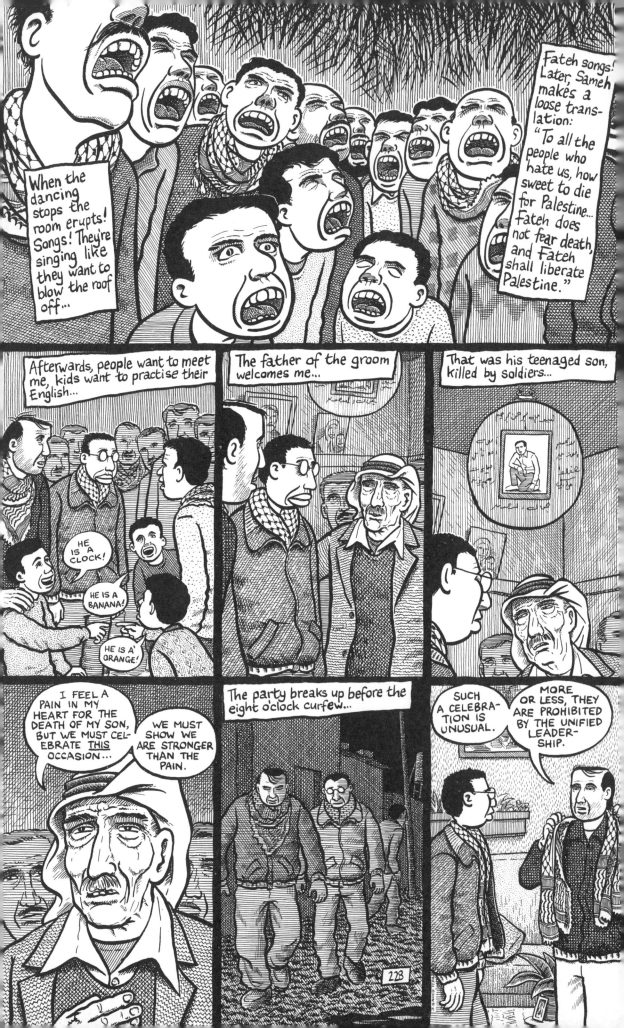

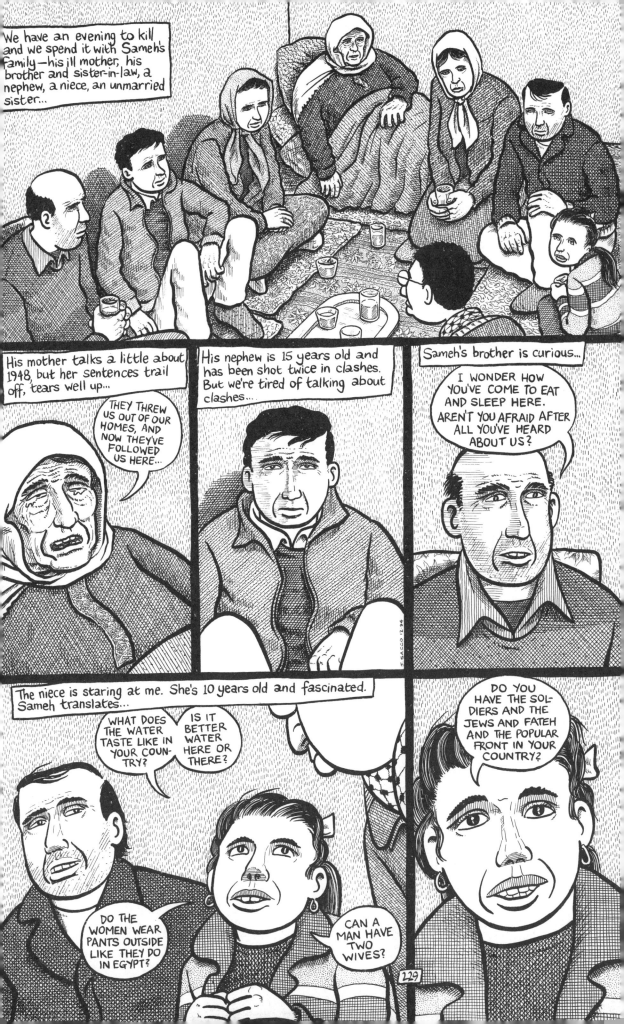

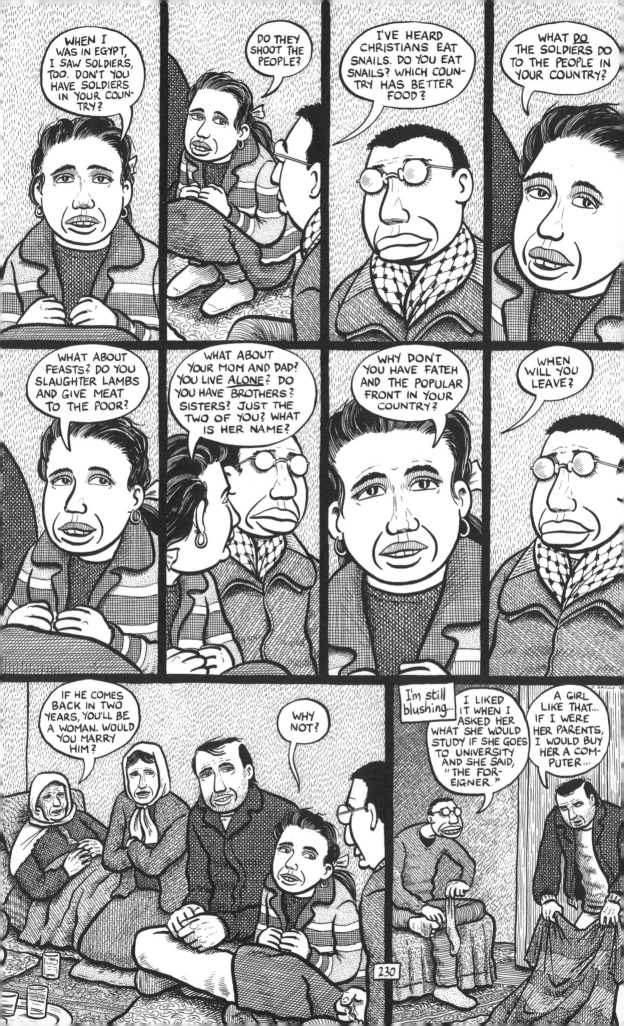

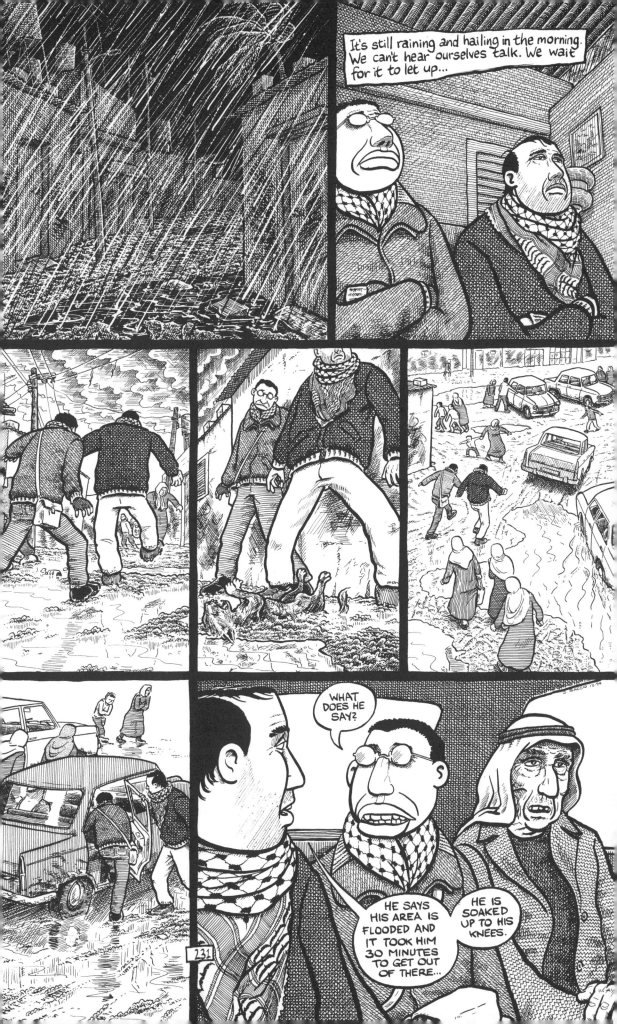

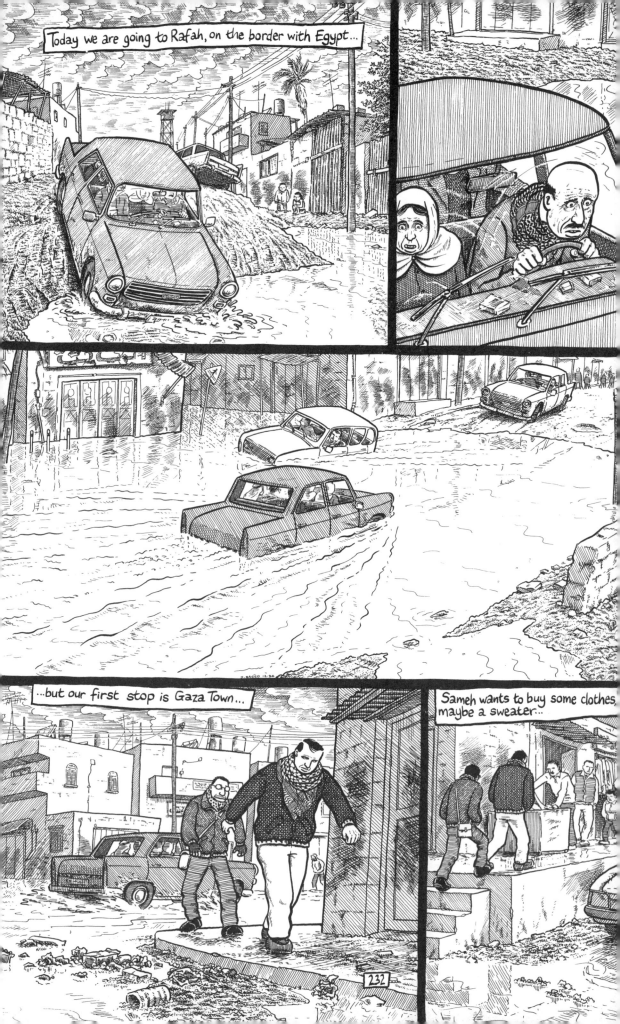

Today we are going to Rafah, on the border with Egypt...

...but our first stop is Gaza Town...

Sameh wants to buy some clothes, maybe a sweater...

232

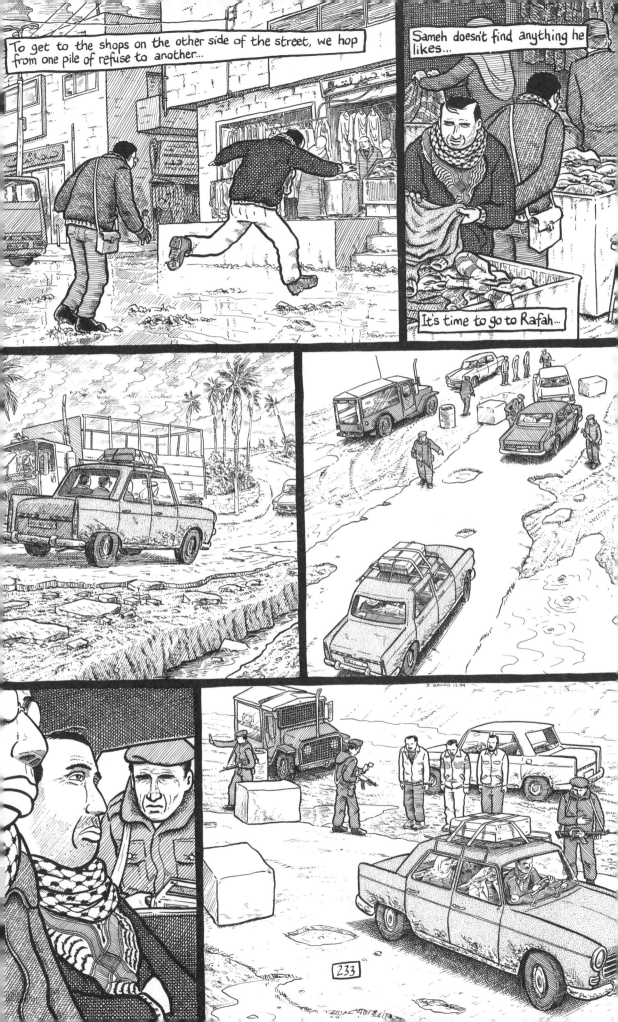

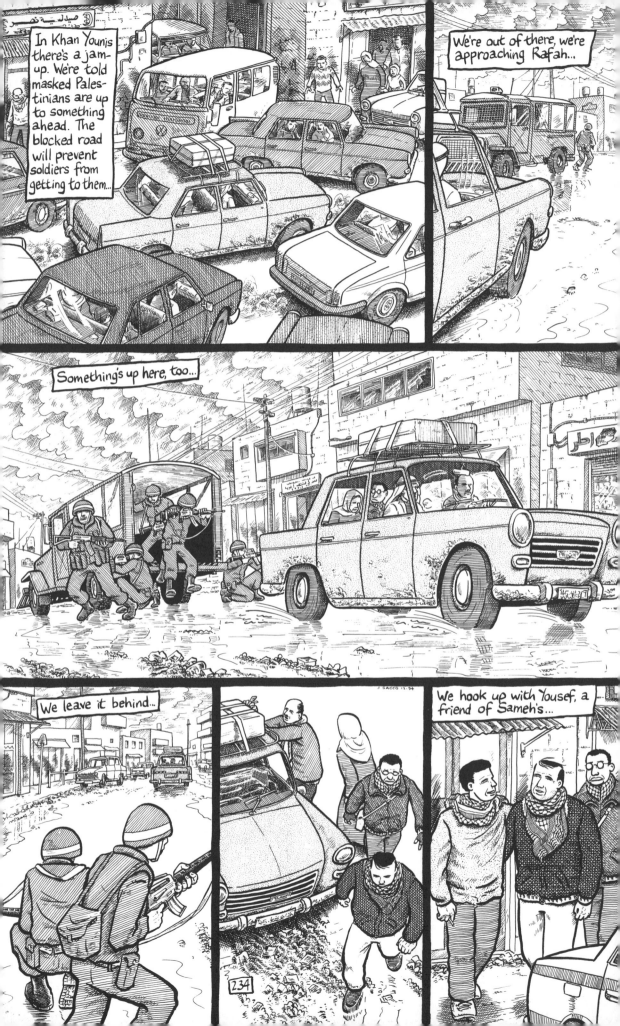

A short car ride later and we're sitting in a home in a refugee camp with a woman and her youngest son... Tea is served, I get my pen out, and we get right to business... Sameh is translating...

WE WERE SITTING HERE WHEN THE SOLDIERS ATTACKED OUR AREA...

"They were throwing gas... so the children and old people became sick...

"A gas bomb landed in our courtyard...

"The women went out, shouting for help. All the people were running out, gathering... throwing stones at the soldiers...

"The youth put up a barricade, including a fridge. They didn't want the jeeps to enter...

"I told my neighbors, 'Why are you staying in your house? The soldiers might be coming to take our sons... We have to stop them...'

"My son Basel wanted to help the people affected by the tear gas. He went to see if the soldiers were still outside...

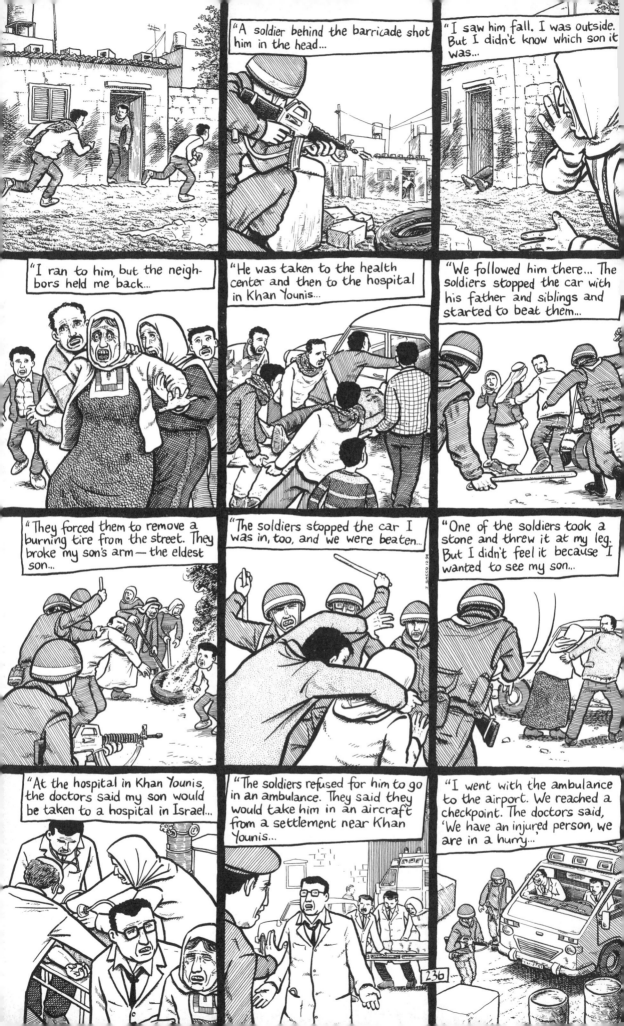

"A soldier behind the barricade shot him in the head...

"I saw him fall. I was outside. But I didn't know which son it was...

"I ran to him, but the neighbors held me back...

"He was taken to the health center and then to the hospital in Khan Younis...

"We followed him there... The soldiers stopped the car with his father and siblings and started to beat them...

"They forced them to remove a burning tire from the street. They broke my son's arm — the eldest son...

"The soldiers stopped the car I was in, too, and we were beaten...

"One of the soldiers took a stone and threw it at my leg. But I didn't feel it because I wanted to see my son...

"At the hospital in Khan Younis, the doctors said my son would be taken to a hospital in Israel...

"The soldiers refused for him to go in an ambulance. They said they would take him in an aircraft from a settlement near Khan Younis...

"I went with the ambulance to the airport. We reached a checkpoint. The doctors said, 'We have an injured person, we are in a hurry...'

236

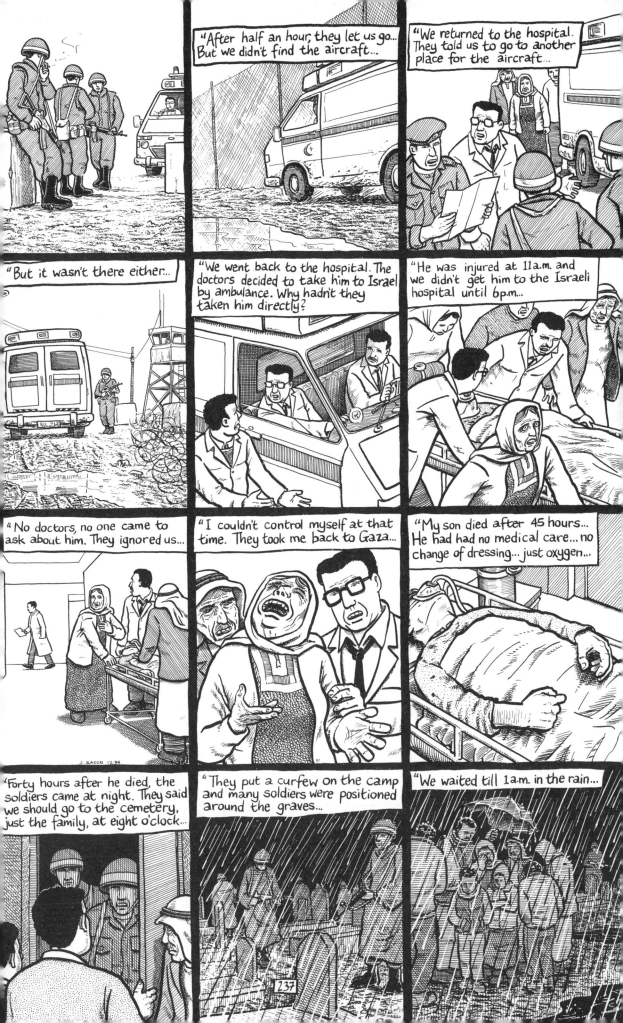

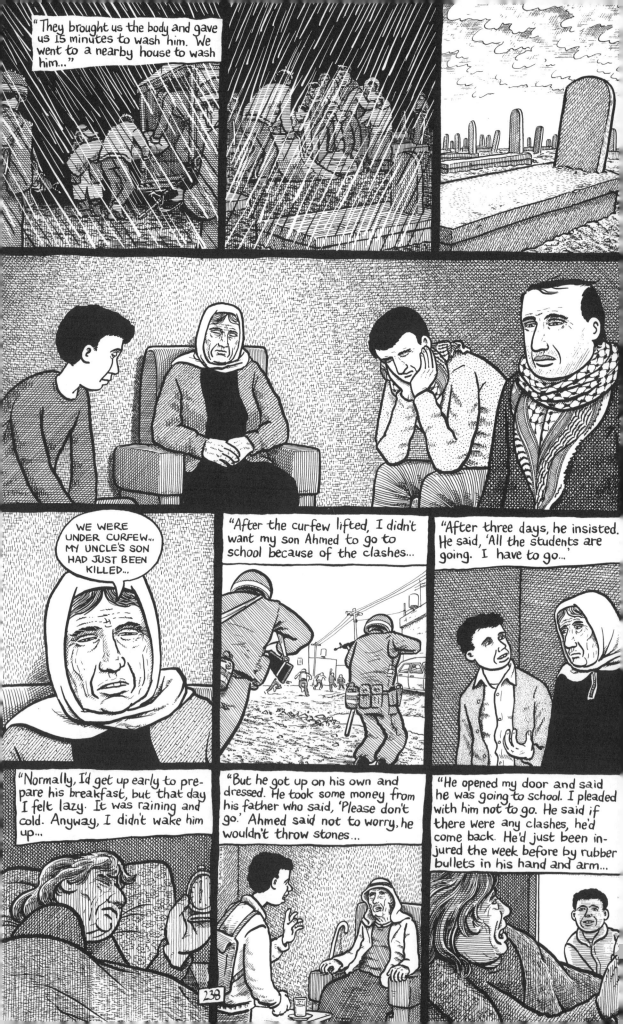

"They brought us the body and gave us 15 minutes to wash him. We went to a nearby house to wash him..."

WE WERE UNDER CURFEW... MY UNCLE'S SON HAD JUST BEEN KILLED...

"After the curfew lifted, I didn't want my son Ahmed to go to school because of the clashes...

"After three days, he insisted. He said, 'All the students are going. I have to go...'

"Normally, I'd get up early to prepare his breakfast, but that day I felt lazy. It was raining and cold. Anyway, I didn't wake him up...

"But he got up on his own and dressed. He took some money from his father who said, 'Please don't go.' Ahmed said not to worry, he wouldn't throw stones...

"He opened my door and said he was going to school. I pleaded with him not to go. He said if there were any clashes, he'd come back. He'd just been injured the week before by rubber bullets in his hand and arm...

236

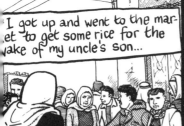
I got up and went to the market to get some rice for the wake of my uncle's son...

"...People there looked at me strangely. They knew Ahmed had just been shot, but they didn't want to tell me...

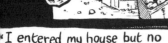
"I entered my house but no one was there...

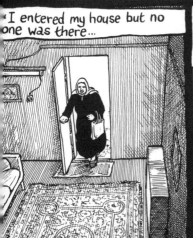

"A neighbor told me four students had been injured in a clash at the school... Two of my sons went to that school...

"I went to my daughter-in-law. She didn't want to tell me anything, and then she started crying. She said, 'Ahmed is injured.'

"We went to the hospital in Khan Younis, but we didn't find him there...

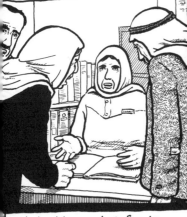

"They told us the soldiers had taken him to an army hospital in Israel. I couldn't control myself. I thought the same thing would happen that happened to my son Basel...

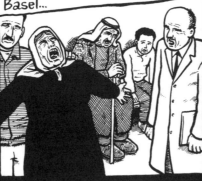

"We left to see him. It took us till 6 p.m....

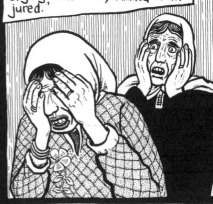

"He had been shot five times... in the forehead, the neck, the arm, the heart, and the cheek. He was still alive...

"We wanted to take him to Al-Makassad hospital in Jerusalem... but they refused...

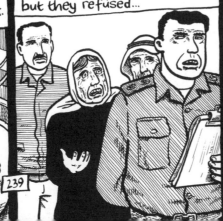
239

"I asked again the next day. I went to the director to kiss his feet and hands to let me take my son...

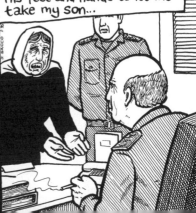

"He told me I had to bring Arab doctors and an ambulance to take him...

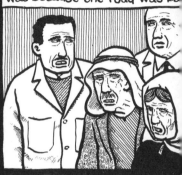

"My son, Ahmed's brother, went back to Gaza to get the ambulance and doctors, and they returned when it was dark...

"When the Arab doctors saw him, they advised us not to take him. They knew he would dead soon, but they told us i was because the road was ba

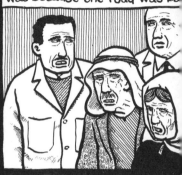

"That night...we left for Gaza. We left two people at the hospital... They slept there...

"At 1 a.m. the soldiers woke them to tell them Ahmed had died. They said they would bring them the body...

"But they took them and left them on a road in Israel in the middle of the night...

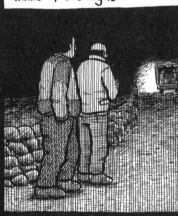

"They walked 10 kilometers before they reached a petrol station... and they had to wait till 4 a.m. to cross into Gaza because of the night curfew...

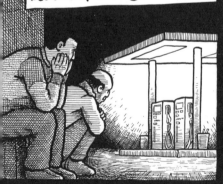

"In Rafah we hadn't received a phone call. The soldiers put a curfew on the town... so how was I going to go to the hospital to see my son?

"The two who had been with Ahmed reached the camp. They told my son, Ahmed's brother...

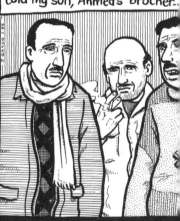

"My son didn't want to tell me directly. He said, 'If he's dead, he's better off than us.' 'No!' I said, and I knew Ahmed was dead...

"My son and husband went to the military to get Ahmed's body. The soldiers said they would bring him at eight o'clock...

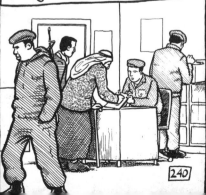

"We wanted to bury him next t his brother, but the soldiers refused... until we phoned a human rights organization i Jerusalem. They intervened o our behalf...

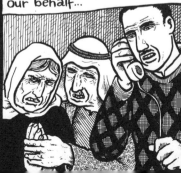

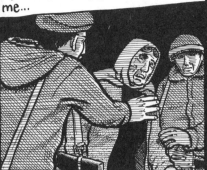

"The burial was like the one before. The soldiers didn't bring the body till 1 a.m. Only the family was allowed...

"They gave us five minutes to wash him. I forgot some of the material to cover his body. I went to get it, but the soldiers wouldn't let me...

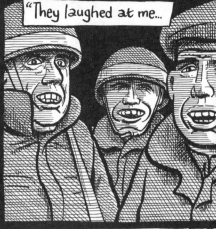

"They laughed at me...

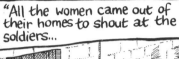

"At the wake... the soldiers attacked our home. They beat ladies. They injured my eldest son in the head. They wanted to take him...

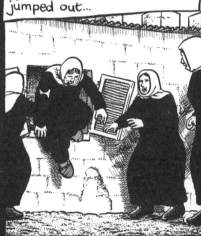

"All the women came out of their homes to shout at the soldiers...

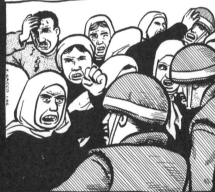

"They pushed us into a room and closed the door...

"But I broke a window and jumped out...

"They couldn't take my son because there were so many people, but they took his identity card...."

SEVEN MONTHS AFTER AHMED DIED, MY HUSBAND DIED...

HE HAD A HEART PROBLEM...

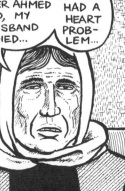

THEY DIDN'T GIVE HIM PERMISSION TO GO TO EGYPT TO BE TREATED UNTIL THE END...

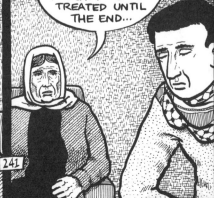

HE DIED ON THE ROAD...

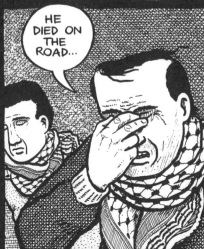

241

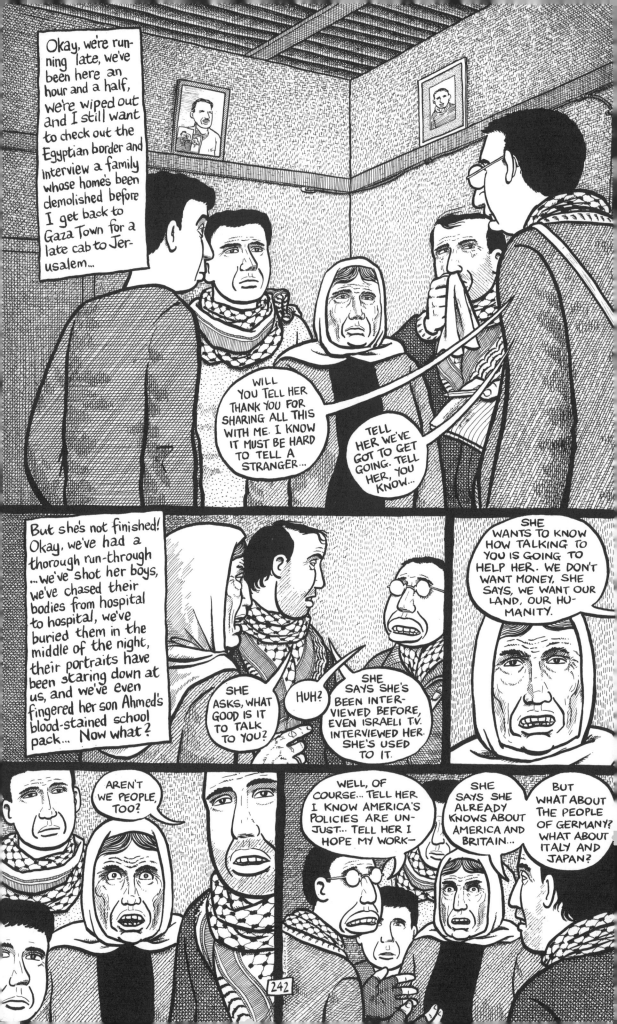

Okay, we're running late, we've been here an hour and a half, we're wiped out and I still want to check out the Egyptian border and interview a family whose home's been demolished before I get back to Gaza Town for a late cab to Jerusalem...

WILL YOU TELL HER THANK YOU FOR SHARING ALL THIS WITH ME. I KNOW IT MUST BE HARD TO TELL A STRANGER...

TELL HER WE'VE GOT TO GET GOING. TELL HER, YOU KNOW...

But she's not finished! Okay, we've had a thorough run-through ...we've shot her boys, we've chased their bodies from hospital to hospital, we've buried them in the middle of the night, their portraits have been staring down at us, and we've even fingered her son Ahmed's blood-stained school pack... Now what?

SHE ASKS, WHAT GOOD IS IT TO TALK TO YOU?

HUH?

SHE SAYS SHE'S BEEN INTERVIEWED BEFORE, EVEN ISRAELI T.V. INTERVIEWED HER. SHE'S USED TO IT.

SHE WANTS TO KNOW HOW TALKING TO YOU IS GOING TO HELP HER. WE DON'T WANT MONEY, SHE SAYS, WE WANT OUR LAND, OUR HUMANITY.

AREN'T WE PEOPLE, TOO?

WELL, OF COURSE... TELL HER I KNOW AMERICA'S POLICIES ARE UNJUST... TELL HER I HOPE MY WORK—

SHE SAYS SHE ALREADY KNOWS ABOUT AMERICA AND BRITAIN...

BUT WHAT ABOUT THE PEOPLE OF GERMANY? WHAT ABOUT ITALY AND JAPAN?

242

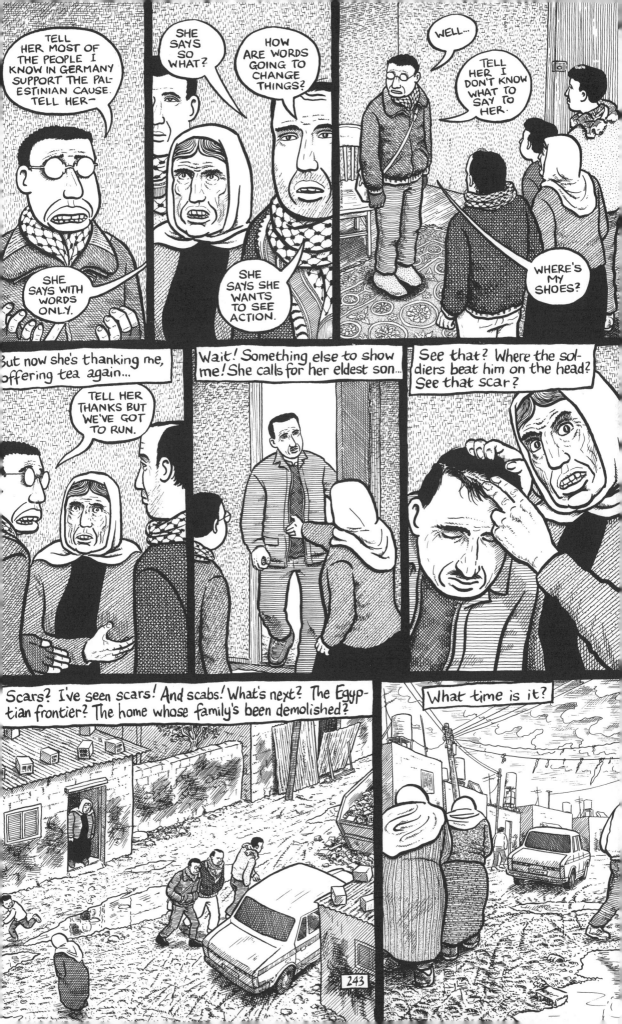

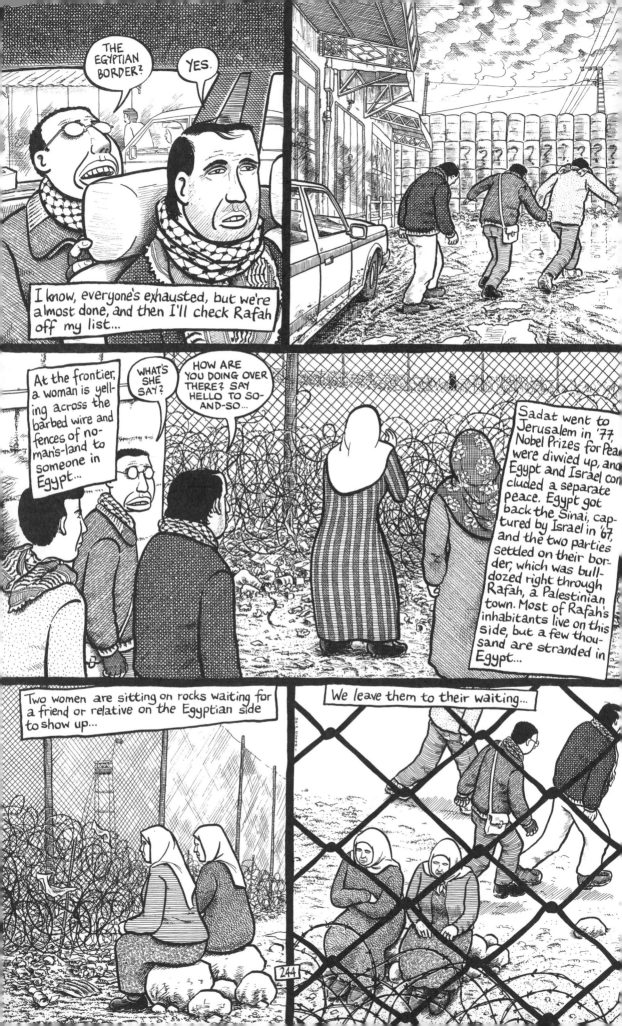

THE EGYPTIAN BORDER?

YES.

I know, everyone's exhausted, but we're almost done, and then I'll check Rafah off my list...

At the frontier, a woman is yelling across the barbed wire and fences of no-man's-land to someone in Egypt...

WHAT'S SHE SAY?

HOW ARE YOU DOING OVER THERE? SAY HELLO TO SO-AND-SO...

Sadat went to Jerusalem in '77, Nobel Prizes for Peace were divvied up, and Egypt and Israel concluded a separate peace. Egypt got back the Sinai, captured by Israel in '67, and the two parties settled on their border, which was bulldozed right through Rafah, a Palestinian town. Most of Rafah's inhabitants live on this side, but a few thousand are stranded in Egypt...

Two women are sitting on rocks waiting for a friend or relative on the Egyptian side to show up...

We leave them to their waiting...

244

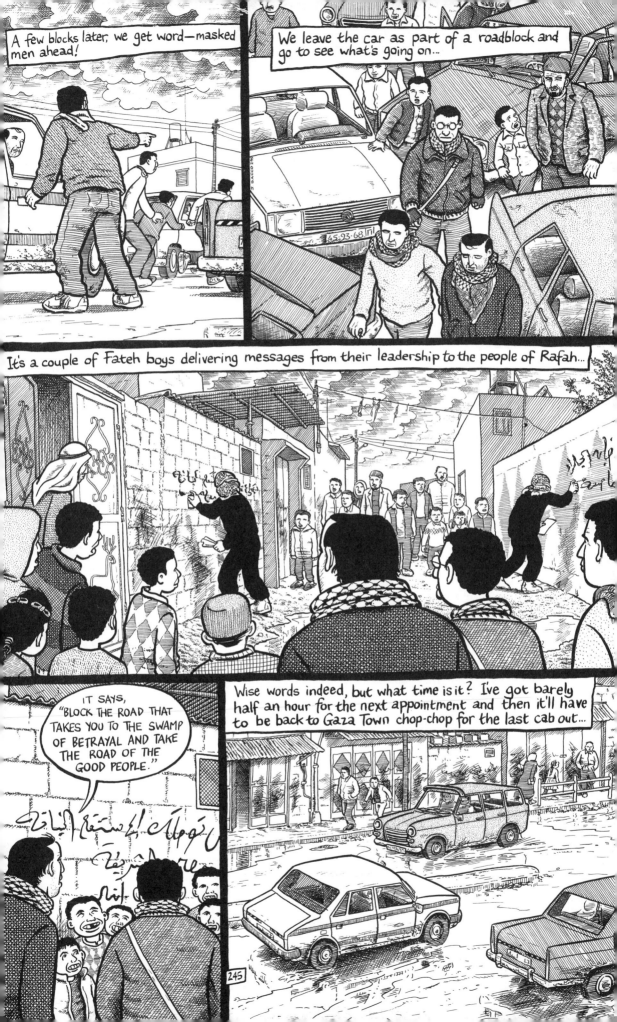

A few blocks later, we get word—masked men ahead!

We leave the car as part of a roadblock and go to see what's going on...

It's a couple of Fateh boys delivering messages from their leadership to the people of Rafah...

IT SAYS, "BLOCK THE ROAD THAT TAKES YOU TO THE SWAMP OF BETRAYAL AND TAKE THE ROAD OF THE GOOD PEOPLE."

Wise words indeed, but what time is it? I've got barely half an hour for the next appointment and then it'll have to be back to Gaza Town chop-chop for the last cab out...

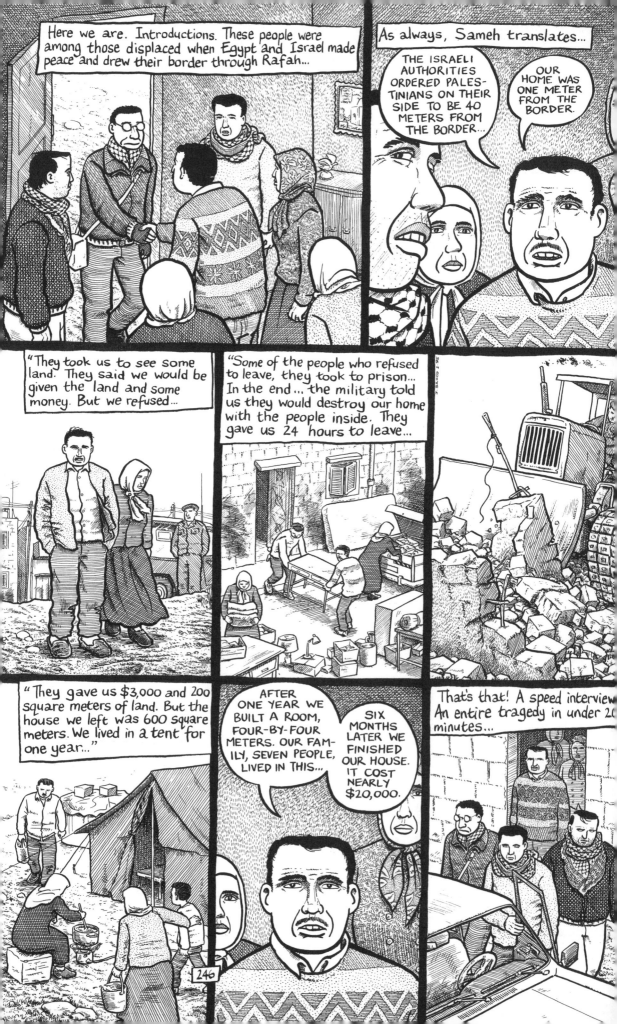

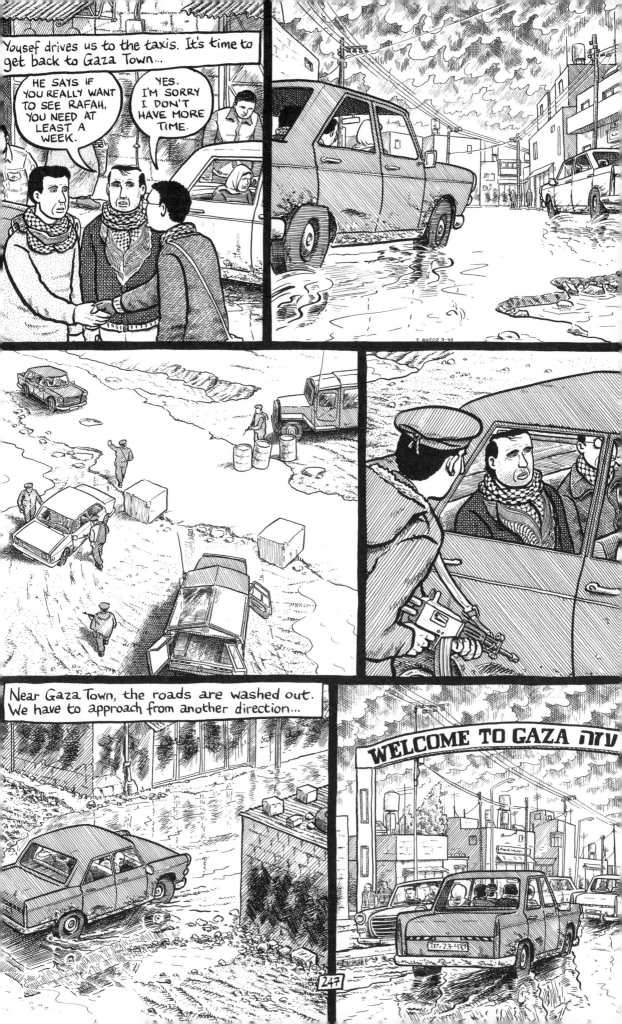

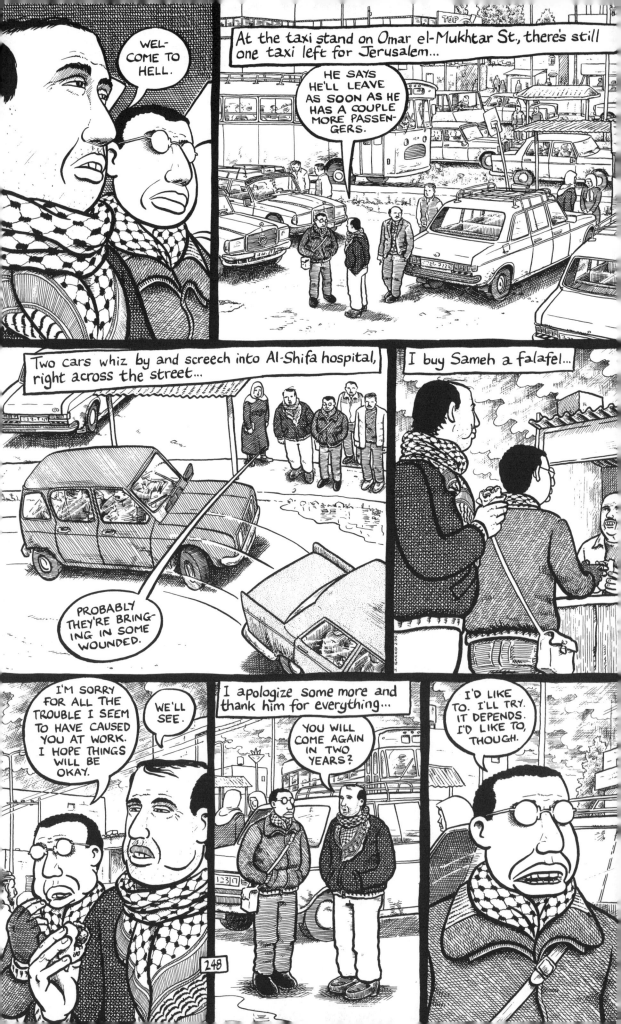

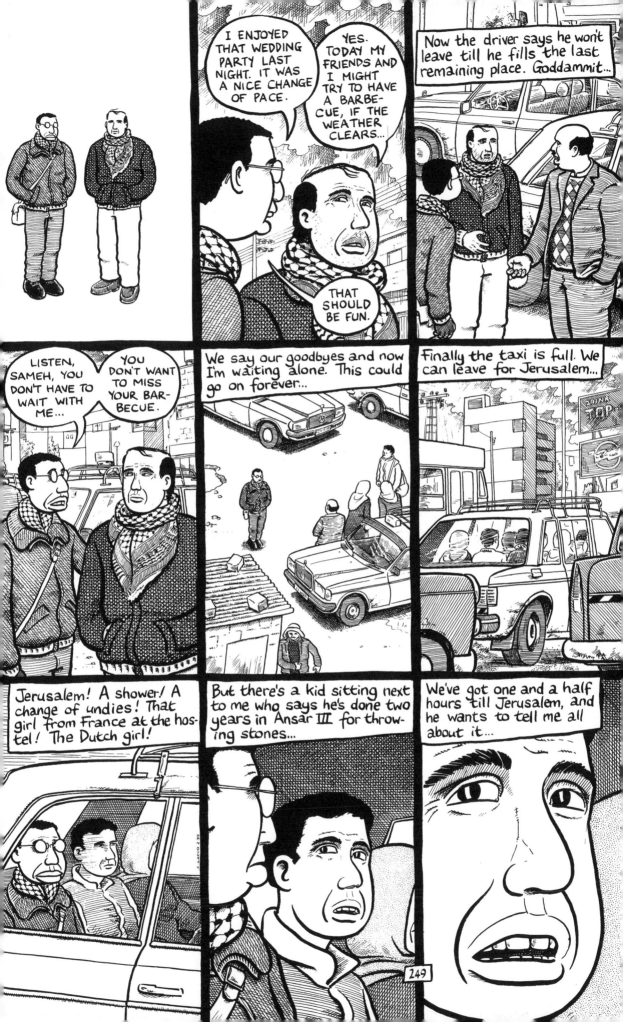

Chapter Nine

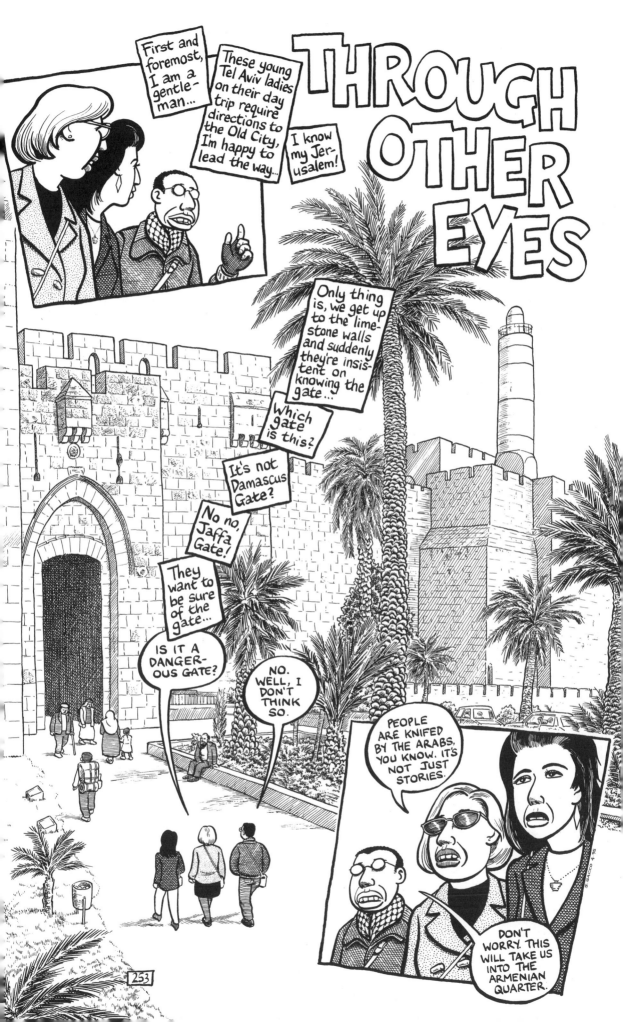

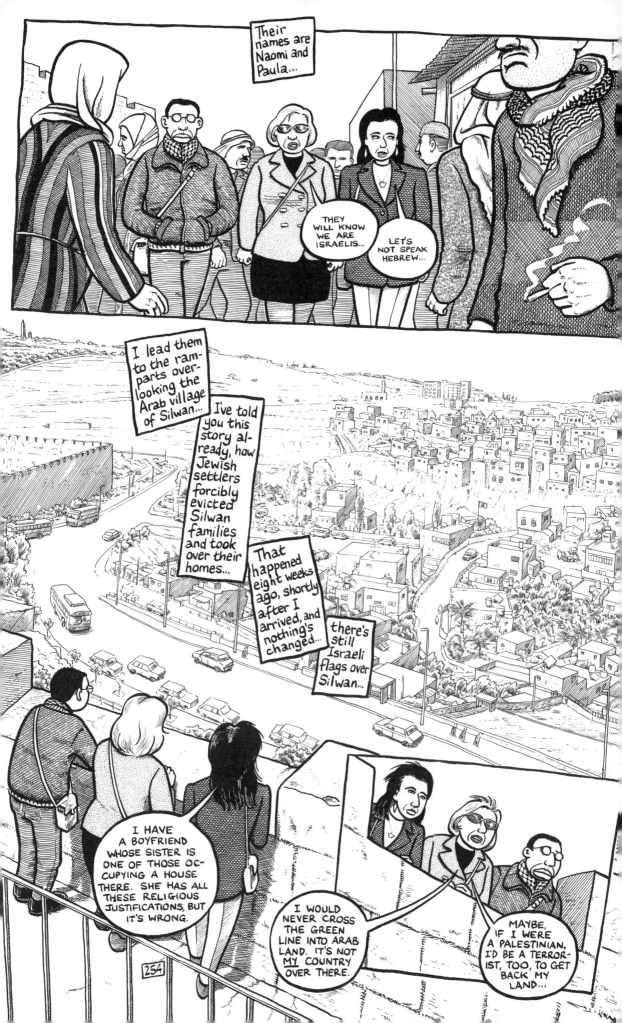

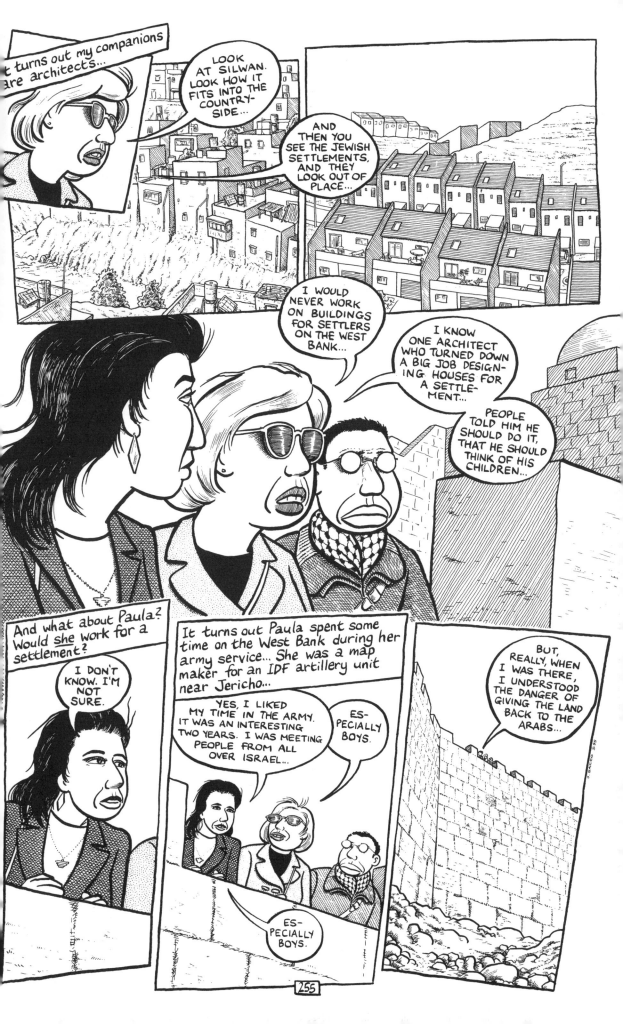

It turns out my companions are architects...

LOOK AT SILWAN. LOOK HOW IT FITS INTO THE COUNTRYSIDE...

AND THEN YOU SEE THE JEWISH SETTLEMENTS, AND THEY LOOK OUT OF PLACE...

I WOULD NEVER WORK ON BUILDINGS FOR SETTLERS ON THE WEST BANK...

I KNOW ONE ARCHITECT WHO TURNED DOWN A BIG JOB DESIGNING HOUSES FOR A SETTLEMENT...

PEOPLE TOLD HIM HE SHOULD DO IT, THAT HE SHOULD THINK OF HIS CHILDREN...

And what about Paula? Would she work for a settlement?

I DON'T KNOW. I'M NOT SURE.

It turns out Paula spent some time on the West Bank during her army service... She was a map maker for an IDF artillery unit near Jericho...

YES, I LIKED MY TIME IN THE ARMY. IT WAS AN INTERESTING TWO YEARS. I WAS MEETING PEOPLE FROM ALL OVER ISRAEL...

ESPECIALLY BOYS.

ESPECIALLY BOYS.

BUT, REALLY, WHEN I WAS THERE, I UNDERSTOOD THE DANGER OF GIVING THE LAND BACK TO THE ARABS...

And standing there with two girls from Tel Aviv, it occurs to me that I <u>have</u> seen the Israelis, but through Palestinian eyes—that Israelis were mainly soldiers and settlers to me now, too...

I guide them through the Jewish Quarter to the Western Wall...

We talk some more and I drop my guard, I tell them about my project, that I've come to meet Palestinians...

YOU'VE BEEN HERE TWO MONTHS AND YOU HAVEN'T BEEN TO TEL AVIV?

TO HAIFA?

SHOULDN'T YOU BE SEEING OUR SIDE OF THE STORY, TOO?

And what can I say? I say I've heard nothing but the Israeli side most all my life, that it'd take a whole other trip to see Israel, that I'd like to meet Israelis, but that wasn't why I was here...

DO YOU WANT TO WALK THROUGH THE ARAB MARKET?

NO NO! IT'S TOO DANGEROUS!

NOTHING WILL HAPPEN. IT'S REALLY COLORFUL. THERE'S ALL THESE STALLS AND SHOPS. NOTHING'S EVER HAPPENED TO ME.

JEWS GET STABBED IN THERE.

I SEE ORTHODOX JEWS WALKING THROUGH THERE... AND THERE'S ALWAYS TOURISTS.

I'LL GO.

WELL, I'M NOT GOING.

J. SACCO 5/95

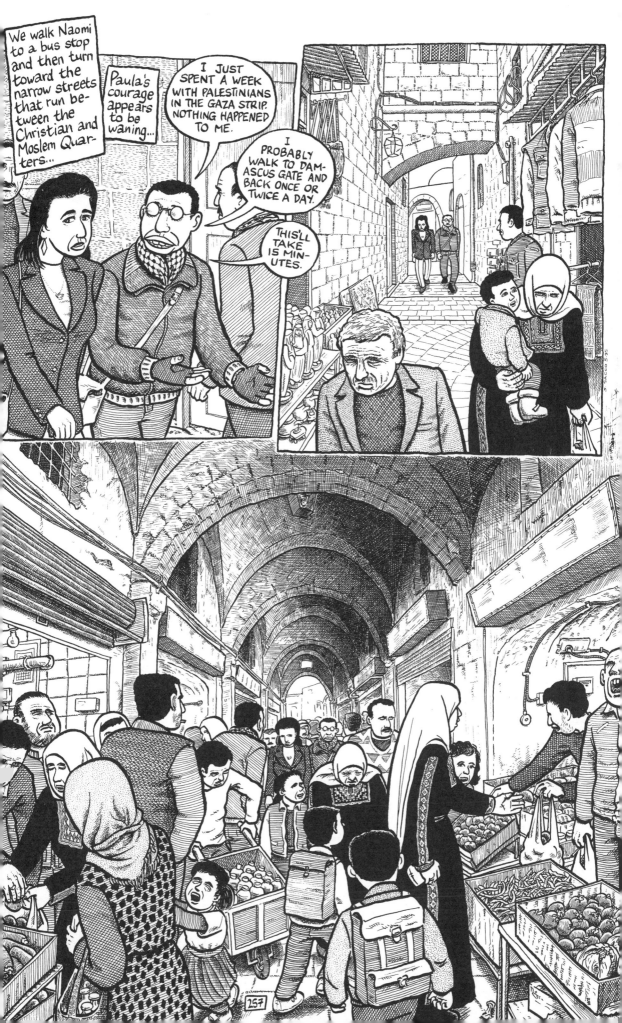

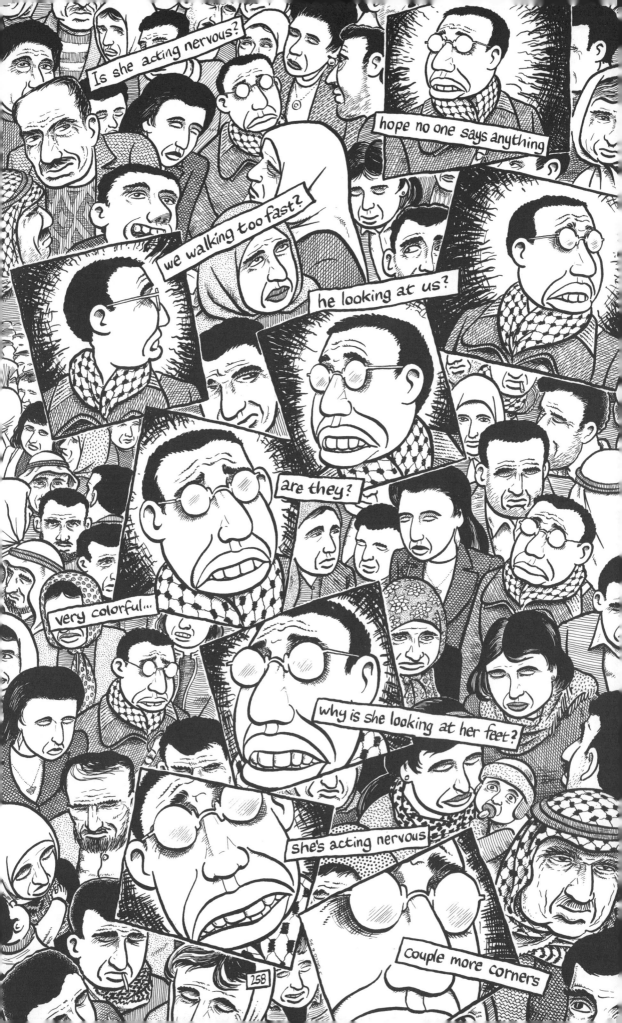

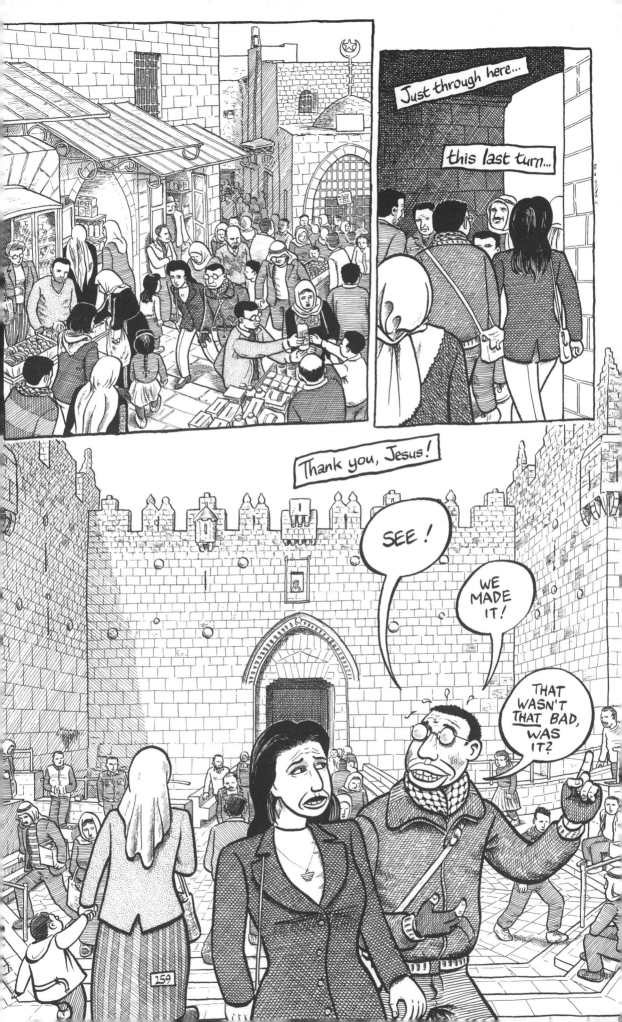

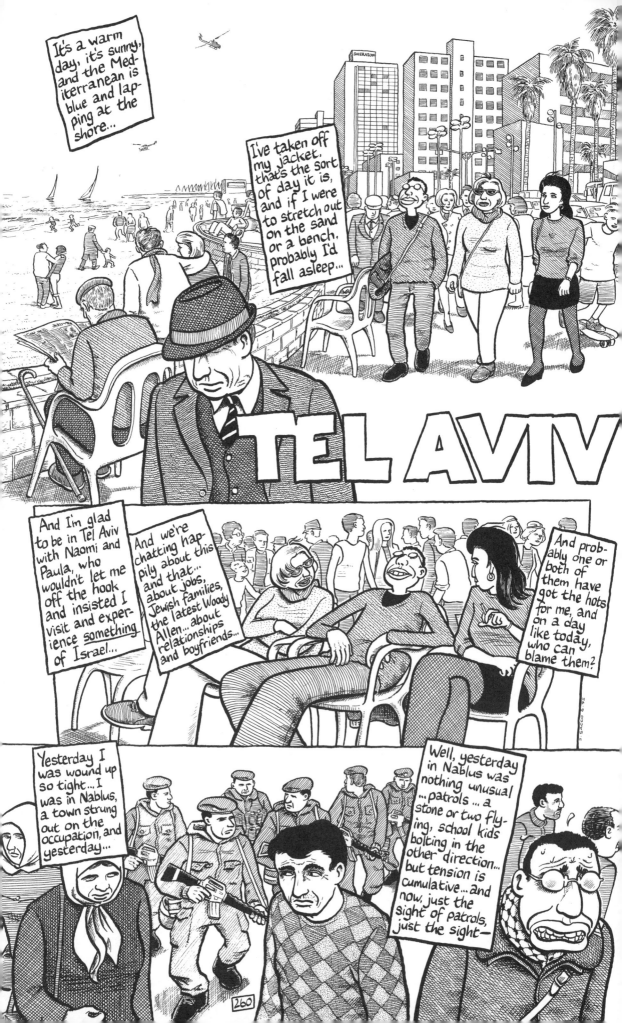

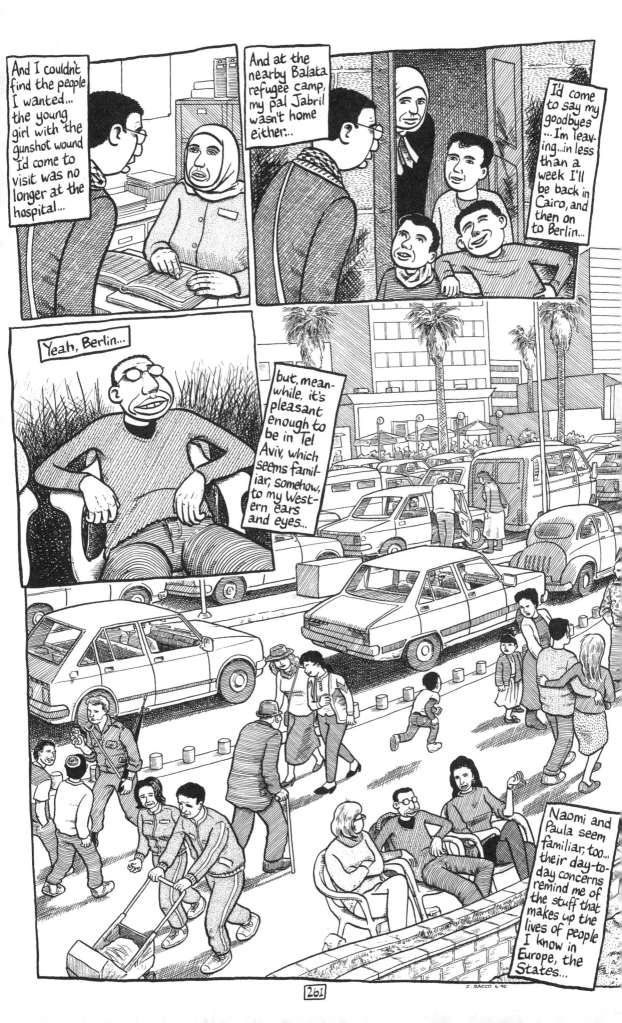

And I couldn't find the people I wanted... the young girl with the gunshot wound I'd come to visit was no longer at the hospital...

And at the nearby Balata refugee camp, my pal Jabril wasn't home either...

I'd come to say my goodbyes... I'm leaving... in less than a week I'll be back in Cairo, and then on to Berlin...

Yeah, Berlin...

but, meanwhile, it's pleasant enough to be in Tel Aviv, which seems familiar, somehow, to my Western ears and eyes...

Naomi and Paula seem familiar, too... their day-to-day concerns remind me of the stuff that makes up the lives of people I know in Europe, the States...

J. SACCO 6-95

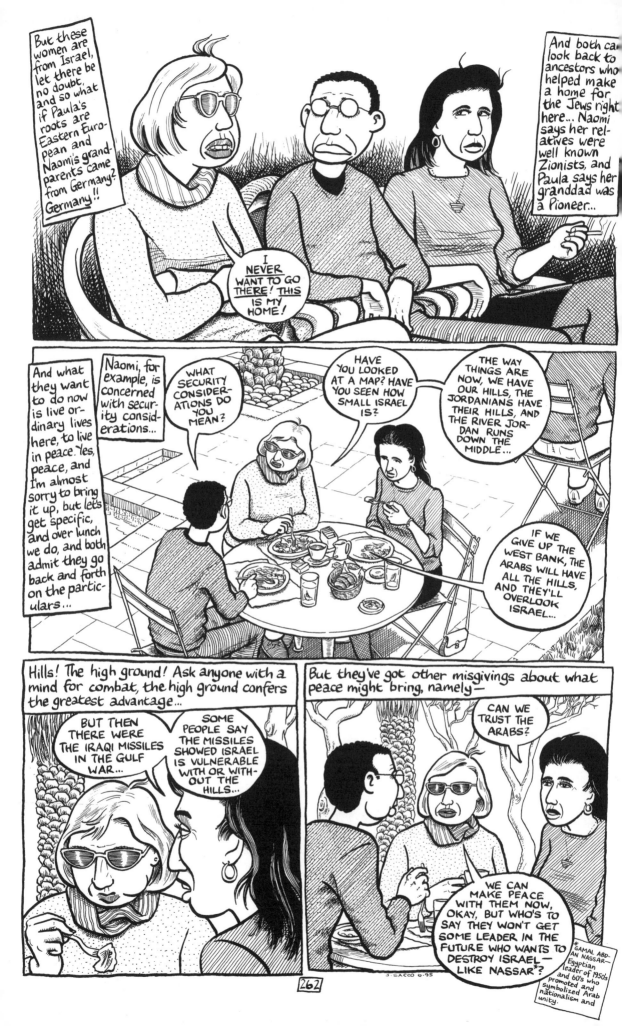

But these women are from Israel, let there be no doubt, and so what if Paula's roots are Eastern European and Naomi's grandparents came from Germany? Germany!!

And both can look back to ancestors who helped make a home for the Jews right here... Naomi says her relatives were well known Zionists, and Paula says her granddad was a pioneer...

I NEVER WANT TO GO THERE! THIS IS MY HOME!

And what they want to do now is live ordinary lives here, to live in peace. Yes, peace, and I'm almost sorry to bring it up, but let's get specific, and over lunch we do, and both admit they go back and forth on the particulars...

Naomi, for example, is concerned with security considerations...

WHAT SECURITY CONSIDERATIONS DO YOU MEAN?

HAVE YOU LOOKED AT A MAP? HAVE YOU SEEN HOW SMALL ISRAEL IS?

THE WAY THINGS ARE NOW, WE HAVE OUR HILLS, THE JORDANIANS HAVE THEIR HILLS, AND THE RIVER JORDAN RUNS DOWN THE MIDDLE...

IF WE GIVE UP THE WEST BANK, THE ARABS WILL HAVE ALL THE HILLS, AND THEY'LL OVERLOOK ISRAEL...

Hills! The high ground! Ask anyone with a mind for combat, the high ground confers the greatest advantage...

BUT THEN THERE WERE THE IRAQI MISSILES IN THE GULF WAR...

SOME PEOPLE SAY THE MISSILES SHOWED ISRAEL IS VULNERABLE WITH OR WITHOUT THE HILLS...

But they've got other misgivings about what peace might bring, namely—

CAN WE TRUST THE ARABS?

WE CAN MAKE PEACE WITH THEM NOW, OKAY, BUT WHO'S TO SAY THEY WON'T GET SOME LEADER IN THE FUTURE WHO WANTS TO DESTROY ISRAEL— LIKE NASSAR*?

*GAMAL ABD-AN NASSAR— Egyptian leader of 1950's and 60's who promoted and symbolized Arab nationalism and unity.

J. SACCO 6-95

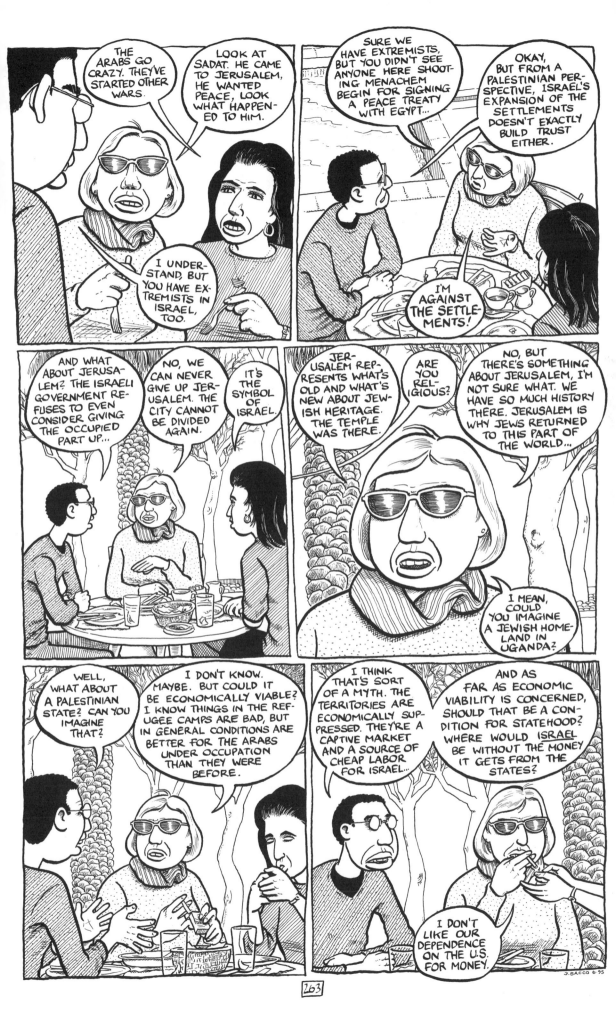

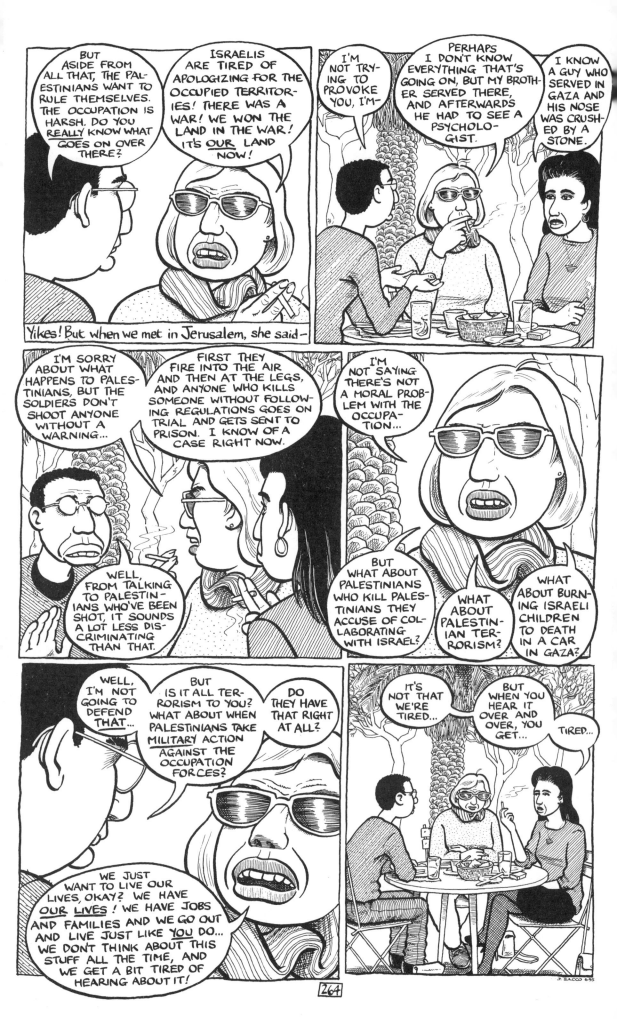

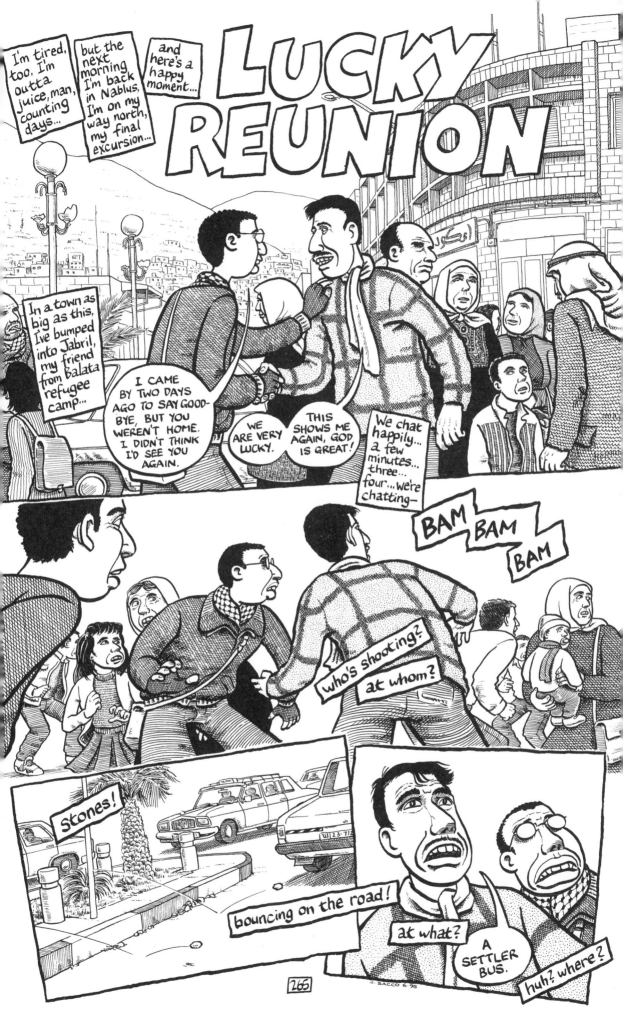

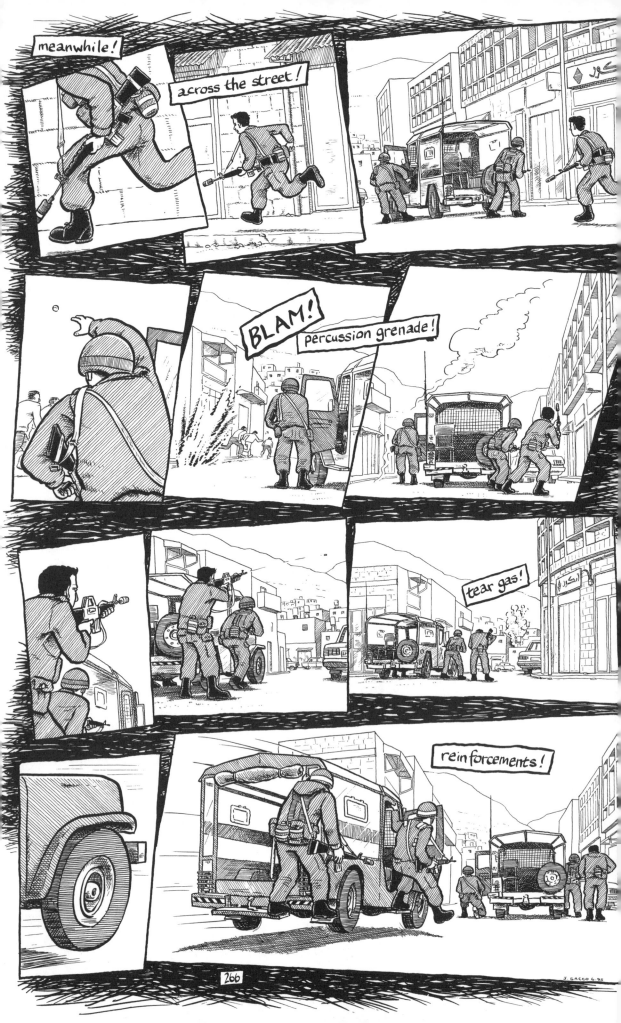

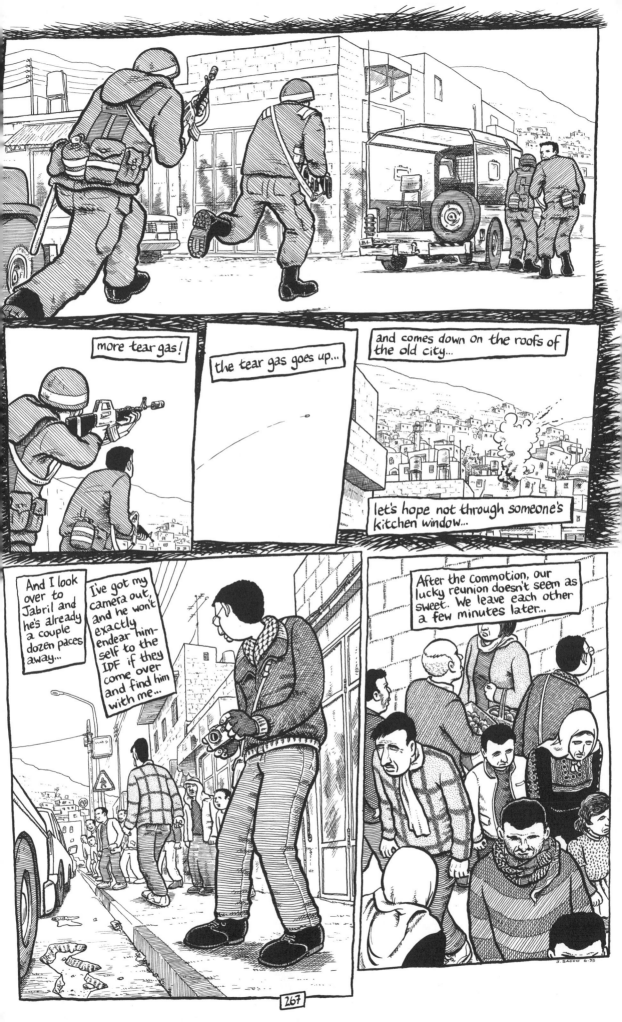

more tear gas!

the tear gas goes up...

and comes down on the roofs of the old city...

let's hope not through someone's kitchen window...

And I look over to Jabril and he's already a couple dozen paces away...

I've got my camera out, and he won't exactly endear himself to the IDF if they come over and find him with me...

After the commotion, our lucky reunion doesn't seem as sweet. We leave each other a few minutes later...

J. SACCO 6-95

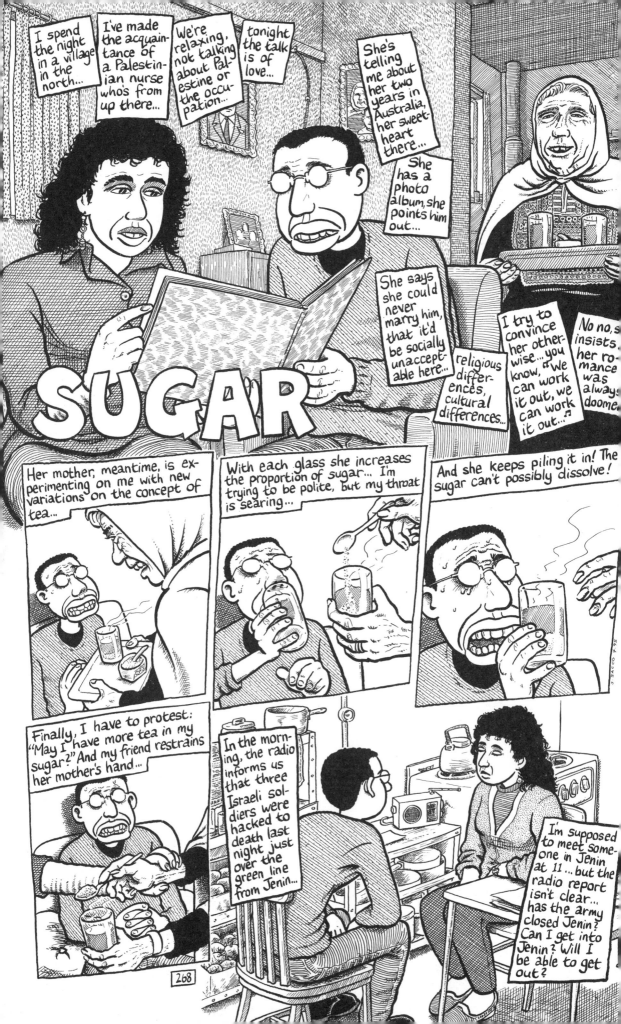

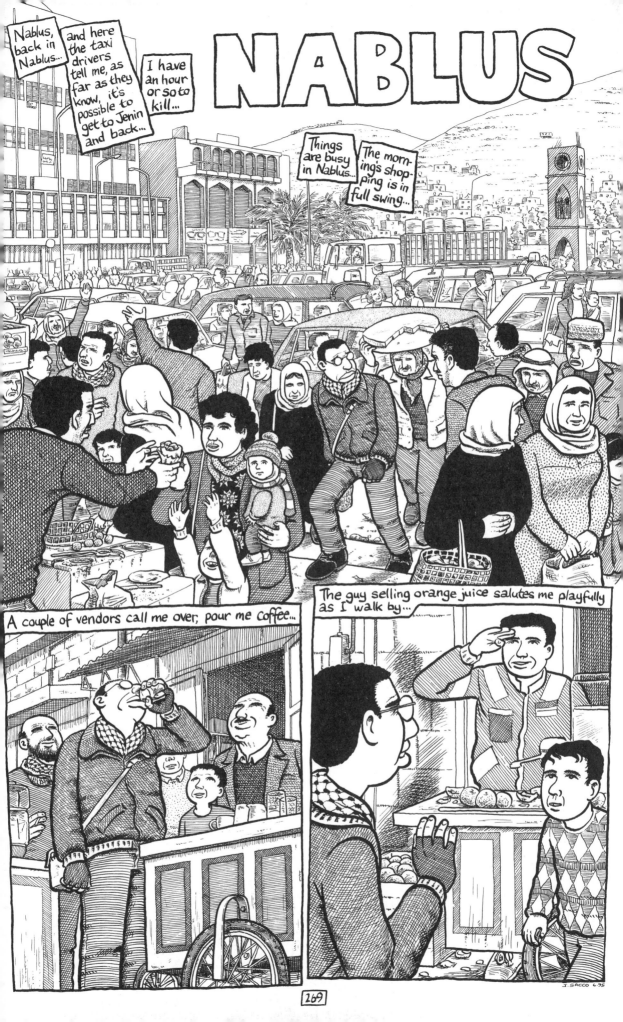

NABLUS

Nablus, back in Nablus... and here the taxi drivers tell me, as far as they know, it's possible to get to Jenin and back... I have an hour or so to kill...

Things are busy in Nablus... The morning's shopping is in full swing...

A couple of vendors call me over, pour me coffee...

The guy selling orange juice salutes me playfully as I walk by...

J. SACCO 6-95

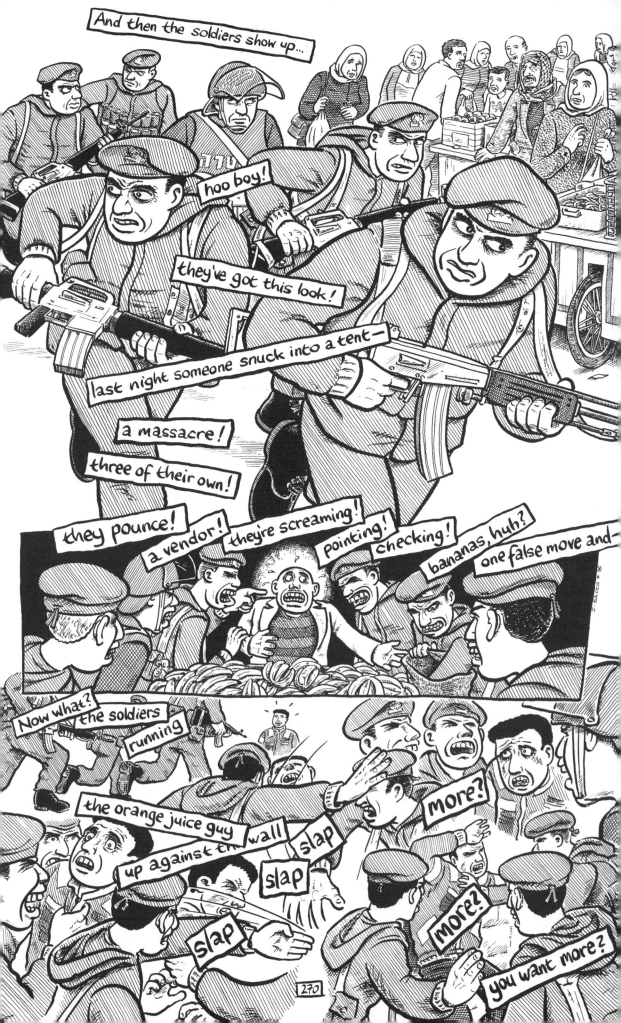

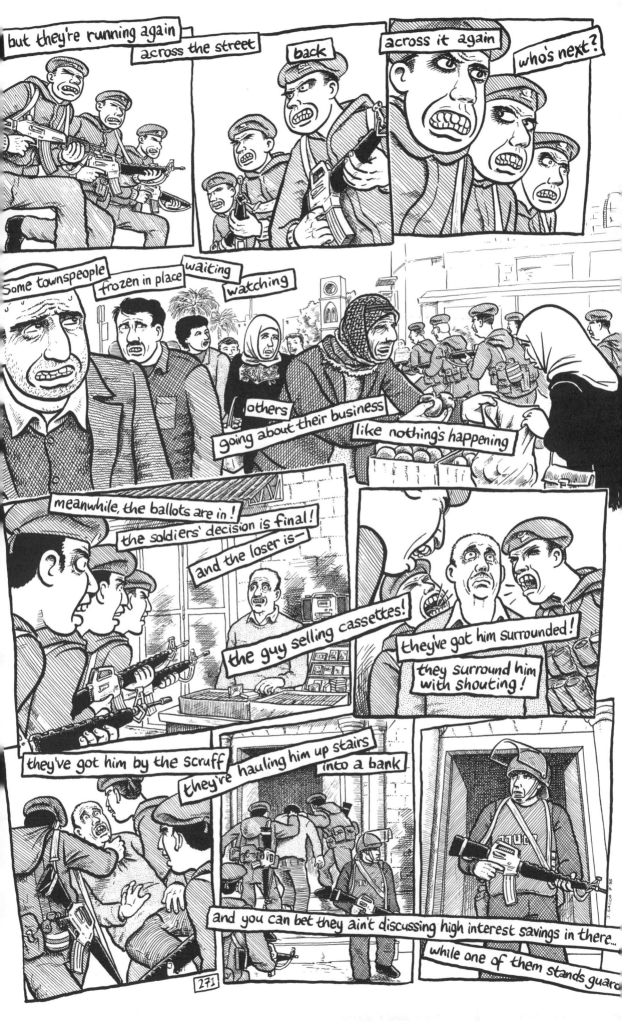

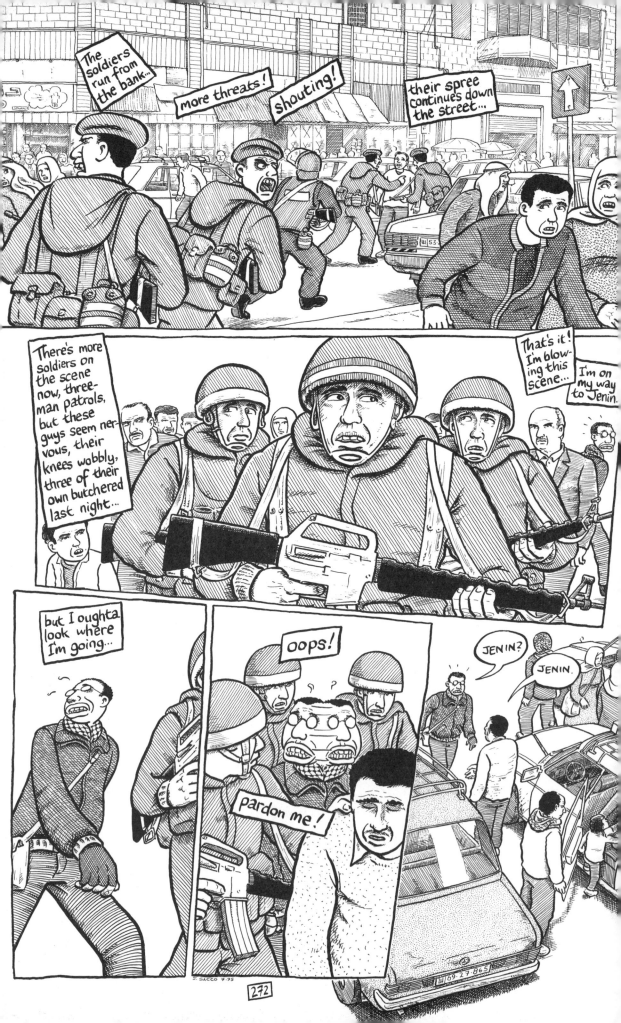

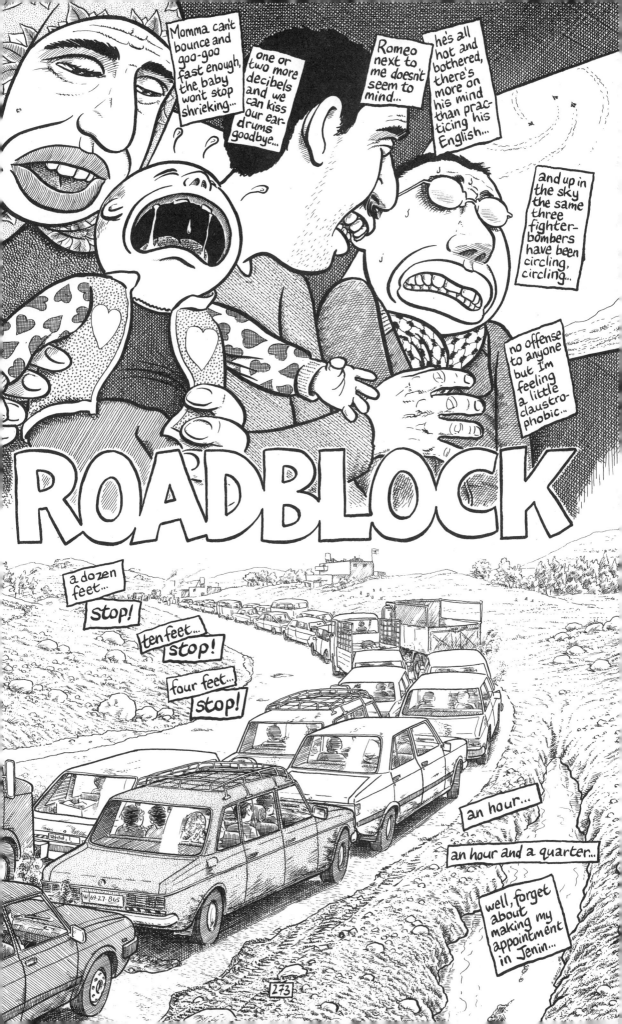

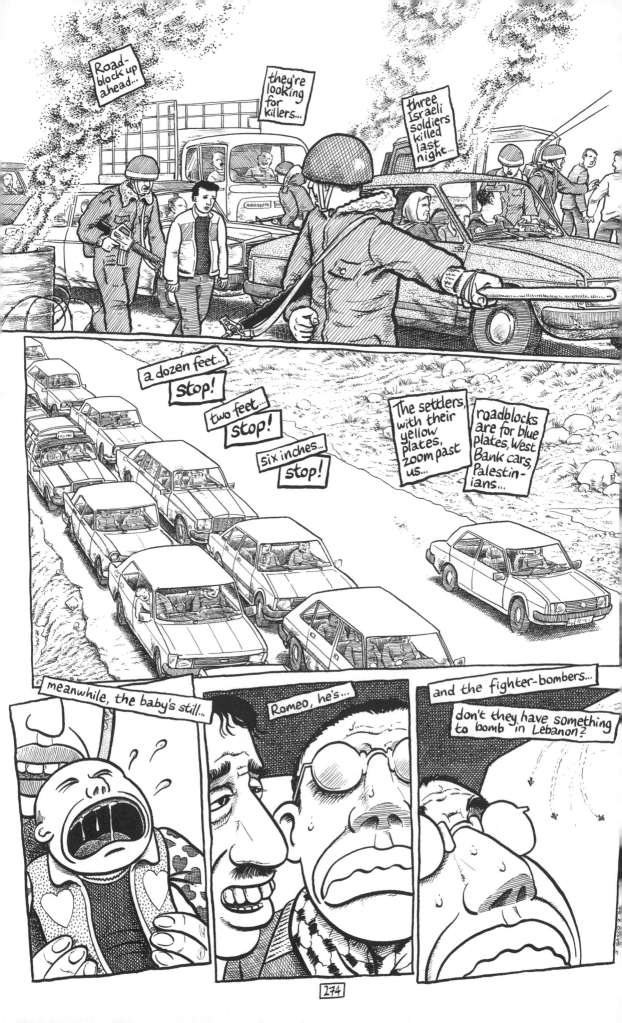

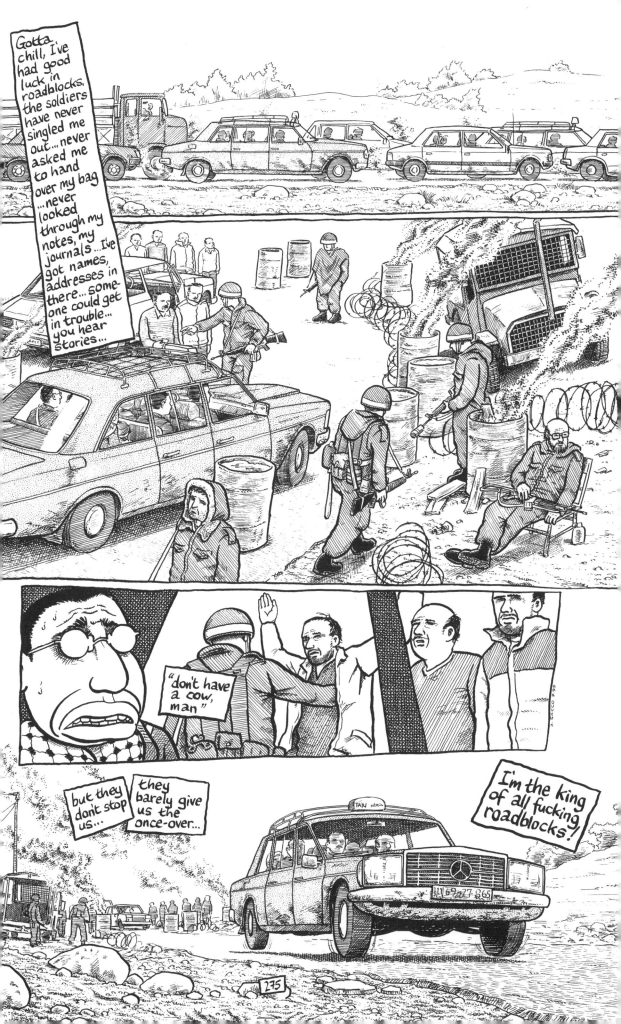

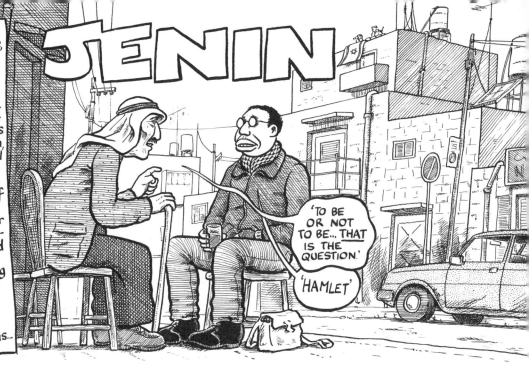

JENIN

All right, I got here late, I've missed my appointment, so I wander aimlessly until I come across an older man, an ex-school teacher... he sits under the gaze of Israeli soldiers in their rooftop positions and gets to speculating about the future of Palestine and the Palestinians...

'TO BE OR NOT TO BE... THAT IS THE QUESTION.'

'HAMLET'

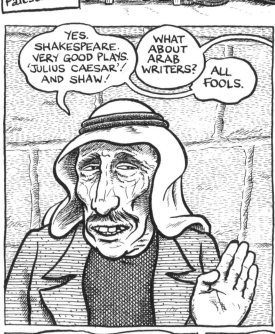

YES. SHAKESPEARE. VERY GOOD PLAYS. 'JULIUS CAESAR'! AND SHAW!

WHAT ABOUT ARAB WRITERS?

ALL FOOLS.

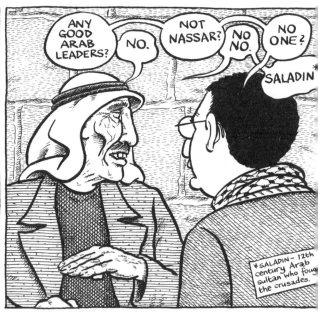

ANY GOOD ARAB LEADERS?

NO.

NOT NASSAR?

NO NO.

NO ONE?

SALADIN*

*SALADIN— 12th century Arab sultan who fought the crusades.

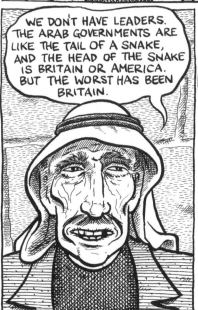

WE DON'T HAVE LEADERS. THE ARAB GOVERNMENTS ARE LIKE THE TAIL OF A SNAKE, AND THE HEAD OF THE SNAKE IS BRITAIN OR AMERICA. BUT THE WORST HAS BEEN BRITAIN.

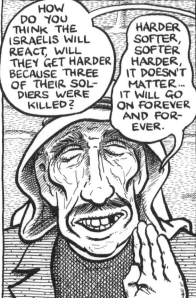

HOW DO YOU THINK THE ISRAELIS WILL REACT, WILL THEY GET HARDER BECAUSE THREE OF THEIR SOLDIERS WERE KILLED?

HARDER SOFTER, SOFTER HARDER, IT DOESN'T MATTER... IT WILL GO ON FOREVER AND FOREVER.

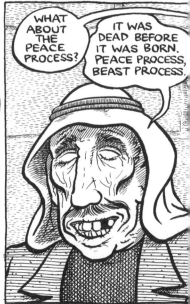

WHAT ABOUT THE PEACE PROCESS?

IT WAS DEAD BEFORE IT WAS BORN. PEACE PROCESS, BEAST PROCESS.

276

J. SACCO 8

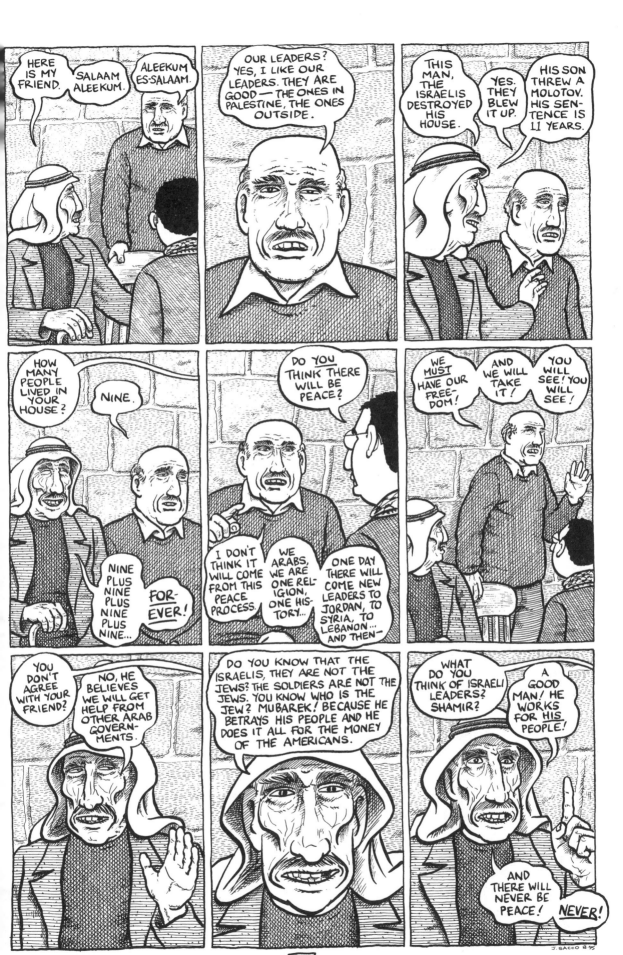

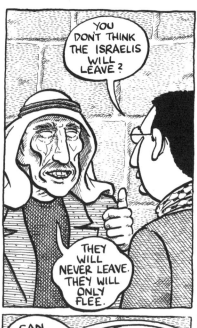

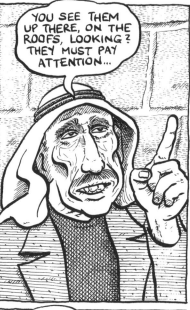

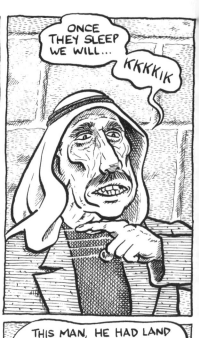

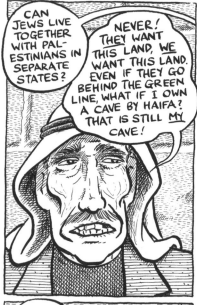

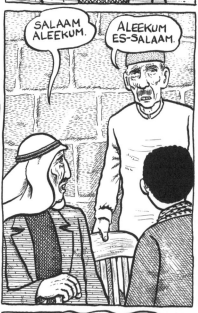

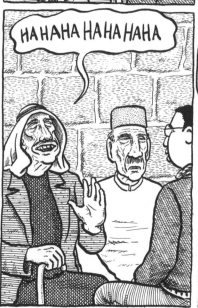

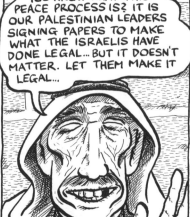

A BOY IN THE RAIN

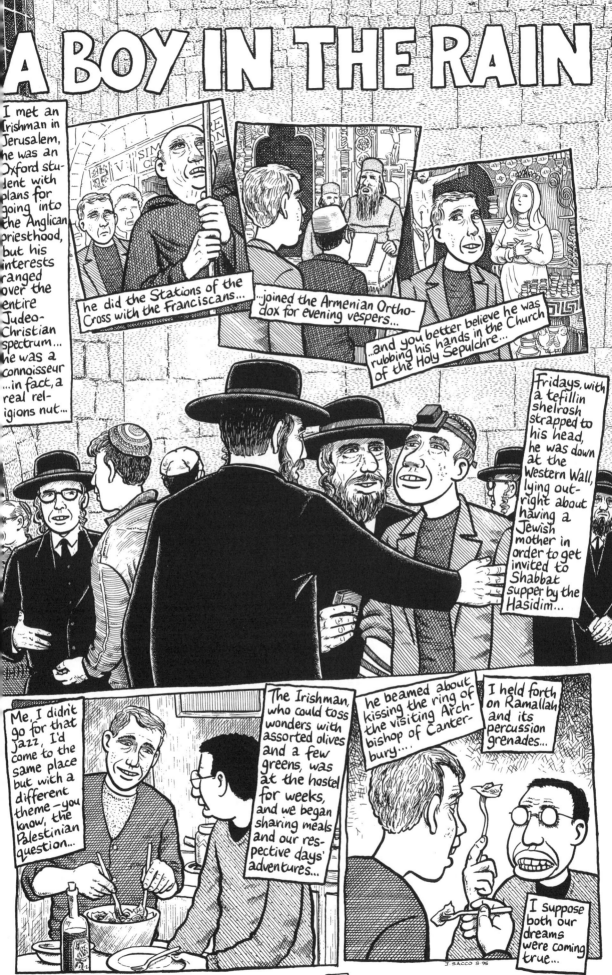

I met an Irishman in Jerusalem, he was an Oxford student with plans for going into the Anglican priesthood, but his interests ranged over the entire Judeo-Christian spectrum... he was a connoisseur ...in fact, a real religions nut...

he did the Stations of the Cross with the Franciscans...

...joined the Armenian Orthodox for evening vespers...

...and you better believe he was rubbing his hands in the Church of the Holy Sepulchre...

Fridays, with a tefillin shelrosh strapped to his head, he was down at the Western Wall, lying outright about having a Jewish mother in order to get invited to Shabbat supper by the Hasidim...

Me, I didn't go for that jazz, I'd come to the same place but with a different theme — you know, the Palestinian question...

The Irishman, who could toss wonders with assorted olives and a few greens, was at the hostel for weeks, and we began sharing meals and our respective days' adventures...

he beamed about kissing the ring of the visiting Archbishop of Canterbury....

I held forth on Ramallah and its percussion grenades...

I suppose both our dreams were coming true...

J. SACCO 8-95

179

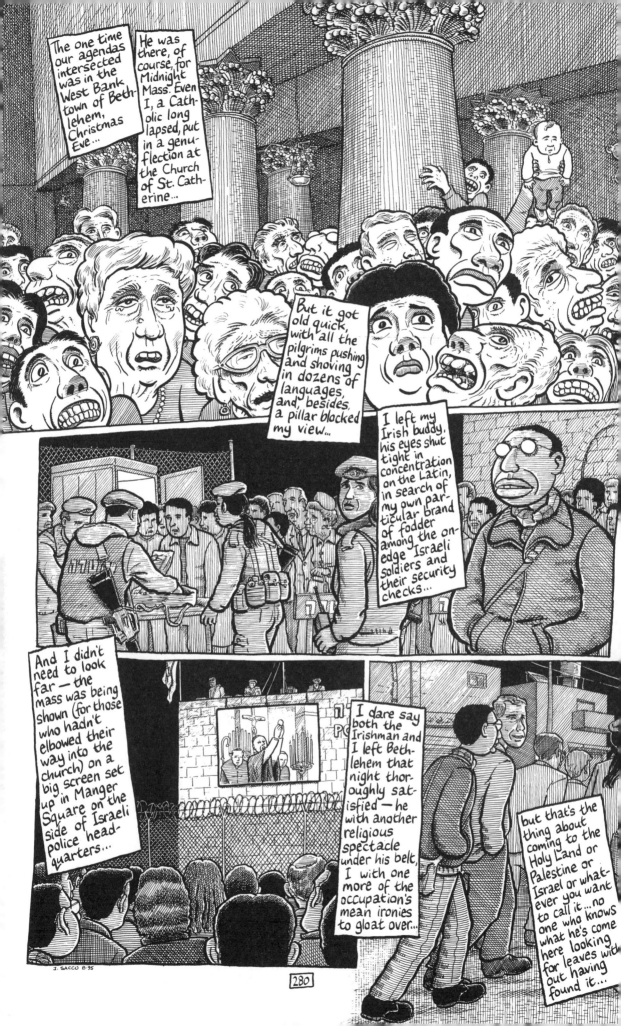

The one time our agendas intersected was in the West Bank town of Bethlehem, Christmas Eve...

He was there, of course, for Midnight Mass. Even I, a Catholic long lapsed, put in a genuflection at the Church of St. Catherine...

But it got old quick, with all the pilgrims pushing and shoving in dozens of languages, and, besides, a pillar blocked my view...

I left my Irish buddy, his eyes shut tight in concentration on the Latin, in search of my own particular brand of fodder among the on-edge Israeli soldiers and their security checks...

And I didn't need to look far — the mass was being shown (for those who hadn't elbowed their way into the church) on a big screen set up in Manger Square on the side of Israeli police headquarters...

I dare say both the Irishman and I left Bethlehem that night thoroughly satisfied — he with another religious spectacle under his belt, I with one more of the occupation's mean ironies to gloat over...

but that's the thing about coming to the Holy Land or Palestine or Israel or whatever you want to call it ...no one who knows what he's come here looking for leaves without having found it...

J. SACCO 8-95

And a few weeks later, on the bus out, bound for Cairo, I met a lady who had found what she'd come for, too...

She was Jewish, from New York, the large part of her family had been liquidated in the Holocaust, she'd been taken out of Germany in the nick of time... And she'd just spent three weeks of her vacation doing volunteer work for the Israeli army... She'd come to see the beautiful, vibrant, besieged Israel, and she wasn't leaving disappointed either...

ISRAEL IS WONDERFUL...

THE ISRAELIS ARE WONDERFUL...

IT'S SAD THOUGH, IT'S SAD, TO SEE THOSE YOUNG PEOPLE HAVING TO CARRY GUNS BECAUSE THERE'S ALWAYS A THREAT...

AND AFTER ALL THEIR PEOPLE HAVE BEEN THROUGH...

WELL, THERE'S ANOTHER SIDE TO THE STORY OF ISRAEL. THE PALESTINIANS—

ALL I'M SAYING IS I WANT PEACE.

Yes yes, we all want peace, whatever that is, but peace can mean different things, too, and isn't described identically by all who wish to imagine it...

One of my first days in Jerusalem, I found myself sitting in the back room of an Arab jewelry shop with a Palestinian, an Israeli, and two Americans who did press work for a non-governmental organization. We were analyzing the current peace process, envisioning, as one does, what, if anything, might work...

SOMETIMES I THINK ONE PLURALISTIC STATE OF ARABS AND JEWS WOULD MAKE THE MOST SENSE —IN THE LONG TERM, ANYWAY.

I THINK THE MOST PREVALENT IDEA IS THAT A TWO-STATE SOLUTION IS THE ONE WITH THE BEST CHANCE OF ACCEPTANCE AND SUCCESS.

J. SACCO 8-95

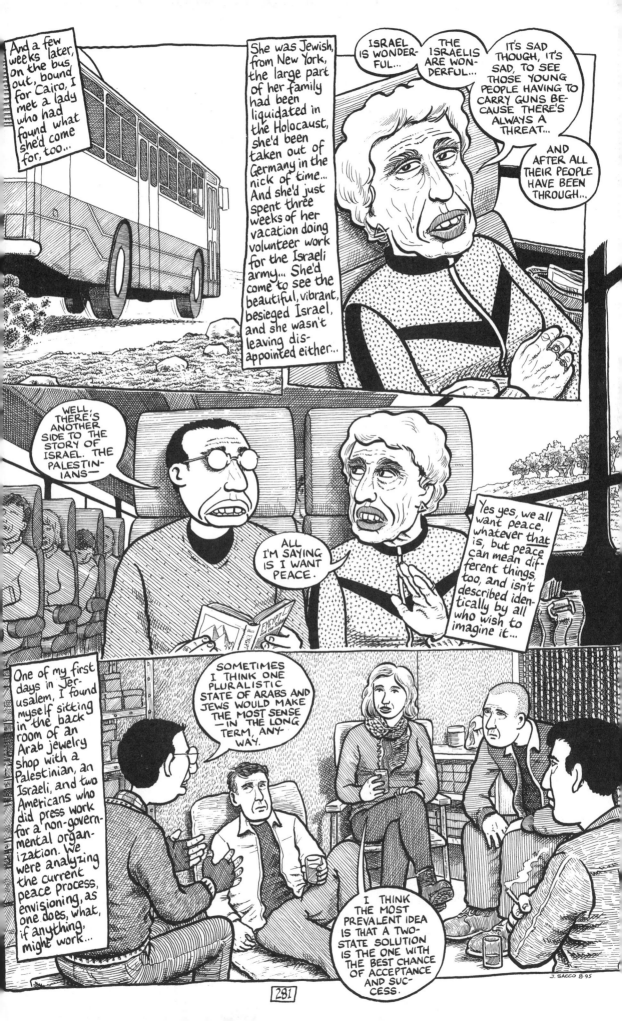

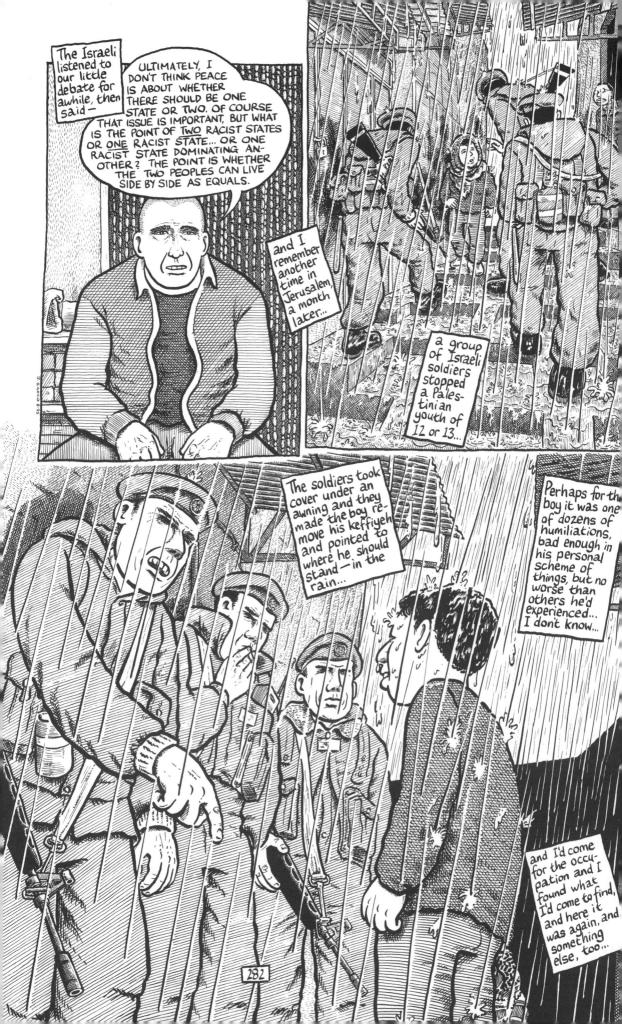

The Israeli listened to our little debate for awhile, then said—

ULTIMATELY, I DON'T THINK PEACE IS ABOUT WHETHER THERE SHOULD BE ONE STATE OR TWO. OF COURSE THAT ISSUE IS IMPORTANT, BUT WHAT IS THE POINT OF TWO RACIST STATES OR ONE RACIST STATE... OR ONE RACIST STATE DOMINATING ANOTHER? THE POINT IS WHETHER THE TWO PEOPLES CAN LIVE SIDE BY SIDE AS EQUALS.

and I remember another time in Jerusalem, a month later...

a group of Israeli soldiers stopped a Palestinian youth of 12 or 13...

The soldiers took cover under an awning and they made the boy remove his keffiyeh and pointed to where he should stand—in the rain...

Perhaps for the boy it was one of dozens of humiliations, bad enough in his personal scheme of things, but no worse than others he'd experienced... I don't know...

and I'd come for the occupation and I found what I'd come to find, and here it was again, and something else, too...

282

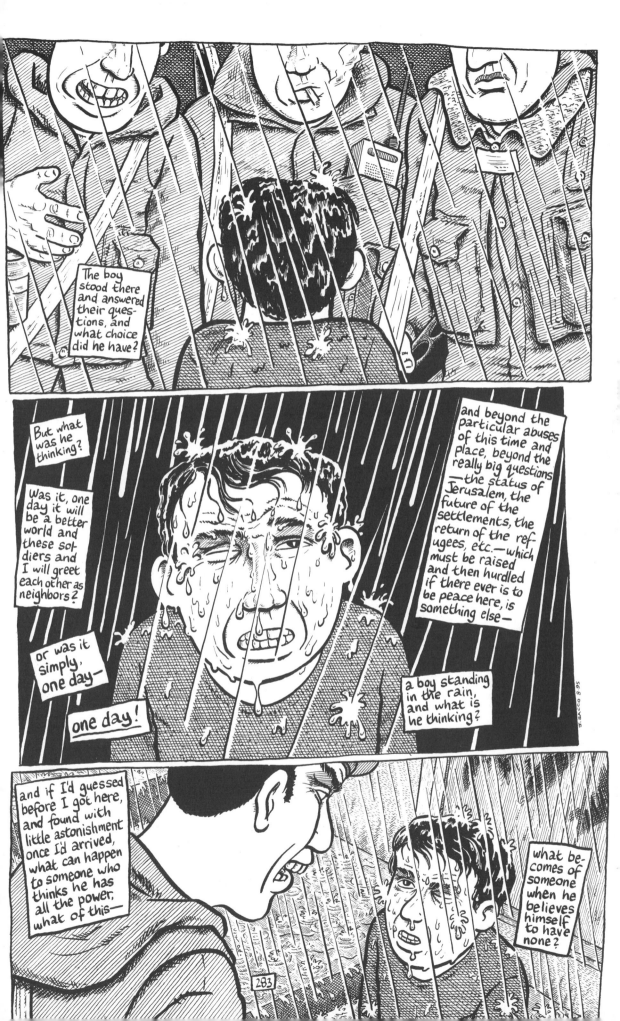

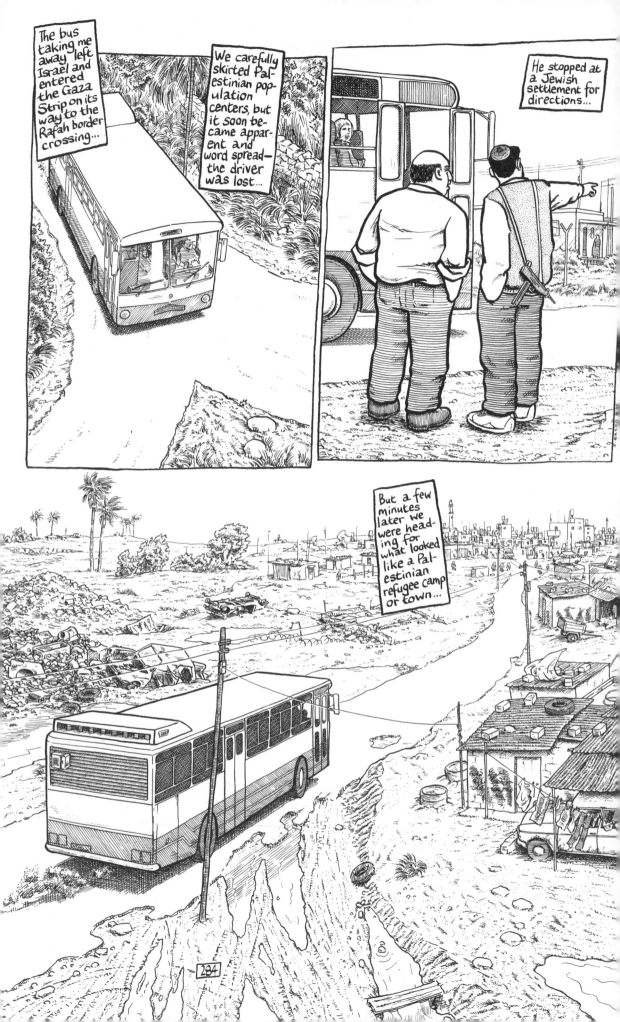

The bus taking me away left Israel and entered the Gaza Strip on its way to the Rafah border crossing...

We carefully skirted Palestinian population centers, but it soon became apparent and word spread— the driver was lost...

He stopped at a Jewish settlement for directions...

But a few minutes later we were heading for what looked like a Palestinian refugee camp or town...

284

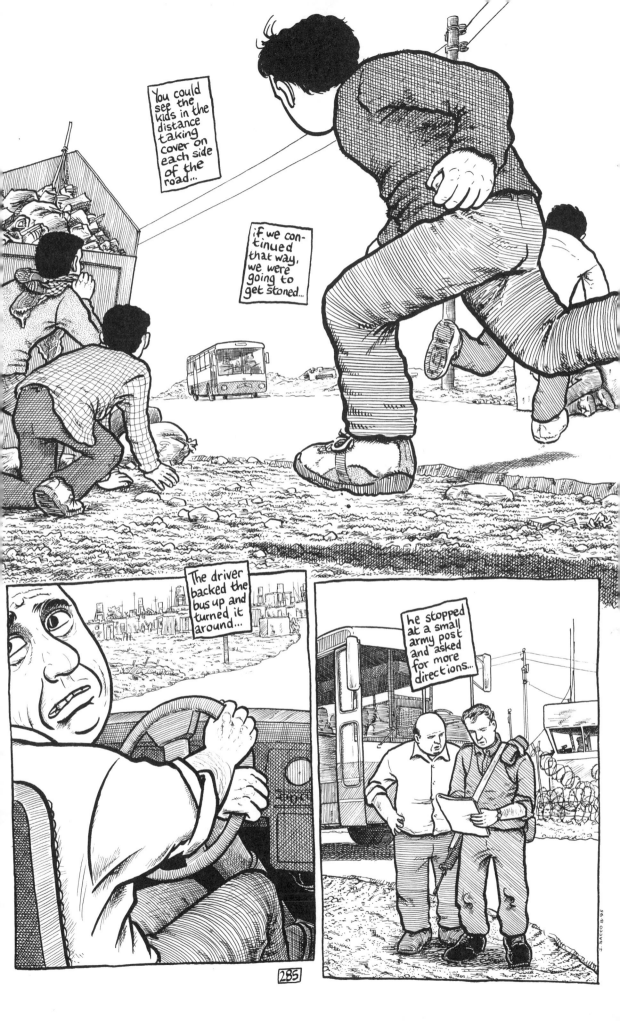

You could see the kids in the distance taking cover on each side of the road...

if we continued that way, we were going to get stoned...

The driver backed the bus up and turned it around...

he stopped at a small army post and asked for more directions...

About the Author

photograph by Michael Tierney

Joe Sacco was born in Malta. He graduated from the University of Oregon with a degree in journalism. His comic book *Palestine*, about his time in the Occupied Territories, won an American Book Award in 1996, and his graphic novel *Safe Area: Gorazde*, about his time in Bosnia won the Will Eisner Award for Best Original Graphic Novel in 2001. Sacco has also contributed graphic journalism pieces to *Details*, *Time* magazine, and *Harper's*. His most recent book, *Footnotes in Gaza*, a sequel to *Palestine*, was released in late 2009 by Jonathan Cape.

Published by Jonathan Cape 2003

16 18 20 21 19 17

First published in the United States in *Palestine* 1–9 by Fantagraphics Books

First published in Great Britain in 2003 by
Jonathan Cape
Random House, 20 Vauxhall Bridge Road,
London SW1V 2SA

www.rbooks.co.uk

Addresses for companies within The Random House Group Limited can be found at:
www.randomhouse.co.uk/offices.htm

The Random House Group Limited Reg. No. 954009

A CIP catalogue record for this book is available from the British Library

ISBN 9780224069823

Printed and bound in Great Britain by
MPG Books Ltd, Bodmin, Cornwall